Sculpture

Sculpture

Tools, Materials, and Techniques

SECOND EDITION

Wilbert Verhelst

PRENTICE–HALL, INC., Englewood Cliffs, New Jersey 07632

Library of Congress Cataloging-in-Publication Data

VERHELST, WILBERT, 1923–
 Sculpture: tools, materials, and techniques.

 Bibliography
 Includes index.
 1. Sculpture. I. Title.
NB1140.V47 1987 731.4 86-18650
ISBN 0-13-796749-7

Editorial/production supervision and
 interior design by Martha Masterson
Cover design: Lundgren Graphics, Ltd.
Manufacturing buyer Raymond Keating

© 1988 by Prentice-Hall, Inc.
A Division of Simon & Schuster
Englewood Cliffs, New Jersey 07632

Printed in the United States of America

10 9 8 7 6 5 4 3 2 1

ISBN 0-13-796749-7 01

PRENTICE-HALL INTERNATIONAL (UK) LIMITED, *London*
PRENTICE-HALL OF AUSTRALIA PTY. LIMITED, *Sydney*
PRENTICE-HALL CANADA INC., *Toronto*
PRENTICE-HALL HISPANOAMERICANA, S.A., *Mexico*
PRENTICE-HALL OF INDIA PRIVATE LIMITED, *New Delhi*
PRENTICE-HALL OF JAPAN, INC., *Tokyo*
PRENTICE-HALL OF SOUTHEAST ASIA PTE. LTD., *Singapore*
EDITORA PRENTICE-HALL DO BRASIL, LTDA., *Rio de Janeiro*

Contents

Preface

This book is intended primarily as an introduction to tools, materials, and techniques. Although directed at sculptural design, it should prove equally useful in other three-dimensional areas. As well as introducing traditional processes, I was particularly interested in providing basic information on recent industrial materials, tools, and processes that have become applicable to the field of sculpture and dimensional design.

Often beginning sculpture students are not overly familiar with the newer tools and materials. The language that is normally associated with industry or with wood, metal, or plastic fabricators has also become the language of sculptors. In many cases, rather than rely on sculpture supply houses, the sculptors have turned to hardware stores, lumber yards, or industrial suppliers. They are no longer so concerned with mallets, chisels, clay, or modeling tools but rather they are interested in nails, nuts, bolts, resins, and other kinds of industrial material and equipment. It has become as essential to know how to handle power saws and welding equipment as it is to know how to manipulate clay tools and chisels. Sculptors today should be as much at home in wordworking or metal shops as they are in modeling studios.

As a result of students' need to know more about the more recent developments in sculpture, this book emphasizes information about and photographs of tools, materials, equipment, and sculpture in process. It presents simple tools and techniques suitable for beginners as well as more advanced information for advanced students and for the practicing sculptors.

The abundance of twentieth-century technology applicable to sculpture means that limitless resources are also available for creative sculpture or design. To present precise detail for all processes used in sculpture today or industrial processes with potential are beyond the scope of an introductory book of this kind. This area has become so vast that it would require numerous volumes. At best, this book can hope to serve as a reference and guide to more extensive research in specific areas.

Acknowledgment is due the many individuals, industrial firms, and suppliers who have helped to make this book possible. My indebtedness to students, sculptors, and other specialists cannot be overlooked. Learning about tools, materials, and techniques has oftentimes been a mutual experience that took place in the classroom, studio, or fabrication shop, or during a rap session over a cold drink. Many of the industrial suppliers listed in the supply section of this book have generously contributed product and technical information. The bibliography lists numerous

sources that proved helpful in developing concepts about tools, materials, and processes. I would like to particularly express my appreciation to Southern Methodist University and The Meadows School of the Arts. Their generous research leaves gave me the time to make the current revision of this book possible.

WILBERT VERHELST

Introduction

Over the past two decades new—or, if not new, at least highly dissimilar—attitudes have emerged about sculpture. These attitudes have had distinct bearing on our acceptance of new technology and approaches to solving sculptural problems.

As well as interest in new materials and devices, a new spatial concept for sculpture, working beyond the limits of the pedestal, has developed new interest in large-scale works. Concepts encompassing exterior space or the interior environments of galleries, rooms, and buildings have further developed artists' visions.

These concepts, along with an interest in technological advances and their application to sculpture, have produced a new form of sculpture as well as a new kind of sculptor. In many instances sculptors no longer work as lone individuals but must rely on technical assistance from industry. The complexity of form or of presentation often demands that other individuals must carry out the execution or production of their concepts; the work becomes a team effort rather than the product of one individual. Environmental art, happenings, and multimedia presentations with increased spectator involvement become new art forms alien to the traditional concept of sculpture.

This new interest in technology has placed new demands on the artist and sculptor. The use of computers, lasers, electronic devices, and circuitry has placed the artist in a position to use knowledge and techniques not ordinarily associated with sculpture or the arts.

Until recently, much sculptural expression was the result of concepts of materials which had historical precedence. A proper approach to form was to think in terms of wood, cast bronze, or stone. The creative concept was bound to a notion of permanence. Self-expression was not closely linked to twentieth-century technology. Many of us educated thirty or forty years ago remember only too well the rigidity of our education, the disdain for plastic or new materials, the dogma of purity of form and material. A concept of prior knowledge of art as the most essential criterion for creative development denied the value of the logical evolution of tools and materials. The semantic and scientific rationale of experimentation and investigation as a means to discovery (the backbone of technology) was often denied to art students. Their creative spirits were inhibited by aesthetic criteria for both form and material. In these surroundings the students' products too often simply mirrored prior works of art. They were bound to their pasts by carefully packaged curricula and avenues of recognition.

Permanence of material, although undoubtedly desirable for some sculpture, should not be the de-

termining factor in judging aesthetic merit. Sculptors who accept impermanence as a condition of achieving self-expression certainly hold an acceptable and valid position. The choice of form and material should rest with the sculptors.

Traditional materials as well as the new continue to serve sculptors as avenues to self-expression. Prejudice against the traditional processes can be as limiting as prejudice against the new. Misplaced concepts of aesthetic worth and significance are frequently attributed to both.

The discovery of a material or a visual property in a material or the restatement of a quality in a traditional material does not in itself constitute a work of significance. Ultimately, it is sculptors' abilities to transform the materials into their statements that give works import.

Formal notions about design and form, although effective means to conceptualization, also serve as obstacles to creative development. Exploration of unknown visual qualities and the willingness to experiment and depart from established concepts allow growth and subsequent new visual forms and experiences.

Materials are not easily shaped into the forms sculptors desire. The finished forms may result in only approximations of what they expected, and they are compelled to continue their searches. They must learn to live with the insecurity of the unknown qualities that accompany experimentation. Attempting to reveal a personal feeling about form is not a comfortable or easy task. Developing the necessary skills with tools and material is essential to achieving this kind of personal ability. Results cannot always be expected to come from the first efforts. There is no substitute for accumulating experience by working with a material. Through experience, each sculptor develops many personal variations to material and technique in order to achieve his or her own form and style and technique.

Failure of first attempts should not be interpreted as a lack of ability; it should be recognized as a natural condition of attempting to master the complexity of three-dimensional expression. It is many times a case of reeducating the senses and acquiring those skills which make self-expression possible.

Sculpture

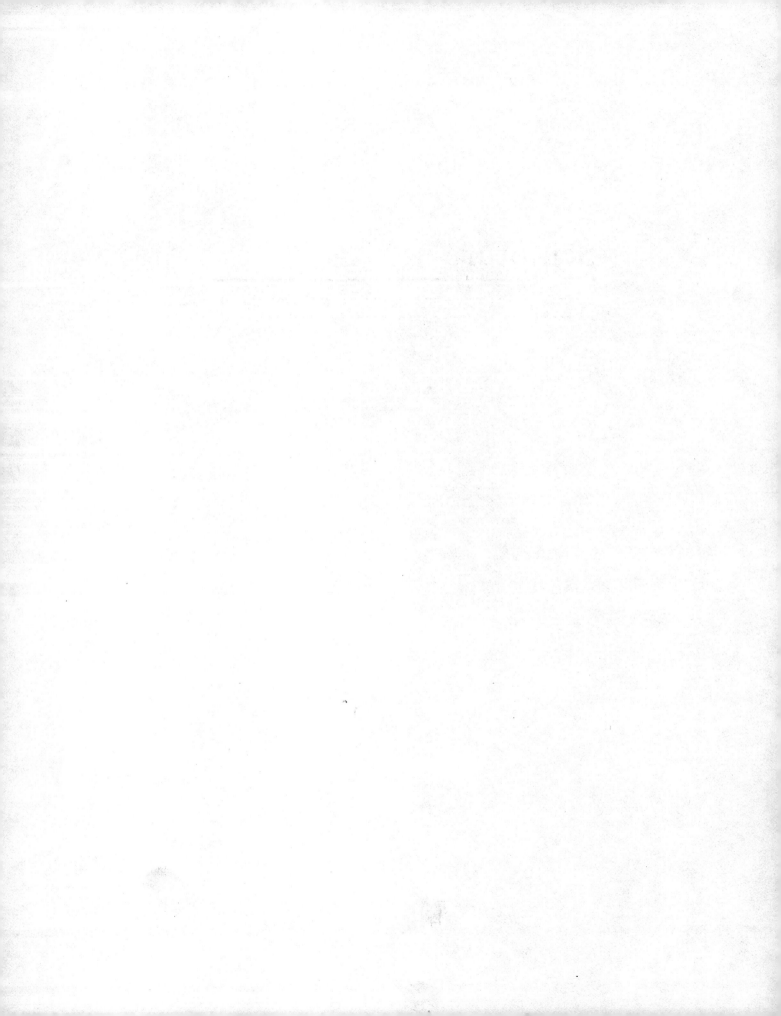

Modeling
and
Pattern-Making

1

Modeling or pattern-making involves using temporary or impermanent materials—because the basic objective is to arrive at a sculptural form that can serve as a pattern or model to be reproduced in a more permanent material. Patterns can be of wood, wax, clay, urethane or polystyrene foam, plastic, plaster, metal, cardboard, or any other suitable material. The degree of permanence required of the pattern often depends on the number of times it is to be used. Generally, a sculptor is satisfied with a pattern material sufficient for a single reproduction, whereas industry demands permanent patterns for mass production.

In a sense, the casting technique, the material, and the form of the final reproduction all determine the pattern material. Complex forms with textural surfaces usually merit modeling in clay or wax. Simple plane forms can be built more rapidly out of wood, cardboard, or other rigid materials. Proper selection of pattern-making material can save time and improve the quality of the final sculpture.

CLAY

Traditionally, modeling was done with earth clays, which are available from sculpture and ceramic-material suppliers either as prepared modeling clays or as dry powders to be mixed with water. The prepared modeling clays are most convenient for the sculptor and should be kept moist while in storage and during the modeling process. If allowed to dry out, earth clays can be reconditioned by breaking them into small pieces and soaking them in water; excess water is removed from the reconditioned clay mass by placing it in layers about 2 inches thick on dry plaster slabs, allowing the clay to dry until the desired working consistency is achieved. An unpainted concrete floor will work as effectively as plaster bats.

Synthetic clays with oil bases are also available. Since they do not dry out, they are preferred by some sculptors. Oil-based clay can be made by mixing dry powdered clay with wax, oil, and grease. A typical formula would be:

5 qts. no. 30 motor oil;
5 lbs. medium weight grease;
20 lbs. microcrystaline wax;
50 lbs. fine powdered clay.

The oil, grease, and wax are first heated in a metal container. After the wax has melted, the powdered clay is mixed into the hot solution. A heavy-duty, one-half-inch electric drill with a mixing blade is used to

1

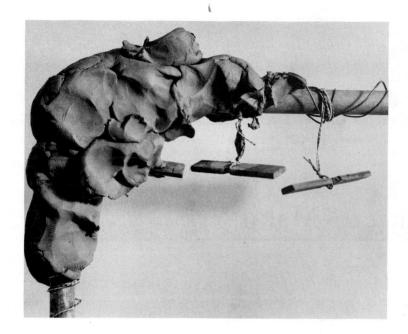

Figure 1–1
Wood supports for clay—called butterflies—on a pipe armature.

blend the mixture. If the clay is too hard, the mixture can be reheated and more oil can be added. If a harder mixture is desired, more clay is added. The clay solution can be poured into small greased cardboard boxes to cool to a putty-like consistency. In many cases, the earth clays are preferred because of their textural possibilities, ease of handling and tooling, and plasticity in finishing.

In simple massive forms, clay can be built up to the desired shape without using internal supports. However, in many cases an armature will be needed. The armature, like the steel framework of a building, serves to support the material. Simple armatures for heads and figures are sold by sculpture suppliers and are useful for small figurative work. In most cases today, however, the form the sculptor visualizes does not adapt itself in scale or configuration to this kind of armature.

An armature can be made from any material that will provide the needed form and support for the clay. In fact, careful consideration should be given to the armature material in relation to the sculptural design problem to be solved. Having a well-constructed armature of the right material will save you time and frustration, because a faulty armature often results in loss of the pattern or rebuilding of the work.

When the only needed support is a center shaft or core, it can be made from wood, a polystyrene foam block, or a piece of galvanized pipe. Complex armatures can also be made of wood, galvanized pipe, or concrete reinforcing rod and wire mesh. Wood and pipe armatures are usually wrapped with wire to hold the clay to them. Clay is held in place on the underneath surfaces of the form by the use of wood cross members called "butterflies." (Figures 1–1 and 1–2)

Wood armatures can be assembled with nails or, for maximum strength, with wood screws. Fir or yellow pine is usually an adequate material. The wood armature should be sealed with two coats of shellac to partially waterproof it. If necessary, poultry netting, or ¼-inch mesh hardware cloth can be stapled or tacked to the wood to hold the clay. (Figures 1–3,

Figure 1–2
Wire armature for a small figure.

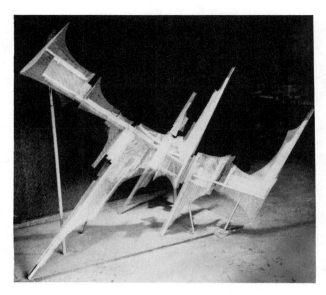

Figure 1–3
Wood armature with wire hardware cloth covering. Covering could also be made of metal lath.

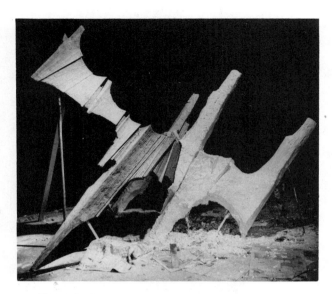

Figure 1–4
Armature has been covered with clay, construction of the mold was begun on the right half. By author, 1968.

1–4, 1–5, and 1–6) Although a wood armature is sometimes the best support for a clay structure, in many cases, a metal armature is far superior.

If you own oxyacetylene or arc-welding equipment, a welded armature constructed out of ⅜-inch reinforcing rod is by far the best approach for making large linear or complex armatures. The rod can be easily cut to appropriate lengths with the cutting torch. By heating the rod to a bright red, it can be bent into any desired configuration. The rods can be assembled by fusion welding or brazing. Building a steel armature is like building a bridge: diagonal supports are welded to transfer stresses and give the armature stability. To prevent rust, the armature can be primed

Figure 1–6
Plaster and fiberglass mat applied over armature as a support for a finishing layer of clay. By Chuck Tomlins.

Figure 1–5
Section of a steel pipe, wire poultry netting, and wood armature. By Chuck Tomlins.

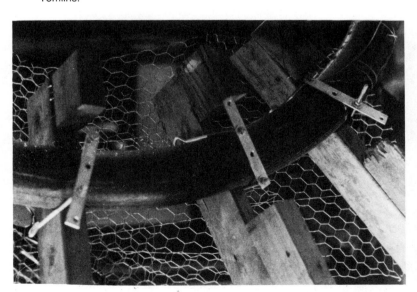

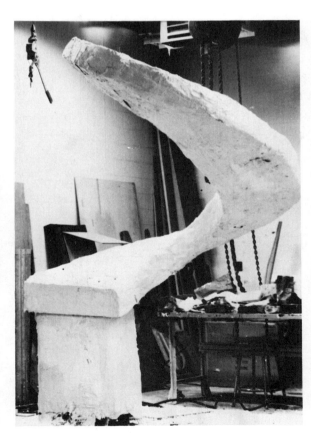

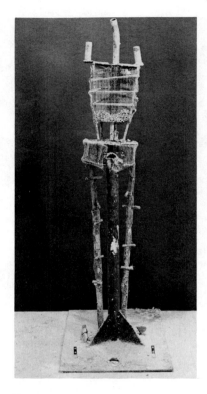

Figure 1–7
Welded steel and hardware cloth
armature.

degree and 40-degree elbows and tees are used to change directions. Piping can be purchased in various lengths, prethreaded to facilitate assembly.

After the armature is constructed, the clay is packed around it. The core of clay on the inside should be reasonably firm and drier than the outer layer. This can be accomplished by allowing the core to dry slightly and firm up before applying successive layers. Small blocks of polystyrene might be included in the inner core to provide some of the bulk. Excessively moist clay on the inner layer will result in a greater degree of shrinkage, and will produce surface cracks as the work develops and nears completion. As the clay is being applied, it can be packed with a wood mallet or large, flat stick.

Application of the final layer of clay will depend on the surface texture you desire. Some sculptors achieve complex surface variations, maintaining the plastic quality of the clay as an ultimate aesthetic. Tooling and applying clay with fingers, both producing varied textural results, are typical of this approach. (Figure 1–9) In another approach, sculptors are unconcerned with the texture of the clay; they use the material merely as a pattern-making device. The clay is modeled to a smooth surface, and the sculptors are concerned with the texture and qualities of the material in the final casting.

To give a clay model a smooth finish, the surface of the clay must be allowed to become firm. If the clay is too moist and soft, it tends to shift, and the finishing tools dig into the surface. This is why earth clay is usually preferred: The sculptor can allow moisture to evaporate until the surface achieves the desired firmness for finishing. Applying water to clay and attempting to smooth it with the fingers is a poor way

with a rust-inhibiting primer, although this is not necessary. (Figure 1–7)

If welding equipment is not available, excellent metal armatures can be constructed out of ½-inch, or larger, galvanized steel pipe instead. (Figure 1–8) Flanges are screwed or bolted to the wood base. 90-

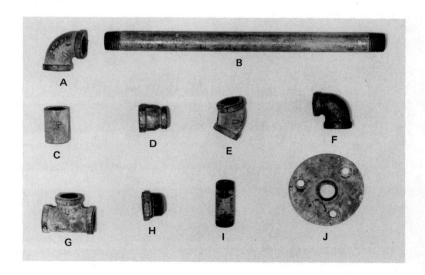

Figure 1–8
Fittings used to construct steel-pipe armatures: (A) 90° elbow; (B) steel pipe; (c) coupling; (D) reducing coupling; (E) 45° elbow; (F) reducing elbow; (G) tee; (H) reducing bushing; (I) nipple; (J) flange.

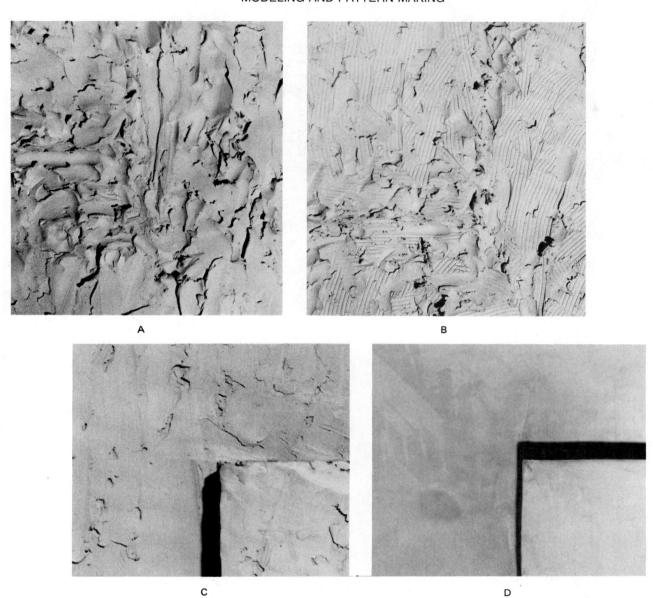

Figure 1-9
Clay textures. Clay: (A) roughly applied with fingers; (B) roughly applied with toothed tool texture; (C) roughly applied, flattened, and smoothed with flat wood tools; and (D) finished with flat wood tools. Final smooth finish is achieved with steel scrapers.

to achieve a smooth surface; it softens the surface and encourages irregularities.

Another important concern in achieving good surfaces and contours is the direction the clay is tooled. Whenever possible, work across the contours. Figure 1–10 illustrates how irregularities are removed by working across the contour with the straight edge of

a tool. Figure 1–11 illustrates the improper method, working in the direction of the contour.

Clay-modeling tools can be obtained in a wide variety of shapes. There are flexible steel scrapers and rubber shapes, ideal for smooth finishing; wooden shapes, for contouring and for finishing in curved or inaccessible areas; and wire clay cutters for cutting off

Figure 1–10
Proper finishing technique, working across the contour of a clay pattern.

Figure 1–11
Improper finishing technique, working in the direction of the contour.

Figure 1–12
Flexible steel scrapers.

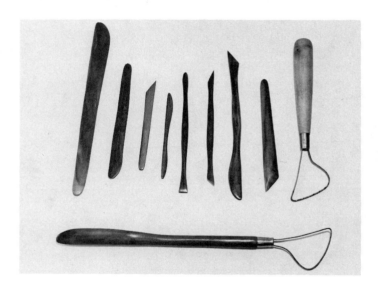

Figure 1–13
Clay finishing tools.

Figure 1–14
Studio-built clay finishing tools. A, B, N, and K are fashioned from pieces of old bandsaw blades; C and M, wire-cutting and scraping tools; D through J, wood tools; and L, paddle for packing clay.

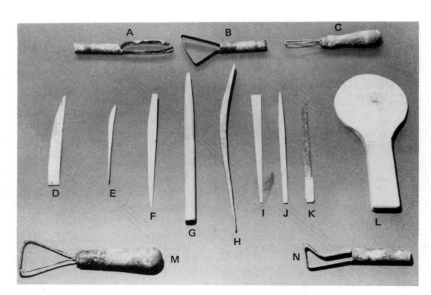

excess material, texturing, and roughing out the form. (Figures 1–12 and 1–13)

Each sculptor usually discovers the tools that most satisfactorily meet his or her needs. Many also fashion their own tools to solve particular modeling problems. Wire clay cutters, for example, are simple to construct; thin sheet metal (about 26-gauge) can be cut to any desired shape for scrapers; wood shapes can also be cut—on a band saw—or carved and sanded to any desired form. (Figure 1–14) I have always preferred to fashion most of my tools from strips of wood or sheet metal, which allows me to design a tool to a particular need, to reach inaccessible areas, to fit a particular contour, or to produce textural effects. For example, a rough-cut tool, slightly sanded or unsanded, will apply clay differently from a smoothly sanded tool. A tool design I have found extremely useful is the long-curved shape in Figure 1–14H, which can be made with wide, flat ends, round ends, or points. The principal advantage of the curve over the more conventional, straight tool is that it keeps the knuckles of the hand away from the surface and adapts to a greater variety of surfaces.

FOAM PATTERNS

Foam patterns are relatively new to the sculptor. Undoubtedly, their use will increase as more sculptors become aware of their potential. The light weight and ease of forming foam make it an exceptionally good material for large-scale patterns.

Polystyrene and urethane foam, readily available in sheets and blocks, can be carved, rasped, and easily fabricated into large shapes. A length of band-saw blade wrapped with masking tape on one end or a key hole saw can also be used for sawing holes and for shaping the foam. An electric cutting wire can be used to cut the foam easily. (Figure 1–15) Be sure to have proper ventilation, because inhaling the fumes from the burning foam may be irritating or toxic. A simple cutting tool you can make yourself is shown in Figure 1–16.

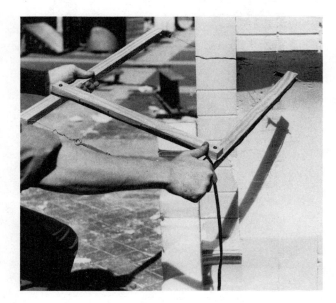

Figure 1–15
Cutting foam with the hot-wire cutting tool.

Figure 1–16
Hot-wire cutting tool for cutting plastic foams.

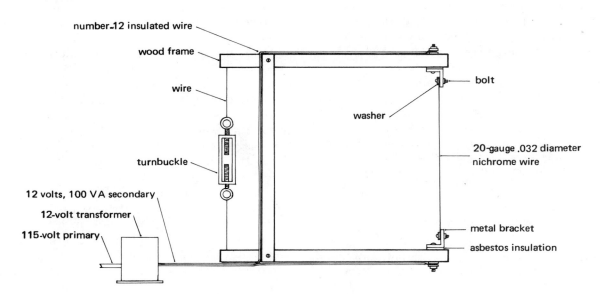

number-12 insulated wire

wood frame

wire

turnbuckle

12 volts, 100 V A secondary

12-volt transformer

115-volt primary

bolt

washer

20-gauge .032 diameter nichrome wire

metal bracket

asbestos insulation

Figure 1–17
Foam pattern being developed.
Student project, Southern Methodist University.

illustrated in Figure 2–23, is often used. (In this process plaster cannot be used for joining foam.)

4. The polystyrene foam pattern is covered with a layer of wax approximating the metal thickness desired. The wax is developed to the desired surface finish and the foam pattern is dissolved with acetone. The resulting wax pattern may then be used for lost-wax casting. This is becoming a highly successful way of doing large works; the wax pattern is cut into sections for the final casting. In some instances, the foam is left in the wax pattern until the outer mold is built.
5. The foam pattern is covered with plaster, or fiberglass, or plastic resins and fillers, resulting in a finished work.

In addition, liquid urethane can be poured into large cardboard boxes to cast solid blocks of urethane.

WAX PATTERNS

In lost-wax casting, the wax model can be solid if the work is small; larger works require hollow patterns, however, because of the weight of the metal and excess shrinkage of large metal masses.

The hollow wax pattern is achieved either by building the form directly out of wax or by building the form out of another material, making a plaster piece mold or flexible mold (described in Chapter 2, pages 15 and 17), and casting a wax pattern. Some sculptors prefer the spontaneity of working directly with the wax, although this is somewhat risky; if the casting is unsuccessful, the work is lost and a new pattern must be built. On the other hand, it is simple to cast a new wax pattern from a mold if the metal casting fails. (Figures 1–18 through 1–21)

Although there are formulas (containing beeswax or paraffin) for making modeling wax, this practice is somewhat outdated, because a wide variety of prepared waxes are readily available. The wax most sculptors use today is a petroleum derivative called "microcrystalline wax." Less expensive than beeswax formulas, it is available in various hardnesses. The wax is usually tinted dark brown, almost bronze-colored, making it easy to distinguish surface texture and details as they would appear in a bronze casting. If the wax you purchase is not dark brown, you can tint it readily by adding powdered lampblack pigment to the melted wax.

Soft waxes are at times preferable for directly built patterns, whereas harder waxes are best for cast patterns, for reducing distortion in large patterns, and, sometimes, for accommodating variance in room temperature. A wax handled easily at 70 degrees might be too soft at 90 to 100 degrees. This problem can be overcome by adding paraffin to harden the wax, vase-

Pieces can be cemented together with plaster of Paris mixed to a paste-like consistency or with adhesives. The blocks or pieces can be temporarily pinned with nails until the plaster sets. Patching and buildup can be achieved by using plaster of Paris. (Figure 1–17)

Some of the common ways foam is used are as follows:

1. The foam is carved, rasped, and sanded to arrive at finished forms, from which a negative mold is made, incorporating the texture of the foam. Urethane foam has a finer texture than polystyrene and should be used when finer surfaces are desired.
2. The foam model acts as a core or armature, and the final surface is developed with modeling clay to provide a finished work from which a negative mold is made.
3. The foam pattern is packed in sand and directly cast in metal. The hot metal vaporizes and displaces the foam. A gating system (described in Chapter 2) must be attached to the pattern. Top gating or pouring, as

Figure 1–18
Pouring wax into a plaster piece mold.

Figure 1–19
Removing plaster mold from wax pattern.

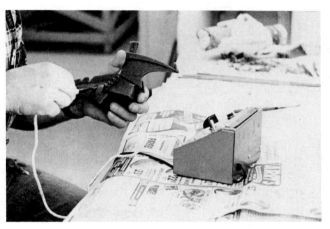

Figure 1–20
Finishing wax pattern with an electric finishing tool.

Figure 1–21
Finished wax patterns for a sculpture multiple. Pouring cups and vents have been attached in preparation for ceramic shell investment. (Note use of polystyrene cups to form pouring cups and soda straws as vent material.

line or 30-weight motor oil to soften it. If you are doing a lot of wax modeling, it is more practical to purchase quantities of wax with different working consistencies.

To develop a direct wax pattern, first melt the wax and pour slabs to the desired thickness of the final metal casting (usually ⅛, 3/16, or ¼ inch, depending on the size of the work). The wax can be melted in a commercial melting pot. (Figure 1–22) For small quantities, less expensive devices you can use are double boilers, electric saucepans, or electric frying pans. Heat only to the melting point—do not overheat. After the wax has melted, pour it on a moist plaster slab recessed to the desired thickness to contain the molten wax. If the plaster is too wet, small pot marks will form on the surface of the wax slab. After they have cooled, the wax sheets are removed and are ready for use. They can be cut and bent into the desired shapes and joined with a hot metal spatula warmed over a bunsen burner. Sometimes, the wax

Figure 1–22
Wax melting pot.

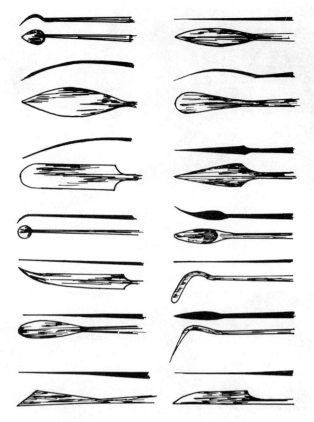

Figure 1–23
Typical tool shapes for wax modeling and finishing.

Figure 1–24
A simple pattern being developed from plaster using a wood template as a screed. *By sculptor James Surls, 1970.*

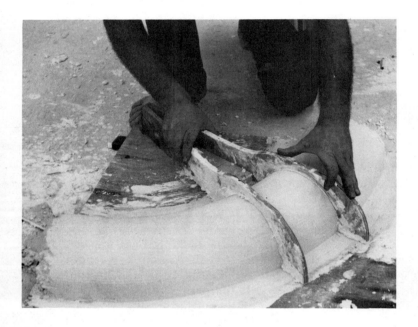

pieces may need slight warming to make them softer and more flexible. One of the least expensive devices for this is an infrared bulb mounted over a table.

Tools for wax modeling can be made of metal or wood. Metal plaster-modeling tools are very adaptable; you could also fashion your own tools out of strips of sheet metal, wire, and so on.

The wax pattern can be finished by tooling with a warm metal tool or textured with small pieces applied with the fingers. The potential for creating surface qualities are many, and only by working with the wax can you discover its potential. (Figure 1–23)

To make large wax patterns, it may be necessary to build internal supports, particularly when the pattern is cut into sections for casting. In this case, the supports should be constructed laterally, across the cut area, to prevent distortion in the handling of the pattern during the casting. Each pattern has its own design problems. Learning which areas of your wax pattern need support is, essentially, a matter of experience.

In casting a wax pattern, the melted wax is poured into a moist plaster mold or a flexible mold treated with a separator. As the wax cools, a layer of wax is formed next to the mold wall. The temperature of the wax should remain as low as possible (about 150 degrees). If you do not have a melting pot with a temperature control, heat the wax until melted and then allow to cool until a thin skin forms over it. At that point the temperature should be approximately right. Break the surface skin and pour the wax. As soon as the layer of wax is your desired thickness, pour the excess wax back into the container. In some cases, you might want to build the wax pattern up into several layers, each about 1/16-inch thick; empty the mold several times. This practice seems desirable for making complex patterns because it ensures a more uniformly thick pattern wall. For open-face relief molds or large molds that have the surfaces accessible, you can brush the wax on until you achieve the desired thickness.

Another approach to direct wax patterns is to build the wax pattern and not be concerned with the thickness of the wax wall. In this technique, the wax

pattern is covered with the investment material, the investment shell is dewaxed with steam, and the outer shell is recharged with melted wax and poured off when the desired thickness is achieved. A core is then added, and the work is ready for casting after burnout. Details of this approach are similar to the mold techniques discussed on pages 30 and 31 in Chapter 2.

Principal advantages of this approach are not having to worry about the thickness of the wax wall in developing the pattern, greater rigidity in the pattern (minimizing distortion of the pattern during application of the investment material), and the elimination of pattern distortion due to wax shrinkage.

PLASTER

Plaster patterns are achieved by casting into a plaster or flexible mold or by building the plaster directly on an armature. For simple forms, special jigs or screeds can be used to contour the plaster forms. (Figure 1–24) Chapters 3 and 4 contain basic techniques for casting or building patterns directly.

WOOD

Wood patterns can be built with basic wood-carving or wood-fabrication techniques. The wood pattern is used when semipermanent molds are desired or when the pattern can be constructed readily out of wood. Flat shapes or shapes that can be turned on a lathe are typical examples. (Figures 1–25 and 1–26)

PAPER AND CARDBOARD

Patterns can be built out of paper mache (strips of newspaper and thin wheat paste) or cardboard. Patterns of this kind are particularly applicable to direct techniques with a final, more permanent surface of fiberglass and polyester resin. When building simple geometric shapes, flat, rigid cardboard patterns can be constructed as a substitute for wood forms. The cardboard form is sealed with two coats of shellac or lacquer and treated with a paste wax or oil-based release agent if a plaster mold is to be made from the cardboard pattern.

Figure 1–25
Wood patterns for parts of a cast sculpture. *By sculptor James Surls, 1970.*

Figure 1–26
A wood and oil clay pattern on the left with the sand mold removed on the right. *By sculptor James Surls, 1970.*

Mold-Making Techniques

2

With traditional and present-day materials, there are many methods for mold-making. Some molding materials date far back into history. Early molds were, undoubtedly, earth materials such as loams or natural clays, followed by plaster sand investments. Today, technological research by industry has produced investment and molding materials capable of coping with almost any molding problem that might arise. Generally, some of the simpler techniques serve the sculptor's needs quite well, and conditions unacceptable to industry are often suitable for individual sculptural design.

Good craftsmanship and work habits are essential in mold-making. Faulty or sloppy mold construction usually results in excessive time required finishing the cast positive. A poorly constructed mold can also cause irreparable damage to, or loss of, the casting. Perfect results cannot be expected on the first attempt, however, and it is advisable to keep the first project small and simple, not risking loss of a work in which considerable time has been spent.

The selection of a molding technique and material generally depends on a variety of factors, some of which are as follows:

1. Suitability to ultimate casting media.
2. Number of castings desired from a single mold.
3. Suitability to form being cast.
4. Accuracy desired in reproduction of pattern.
5. Accuracy desired in surface detail.
6. Handling; weight of mold.
7. Cost of molding materials.
8. Availability of materials.
9. Time involved in mold technique.
10. Feasibility in relation to studio and equipment available.

Some of the more common molding processes used by the sculptor are plaster waste or piece molds, for simple casting of plaster, concrete, plastic resins with fillers and fiberglass. Sand, plaster investment, and ceramic shell molds are used for metal. Wood, cardboard, foam, and other materials can be used for simple direct molds for casting plaster, concrete, and plastics.

PLASTER WASTE MOLD

The waste mold is usually the simplest to construct and the most economical to build. Plaster waste molding is an efficient method of achieving a negative from a clay or foam model when a single casting is desired in gypsum cements, plastic, or fiberglass. Making a plaster waste mold involves the fundamental steps

necessary to build any mold. Once these procedures are grasped, it is easy to attain more complexity in mold construction.

As the term implies, the waste-mold technique involves wasting or destroying the mold by breaking and chipping it away from the cast positive. The first step in preparing a clay pattern for a waste mold is to divide the pattern into two or more sections. This is accomplished by inserting a wall of metal shims, or building a wall of clay strips, to section off the work. In selecting the sections, try to eliminate as many undercuts as possible. Wherever the mold joins, a slight seam will show on the cast positive, so try to locate the dividing lines where the seams will be most accessible. If you use the clay rather than metal shims, make several indentations in the clay wall to serve as registration marks for mold alignment.

When the clay wall is used to section the mold, the mold is made a section at a time. The edges of each mold section must be treated with a separator, such as liquid soap or vaseline, before the next section is built. The principal advantage in using a clay wall is that there is less of a seam, and the cast positive and mold alignment are usually better.

After the work is divided into sections, the next step is to spatter, spray, or brush a thin coat of molding plaster on the pattern section being molded. An R-2 all-materials spray, particularly useful for large molds and surfaces, can also be used for spraying plaster. U.S. Gypsum No. 1 molding plaster is used by most sculptors. This first coating should be tinted with household bluing or a small amount of colored pigment. This allows easier location of the cast positive in the process of removing the mold.

To mix the plaster, sprinkle it into the water until it floats and forms a dry film on top of the water. Let the mixture stand for a few minutes to allow lumps to dissolve, and then complete the mixing. If a thick mixture is needed, allow the mix to sit until it reaches the desired consistency, and then very rapidly apply it to the mold. Otherwise, you will have to add more plaster until the desired consistency is achieved.

After the spatter coat has set, apply additional coats of untinted plaster to the mold until a thickness of about ½ to ¾ inch is achieved. The plaster can be mixed to a putty-like consistency for this application. For large molds, the plaster should be thicker and the mold sections should be reinforced with wood strips, concrete reinforcing rod, wire mesh, burlap, jute, or hemp fiber dipped in plaster.

After the mold sections have been completed, the plaster is chipped away along the seams to expose the separation lines of the mold.

Another, preferred method is to build the mold

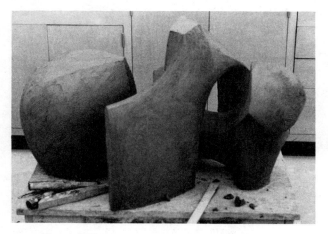

Figure 2–1
Clay pattern ready for a waste mold. *Sculpture by Charles Aberg.* Ca. 1966.

carefully without covering the separation lines. Next, wooden wedges are gently tapped into the seam to separate the mold sections from the clay pattern. Any remaining clay is removed from the mold sections and the sections are cleaned with soap and water. If steam cleaning is available, it is an efficient way to clean molds.

After being cleaned, the mold sections are ready for treatment with a separator, such as liquid soap, vaseline, or paste wax, and are assembled for casting. (Figures 2–1 through 2–7)

Figure 2–2
Clay wall has been built over the midsection of the clay sculpture; the plaster spatter coat is being applied.

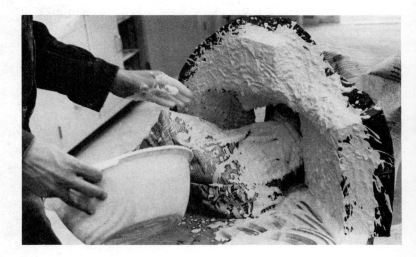

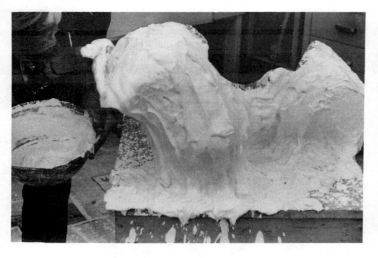

Figure 2–3
Thick plaster is being applied to build
up the outer layers of the mold.

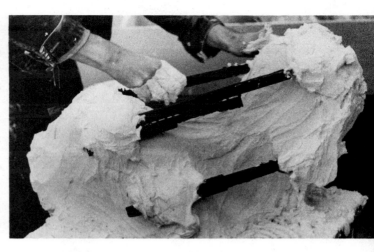

Figure 2–4
Reinforcing strips have been added to the mold.

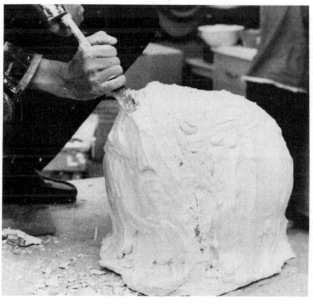

Figure 2–5
Completed mold for left section of the clay pattern.
Parting seam is being cleared.

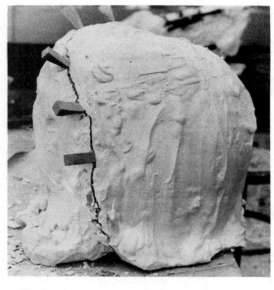

Figure 2–6
Wooden wedges are gently driven into parting seam
to separate mold sections.

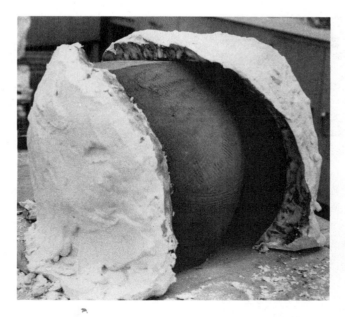

Figure 2–7
Mold sections separated, showing the clay pattern
inside the mold.

PLASTER PIECE MOLDS

Rigid plaster piece molds are effective for making several castings when the form is not too complex. Knowledge of this process is useful, not only where multiple castings are required, but also for constructing outer containing molds for flexible molds.

Prior to the development of flexible molds, reproducing a complex form with a plaster piece mold was a complicated, time-consuming procedure. Generally, when a work has numerous undercuts, a flexible mold is recommended; the plaster piece mold should be considered only if you are making a few simple parts small enough to be handled manually.

Building a piece mold is fundamentally the same as building a waste mold. The difference is that you need to build a mold of enough pieces that the pattern can be removed without causing damage to it or the mold. A careful study of the pattern is thus essential. Figure 2–8 illustrates a typical beginning of piece-mold construction. It is easy to identify the clay wall, a completed mold section, the spatter technique for

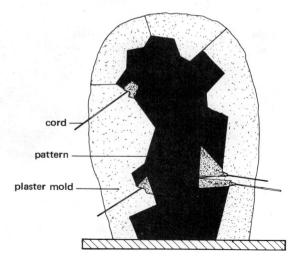

Figure 2–9
Cross-section of a piece mold involving undercuts.

the first coat, and the three, small, light dots along the seam indicating the interlocking registration points. Figure 2–9 is a diagram of a plaster piece mold. Note how the inner section accommodates an undercut and fits into the notched surface of the mold. The inner sections are built first. The exposed surface and cord are covered with vaseline prior to construction of the outer mold. The vaseline-coated cord attached to the inner section is pulled snug and tied to a wooden peg to hold the pieces in place.

Figure 2–8
Large piece mold being constructed from a clay pattern. By author, 1958. *Photograph by Marshall Brooks.*

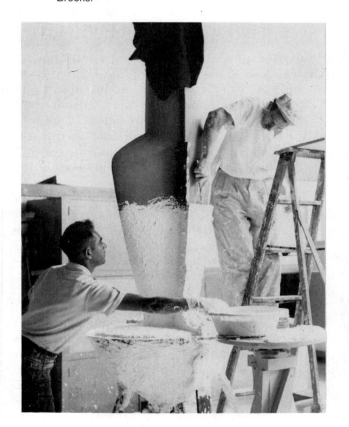

FIBERGLASS PIECE MOLDS

In recent years, fiberglass piece molds have been used in place of the typical plaster piece molds. Undoubtedly, if you are planning more than one casting, you should use the fiberglass mold.

The mold is essentially the same as the plaster piece mold, except layers of polyester resin and fiberglass reinforcing materials are used instead of layers of plaster. The pattern should be waxed with a paste wax. The fiberglass layup should be handled in the same manner as fiberglass positives, described in Chapter 3. (Figures 2–10 through 2–12)

The principal advantages of the fiberglass mold are its strength and ease of handling. It weighs less than a plaster mold, does not chip or break as readily, and can withstand a considerable number of castings. In fact, fiberglass molds actually possess a small degree of flexibility; moreover, an elastomer can be added to the resin to produce an even less rigid mold. Although still not as flexible as rubber mold materials, fiberglass with elastomer added allows for contours that a plaster mold cannot accommodate.

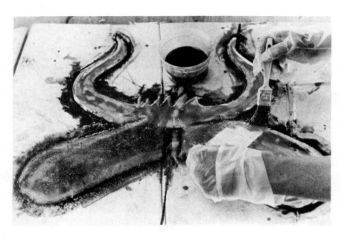

Figure 2–10
Wood pattern divided into two parts, gel coating of polyester resin has been applied. The fiberglass and resin are being applied to build up the mold.

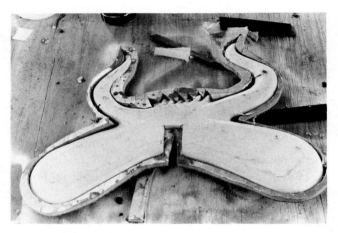

Figure 2–11
The board dividing the pattern has been removed, edges of mold have been trimmed, separator has been applied to pattern and mold edge fiberglass is applied to second side in the same manner as in Figure 2–10.

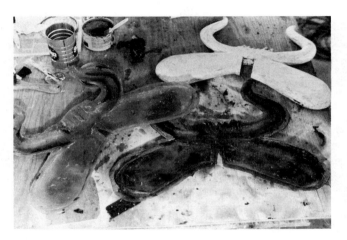

Figure 2–12
The two mold halves with the pattern removed.

The casting industry uses fiberglass molds for small-production runs for which the cost of metal molds is prohibitive; constructing a new fiberglass mold every several hundred castings proves more economical. Wood and fiberglass molds are also quite common in the boat-building industry.

DIRECT RELIEF MOLDS

Some sculptural reliefs are not adaptable to full three-dimensional forms. Several possibilities exist for constructing molds for such sculptures. These processes involve building molds directly as negatives; when complete, they are ready to receive cast media. In addition to foam, sand, clay, and wax, direct molds have been built from wood, paper, cardboard, inflat-

able sections of rubber, and combinations of these materials.

These direct-mold techniques are used in the classroom for spontaneous projects and have been overlooked as serious sculptural media. However, greater emphasis on sculptural forms in architecture in recent years have resulted in these processes being used with considerable success in the execution of large-scale, sculptural wall reliefs. For example, sculptor Albert S. Vrana, working in Florida, who has refined the use of direct polystyrene foam molds, utilizes them on a monumental scale. He works closely with architects, engineers, and building contractors to complete and execute his designs. Figures 3–10 through 3–17 show several steps in the construction of a direct mold and completion of a large wall relief.

Perhaps one of the most difficult problems with using the direct mold is learning to think in the negative. The student attempting this technique must realize that the deepest part of the mold becomes the furthest projection on the finished casting.

Figure 2–13 illustrates a typical direct-relief mold technique, using sand as the mold material. For this type of mold, you must moisten masonry sand or fine silica sand with old crankcase oil and pack it in a wooden frame. For small works, the sand can be moistened with water; for large works, however, the water-sand mixture dries too fast.

After the sand has been packed, the desired sculptural form is carved out of the sand, and, when completed, it is ready for casting. This technique is particularly suited to plaster or concrete castings when the forms are bold and simple. It is possible to carve directly into slabs of sand bonded with a no-bake binder. These can be used for metal casting.

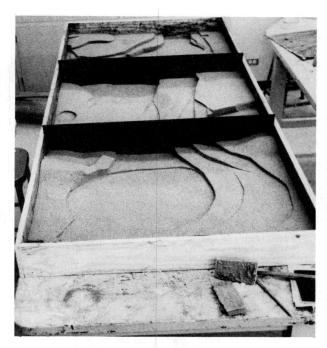

Figure 2–13
Direct relief mold in sand. *Student project, Southern Methodist University.*

If you are making intricate or detailed forms, moist modeling clay or wax can be used instead of sand. This approach lends itself to plaster or concrete casting. For exceedingly complex designs, plastic resin with filler material works effectively as a casting material.

Polystyrene foam or urethane foam offer many possibilities for creating direct molds. The foam pieces are nailed or glued to a plywood or foam backing. Large-scale architectural reliefs can be produced by fastening the foam to the inside surfaces of concrete forms and pouring the relief and wall at the same time. Or, preformed panels can be constructed, as in the work of Albert S. Vrana.

Using foam also allows you to create angular or rectangular forms or unusual textural surfaces—for instance, by burning or melting the foam or using poured urethane foam. Note though, if fiberglass or polyester resin and fillers are to be used as the casting material, it is advisable to use urethane foam to build the mold. Polystyrene will disintegrate when it comes into contact with polyester resins.

FLEXIBLE MOLDS

To make complex patterns—those from which you want more than one casting—or to prepare complex

hollow wax models for lost-wax techniques, the flexible mold is essential. Although using the plaster piece mold is a feasible way of producing complex forms, it is difficult to justify the time involved in that approach. Flexible molding materials have made producing a mold for intricate castings a relatively simple procedure.

Rubber molding compound has become the principal material used by industry and sculptors to produce flexible molds. Early rubber molds were made of air-curing latex materials. The more recent materials are silicone or polysulfide rubbers, which cure chemically at room temperature in anywhere from 24 to 48 hours. You can accelerate curing time by increasing the amount of catalyst, increasing room temperature, or using a curing oven. Follow manufacturers' recommendations on using these materials.

Generally, sculptors get good results using either air-curing or chemically curing materials at room temperature. The room temperature should be relatively warm (72 degrees or higher), because cool room temperatures may lengthen the curing time or, in many cases, result in incomplete curing and inferior molds. An inferior mold caused by bad curing conditions will usually lack tear strength and, for all practical purposes, be useless.

If room temperatures are too low, a simple curing oven for temperatures up to 150 degrees can be constructed with a wood frame covered with insulation board or foam sheet. This is lined with aluminum foil and equipped with several 100 watt light bulbs to achieve the desired temperature.

Silicone-rubber molding compounds are the costliest, but they produce the highest quality molds. They generally do not need release agents or separators and withstand numerous castings before losing their shape. For the sculptor, however, the less expensive rubbers are more than adequate for several castings.

There are two basic approaches to building a rubber mold. The molding material can be cast around the work, or it can be brushed on and built up with successive layers. The first process is practical for small forms and is frequently used by industry; the second method is more applicable to sculptured forms too large for the cast approach.

For the brushed layered technique, apply consecutive coats of the molding compound until the mold reaches the desired thickness (⅛ to ¼ inch, depending on mold size). Undercuts can then be eliminated by bridging over the spaces with fabric or fiberglass cloth dipped in or brushed with the molding compound. Pieces of sponge can also be fitted into undercut areas and coated with subsequent layers of molding com-

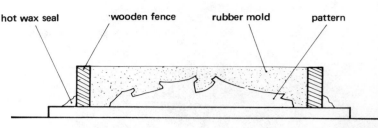

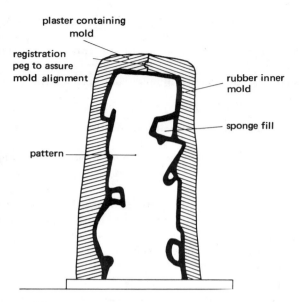

Figure 2–14
Flexible mold construction with molding compound brushed on.

Figure 2–15
Poured flexible mold technique for a relief.

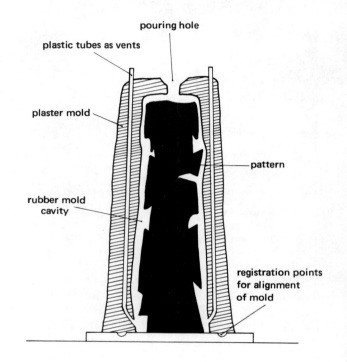

Figure 2–16
Containing mold and details of poured flexible mold.

pound. Like the plaster piece mold, the rubber mold can be made in several sections, or the whole pattern can be covered and the mold removed by slitting the rubber with a razor blade. Air-drying latex, the least expensive, is efficient for this approach, if ample time is available to allow for the drying of each coat. I prefer using two-part chemically curing materials, because it allows me to apply thicker coatings and mold construction thus takes considerably less time.

After the rubber mold is completed, a containing mold is needed to support the rubber. This is usually a two- or three-piece plaster mold for small works or a fiberglass piece mold for larger works. To facilitate removing of the rubber mold from the containing mold, the rubber can be covered with a layer of wet tissue or plastic film, such as Saran® Wrap, prior to building the containing mold.

If the sculpture pattern being reproduced is other than clay, it should be covered with a thin coating of paste wax before starting mold construction. (Figure 2–14)

When the rubber molding material is cast around the sculpture pattern, the containing mold is built first. In relief work, the process is quite simple, since all that is needed is a wooden fence or frame around the relief, with the edges sealed with masking tape, hot wax, or wet modeling clay. (Figure 2–15)

For three-dimensional forms, the problem is slightly more complex. The first step is to fasten the pattern to a board and cover it with a layer of Saran® Wrap. Countersink tapered holes into the board to assure positioning of the containing mold. The pattern is then covered with about ½ inch of soft, moist modeling clay, eliminating all undercuts. Sometimes it is necessary to include several vents to allow air to escape during the pouring of the rubber. This can be achieved with plastic tubing. After the pattern is covered with clay and the vents positioned, build a plaster or fiberglass mold in the usual fashion.

After the piece mold is completed, it is removed from the pattern. The layer of clay and Saran® Wrap are also removed. If the pattern is not made of clay,

the pattern and inside surface of the containing mold are then waxed when this is necessary, and the containing mold is reassembled around the pattern. The containing mold should be tied together and the edges sealed with plaster or hot wax. The mold is now ready for pouring. (Figure 2–16)

A room-temperature-cure molding compound is used in the cast-mold (sometimes called "closed mold") technique. Manufacturers' instructions should be followed. Generally, the molding materials are two different colored parts, which you should mix until all streaks disappear; using a mixing blade on an electric drill usually ensures that you will achieve a uniform, adequate mix. To make technically perfect molds, the mixed compound should be placed in a vacuum chamber to remove air bubbles from it (this is usually not essential for sculpture). Room temperature and mold temperature should be 72 degrees or higher. After the mold is poured, it should be vibrated slightly for a few minutes to eliminate air bubbles next to the surface of the pattern. (Figures 2–17 through 2–21)

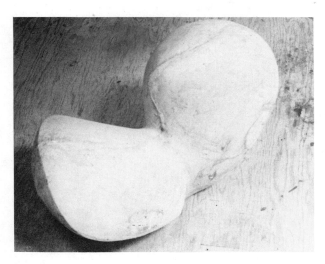

Figure 2–17
Plaster pattern for a flexible mold. *By sculptor Roger Kotoske*, 1970.

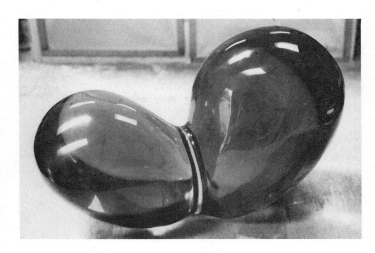

Figure 2–19
Completed cast polyester sculpture. *By sculptor Roger Kotoske*, 1970.

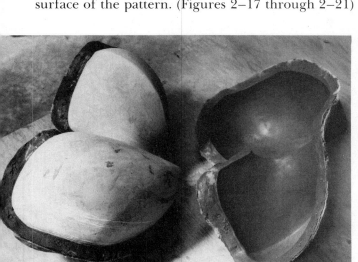

Figure 2–18
Flexible mold brush applied showing the pattern; flexible mold and the edges of the fiberglass containing mold. *By sculptor Roger Kotoske*, 1970.

Figure 2–20
Typical supplies and equipment for pouring flexible molds. (1) Vacuum chamber for removing air from mixture; (2) vacuum pump; (3) reusable polyethylene buckets; (4) vac-Seal grease for cover and chamber; (5) gyro plastic mixers; (6) hand cleaner. *Photograph courtesy of Plaster Supply House Industries, Inc.*

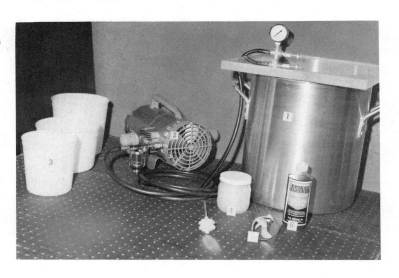

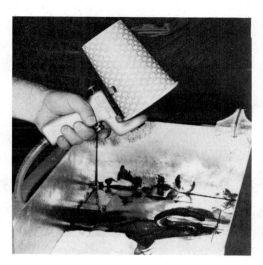

Figure 2–21
Spraying rubber molding material into a negative mold with an R-2 spray gun. *Photograph courtesy of Plaster Supply House Industries, Inc.*

PLASTIC MOLDS

When working with patterns of wood, metal, or materials that can withstand temperatures up to 400 degrees, several plastic materials make suitable flexible molds. These are particularly useful for relief molds or closed molds in which the form is not exceedingly complex and maximum flexibility is not needed.

Vinyl or polyethylene materials in powder, pellet, or shredded form are melted at 250 to 400 degrees and poured in the same manner as rubber molding materials. The vinyl or polyethylene are natural-release materials and release agents are not usually needed on the patterns or containing mold. The material can be melted in a commercial melting pot, oven, an electric frying pan, or deep-fry pan; with reasonable care, it can be melted in a double metal container on a hot plate.

Flexible polyesters and polyurethane foams can be used as mold material and should yield results for the student or sculptor who wishes to experiment with them.

METAL-CASTING MOLDS

A mold for metal casting consists of two basic ingredients: a material for bulk and strength and a substance to bind the material together. The bulk investment materials can be sand, perlite, earth-clay materials such as grog, pulverized investment material from old molds called "Luto," silica sands, and as-

bestos fiber. Binders may consist of clay, chemicals, plaster, or any of a variety of organic or inorganic materials.

The investment material and subsequent mold must be strong enough to withstand the weight and shock of hot molten metal. It must be sufficiently porous to accommodate gases from the molten metal, yet fine enough in texture to reproduce the detail and surface of the original pattern.

Today, a great variety of sands, fillers, and binders are available to sculptors and foundries. Materials and mold techniques vary considerably among sculptors and foundries, depending on the nature of their patterns, the quantities desired, and the metals or alloys being poured. Commercial foundries have, in fact, developed precise mold techniques capable of achieving high-quality castings within dimensional tolerances of a few thousandths of an inch.

There are three basic types of molds for metal-casting sculpture: sand molds, plaster investment molds, and ceramic shells. Until recent years plaster investment and the lost-wax process were the usual procedures for casting sculpture. However, in the past 20 years, new materials and broad experimentation by sculptors and foundries have resulted in the development of many simple and successful mold-making techniques. The particular mold technique a sculptor selects may depend on the piece he or she is casting, its material and size, his or her technical ability, personal preference, and the facilities and equipment at his or her disposal.

Small molds can be constructed and cast readily in the average studio; bulky, heavy molds require specialized handling equipment. Nonetheless, all metal-casting molds can be described with similar terms and characterized by similar features. The mold material may vary somewhat, but the essential components remain the same. The system for getting the molten metal into the mold cavity is referred to as the "gating system." Figure 2–22 is a typical example of a sand mold. Although sculptors seldom use sand molds in this precise form, many of their mold techniques are adaptations of the basic, foundry sand-mold process.

Following is a brief description of mold terms and the gating system:

Flasks. Containers used to hold the mold material during the construction of the mold or during the pouring. Steel and castiron flasks are used in the foundries. Wood flasks are sometimes used for short runs or odd-sized jobs. The lower section of the flask is referred to as the "drag," the top section is the "cope," and center sections are the "cheeks." Improvised wood flasks, usually used by sculptors, may be rectangular or irregular shapes that follow the con-

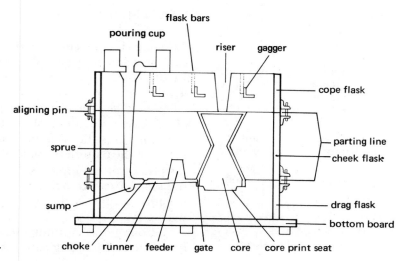

Figure 2–22
Foundry sand mold system.

figuration of the sculpture pattern. (Sections of 25- or 50-gallon drums are also useful.) In mold techniques which do not use flasks, reinforcing materials, such as wire mesh or steel rods, hold the mold together.

Pouring basins. A basin carved into the top of the sand mold to feed metal directly into the sprue. It is difficult to prevent dross from entering the mold with this technique.

Pouring box or cup. In sand or plaster, the pouring box set on top of the mold, over the sprue, or a cup attached to the wax sprue in investment casting. The pouring box or cup can be designed with a strainer or skimmer arrangement that prevents dross from entering the feeding system. Using insulating and preheated boxes and cups can help maintain the metal temperature. A proper-sized pouring box or cup can ensure having adequate molten metal for the gating system. Pouring cups and boxes can be made from investment materials or purchased precast.

Sprues. These are the vertical shafts receiving the molten metal. In large castings, there may be more than one sprue. The sprue must be of sufficient size to handle the charge of metal as it feeds from the cup. It may be round or square; square sprues are believed to produce less turbulence in the molten metal as it is being poured. An undersized sprue may result in the metal's "freezing" in the sprue before the pour is completed.

Runners. The horizontal feeds that run from the mold cavity to the sprue. These may be located on several levels, running from the sprue and feeding metal into the mold cavity.

Chokes. These may be included in the runner to control the flow of metal and to trap dross.

Gates. The openings at the end of the runners entering the cavity. Their size controls the rate at which the metal feeds into the mold. Feed into the mold is also affected by the size of the sprues, runners, and feeders, and the pressure they provide at the gate.

Feeders. These supply additional metal to the cast-

ing as the metal shrinks and cools. They may also trap particles of dross.

Risers. Risers provide metal to compensate for shrinkage. Open risers, as illustrated in Figure 2–22, also serve as escape routes for gases formed during the pour. Blind risers do not open to the outside of the mold. They may be located at various essential points in the mold to control shrinkage.

Bottom boards. These serve as a platform on which to build the mold. Aligning pins assure correct alignment of the mold parts. Register marks are also used when the flasks consist of random stacked shapes.

Cores. Cores form the inner mass that maintains the wall thickness of the casting. Core materials may be the same as the mold material being used or they may be formulated to meet special requirements. A core material must be soft enough to yield as the metal shrinks, to prevent tears in the metal. It must be porous enough to allow gases to escape. The core may be vented to allow gases to leave the core as they penetrate into it. Venting can be accomplished by piercing the core with wire or by building the core hollow. Large hollow cores may be filled with coke; small cores can be filled with dry sand. The gases readily penetrate the coke or sand and escape.

Pattern boards. These are used as a surface on which to place the pattern in constructing the drag section of the mold.

Flask bars. Horizontal cross-bars in the cope, which help support the sand.

Gaggers. Angular iron strips placed against the flask bars as additional support for the sand.

Facing. A fine sand, investment material, or coating that forms the mold surface next to the pattern. It is utilized to ensure maximum reproduction of the pattern surface. In sand casting it may also serve as a more resistant surface, to prevent erosion of the mold surface as the hot metal is poured. Facing materials can at times be troublesome. If the bond between the facing and the backing is not adequate, the facing may spall or chip off and mar the surface of the casting.

Backing or backup. The material used on the outer portions of the mold parts. It is often coarse and permeable. Pulverized or reclaimed mold material is often used as backing, to reduce mold cost.

Unit sand or unit mold. A mold in which the facing and backup are made of the same material. When possible, this is highly desirable, as it eliminates the possibility of defective castings due to spalling or chipping of the face coat.

Dross. The accumulation of metal oxides, impurities, and fluxing materials that form on the top of the molten metal as it is melted.

Chaplets. Fasteners used to keep the core in position if it cannot be anchored directly to the mold. They may be double or single headed and may vary in design. Nails can be used as core pins; they need to be removed on bronze castings, however, and the holes filled by tapping a thread and screwing in a threaded bronze rod.

Parting lines. The points of separation for the mold. Each mold section, as well as the pattern, is treated with parting compound to prevent the mold pieces from adhering to the pattern and to each other. In sand molds, the parting compound is talc or silica flour. The compound is dusted on the surfaces by shaking a porous cloth sack filled with it over the surfaces. The sack can also be dabbed against vertical surfaces. Parting lines may also run vertically through mold sections so that a section can be removed in pieces.

Vents. A means for air and gas to escape the mold cavity as the metal is poured. The extent to which venting is required depends on the pattern being cast and the porosity of the mold material.

Refractory washes. Coatings used on sand-mold surfaces to prevent erosion and penetration of the mold surface by the molten metal. Preventing metal penetration into the sand improves the surface quality of the casting; it also allows the mold to release from the casting more readily. Washes consist of carbonaceous materials, such as graphite or coal dust, and refractory materials, such as zircon. Binders are added to form brushing or spraying solutions. Commercially prepared washes are available from foundry supply houses.

Draft. The slight angle provided on the sides of the patterns to allow the mold to be readily removed from the pattern.

There are two ways to design a gating system in a mold. Figure 2–23 illustrates bottom and top pouring or gating. In bottom gating, the metal feeds into the bottom of the mold; in top gating, which is simpler and more adaptable, the sprue gates directly into the top edge of the casting. It is vented from the other side. Additional vents may be introduced into areas where there is danger of gas entrapment. The decision to top-pour or bottom-pour depends on the piece being cast, the mold material, or, in many cases, simply personal preference.

SAND MOLDS

The sand-mold technique, one of the oldest in metal casting, is still used extensively for commercial casting. In the commercial foundry, the sand-mold process involves packing sand around a pattern, disassembling the mold, removing the pattern, placing the core, and reassembling the mold. If the pattern is complex, the mold must be sectioned sufficiently to make removal of the pattern possible. Patterns are often made to split, or of loose pieces, to facilitate disassembling the mold. In sand molding, the material is often sufficiently porous so that venting is minimized or unnecessary.

Commercial foundry techniques are primarily geared to reproducing patterns to be used in quantity. Because sculptural casting is usually concerned with making a single copy or reproduction, the mold procedures are somewhat different.

The sand-mold material consists of the sand and a binder to hold the sand together. The sand can be natural, with a binder such as clay present in it, or synthetic, which is dried with the binders and impurities removed. The desired amount of binder is added to synthetic sands when the mold material is being prepared.

Sands are classified by grain size or mesh (number of particles per linear inch). Sand particles may be round, angular, or a composite of both. Round particles allow greater mold permeability, whereas angular particles produce greater mold strength with less permeability. Uniform particle sizes also provide more permeability; a variety of sizes results in a more compact, less permeable mold.

Binders added to the sand may also be natural or synthetic. Clay is a natural binder. Kaolinite and Bentonite are clay binders. Bentonite, a derivative of volcanic ash, has particularly outstanding qualities, because it produces a mold of greater strength. Silica flour, iron oxide, and portland cement can also act as

Figure 2–23
Bottom and top pouring system.

TOP POURING

Core Pins

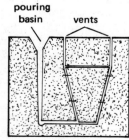

BOTTOM POURING

binders. Small percentages of such materials as molasses, linseed oil, resin oil, dextrin, gelatine, vegetable oils, petroleum derivatives, and plastics form another group of binders.

Three basic types of sand-binder mixtures can be defined: green sand, bake, and no-bake.

Green-sand mixtures utilize sand with binders such as clay. When packed in a mold, they possess sufficient strength to withstand handling and the weight and pressure of the molten metal. Moisture content of a green-sand mold is kept low: It may run from 3 to 5 percent.

Baked-dry-sand mixtures utilize clay, oil, or other binders. They are stronger than green-sand mixtures. Baking temperature may run from 300 to 500 degrees. A refractory wash may be sprayed or brushed on the mold to ensure a clean surface on the casting and to prevent the molten metal from penetrating the mold.

Molds of high strength can be constructed with no-bake binder mixtures. In this process, a small amount of resin is mixed into the sand in a mixer or muller. After the resin is well mixed into the sand, an additive or catalyst is added and mixed. The resin and additive interact, causing the sand-mold mass to solidify. The action might be compared to the catalytic process that occurs when working with polyester or other resins. Sand-mold resins and additive should never be mixed together without the addition of sand, as some formulations may react violently.

Some no-bake binders are furan resins, vegetable oil, and petroleum derivatives. Only minute amounts of resin and additive should be used; the exact ratio will vary according to the product and manufacturer. In a typical sculptural application with a binder such as Aristo, 100 pounds of sand would require 2 pounds of resin and about 6 ounces of additive. The sand might be about 80 to 100 mesh. About 1.5 percent (by weight) of iron oxide can be added to the sand to improve its refractory properties.

For sculpture, no-bake mold processes are perhaps the simplest and most satisfactory ways for working with sand. They provide high strength without using drying ovens and complex equipment and they are adaptable to a variety of sculpture and casting techniques. Water soluble no-bake binders are particularly desirable for easy cleanup and for improving the ecology of the foundry area. Smoke, odor, and fume emissions are either absent or at a very low level. Theim ChemBond #31 is a good system that I have used with good results. It is used at a range of 3 to 4 pounds to 100 pounds of the sand. The ChemBond catalyst is used at 10 percent of the weight of the ChemBond #31 binder which would be 4 to 6 ounces per 100 pounds of sand. Different strength catalysts are available to stretch sand-setting times from 6 to 10 minutes to 75 to 85 minutes at sand temperature of 70 degrees.

Another no-bake process that is simple and inexpensive involves making a cement-sand mold. To make such a mold, high-early-strength portland cement is mixed with sand in the ratio of one part cement to ten parts sand. Then 4 to 8 percent water is added to the mix. It is desirable to keep the water content as low as possible. The mold should be kept covered with a moist cloth and plastic film for the first 24 hours to allow the cement to set and cure. It is then uncovered and allowed to dry for several days. After casting, the discarded mold material can be pulverized. With a small addition of cement and water, the material can be reused as backing. New cement and sand are used for the face coating.

A no-bake mold not using resin or cement is the CO_2 process (carbon dioxide). In this technique, three to five percent sodium silicate is mixed with the sand. When carbon dioxide is passed through the sand mass, it reacts with the silicate and causes it to set and harden. The carbon dioxide is introduced into the sand with a probe or lance; also, a cup, or plywood cover with appropriate fittings, can be used on top of the mold.

PLASTER MOLDS

Plaster investment materials consist of plaster combined with fillers such as sand, perlite, asbestos fibers, fibrous talc, silica flour, crushed brick, and grog. The fillers add bulk, strength, and porosity to the mold. Asbestos fibers, for example, add strength and increase porosity. Typical investment mixtures might be equal parts (by volume) of sand or grog, plaster, and perlite; two parts sand or grog to one part plaster; or grog and equal parts luto and plaster. Grog produces a better mold; it should be fine (about 80 to 100 mesh) for face coatings and fine to 15 mesh when a face coating is not used (unit mold). Mixtures using equal parts of castable refractory material, plaster, and sand make excellent molds. For example, if equal parts of calcium aluminate cement, plaster, and fine sand (by weight) are mixed with water it will produce a slurry-like mixture. A first coating of this slurry is allowed to dry and is followed by 2 or 3 layers of ¾ ounce fiberglass mat dipped in the slurry to produce a relatively thin mold. It can be burned out like a ceramic-shell mold. (See the next section).

Plaster ingredients should be dry-mixed and then added to the water. Water content will vary according to the ingredients and depending on whether the mix

is to be poured in a flask or stuccoed on the pattern.

Face coatings, though unnecessary for most plaster investments, can be made from a mixture of two parts silica flour to one or one and a half parts plaster. Facings can also be purchased from foundry suppliers.

The release agents for patterns and mold parts can be thin, oily, or wax films, or releases such as those discussed in Chapter 3 (pages 39 through 40).

Because plaster molds are highly insulative, they allow sculptors to make thin and intricate castings quite readily. Plaster also reproduces fine detail and surface finish. The major disadvantages of using plaster investment molds are the length of time they need for burnout and their lack of permeability, which means they require complex venting.

Commercial investments, such as U. S. Gypsum metal-casting plaster, are convenient to use and fairly foolproof if their directions are followed accurately. A relatively new, highly permeable plaster called "HYDROPERM® B–32," which is available from U. S. Gypsum, utilizes a foaming agent to produce air spaces in the mold to increase permeability. With a mechanical mixer, 100 parts HYDROPERM® is mixed with eighty parts water. The volume of the mix increases from 50 to 100 percent as the air is added to the mix by the action of the mixer. An excellent mixer can be made by attaching a 5- or 6-inch-long piece of 1/8-inch thick rubber to the shaft of an electric drill.

CERAMIC-SHELL MOLDS

Even though ceramic-shell molds have comparatively thin walls, they are very strong because they are made from highly refined binders and refractories. Typically, a binder consists of sodium silicate that has had most of the sodium removed. The resulting extremely fine particles of silica that are suspended in water form the binder. A single drop of binder contains millions of particles. The refractory used with the binder is a fused silica possessing a very low coefficient of thermal expansion. A less expensive, reasonably strong mold can be made by using 300 to 400 mesh zircon flour instead of fused silica flour. The grain sizes are carefully controlled to produce the desired results.

The ceramic-shell mold is one of the simplest and most practical approaches to investing wax patterns. Some of its principal advantages are: the bulk of the mold is decreased, allowing maximum burnout space in the furnace; burnout time is reduced to a fraction of that required with plaster investments; it excels in surface reproduction of the pattern; and, because it is highly porous, it minimizes or makes unnecessary the need to vent. (Note that burnout is

discussed later in the chapter.) Within reason, mold size is not a problem; its limits are determined generally by the size of the burnout facility and the mechanical means available for handling large molds. Large wax patterns can be cut into sections, cast in smaller pieces, and later welded together.

The two basic ingredients of ceramic-shell molds are refractory slurry to coat the mold and refractory stucco material. Several manufacturers make these materials.

The slurry is mixed in a stainless steel container or other rigid, noncorrosive container. Mechanical mixing of the slurry is fairly essential. Mixers are available that mix the liquid and operate on programmed timers to keep the slurry-silica particles in suspension. The small quantities needed to build sculptural molds can be mixed with a mixer blade on an electric drill.

The colloidal silica or ethyl silicate binder is placed in the container, and the fused silica flour is added and mixed until the desired viscosity is achieved. Some variance in the viscosity can be tolerated for sculptural casting; most sculptors simply judge the mixture by weight and feel. A sort of thick, creamy consistency is ideal.

If you wish to be accurate about the viscosity of the slurry, it can be checked with a Zahn viscosimeter cup. The cup is filled with slurry, and the slurry runs out of the cup through a calibrated hole. By recording the seconds required for the cup to empty, the viscosity of the mixture can be determined.

A few drops of wetting agent are added to the slurry to improve its ability to cling to the wax pattern. Adding too much wetting agent may cause air bubbles to form in the mix. Allow such bubbles to rise to the surface and skim off with a spatula covered with a defoaming agent. (Note that slurry can be used successfully without a wetting or antifoaming agent.) After mixing, allow the slurry to stand for about 5 hours before you use it. If the mixture thickens because of evaporation, you can add small amounts of water. This is a haphazard procedure, however, because it is difficult to estimate the remaining silica content.

In recent years, some sculptors have developed slurries that are less expensive. They are out of readily available materials and they stay in suspension without having to be constantly mixed. Chuck Tomlins has had consistent success with a slurry he uses at the University of Tulsa. His formula is as follows: two parts colloidal silica, one part H_2O, nine parts silica flour (185 mesh), one part Bentonite (225 mesh), .003 part DCH-10 anti foam, and .001 part wetting agent. The silica flour and Bentonite are dry-mixed, then slowly added to the liquids (colloidal silica; H_2O; DCH-10; wetting agent) with a power mixer. The mixing

is continued until the desired viscosity is reached. In this case the slurry measured 8 to 10 seconds with a G.E. Zahn #5 viscometer.

To further reduce cost Tomlins utilizes silica (PEEN SAND) of 110 mesh instead of aliumio-silicate mesh which is normally used in the ceramic-shell process. The pattern can be dipped or the slurry can be poured or applied with a brush.

After the first two coats it is possible to proceed with the same slurry utilizing the 110-mesh silica sand to stucco the subsequent layers. It is also possible to prepare a backup slurry by reducing the silica flour in the original formula to eight parts and substituting the one part of flour with one part #40 brick grog.

Another completely suspended mixture that does not need constant mixing is SHELLSPEN™ ceramic slurry. It is available in small to large quantities and dry or premixed. It comes with complete instructions on its use. (See SHELLSPEN™ in the list of suppliers at the end of this book.)

There are several other applications for ceramic-shell materials. Slurries and refractories can be used over wood, plaster, or other patterns to produce mold facings that can be backed up with sand in split molds. Colloidal silica can also be used as a binder and vehicle with refractory powders for mold washes.

Preparing slurries and utilizing stucco material become somewhat more complex in commercial foundries, where precise control of the casting is necessary. Information on their procedures for mixing, determining slurry viscosity, maintaining slurries, applying stucco material, burnout, and casting can be obtained from the suppliers.

SCULPTURAL MOLDS FOR METAL CASTING

Having discussed three basic materials suitable for metal-casting sculpture, we might now examine several applications in the actual construction of a mold. The diagrams, at best, indicate procedures. Ultimately, learning to design a mold and to judge what material to use, as well as where to gate, sprue, and vent, is a matter of personal experience. Do not worry about losing a casting or sculpture piece: It is an inevitable part of learning mold construction.

For many procedures, it is possible to use any of the mold materials. As an example, to make the molds in Figures 2–24 through 2–28, it would be possible to use plaster investment or sand. If a burnout kiln were not available, sand with a no-bake binder would be an appropriate choice. It would be simpler and, if a fine sand were used, surface detail of the pattern could still be picked up.

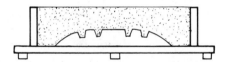

Figure 2–24
Pattern on pattern board with flask and mold material.

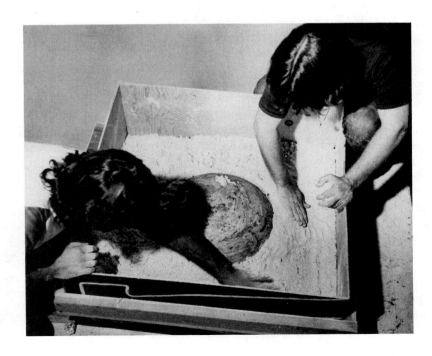

Figure 2–25
Flask with pattern; sand with a no-bake binder is being packed around pattern.

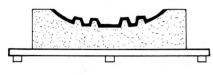

Figure 2–26
Mold with clay liner.

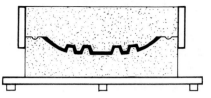

Figure 2–27
Mold with cope and drag sections formed.

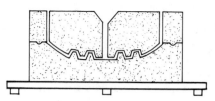

Figure 2–28
Completed mold, bottom gating.

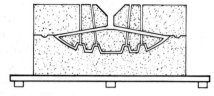

Figure 2–29
Top gating system.

Figures 2–24 through 2–28 illustrate how to cast a simple relief. If you understand this process, you can adapt it readily to more complex reliefs or three-dimensional forms. Figure 2–24 illustrates a pattern without undercuts on a pattern board. A flask or wooden frame is placed around the relief. A suitable release agent is applied to the pattern board, pattern, and inside edges of the flask. Plaster investment could be poured into the flask or a sand-mold technique could be used. For plaster, strips of wire mesh would be imbedded in the plaster for reinforcement. For large sand molds, reinforcing rod might be used.

Figure 2–26 shows the mold removed from the flask and turned over. The pattern has been replaced with a layer of clay approximating the thickness of the metal. An oil base clay should be used if the mold material is to be sand with a no-bake binder. If the mold were plaster investment for lost wax, hot wax could be poured or brushed into the mold. Besides clay, any material can be used that is the right thickness and readily follows the contour of the mold. A release material is next applied to the edges of the mold.

Figure 2–27 shows the mold with the cope and drag sections formed. The cope section of the mold has been filled with the desired mold material.

Figure 2–28 shows the completed mold. To complete the mold, the drag and cope section was separated, the clay was removed, vents and sprues were drilled out, and the pouring basin was carved. In this case, we have bottom gating, with the metal entering at the bottom of the mold. If sand with a no-bake binder were being used, the mold surface would be treated with a refractory wash, reassembled, and wired together—ready for casting.

A plaster-investment mold could be wired together or held together by placing a piece of wire

Figure 2–30
Pattern with flask around the pattern. *Student project, Southern Methodist University.*

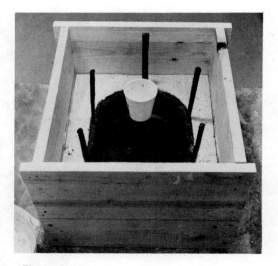

Figure 2–31
Mold sections with pattern removed. Wax liner, vents, and pouring cup have been attached. Cope section of flask is in place.

mesh around the side and stuccoing with investment materials. For plaster, the mold would have to be heated in a burnout kiln to drive off all of the moisture.

Figure 2–29 shows the mold detailed for top gating, with the metal first entering at the top edges of the cavity. In this case, bottom gating would be preferable, because the metal would have less distance to travel and there would be less chance for gas and air entrapment.

Figures 2–30 through 2–32 show several steps in the construction of an actual mold, as previously diagrammed in Figures 2–24 through 2–28. (Figure 2–33)

As patterns become more complex, molds require more pieces. Figure 2–34 illustrates how the drag section of the mold can be constructed in three pieces to accommodate an undercut on a rigid pattern. If the undercuts are on the surface, as in Figure 2–35, a separate piece is built that dowels, or fits, the inside surface of the mold. This piece can be cemented in with core paste. If the mold is being built over a clay pattern, it is possible to accommodate some undercuts without making the mold complex, because the clay can either be broken away or dug out of the areas. The undercuts can be accommodated by allowing increased metal thickness in some areas. (Figure 2–36)

Building reliefs by carving into the mold material is a spontaneous and direct approach. In this case, the drag would be placed on the bottom board and rammed with sand or filled with plaster investment. The relief would be carved into the mold material, the cavity would then be lined with clay, and the procedure would progress as in Figure 2–26.

Sculptor James Surls uses this technique with three-dimensional forms. He carves the sides and then stacks and assembles the mold pieces. He can cement the pieces together with core paste or a refractory cement. He surrounds the mold with flasks and rams

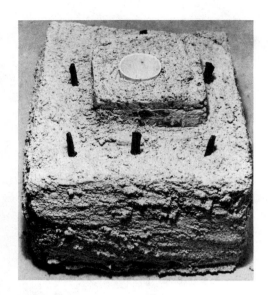

Figure 2–32
Mold completed and ready for burnout.

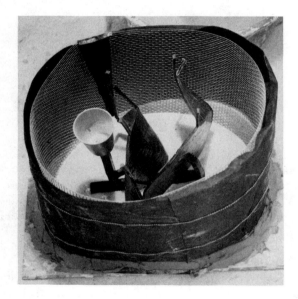

Figure 2–33
Wax pattern in a tar paper flask, ready for casting.

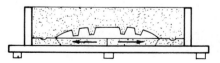

Figure 2–34
Piece-mold construction to accommodate side undercuts.

Figure 2–35
Piece-mold construction to accommodate surface undercuts.

Figure 2–36
Mold construction to accommodate undercuts by varying the thickness of the casting.

Figure 2–37
Partial sand mold in random pieces.
Note that the mold has been lined with
clay in preparation for adding the core.
By sculptor James Surls, 1970.

it with moist, sandy loam to give added support to the
mold pieces. (Figure 2–37)

Sand-mold construction in three dimensions is,
primarily, a more complex application of the relief
technique. Essentially, it is still a matter of building
the mold sections, disassembling, lining with clay, and
reassembling. For small works, the mold is built around
the pattern and turned over to ram up the core. If
the mold is large and cannot be turned over, the mold
is constructed as in Figure 2–38.

In this case, the core will rest on a slab of mold
material placed on the floor of a bottom board; chap-
lets are not necessary. The core can be held in place
with metal reinforcing rods, and rammed up pro-
gressively, as the sections are stacked. It is a good idea
to use less binder and additive in the core material so
that it will be softer than the mold. The core is rammed
up to about 1 inch from the top of each section. When
the next cheek section is placed, it is necessary to reach
into the mold and join the two sections of clay wall.
Core material is then rammed up; subsequent sections
progress in the same fashion. Between sections four
and five, the core is completed and trimmed. A layer
of clay is placed on top of the core; it is detailed or
finished, and section five is completed. The mold is
then disassembled, the clay is removed, and refractory
washes are applied when needed; sprues, vents, and
gates are drilled or carved, and the mold is reassem-
bled. The pieces may be cemented together with core

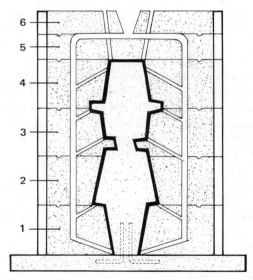

Figure 2–38
No-bake binder sand piece-mold construction built in
flasks.

paste, which can be made simply by mixing thinned
lacquer and talc.

There are numerous variations to this approach.
A simpler procedure is to build a core approximating
the sculpture. The core should be about ⅛ to ¼ inch
smaller than the finished work. Then, the clay is ap-
plied to represent the metal thickness, and the sculp-
ture is finished with the surface qualities desired. The

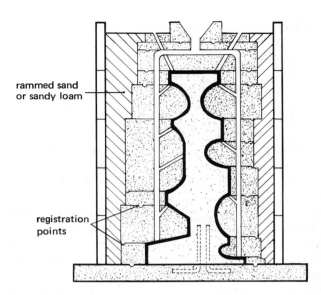

Figure 2–39
No-bake binder sand piece mold built with random pieces.

mold is then built around the work. (Figures 2–35 and 2–37)

In another approach (Figure 2–39), the mold is built around the sculpture pattern and core, randomly following the contour of the pattern. Registration marks or pegs must be placed on the individual pieces so that the mold can be readily realigned when it is assembled. After the mold is completed, it is disassembled. The clay is then removed, a gating system is added, a refractory wash is applied to the mold surface, and the mold is reassembled. The parts are cemented together with core paste and bound with wire. After the mold has been completed and assembled, flasks are placed around the mold, and it is rammed up with backup sand or loam. Rather than using the flasks, the mold can be bound together with wire and reinforcing materials. (Figure 2–40)

Yet another approach would involve building over the core with wax instead of clay. Fine detail and texture can be reproduced by covering the wax with a face coating. The mold is built in random pieces. Sprues, vents, and wax drains are made of wax and attached to the wax pattern as the mold is being built. Wire, wire mesh, and concrete reinforcing rod can be added for reinforcement.

If the mold is too large to handle, the meltout furnace can be constructed around the mold. Such a large mold should have been built on a layer of fire bricks. The temperature of the melt-out may be 300 to 500 degrees for sand, depending upon the heat resistance of the binder used. (Note that the meltout is discussed in detail later in this chapter.)

Figure 2–40
Sand molds being poured at Cameron University, Art Dept. Lawton, Oklahoma.

Figures 2–24 through 2–38 illustrated molds built in flasks. Molds can also be constructed without such flask-like devices. For this type of application, the mold material is spattered, stuccoed, troweled, or applied by hand. Plaster investment mixtures are usually used. The procedure starts out the same as in building a plaster piece mold for casting other materials. However, sprues, vents, and so on must be included as the mold is being built; or, they can be carved or drilled, as in previous techniques.

When the mold is completed, it is disassembled and lined with clay. It is reassembled, and the core is poured. It is then disassembled, and the clay is removed. The mold pieces are then reassembled; the core is held in place with chaplets. The mold is oven-cured prior to pouring by drying in an oven not exceeding 250 degrees, until all the moisture has left the mold.

Rather than a clay lining, the lost-wax process is often used with the plaster mold. The plaster mold can be assembled and held together with plaster and reinforcing wire. If it is small enough to handle, it can be filled with melted wax. As soon as the desired wall thickness has accumulated, the excess wax is poured out. If it is possible to reach into the mold, core pins can be pushed through the wax pattern into the mold

wall. If the inside of the mold is not accessible, small holes can be drilled through the mold wall and wax pattern. The metal rods or core pins are pushed through the holes until they protrude into the core cavity. The core is then poured. After the mold has set for a day, it is ready for meltout or burnout.

A more traditional approach is to build the plaster investment over the wax pattern as a single homogeneous mass rather than making a piece mold. Sprues, vents, and runners are attached to the wax pattern. Core pins are pressed through the wax pattern, protruding sufficiently to anchor into the mold. The pattern is then turned upside down, placed in a flask, and investment is poured around the pattern and into the core. (Figures 2–41 and 2–42) Because plaster is not as porous as sand, extra care must be exercised in locating the vents. They should be located at high points that could otherwise result in air or gas entrapment. (Figure 2–41)

If the wax pattern and mold are too large to handle, drains can be provided for melting out the wax. The mold can be built on a firebrick slab, with channels running from the drains to allow the wax to run out. The furnace can be built around the mold. The core is poured by providing an access hole on the top of the mold.

In building a plaster mold where a face coating is used, a good bond must exist between the face coating and the backup material. Backup material should never be applied to a dry face coating. The surface of the coating should be roughed with a piece of saw blade or toothed scraper. Sprinkling sand on the face coating before it has set can provide additional bond.

CERAMIC SHELL MOLDS

Building a ceramic-shell mold is somewhat like building up a plaster mold by stuccoing or hand applying the investment material. The essential difference is that the layers are thinner and correspondingly stronger.

The wax pattern for ceramic shell should be properly gated. Top pouring works well on ceramic-shell molds of moderate size. The sprues, runners, gates, and vents should be hollow, preferably, and of a lower melting point than the pattern. This will facilitate removing the wax during meltout. If the pattern has a deep core cavity, cut a hole through the end. (Figures 2–43 through 2–46) This allows better air circulation for drying and provides an additional anchoring point for the core shell. The piece cut out can be attached to the sprue and cast. It is welded back upon completion of the casting.

Prior to applying the first coat of slurry, the pattern should be degreased or etched so the slurry will cling to it. Washing with trichloroethane, full-strength or diluted with half isopropyl alcohol, will clean and etch the surface. Another approach is to brush the pattern with Johnson's Glo Coat® floor wax. This floor wax is water soluble and seems to produce a surface to which the slurry readily clings. Apply the slurry immediately after the wax has dried.

In commercial foundries, the wax patterns are dipped into the slurry. Most sculptors do not do sufficient volumes of work to merit the cost and justify the large quantity of slurry necessary for such an application. Consequently, the most practical approach

Figure 2–41
Plaster investment top gating.

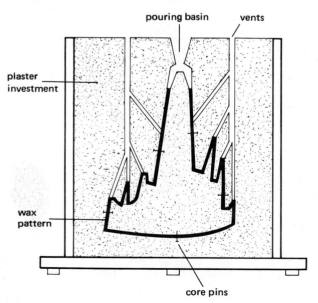

Figure 2–42
Plaster investment bottom gating.

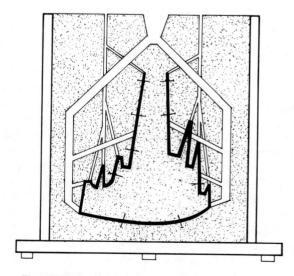

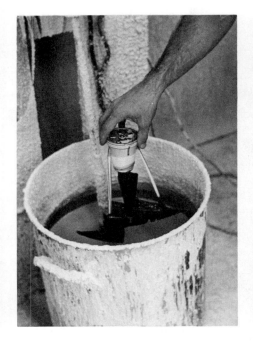

Figure 2–43
Wax pattern being dipped into ceramic shell slurry.

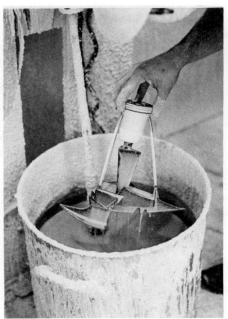

Figure 2–44
Draining excess slurry off of the pattern.

Figure 2–45
Stuccoing the pattern with fused silica.

for sculptors is to mix small amounts of slurry and brush it on or pour it over the pattern. The slurry can also be sprayed on using an R–2 spray gun. Pouring the slurry over the pattern works well if the pattern is small enough to handle. The pattern should be rotated over a shallow tray while the slurry is poured. When the pattern is covered, the excess slurry is drained off until the dripping stops.

The next step is to sprinkle the stucco material over the wet pattern until it is covered. The best stucco material is fused silica. Calcine clay (grog) can be used with a zircon flour slurry mixture. Grain size for the first two coats of stucco should be 80 to 100 mesh, and that of subsequent coatings, 30 to 50 or 20 to 50 mesh. (Note: Always wear a suitable dust mask when working with silica flour, Zircon, or fused silica; they are all hazardous materials.) As mentioned earlier Chuck Tomlins uses silica (Peen sand) 110 mesh for his first coats. After the first two coats it is possible to proceed with utilizing the 110-mesh silica sand and slurry for all subsequent coatings. Otherwise it is possible to stucco with 20-mesh brick grog for more rapid buildup and weight reduction. The stucco material can be kept in a covered, shallow tray large enough to catch it as it is being sprinkled. Occasionally, it may be necessary to sift the stucco material with a wire-mesh screen to remove investment particles.

After the pattern has been sprinkled, it is allowed to dry. The drying time depends on the temperature and humidity. With warm temperatures, low humidity, and fans to circulate the air, drying is rapid. With fused silica the pattern will appear white when

dry. Because speed and production are not major concerns for sculptural casting, drying time is not critical. Application of one coat per day is a practical procedure; 24 hours are more than adequate to assure drying under normal room temperature. Accumu-

Figure 2–46
Ceramic-shell mold ready for burnout.

lating several patterns for investing is a good practice, to economize on time and material.

Although final coatings need not be thoroughly dry, dry coatings do ensure a mold of maximum strength. Ideally, it is also desirable to have consistent temperature and humidity during drying. Temperatures of 80 to 85 degrees and humidity of 45 to 50 percent seem to produce optimum results. If ceramic-shell mold construction is going to be a regular operation, it would undoubtedly be worth while to construct a drying room with circulating air and temperature and humidity controls.

After the first coating is applied, the pattern is wetted with the colloidal silica, which can be poured over the mold in the same fashion as that used in applying the slurry. Another coating of slurry and stucco is then applied, and the pattern is again allowed to dry. This procedure is repeated until the desired mold thickness is achieved.

The mold thickness depends on the size of the work. Small works of about 12 inches, involving 10- or 20-pound pours can be produced in shells that are about ⅛ inch thick. Four to six coats would produce a shell about ⅛ inch or thicker. If there is any doubt about the thickness, apply an extra coating or two. The cost is minor compared to the risk of losing the work altogether.

Large molds can be reinforced during the last two coatings. Strips of thin fiberglass matting or other fiberglass reinforcing fibers can be dipped in the slurry and applied to critical areas. Flat-surfaced patterns, need reinforcement, particularly on the corners and edges. Stainless steel wire mesh can also be used for reinforcing on larger molds.

DEWAXING AND DEFOAMING

Because dewaxed molds can easily be used in the casting of plastics and metals, we include the dewaxing or defoaming process in this chapter; it is no longer considered purely as a metal-casting problem. Using foam and wax patterns, however, does involve the additional concern of pattern removal. Pattern removal can be accomplished by two methods: by solvents or by meltout or burnout.

Solvent removal of foam in plaster or ceramic-shell-invested patterns is a simple matter of pouring a solvent such as acetone or lacquer thinner on the foam. You should use polystyrene foam because it dissolves more readily than others. Be sure to apply a good coating of a paste wax or hot melted wax on the foam to contain the solvent and minimize its absorption into the mold material. As the term indicates,

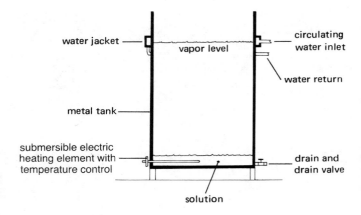

Figure 2–47
Vapor de-waxer

during burnout for metal casting, the film of wax is burned out. Likewise, for plastic casting, the wax film and residue from the dissolved foam are also burned out.

Solvent removal of wax is a vapor process; patterns removable by solvent are limited in size to the size of the vapor dewaxer used. A simple vapor dewaxer can be built out of a 55-gallon drum or large metal container and an electric heating element with temperature control. (Figure 2–47) When the dewaxing solvent is heated, the vapors dissolve the wax. Trichloroethylene is one of several solvents that can be used. The mold is placed in the dewaxer with the pouring cup down. The mold can be held above the liquid on several bricks or on a rack fabricated out of steel. A metal container can be placed below the mold to catch the dissolving wax. About an inch of solvent is placed in the degreaser. Because trichloroethylene vapors are toxic, dewaxing should take place in an outdoor area or in an area with proper ventilation. An adequate protective mask should also be used.

Vapor removal of wax is especially applicable to ceramic-shell molds. As with foam, it provides a way of eliminating the expansion problem of furnace dewaxing, since the expanding wax pattern may crack the mold before it starts to melt.

In plaster-investment molds, the wax can be melted out by using steam. A simple steam dewaxer can be built in the same way as the vapor dewaxer. (The gas burner can be purchased new or can often be salvaged from an old hot-water heater.) In this case, the cooling coil is not necessary. The mold is placed in the drum over about an inch of water. As the water heats and steam forms, the wax melts. As with the vapor dewaxer a metal container can be placed below the mold to catch the melting wax. This method allows you not only to recover wax for reuse, but also to

achieve a partial meltout. After this type of meltout, the mold must still go through the burnout process. (Figure 2–48)

Steam dewaxing cannot be used on ceramic-shell molds unless it is carried out in a pressurized steam autoclave. The pressure counteracts the wax expansion and prevents the mold from cracking.

Burnout or meltout is the traditional approach for removing the wax from plaster investments. Ceramic-shell burnout utilizes a different method from plaster investments.

The burnout or meltout of plaster investments requires considerable time. In meltout, the mold is placed in the furnace with the pouring cup and vents down. The temperature is slowly raised 200 to 300 degrees. As the wax melts and runs out through a trough or drops through a hole in the furnace floor, collect it in a partially filled bucket of water for reuse. After the initial meltout, which may take from several hours to a day, the temperature is gradually increased until the mold reaches a temperature of 1000 to 1500 degrees. This may take several days for a large mold. The wax and carbon must be completely burned out and all moisture expelled. The ultimate temperature depends on the investment being used. Lower meltout temperature takes more time but results in less shrinkage. The furnace temperature can be checked with a pyrometer or a visual estimate can be made on the basis of the color of the mold or the length of time the mold has been in the furnace. The mold should be a dull red if the investment is heated to 1,500 degrees. Black carbon present on the mold indicates insufficient burnout. Wax and materials still burning in the mold can be identified by the presence of a yellow-tipped flame burning out of the cup or vents.

If the wax is not going to be reclaimed, another approach is to burn out the mold with the pouring cup and vents up and allow the wax to simply burn off.

In burning out ceramic shell, the furnace temperature is brought up to 1500 degrees. The shell is placed cup-down in the furnace at this temperature. The objective is to get the wax pattern to melt before it has a chance to expand. The wax is usually partially collected as in the dewaxing of plaster molds. After the wax has melted, the temperature may be kept at a level of 1500 degrees. The burnout period runs from 15 to 30 minutes, depending on the size of the mold. When the mold is ready for removal, its condition is either a dull red color or there is no black carbon on the shell.

In order to minimize wax expansion, some sculptors melt out some of the wax with an oxyacetylene torch or a gas burner. The mold cup is placed

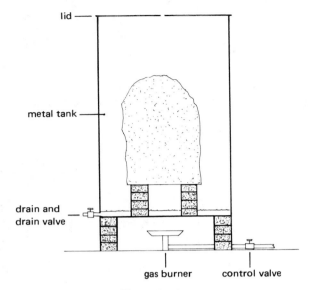

Figure 2–48
Steam dewaxer.

down on two bricks; the heat is directed into the cup. As the wax melts, the heat is slowly moved around and up the lower mold surface. Burnout is still required prior to casting.

FURNACES FOR DEWAXING AND BURNOUT

Essentially, the furnace for dewaxing or burnout can be an uncomplicated thing. A small furnace can be constructed easily out of stacked fire bricks or a 50-gallon steel drum. The steel drum can be lined with firebricks or the refractory can be cast or stuccoed into the interior. Numerous refractories are available today. A simple refractory for burnout furnaces can be made by mixing one part aluminite cement, one part powdered fire clay, and five parts perlite which can be cast or stuccoed into place. The burner can be an atmospheric or forced-air type burner. (Figure 2–49) The atmospheric burner draws air from the atmosphere without using a blower. Some space must be allowed around the burner where it enters the furnace to let in additional air for the flame. The atmospheric burner is useful for meltout or burnout when a slow temperature rise is desired. Several burners can be used in larger furnaces to achieve the desired temperature. The forced air burner is excellent for fast heat and higher temperatures. The squirrel-cage-type blower for the forced-air burner has about a one-tenth horsepower, universal-type motor. The volume of air can be controlled with an inexpensive speed control. The flame from the burner should impinge on the refractory wall of the furnace if the furnace is round. It should be baffled with a fire brick

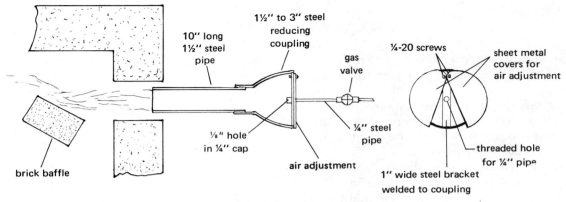

ATMOSPHERIC BURNER

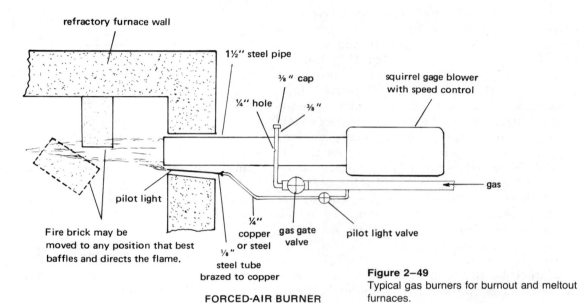

Figure 2–49
Typical gas burners for burnout and meltout furnaces.

FORCED-AIR BURNER

if the furnace is rectangular. Both the atmospheric and forced-air burner require some experimentation and experience to operate. They usually require constant attention and readjustment as the temperature of the furnace rises. Although these burners can be operated without safety controls, the practice is not advisable if the furnace is to be left unattended and certainly should never happen if the furnace is operated inside a building. The safety controls are attached to the burner, fan, and pilot light. If the air supply stops or the flame or pilot light go out, the controls shut off the gas. Johnson Gas Appliance Company is a good source for controls, and burners. Note the fans on the burner in Figure 2–53; lighting instructions and other burner designs are discussed in Chapter 3.

If your mold is plaster, it can be placed in the furnace and the temperature gradually increased. Ceramic-shell molds can simply have a nichrome wire loop on top of the mold. A metal pole is put through the loop, and the mold is lowered into the furnace.

(Figure 2–50 and 2–51) The pole can be left in the furnace with the mold hanging from it, as in Figure 2–50. If the mold is quite heavy it can be placed on the furnace bottom and the pole can be removed. More satisfactory but complex approaches involve the furnace being built high enough to have a drop bottom. (Figure 2–52) Inside a furnace the mold would be placed on the lowered bottom which would then be raised to place the mold in the furnace. The furnace could also be designed with a platform or grate that drops down or is placed into the furnace. Front-loading furnaces can be loaded by moving the mold on a platform, guided by a steel track. (Figure 2–53) Steel components should be of a high-temperature-resistant material.

There are an infinite number of variables to consider in furnace design. Each sculptor seems to find a form that best suits his or her needs. The 55-gallon-drum concept can be expanded to accommodate any size steel container the sculptor finds possible to build.

The most direct and simplest approach (used for

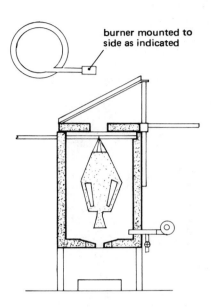

burner mounted to side as indicated

Figure 2–50
Dewaxing furnace.

Figure 2–51
Dewaxing a ceramic-shell mold in a burnout furnace.

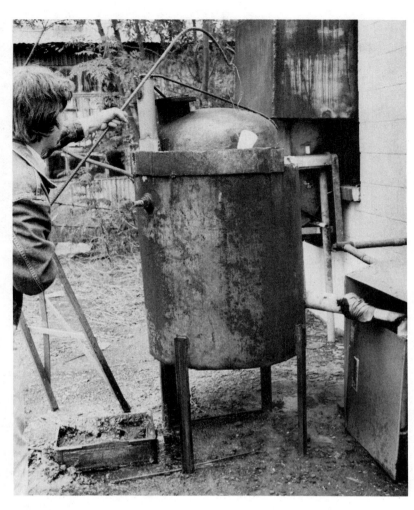

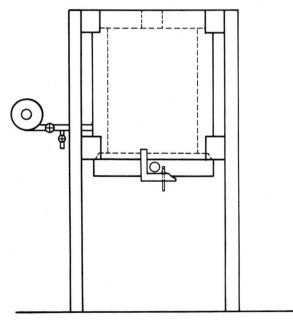

Figure 2–52
Top and side views of a drop-bottom furnace.
A—furnace closed
B—furnace opened for unloading

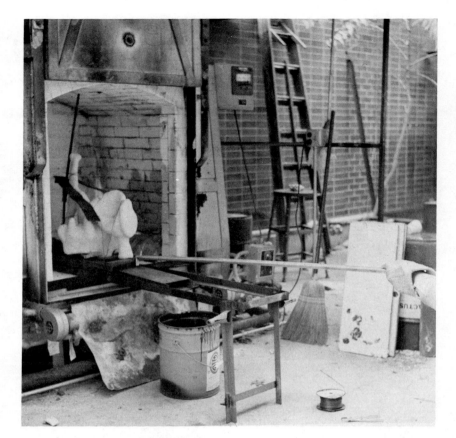

Figure 2–53
Front loading a ceramic-shell mold.
(Note bucket for catching wax from
center trough.)

Figure 2–54
Stacked-brick furnace (furnace should
be round).

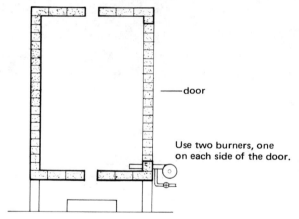

—door

Use two burners, one
on each side of the door.

Figure 2–55
Front-loading furnace.

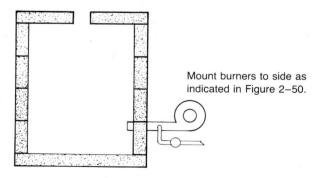

Mount burners to side as
indicated in Figure 2–50.

Figure 2–56
Stacked-ring furnace.

centuries) to dewax large plaster investments is to stack fire brick around the mold, forming a beehive shape. Any cracks can be filled with investment material. Wood was used for fuel in ancient beehive furnaces. Today, a regular gas or oil burner with forced air can be used. (Figure 2–54)

A more permanent furnace of this kind can be designed with a removable door made of fire bricks. Such a furnace can be either stacked or built in a steel frame and hinged; a refractory mortar can be used between the bricks. (Figure 2–55)

Stacked furnaces with banded rings of fire brick or reinforced, cast rings can be built so the height and capacity of the furnace can be varied. (Figure 2–56) Perhaps the best solution is a furnace where the floor rolls out on a track. The molds can then be readily loaded and unloaded away from the heat source. The front door is either designed to roll out with the floor or it is hinged or raised on a track. It seems that the hinged or raised door would be most desirable since the kiln could be kept closed while molds are being handled. Burners could be mounted from the front or back. (Figure 2–57 and 2–58) An excellent source for information on kiln building that can be adapted to investment burnout is *The Energy Efficient Potter* by Regis C. Brodie (published by Watson Guptill Publications, N.Y.)

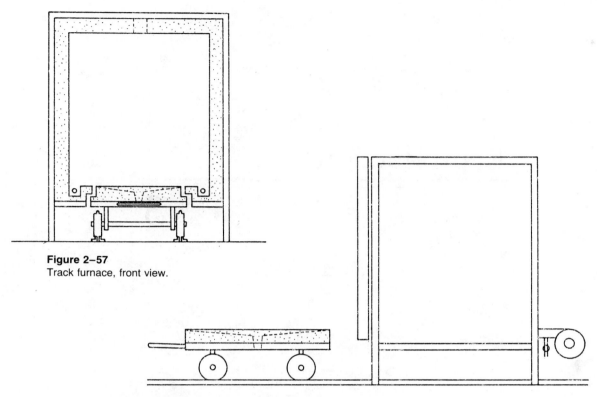

Figure 2–57
Track furnace, front view.

Figure 2–58
Track furnace, side view

Casting
and
Reproduction

3

Today, there are many castable materials. Metal casting, for example, once thought of as primarily bronze casting, now includes casting iron, steel, aluminum, lead, magnesium, nickel, silver, and a vast number of alloys and combinations of alloys. Moreover, clay bodies can be cast in the form of slip castings or pressed into molds. Plaster (gypsum cement), too, is now formulated so that a considerable choice exists as to its density, strength, and permanence. Portland cement combined with aggregates has numerous possibilities as cast stone. And, the emphasis on plastics as a whole new class of castable materials has also radically altered our ideas. The versatility of all these materials has made it possible to produce castings with diverse physical and visual properties.

Choosing a particular casting material depends on the desired visual effect and the purpose of the work. If the sculpture is to be kept outdoors, the choice of materials is, of necessity, limited. If it is to be an interior work, however, the more fragile materials, such as plaster or paper mache, may very well be more suitable than more permanent materials.

Casting techniques have also become more complex. We ordinarily think of "casting" as pouring a liquid or viscous compound into a mold and removing the mold after the material has solidified. Commercially, if spray, hand layup, pressure, or mechanical

means are used to place the compound into the mold or on the mold parts, the process is usually referred to as the "molding technique."

A wide variety of commercial casting and molding techniques for mass production have highly sophisticated and automated the simple process of placing a castable material in a mold and removing it at the proper time. Many metal-casting techniques are automated, and utilize permanent metal molds for quantity production. Semiautomated systems for rapid production and handling of sand, plaster, and shell molds are standard foundry procedure.

Injection, extrusion, rotational, transfer, and compression molding are utilized in the plastic industry to rapidly produce thermosetting and thermoplastic parts. Semipermanent molds of wood or fiberglass are used in the construction industry for casting concrete and for producing structural and decorative modular components for building.

Although sculptors do not usually deal with high-production casting techniques, they should be aware of them, because sculptural adaptations can often be made from commercial procedures. Sometimes, sculptors or artists design for mass production. Today, in fact, mass production of sculpture or components of sculpture is not only feasible, but also, to many, acceptable.

Two obvious requirements for casting or molding are the mold or container to receive the material and a release agent to prevent the material from adhering to the mold. Some materials are their own release agents; others require that release agents be added to the mix, as in the casting of plastic.

In Chapter 2, we discussed many kinds of molds. As we have seen, the selecting of a mold depends on the material to be cast, the number of castings desired, and the surface quality desired on the casting. The plaster waste or piece mold is still one of the most basic and simple molds for casting a single form of almost any material. It may not always be the most desirable or efficient, but if other materials are not available, satisfactory casting can be achieved. Clay slip, pressed clay, plaster, cast stone, and plastics can all be cast in plaster molds. With proper refractories added to the plaster, bronze, aluminum, and low-melting alloys can also be cast in plaster investments.

When casting plaster, cast stones, and plastics, porous mold surfaces need to be sealed prior to the application of a release agent. Moist plaster, dry plaster, cardboard, and wood molds are usually treated with several coats of thinned lacquer or shellac prior to the application of the release agent. Several thin layers are preferable to thick coatings.

Release agents can be simple oils, waxes, soaps, or plastic such as fluoro carbons (Teflon®), silicones, polyethylenes, polyvinyl alcohol, or other materials. The manufacture of release agents has become an industrial specialty, and release agents have been designed for a wide variety of specific applications.

Although release problems are far less exacting for the sculptor than for industry, your taking some care in selecting a release agent can result in a better quality casting and fewer hours spent in finishing the work. For example, some considerations in the selection of a release agent would depend on the mold surface, the quantity being produced, the temperature of the casting material and the casting operation, the material being cast, the desired surface of the casting, and the final surface finish or surface treatment. Mold surfaces can be porous, semiporous, or nonporous; each type—whether silicone rubber, polyethylene, or vinyl—possess natural release properties. Each requires a different release material.

In handling, preparing, and applying release agents, the sculptor should be cautious if the material is toxic or flammable. This is particularly necessary when melting waxes or solids into flammable solvents. Melting these materials in electric saucepans, frying pans, deep fryers, or similar utensils having sealed heating elements and temperature controls is the best practice. Do not overheat the mixture. Good venti-

lation should be provided when spraying solvent-based release materials, and toxicity should be a consideration.

Quantity of production is seldom a problem for sculptors, because they are normally interested in making a limited number of castings. When mass production is a concern, the ability of a release agent to withstand numerous castings per application of release material is important. Temperature of the casting material and the molding process is usually important in injection-molding and other industrial molding processes. However, for sculptors, temperature matters include heat-curing techniques, buildup in plastic casting, or adaptation of industrial processes utilizing heat.

The material being cast can pose many problems. Some resins, such as polyester or epoxy, tend to have a solvent action on the release agent and to be adhesive. Polyurethane is particularly adhesive and often presents release problems unless special agents are used and precautions are exercised. Materials possessing natural release properties or release-property additives may not require release agents.

Release agents should be applied in thin films, because excess buildup may eliminate fine detail, affect surface qualities, and complicate cleaning of the casting. The surface of the casting can, in fact, be affected by improper usage of release materials. They can affect the surface-curing of resins and foams. For rough, textured sculptural casting this may not be a problem. However, for smooth or prefinished surfaces, it becomes a matter of critical concern. The choice of release agent is also important if the surface is to receive posttreatment.

A good example of the importance of these various considerations is in casting plastic, plaster, or concrete, when the surface is to receive further coating or treatment. Wax or oil-based separators may combine with the surface of the casting, providing an undesirable surface or conditions that may make removal of the release agent difficult and time-consuming. In this case, using a release agent that permits painting or surface treatment with minimal cleaning or preparation is desirable. Silicone, water-soluble polyvinyl alcohol, or other plastic release agents are often used. Water-soluble release agents are especially easy to remove.

Aerosol sprays, liquids, pastes, and powdered release agents designed for specific applications are available today from plastic suppliers, molding suppliers, or companies specializing in these products. These are preferable to the simpler soaps, oils, and waxes the sculptor customarily uses (although soaps, oils and waxes still have practical economical value for

some casting techniques or when surface results are not critical).

Release-agent materials can be classified in some of the following categories:

Soaps. Liquid soap, or bar-soap shavings, dissolved in hot water, are used on moist plaster molds. The soap is brushed on the mold and polished with a soft cloth. Several layers are necessary for good release. Soaps are primarily used in plaster casting, because the molds do not require lacquer or shellac sealers.

Fatty compounds. Thin films of tallow and animal fats can be used on sealed wet or dry plaster molds and on wood or sheet-metal molds, in the casting of concrete or plaster. Stearic acid, dissolved at the rate of about ¼ pound per pint of kerosene, is an excellent fatty material that has been used extensively as an inexpensive release agent for many years. It is carefully melted in a container, and the kerosene is stirred into the melted stearic acid. Stearic acid (zinc and aluminum stearate) release agents are commercially available.

Oils. Vaseline thinned with kerosene, light-weight petroleum lubricating oils, and vegetable oils are used on sealed plaster and wood or nonporous molds (such as fiberglass) in the casting of plaster and concrete. Aerosol spray cans of vegetable oil are convenient for the application of thin films on small molds.

Waxes. Paraffin, melted into kerosene or mineral spirits at the rate of about 4 ounces of wax to 1 pint of solvent, provides an inexpensive release agent. Commonly used are commercial paste floor waxes, in their existing paste form or diluted with mineral spirits or other solvents. Waxes can be applied hot or cold, depending on the desired thickness of the film or porosity of the mold. The wax is usually wiped or brushed on the mold surface. Wipe off the excess, polish the mold, and a second coat is applied and polished. Porous molds of wood, plaster, or cardboard can be saturated with a hot application of diluted wax—without prior sealing for plaster, plastic, and concrete castings—when postsurface treatment is not critical. Excess wax should be wiped off. Thin films of wax are used on metal, sealed plaster, and fiberglass molds, for the release of plastic castings. These thin films are often applied along with water-soluble release agents such as polyvinyl alcohol. Commercially formulated wax release agents are available in aerosol spray cans and paste forms.

Plastics. Fluorocarbons (Teflon®), silicones, polyethylene, and polyvinyl alcohol are the most commonly used plastic release agents. For limited usage, small quantities are available in aerosol spray cans. Fluorocarbons and silicones are longlasting and highly desirable in quantity production. To the sculptor, these are of principal interest when wax- or grease-free release is desired. Polyethylene film or sheet can be used as a separator when casting on flat surfaces. Sprayed films of polyethylene or polyvinyl alcohol are excellent release agents for reinforced or cast polyester and epoxy resins.

Internal release agents. These are fatty, wax, or other compounds mixed in with the resin to provide separation from nonporous molds.

Three basic casting or molding techniques are ordinarily used in sculptural applications. Pouring the material into a previously assembled and treated mold is the simplest and, as mentioned, is usually associated with the term "casting." This process is applicable to most materials. Slush or rotational molding is a technique which involves pouring the material into the mold and the mold is turned or tumbled. Some of the material clings to the wall of the mold; the excess material is poured out. This procedure is repeated several times, until the desired thickness is achieved. In casting plaster and thermoplastics, small molds can be rotated and tumbled by hand. A simple rotational-molding machine can be constructed out of an old cement mixer, which allows for a more uniform, continuous rotation of the mold. Slip casting in ceramics is a simple and typical example of this approach. Plaster and plastic resins with fillers or hot, melted thermoplastics can also be cast in this fashion. Open-face molding techniques involve placing the material into the mold sections and assembling the mold before or after the material has solidified. The simplest version of this is the relief mold. Pressing a moist clay body, such as terra cotta, into a dry-plaster mold is a typical example of this procedure; it has been used for many years. Plastic resins with fillers, paper mache, or plastic-reinforced fiberglass are also molded in this way.

CLAY

Clay can be either slip-cast or pressed into a dry plaster mold. Either technique is suitable only if the forms are relatively simple because clay shrinks upon drying. Complex mold surfaces hold the shrinking clay in a rigid position, and thus cause cracks in the clay wall as it dries. In fact, designing clay forms for either technique requires some experience in choosing an appropriate shape for the sculpture and the mold, the proper viscosity for the slip being poured, and the proper way to remove the mold.

SLIP CASTING

Dry, powdered clays suitable for slip casting can be purchased from ceramic suppliers. The dry clay is sprinkled into a rust-proof container of clean, cool water and mixed until a thick, creamy consistency is achieved. The container should be covered, and the slip should be allowed to age for several days. Prior

to pouring the slip, it can be sifted through a 40- to 60-mesh screen to eliminate lumps or foreign particles. It can be thinned if the mixture seems too thick, although it should not be too thin, as a high water content will mean greater shrinkage of the cast form.

In slip casting, the slip is poured into an assembled dry plaster piece mold. Normal procedure is to wire the mold together or hold it together with large rubber bands made from strips of old inner tubes. The seams on the mold are sealed with moist clay. Separators or release agents are not used, since the plaster mold must absorb moisture out of the slip. As the plaster absorbs the water, a clay wall is formed. This may take 10 to 30 minutes, depending on the water content of the slip, the size of the work, and the absorbency of the mold wall. The mold should be kept filled with slip while the wall is forming.

When the wall has reached the desired thickness (¼ to ⅜ inch), the slip is poured out of the mold and is placed with the opening down to allow the mold to drain. In another slip-casting approach, the slip is poured in and out of the mold several times, until the desired wall thickness is achieved. In either case, after the mold has been finally drained, the moisture is allowed to evaporate out of the slip wall, causing the slip wall to shrink away from the plaster mold. When the clay has reached a fairly firm consistency, it is trimmed around the opening, and the pieces of the mold are carefully removed. The clay casting is then tooled, finished, and allowed to dry.

PRESSED-CLAY TECHNIQUE

In the pressed-clay technique, the mold parts are sprinkled lightly with talc, and pieces of moist clay are pressed into the mold, forming a wall of ½ inch or more. The wall thickness is a matter of personal judgment and depends on the size of the piece. The clay must first be wedged to remove entrapped air. This is accomplished by cutting hand size lumps of clay in half several times and repeatedly slapping the two halves together. It is then firmly pressed into the mold so that no air pockets exist in the pressed-clay mass.

The moist clay should be of firm dough-like consistency. Sculptors often add 10 to 15 percent Grog (a pulverized fired clay) to the clay to improve its properties during drying and firing. Terra cotta, a reddish-colored clay with grog added, is ordinarily available. It has been used for centuries as a sculptural media in cultures as diverse as ancient Greece and Mexico. If your pressed-clay sculpture parts are in a piece mold, allow sufficient clay surplus along the edges so that the edges will press together when you assem-

ble the mold. Prior to assembling, the edges should be wetted with a small amount of slip made from the clay being used; this ensures bonding of the edges.

After the mold has been assembled, moisture is allowed to evaporate until the clay wall is reasonably firm. The mold is then removed and the clay casting is tooled, finished, and allowed to dry.

FINISHING

Drying of either slip cast or pressed forms should be rather slow, so that internal stresses can equalize somewhat as the clay dries and shrinks. Dried-pressed or slip-cast clay bodies called "greenware" need to be baked or fired to develop their full strength.

The normal procedure is to first heat the clay for a couple of hours at a very low temperature (100 or 200 degrees), to be certain that all moisture has been removed. Firing normally takes place in an electric or gas-fired kiln. If so, the work is placed in the kiln and the temperature is slowly brought up to about 1800 degrees, over a period of about 18 hours. At this point, the clay matures or vitrifies.

In ceramics, this first firing is called the "bisque firing." After the bisque firing, the work is usually glazed and fired at a higher temperature to mature the glaze and fuse it to the clay body.

There are three basic approaches to achieving color in ceramic sculpture. The natural color of the clay, or the color-producing pigment added to the clay, produce limited colors, from white to buff to brown or reddish tones. Thin-colored slip or glaze materials painted on the clay prior to firing (green ware) can extend the color range. The broadest color range is achieved by glazing the bisque ware and subjecting it to a second firing.

Glazes mature at varying temperature ranges, which you can control by placing three pyrometric cones, set in a piece of clay, in the kiln. Allow the clay to dry prior to placing the cones in the kiln. Observing the melting or bending of these cones through a peephole in the kiln door makes it possible to determine the approximate temperature range.

Glazing is a complex and highly refined art in itself, requiring considerable experimentation in order to produce consistent and desired results.

PAPER

For interior works paper can be a durable and desirable material, especially if light weight and the surface qualities of the paper are considered essential. In most

Figure 3–1
Cast paper sculpture 1985 relief
Legend Series XXXI by Karl Umlauf.

cases almost any paper will work. However, if maximum permanency is desired only use 100 percent rag paper or pulp.

The pulp is prepared by soaking strips of paper in water. Boiling the soaking mass will speed up the process. After the material has soaked it is ground into a pulp utilizing a commercial beater. An old garbage disposal mounted so that it fits over a container will work to grind small quantities. Small quantities of a binder such as wheat paste, white glue, acrylic polymer, or other adhesive, are added to the pulp. Preservative, such as salicylic acid, carbolic acid or formaldehyde are often also added in small quantities to further protect the work. Pulp can be purchased from Twinrocker (see the list of suppliers at the back of this book).

Any kind of mold material will work for casting paper. As with any other casting material, the surface of the mold must be nonporous. Treat it with a wax, silicone, or oil-based release agent.

There are two methods for forming cast-paper sculpture. The simplest is to take strips of paper, dip them in a glue solution, and place them in successive layers in the mold. The other method is to prepare a pulp and place a layer of it in the mold. Press this layer into the mold with a sponge. This packs the pulp and removes excess moisture.

You should build up the surface of the casting with relatively good quality paper strips or pulp. You can, however, make subsequent, backup from lesser refined materials. Note that including a backup layer of gauze or fiberglass mesh is also an excellent practice

if you want to create a more impact- and tear-resistant form. You can also achieve greater rigidity by spraying on a backup layer of urethane foam. To construct three-dimensional forms, cast the sections separately and assemble the pieces after you remove them from the mold. (Figure 3–1)

PLASTER

The casting plaster or gypsum cements available today range from soft to exceptionally hard, durable materials. They are still among some of the most basic, simple-to-handle, and inexpensive studio materials. Sculpturally, plaster has been used for centuries; plaster death masks have been found in ancient Egyptian tombs that date back to around 2500 B.C.

Today, plaster applications include temporary models and experimental works, patterns for metal casting, thermoforming, and permanent-cast interior works. The natural white finish on plaster still has much appeal; castings can, however, be painted or surfaced with plastic or metallic coatings.

The softest gypsum cements are those we refer to as "molding" or "art plasters." Selected grades of gypsum rock are used to produce high-strength plasters. U.S. Gypsum's trade-named products "HYDRO-STONE"® and "HYDROCAL"® are two of the most readily available high-strength gypsum cements. More recently developed plasters, such as TUF-ART® and Industrial Plaster PC and PC–1, incorporate polymers and short strands of fiberglass to add strength and toughness.

The ratio of water to plaster determines a plaster's consistency, setting time, density, and ultimate strength. Plaster usually requires 67 to 80 pounds of water; HYDROCAL® requires 30 to 50 pounds of water, and HYDRO-STONE requires 32 to 40 pounds per 100 pounds of material. For casting, it is desirable to keep the water content as low as possible and yet have a creamy, pourable mix.

If consistent results are to be achieved in determining mixtures, the best practice is to weigh the plaster and water proportions. For nonproduction sculptural casting, however, sculptors often estimate the mix visually.

In preparing the casting mix, the plaster is sprinkled into the water and allowed to stand for several minutes, until fully dissolved. It can then be mixed by hand or with a mixing blade on an electric drill or drill press; or with a specially designed mixer. (Figure 3–2)

Sculptural gypsum-cement castings are usually simple solid castings with wire mesh, hardware cloth,

or reinforcing-rod armatures. Reinforcing materials can be held in place, and away from the mold walls, with an occasional dab of plaster on the reinforcing materials; position these in the mold as you are assembling it. Pour the liquid mix into the mold, after you have treated the mold with a release agent. Then vibrate the mold to work out air bubbles and ensure a dense surface. Vibration is achieved by tapping the mold with your hand, by placing the mold on a vibrator table, or by inserting an air-operated vibrator into the plaster mass for a few seconds. Hand tapping the mold is the simplest and most common approach. The mold is supported while casting in a bucket of sand or in a wooden or cardboard box. If your mold is large, build supports right into it to make it self-supporting.

Plaster can also be molded in a layup or slush-molding technique in molds treated with appropriate release agents. The layup technique is usually used only for relief molds, or if the inside of the form is accessible after the mold has been assembled. In this case, a layer of plaster is brushed or spattered on the inner facing of the mold to a thickness of about ¼ inch. Subsequent coatings are built up by dipping strips of fiberglass cloth or mat in the plaster mix and applying them to the surface until the desired thickness is achieved. The edges of the built-up sections should be kept at a 45-degree angle to allow for joining the parts when the mold is assembled. If an exceptionally strong wall is desired, the final layer is reinforced with wire mesh such as hardware cloth or expanded metal. In this buildup technique, to assure good bonding, the layers should be moist. If a layer has been allowed to dry, it should be wet thoroughly before the application of the next layer.

Figure 3–2
Small-batch mixer for plaster and plastics.
Photograph courtesy of Plaster Supply House Industries, Inc.

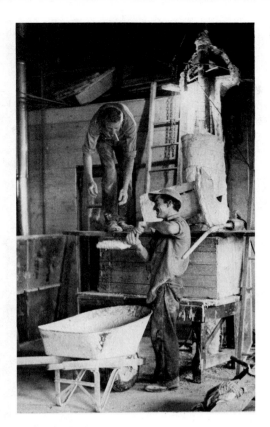

Figure 3–3
Concrete being placed into plaster piece mold. (Note mechanical vibrator behind worker on the right. Sections of the mold are added as the mold is filled.)

After the plaster has been built up to the desired thickness on the mold parts, the mold is assembled, tied together with wire or twine, and held firmly with some dabs of plaster on the mold seams. The layup is completed by reaching into the mold and applying plaster along the seams, followed by layers of fiberglass mat and a final wire reinforcement. If the piece is so large that it is impossible to reach all the way into the mold, join the parts as the mold is partially assembled.

Slush-molding with gypsum cements is only practical if the mold is small enough or light enough to handle. For this procedure, a small batch of plaster, HYDROCAL® or HYDRO-STONE® is poured into the mold, and the mold is tumbled and rotated.

CAST STONE

Sculptural cast stone, a refined version of concrete, has excellent physical properties for interior and exterior works. In recent years, it has had wide aesthetic appeal to both sculptors and architects; the natural, warm, grey color has been used successfully in many sculptural and architectural applications. With color and aggregate additives it is possible to create a diversity of colored and textural effects. (Figures 3–3 through 3–8)

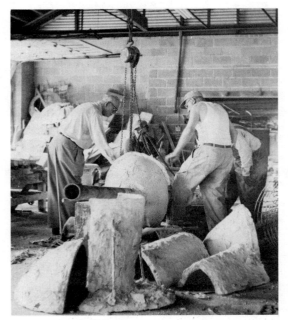

Figure 3–4
Mold sections being removed.

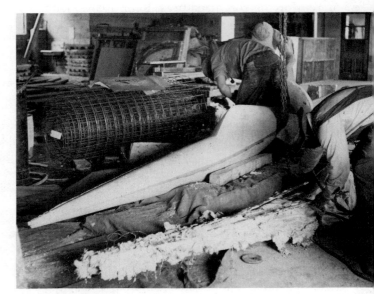

Figure 3–5
The casting with the final mold sections removed. *Photographs of the casting process courtesy of Marshall Brooks.*

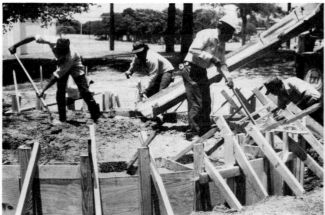

Figure 3–6
Wood forms for concrete sculpture substructure, concrete being poured and placed.

Figure 3–7
Placing precast concrete components.

Figure 3–8
Completed cast concrete sculpture, *A Place To Perform*, 1984 by sculptor Linnea Glatt, Bath House Culture Center, Dallas, Texas.

A

B

C

Figure 3–9
Concrete sand and aggregates. (A) A well-graded coarse aggregate mixture; (B) aggregate separated showing sizes ¼ to ⅜ inch, ⅜ to ¾ inch and ¾ to 1½ inches; and (C) sample of well-graded sand before and after separation. Particles vary from dust to those passing the number 4 sieve (approximately ¼ inch). *Photograph courtesy of Portland Cement Association.*

The ingredients in cast stone consist of Portland cement, sand, and aggregates of varying size. A good distribution of particle size is desirable in the concrete mixture to produce a dense casting of maximum strength. (Figure 3–9) Rough concrete may have sand particles up to ¼ inch in diameter and gravel particles up to 1½ inches. The largest particles in fine cast-stone mixtures, consisting of marble dust and marble aggregates, at times do not exceed ⅛ inch. Large works obviously need larger particles to achieve the desired strength. Fine mixtures need a larger proportion of cement than coarse mixtures. As the aggregate size increases, the proportion of the coarse aggregate is usually larger than the proportion of fine aggregate. With a maximum aggregate size of ⅜ inch the proportion would be about equal parts, coarse to fine. With maximum aggregate size up to 1½ inches, the proportion would be about one-third fine to two-thirds coarse. When the maximum aggregate size is around ⅜ inch, one part Portland cement by weight is added to three or four parts of the fine-coarse aggregate mixture for a typical cast-stone mixture. Mixtures with aggregate size up to 1½ inches would use four or five parts of the aggregate mixture. For small works very fine mixtures have been mixed with proportions of equal parts cement and fine aggregate. Small batches

of concrete can be hand mixed with a shovel, whereas larger batches require a mechanical concrete-mixer.

In hand mixing with a shovel, the dry ingredients are first mixed in a mortar box or on a clean, flat surface, such as a piece of plywood or sheet metal. The water is then added while mixing until the mix reaches a pourable consistency.

In machine mixing, an appropriate amount of water is placed in the mixer, and the dry mix is added to the water until the desired consistency is achieved.

In the construction industry, the ratio of water to other ingredients is carefully measured to insure optimum results. Sculpturally, the primary concern is a matter of the pourability of the mix. Mold cavities with thin cross-sections and surface detail obviously need a thinner mix and smaller aggregates than do large, open molds. Water-to-cement ratio can vary from .40 to .70 percent water (by weight) per pound of cement, depending on the aggregates, moisture content of the aggregate, and the desired consistency of the mix. Note that Portland cement should be stored in a dry place; if it has lumps that you cannot readily crush with your fingers, do not use it.

Water content should be kept to a minimum to insure maximum strength in the casting. The mixture should not be watery; it should be like a thick paste

or thicker. If the mixture is too thin, the aggregate will settle to the bottom of the mold, and the result will be a weak casting and poor distribution of the aggregate.

A cast-stone casting should not be allowed to dry out too quickly. Moisture is essential in a cast-concrete mass, in order to effect fully the chemical action in the setting of the concrete (hydration process) and to allow the mass to cure and reach full strength. Spraying the mold with water and keeping it covered with plastic film is advisable. After the casting is removed from the mold, it should be kept covered with damp cloths and wrapped with plastic film for a week to 10 days.

Portland cement is produced by applying heat to a wet or dry material such as limestone, marl, chalks, clay, silica, blast-furnace slag, slate, and so on. The ground material is passed through rotating kilns. The resulting discharged clinkers are cooled and ground to a fine powder to produce the finished sacks of cement.

A sack of Portland cement weighs 94 pounds and is 1 cubic foot in volume. Portland cement is available in several forms. The most commonly used is Type 1 Portland cement, a general, all-purpose material—most likely found at the lumber yard or builder's supply house when you simply ask for cement.

High early-strength Portland cement, as the name suggests, is used when it is desirable to have concrete reach its maximum strength quickly. Although more expensive, it is recommended if the cast material cannot adequately cure in the mold. White cement is available for white or light-colored castings.

General-purpose, white, and high early-strength Portland cements are generally used for casting small and moderate-sized works in the studio and classroom. Large, outdoor works, formed and cast in place, may require special cements and mixtures. For works of this scale, the sculptor should rely on competent architectural and engineering advice, and the work should be cast by a recognized concrete contractor.

Low-heat Portland cement is used to cast large masses in which the heat produced by hydration may need to be controlled. Air-entraining cements (described later in this section) are used for producing frost-resistant concrete. Portland Pozzolan cements are used largely for underwater structures and dams.

Of special use for casting are some recently developed polymer additives that, when added to cement, increase its strength. Small quantities of this material can be found as concrete patching material at retail building-supply centers. Large quantities can be found at suppliers that provide building-specialty concrete products.

Design-Cast makes a complex calcium aluminosilicate with a polymer acrylic emulsion (DC-62) that is often used for sculptural castings. Sand, rock, fiberglass strands, and other fillers can be added as reinforcement.

Accelerators, retarders, and air-entraining agents are added to concrete to alter its physical properties and workability. Hot water or calcium chloride (1 to 2 pounds per sack of cement) are utilized as accelerators. Retarders are used to lengthen the working time and delay the stiffening action of the concrete. When an exposed-aggregate surface is desired, retarders can be brushed on mold surfaces to prevent surface setting of the concrete. Manufacturers' recommendations should be carefully followed in the use of retarders. Excess quantities of a retarder in a concrete mixture can seriously affect the ultimate strength and quality of the casting.

Air-entraining agents are used to produce more solid, weather-resistant concrete castings with blemish-free surfaces. Because they require less water and improve workability, these materials are especially suitable for casting large architectural outdoor sculptures.

Aggregates can be sand, natural rocks, and pebbles of varied sizes, or rocks crushed and graded to size. Concrete or masonry sand are available, both of which have a good distribution of particle sizes, as illustrated in Figure 3–9. Finely graded white silica sands are often used for cast sculptures. Finely pulverized marble is often used as a substitute for sand in cast-stone mixtures. When combined with colored, pigmented cast-stone mixtures, crushed marble aggregates provide a wide choice of color for cast sculptures. Cinders, haydite, perlite, and vermiculite are used as lightweight aggregates.

Aggregates should be clean and free from organic contaminates. Your selection of an aggregate should depend on the visual and physical properties desired in your cast sculpture. For exterior work for which you envision finely finished, smooth surfaces, abrasion and moisture resistance of the aggregate must be considered. Surfaces with soft aggregates can be affected by wind and abrasive particles in the atmosphere. Also, soft aggregates that absorb moisture can easily deteriorate in freezing temperatures. You can, however, protect soft surfaces with appropriate sealers.

A limited range of colored pigments (cement colors) for coloring concrete is available from building-materials suppliers. A broader range of color can

be achieved by using standard powdered pigments available from paint distributors and manufacturers. Colors are best determined by mixing a sample of the material, prior to casting. Proportions of pigment, cement, and aggregate should be determined by weight or volume. The sample should be allowed to set and dry, to determine its true color. If a sealer is used on the casting, it will darken the color somewhat and should be applied on the sample to determine the final results.

Graded particle size is determined by passing the materials through wire-mesh sieves and counting the number of openings per linear inch. For example, if 100 particles, placed edge to edge in a row, measure approximately an inch, you have "100-mesh silica sand."

Permanent, versatile, and inexpensive, cast stone can be cast in almost any mold material. Plaster, wood, reinforced fiberglass, sheet metal, plastics, rubber, sand, clay, earth, and cardboard have all been used to contain poured cast-stone mixtures. Besides molds produced from formed patterns, direct molds built out of earth, sand, clay, polystyrene, cardboard, wood, and sheet metal provide an opportunity to work spontaneously and directly. (Figure 3–10 through 3–17 show the procedure involved in casting a large-scale architectural work by Albert S. Vrana.)

Normally, to reproduce smooth cast surfaces, mold surfaces should be nonporous. Porous surfaces can absorb moisture, which can weaken the casting and can produce defective surface qualities. Nonporous mold materials, such as rubber, plastic, reinforced fiberglass, and metal, will readily be released from cast stone if a thin film of oil or wax is applied. In addition, if plaster, wood, and cardboard molds are saturated with oily or waxy release agents without using a sealer, good separation results, and a minimum of release agent is transferred to the cast surface. Wipe off any excess release agent.

When pouring concrete into direct-relief molds of earth, sand, and clay, the mold material is kept sufficiently moist to prevent excessive moisture absorption from the mix. The cast-stone mixture is also poured slightly wetter, to compensate for some moisture absorption. These techniques produce a rough textural surface, with some of the mold material adhering to the casting and adding to the surface texture of the cast. Coarse aggregates, metallic pieces, and other materials are often placed on such mold surfaces; by adhering to the casting, they produce textural effects.

Because concrete does not possess high tensile strength, steel reinforcing materials are included in

Figure 3–10
Preparing for large-scale concrete casting. Drawing from cartoon to full-scale work on polystyrene foam backing.

Figure 3–11
Developing negative mold with sheets of polystyrene foam.

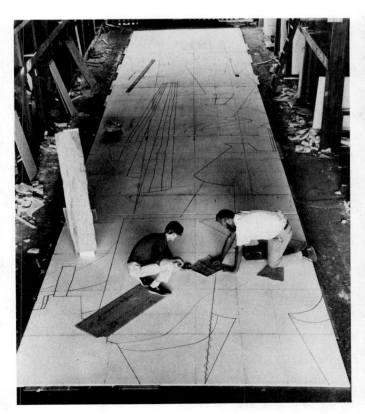

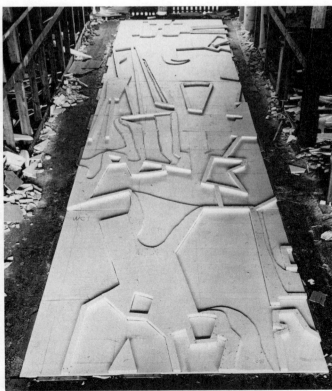

Figure 3–12
Grinding and hand sanding mold to
finish the form.

Figure 3–13
Placing mold in wooden concrete forms to prepare
for casting.

Figure 3–14
Placing concrete in the forms.

Figure 3–15
Picking up panels and stripping off
molds.

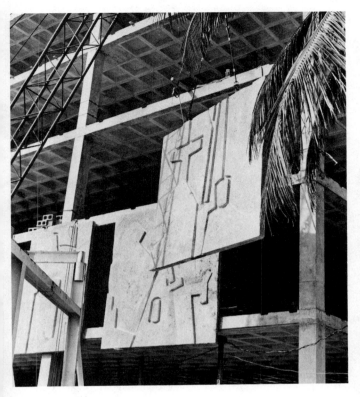

Figure 3–16
Erecting the precast panels.

Figure 3–17
Front view of building, installation completed, ca 1966. *Sculpture relief by Albert S. Vrana. Photographs courtesy of Albert S. Vrana.*

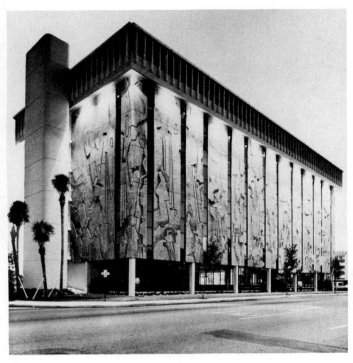

the cast work. The reinforcing is usually deformed rod or wire mesh. Deformed rod has slight projections, or lugs, which provide a mechanical bond to the cast stone.

The problems encountered in pouring a concrete mass are relative to the size of your casting. Small works can be cast readily with a single batch of material, whereas large works may require several or many batches. When more than one batch is required, it is necessary to mix all the needed dry ingredients at one time or measure each batch carefully to ensure uniformity in the mix; this is particularly essential with colored or exposed-aggregate mixtures.

For a dense mixture, the poured mass must be packed and vibrated to eliminate air entrapment. You can hand tap a small mold or vibrate the table on which it is resting. If casting is a daily operation for you, a mechanical vibrating table is advisable. For large molds, mechanical air-operated vibrators are inserted into the poured mass to disperse air entrapment; air-driven tamping devices can be used to compact the material.

Concrete surfaces can be left in their as-cast condition, coated with paints and metallic coatings; or the aggregates can be exposed. Aggregates are exposed by wirebrushing, acid etching with diluted solutions of muriatic acid, mechanical grinding, polishing, or sandblasting. If a rough-aggregate surface is to be exposed, special retarding compounds can be brushed on the mold surface to prevent the concrete surface from hardening. The surface is then simply brushed or washed with water to expose the aggregate.

PLASTICS

Commercially, large volumes of plastic articles are cast by injection molding, rotational molding, and match-die molding. Large, reinforced-plastic articles such as boat hulls are often formed in open molds with spray applications of resin and reinforcing materials. Cast resins and fillers are used for large industrial castings.

Two plastic-casting methods are used in sculpture: reinforced plastics in open-faced molds and cast resin, or resins and fillers, in closed molds. Slush molding and rotational molding are used to produce hollow castings in closed molds.

Casting of any resin should not be attempted without first becoming familiar with the safety precautions outlined in Chapter 15.

49

SOLID CASTINGS

In this section we consider casting in clear and tinted pure resin and resins with filler additives.

In recent years, considerable interest has developed in the visual properties and sculptural possibilities of clear and tinted solid castings. Polyester resins, the most frequently used, are the simplest to handle, inexpensive, reasonably clear, and nonyellowing. Acrylic resins are being cast with dramatic results by some sculptors. For clear castings, this material is superior to any other plastic. However, the technique and equipment necessary for casting acrylic resins are far more complex than for casting polyester.

SOLID CASTING POLYESTER

To make clear, solid castings with polyester resins, selecting a good quality, clear-casting resin is of prime importance. These resins are formulated to accommodate some of the problems unique to casting thick layers and masses, and are different from laminating or general-purpose resins. They usually contain less or different promoters and are more flexible.

The principal problem in casting large masses of resin is in controlling excess heat and thermoexpansion as the mass polymerizes. Fractures and discoloration result if polymerization is too rapid. A fixed ratio of catalyst to resin does not exist. Room temperature, mold material, and the size of the casting are always relative to the amount of required catalyst. The best starting point is the manufacturer's recommendations. Most sculptors making large cast forms have found it necessary to experiment to arrive at workable percentages of catalyst to resin. The amount of catalyst can vary from .01 percent to a small fraction of that amount. Large castings of 10 to 12 inches in thickness may simply require about 100 drops per gallon of resin. A reasonable starting point at 72 degrees room temperature is three or four drops per ounce for 1 inch thickness and two or three drops per ounce for 2 inch thickness. An 8-inch cube would require 150 to 180 drops per gallon. Methyl ethyl ketone peroxide is normally used as the catalyst.

A few guidelines for controlling temperature on thick castings follow:

Use a minimum amount of catalyst and allow a maximum amount of curing time. A huge mass of resin can be allowed several days to a week to cure. If the cure is not complete, postcuring can be accomplished with heat. A simple oven can be constructed of insulation board with several 150-watt light bulbs mounted inside to produce a low temperature. This low-temperature postcure may take from several hours to a full day or more, depending on the size of the casting. (Postcuring is also a good way to accelerate the dissipation of the styrene-monomer solvent from the cast mass.)

Work at room temperature (72 to 75 degrees) when possible, increasing the catalyst for lower temperatures and decreasing it for higher ones. Ninety to 100-degree summer temperatures can require considerable reduction in the quantity of the catalyst.

If a cast resin mass has gelled and appears to be curing too fast, it can be submerged in cold water to assist in the dissipation of the heat.

When possible, molds with low-insulating qualities should be used. Water cooling a fiberglass mold would be more effective than water cooling a plaster, wood, or rubber mold.

If possible, cast large masses or blocks in layers of ½ to 1 inch. This should be done in a relatively dust-free environment. The block for the cast sculpture in Figure 3–18 was cast in this fashion.

From 1 to 10 percent flexible resin can be added to the general-purpose resin, to increase flexibility and allow greater expansion before fracturing occurs. However, when possible, start with an appropriate resin designed for casting. Making solid castings in polyester, or epoxy resins with fillers, poses fewer problems than making clear castings; the fillers act as reinforcement and absorb some of the heat; catalyzing is less critical.

Filler particles vary in size from powders measured in microns (millionths of a meter) to coarse

Figure 3–18
Cast polyester sculpture. *By Roger Kotoske.* ca 1965

Figure 3–19
Typical fillers left to right. Top row: asbestos fibers, glass nodules, perlite.
Bottom row: chopped fiberglass strands, sand, Cab-O-Sil®.

fibers and crushed rocks. (Figure 3–19) Aerated silica (Cab-O-Sil®) is an excellent fine-grade filler that is often used. Tripoli, diatomaceous earth, Kaolinite, aluminum silica, magnesium silica, mica, wood flour, shell flour, calcium silicate, and calcium carbonate are other fine-grade fillers. Pigments and metallic powders also act as fillers, besides producing desired visual effects.

Fibrous fillers can be asbestos, cotton flock and linter, chopped cotton cord, jute, rayon fibers, nylon flock and chopped fabric, polyester fibers, and chopped glass fibers.

Granular fillers may be sand, crushed rock, sawdust, vermiculite, perlite, glass spheres or nodules, and plastic materials.

One of the simplest, most available fillers is perlite, which can be mixed with a resin. About 90 percent resin and 10 percent perlite by weight are used. About 1 cup of Cab-O-Sil® per gallon of resin can be added to help keep the perlite in suspension. The Cab-O-Sil® should be mixed with a small amount of resin and blended (with a mixer blade on a drill) into a paste before it is added to the mixture.

Note that with an appropriate resin, water can be used as an extender instead of a filler. In fact, water-extendable resins that increase the volume of resin by 50 percent are available. These require that water be blended into the resin with a mechanical mixer, resulting in a cream-like emulsion.

Fillers may serve solely as reinforcers for castings, or they may be used as decorative finishes. To expose fillers for decoration cast in transparent or translucent forms, or the surfaces can be abrasive-finished. Abrasive-finishing procedures are similar to the finishing methods outlined in Chapter 10.

If they are to receive large amounts of filler, resins should be thinner than laminating resins. Resins are not thick enough to hold coarse fillers in suspension without the addition of fine-grade fillers. Thick (thicksotropic) resins with fine-grade fillers are available from suppliers or fine-grade fillers can be added to the resin. Fillers in resin are like sand and gravel in concrete mixtures. A reasonable distribution of particles, sizes, or fibers is essential for optimum strength. If the resin is not thick enough to hold the largest particles in suspension, these particles will settle to the bottom of the mold; the result will be an unsatisfactory casting. Heavy fillers, such as crushed rock, need thicker resins (or a more appropriate balance of fine particles) than light-weight fillers, such as milled fiber, asbestos, or perlite.

Resins should be cast in nonporous molds. Any mold material is adequate as long as it will withstand the weight and pressure of the cast material. Mold

cavities produced using the lost-wax process can be filled with resins to produce hollow castings. In this case, the release agent is poured into the mold and then poured out. In casting resins, separation can be accomplished by using wax-based release agents, if the casting is to be abrasive-finished. For cast surfaces that are to be polished or coated, the mold can be coated with a thin layer of wax, which is subsequently buffed. A layer of water-soluble release agent (polyvinyl alcohol) is sprayed over the wax coating. This is easily washed off the casting after it has been removed from the mold. Silicone, fluorocarbon, polyethylene, and other plastic release agents can be used as well. Paintable silicone, or polymer release agents that do not require removal, can be used when the casting is to be painted.

ACRYLIC CASTING

Acrylic (methyl methacrylate monomer) is available in the form of resin, powder, small beads, and pellets.

Resins are available as inhibited and uninhibited, syrupy liquids. Inhibitors are added to some resins to prevent them from polymerizing before they are used. Uninhibited resins are normally used by sculptors for clear casting, to produce the best optical clarity. Inhibitors can be removed from acrylic resins by means of chemical washing or by a process of distillation. When optical properties are of less concern to the sculptor, the action of the inhibitor can be overcome by the catalyzation process.

Pigments, dyes, ultraviolet absorbers, destaticizing agents, plasticizers, and other additives are present in resins or powders. They can also be added prior to casting. Powders, beads, and pellets are often supplied in color.

As stated earlier, casting acrylic is far more difficult than casting polyesters and epoxies. Heat, pressure, and precise control are necessary to cast masses exceeding ½ inch in thickness. Controlling exotherm (heat), shrinkage, and stresses is difficult and requires complex and expensive equipment.

When exotherm in the atmospheric pressure becomes excessive in acrylic casting, the monomer begins to boil, causing the casting to have a bubbly and foamy appearance. This can only be controlled by casting under pressure and in a pressure autoclave. Shrinkage can be controlled by mold design, partially reduced by prepolymerizing the resin prior to casting. Shrinkage and polymerization should occur at the slowest possible rate. Shrinkage problems are simple to overcome in casting flat sheets and tubes, because you can move such masses as they are shrinking. Also

consider using molds that will move with the shrinkage, or break as shrinkage occurs.

Sculptural casts with projections and undercuts require that you relieve stresses, for example, by proper annealing.

Benzoyl peroxide is the catalyst ordinarily used for casting acrylic. If colored pigments or dyes are used, a catalyst such as azo diisolbutyronitrile might be used because benzoyl peroxide can produce bleached effects in colored castings. The quantity of catalyst, even for large, massive castings, is minute; a few drops or .001 or .002 of a part per gallon of resin are sufficient.

Industrially, sheets of acrylic are cast between glass sheets; rods and tubes are cast in aluminum tubes. As the acrylic shrinks, it separates naturally from the mold surface. Any nonporous mold material can be used for sculptural castings. Sealed porous molds, such as plaster, must be dry. Thin coatings of stearic acid, fluorocarbon, or silicone as release agents can be used when necessary.

Besides cast resins, monomer-polymer slurries can be made. Fine acrylic powders are added to their monomers at about a fifty-fifty ratio. As the powder is added to the liquid monomer, it dissolves and swells, forming a thick liquid or slurry. Dyes, pigments, and so on, or colored powders can be used. Shrinkage and exothermic heat are less of a problem in cast slurries than in cast resins.

To cast a large mass, the sculptor first prepares the resin or slurry mixture. A vacuum is applied to the mixture to remove air; the mixture is poured into the mold, and the mold is placed in an autoclave. Heat and pressure is then applied. The autoclave should be professionally designed, with proper safety controls; pressures may be as high as 100 pounds per square inch and are hazardous if attempted in inadequate equipment; also, fumes from resins can be highly flammable; necessary precautions should be taken.

Polymerization for large castings may require from 1 day to several weeks. Temperatures are started low (90 to 115 degrees) and slowly increased to 150 to 250 degrees. The final temperature cycle may also serve as an annealing process, after which the temperature is gradually reduced until the casting reaches room temperature. Programmed timers are used to control temperature.

If a casting receives postmachining and finishing, it is necessary to give it a final annealing to remove the stresses produced by these operations. This is accomplished by slowly heating and cooling, as in the polymerization process. Pressure is not necessary for

Figure 3–20
Cast acrylic sculpture. *By Mac Whitney*, Ca. 1970.

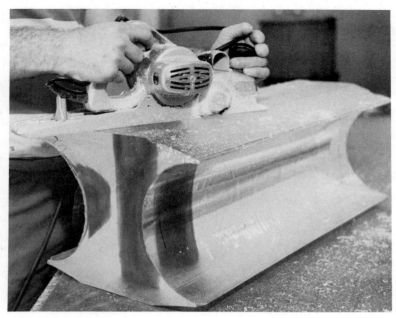

Figure 3–21
Surfaces being planed with a power plane prior to abrasive finishing and polishing. Acrylic casting by Mac Whitney, Ca. 1970.

annealing. The maximum annealing temperature can be 230 degrees, or the work may be annealed at a lower temperature by extending the annealing time. (Figures 3–20 and 3–21)

FIBERGLASS-REINFORCED PLASTICS

Polyester resins are usually used in fiberglass-reinforced plastic, but epoxy resins can be used when their physical properties are considered more desirable. In fiberglass-reinforced plastics, the glass fibers bond with the resins to form a strong, homogeneous sheet or part. Ultimate tensile strength of glass-fiber laminates can be from 30,000 to 50,000 pounds per square inch.

The catalyst used, as with polyester-resin casting, is normally methyl ethyl ketone peroxide. The catalyst is added to the resin at the rate of .5 to 1.5 percent. As the amount of catalyst added to the resin is increased, the setting time decreases. The amount of catalyst should not exceed 2 percent. Ideally, the temperature of the room should not be less than 70 degrees. Cooler temperatures can affect the curing of the resin, unless catalyst is added to compensate for the lower temperature. General-purpose resins for fiberglass layup are readily available from plastic sup-

ply companies. Cab-O-Sil® can be used to thicken the resin when needed; styrene monomer can be added if the resin needs to be thinned.

Fiberglass-reinforcing materials are available in veil, matt, roving, woven roving, and cloth. Veil is a thin layer of glass fibers about 10 mils thick. It is often used as the layer next to the gel coat to ensure the absence of air bubbles between the gel coat and the subsequent layer of glass fiber. Matt is made of chopped strands of glass fiber up to 2 inches long; it has less strength than cloth. Standard thicknesses are from ¾ to 3 ounces per square foot. Roving, untwisted strands of glass fiber available in cylindrical packages, is used in the sprayup process; it is chopped and fed into the stream of sprayed resin. Woven roving, a coarse weave of untwisted strands of glass fiber, is stronger than matt and conforms more readily to contours. It weighs from 13 to 27 ounces per square yard. Cloth is the strongest woven material and comes in weights from 2 to 40 ounces per square yard. It is available in different types of weaves, such as twill, crowfoot, or satin. Satin is the strongest and conforms most readily to curved surfaces. (Figure 3–22)

The two most common methods of working with fiberglass are hand layup or sprayup applications. Hand layup, most often used sculpturally, is one of the sim-

Figure 3–22
Fiberglass mat, (left); fiberglass cloth (right).

plest and most inexpensive ways to produce reinforced fiberglass in sculptural molds.

Hand Layup

For fiberglass layup, if the mold is porous, it is sealed with two coats of lacquer or 3-pound cut shellac. Aerosol spray cans of lacquer are convenient to use for small molds. After the lacquer or shellac has dried, the mold should be coated with paste wax, such as Johnson's, or a wax separator designed for plastic molding. Do not apply the wax too thickly. After the wax has dried, it should be buffed with a soft cloth, and a second coat should be applied. After it has dried, it should again be buffed lightly. If the final molding is to be painted, the mold should be coated with a separating film of polyvinyl alcohol. This can be washed off easily with water after the molding has been removed. It is also possible to use paintable release agents rather than the wax and polyvinyl alcohol.

The first coating on the mold is called the "gel coat." It is slightly more flexible, has better impact strength, and keeps the glass fiber from showing on the surface of the casting. Prepared gel coats can be purchased in a wide variety of colors from resin suppliers, or it is possible to add your own coloring agents. In industrial applications, the gel coat is sprayed on. A DeVilbiss-JJA502 spray gun with an E-fluid tip and 704 air cap can be used. An R-2 all-material spray gun also works quite satisfactorily. If spray equipment is not available, the gel coat can be brushed on, but the results are not as satisfactory. For simple beginning castings in which there is not a great concern for technical perfection, a gel coat can be made by adding Cab-O-Sil® to the general-purpose resin used for the layup. Mix the resin with Cab-O-Sil® using a mixing blade on an electric drill. Mix a rather thick paste first (this assures good blending of the Cab-O-Sil® and the resin) and then thin with additional resin until the desired brushing consistency is achieved. Then add 2 percent catalyst per volume of mixture and brush on the mold surface. Be certain that the mold surface is at a room temperature of at least 70 degrees, or the coating may not set. In addition to coloring agents, you can add small rocks, marble dust, or metallic powders to the gel coat (from 150 to 300 mesh). After the casting is removed, the surface can be made metallic by light sanding and polishing. In this case, apply two layers of gel coat so that the abrasive finishing does not go through to the fiberglass backup material.

After the gel coat has set, mix a container of resin with catalyst and brush part of the resin onto a section of the mold surface (about 1 square foot). Stick a piece of ¾-ounce matt or veil (2 inches by 2 inches or larger, depending on the contour of the mold) on the wetted mold surface and dab with brush and resin until the matting is saturated. Repeat this process, overlapping the matt or veil pieces until the mold is covered. Be certain to work out all the air bubbles as the matt and resin are applied. For larger, flat surfaces, greater areas of the surface can be wetted with resin and larger pieces of matting can be used. A special roller can be used to roll down the resin-saturated matting to squeeze out all the air bubbles.

The next layer should be ¾- or 1½-ounce matting, depending on the thickness desired. For small moldings of no more than 2 square feet of surface, an additional ¾ ounce is adequate for a light-weight casting. For larger works, the second layer should be 1½ ounces. This might be two layers of ¾ ounce each, if the contours are complex. The next layer should be woven roving or 6- to 10-ounce cloth. If this is the final layer, cloth should be used. For an extremely large layup in which additional strength is required, the remaining layers should be alternating layers of matt and woven roving. The molding will release more readily from the mold if it is removed as soon as the resin has set or polymerized. Some of the heat from the polymerization process tends to soften the wax release agent that facilitates the removal of the molding.

Resins can be mixed in paper-disposable containers or cups. Do not use polystyrene cups, as the resin will dissolve them. A container can be used more than one time, if the film of resin left in the cup is

Figure 3–23
Fiberglass layup into negative fiberglass mold.

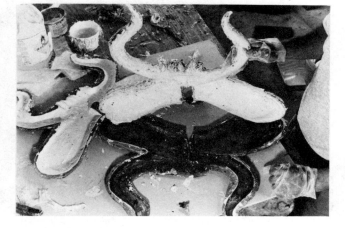

Figure 3–24
Fiberglass casting being trimmed with utility knife. Trimming should take place immediately after resin has set and cast still has a rubbery consistency.

Figure 3–25
Casting being removed from mold.

Figure 3–26
Roller for working out air bubbles in fiberglass layup.

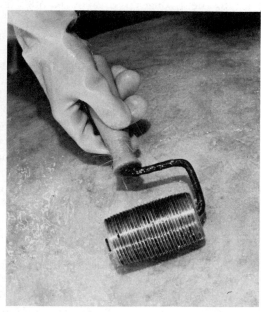

allowed to set before it is used again. Acetone can be used for cleaning brushes and equipment. Rubber gloves or disposable plastic gloves should be worn. It is best to work in a well-ventilated area, as resin solvents and catalysts are toxic. (Figures 3–23 through 3–26)

SPRAYUP MOLDING

In the sprayup process, a spray gun with a chopper is used to apply the resin and glass fiber over the gel coat. The chopper cuts the glass fiber and propels it toward the mold surface. The chopped fiber converges with the stream of catalyzed resin from the gun and is deposited on the mold surface. The roving is fed to the chopper from spools mounted on the machine. The air supply to the machine should be at least 5 H.P. and should be able to maintain a working pressure of 100 p.s.i. (pounds per square inch). Note that many cities have fiberglass product manufacturers who may be willing to spray up your molds for you for a reasonable cost.

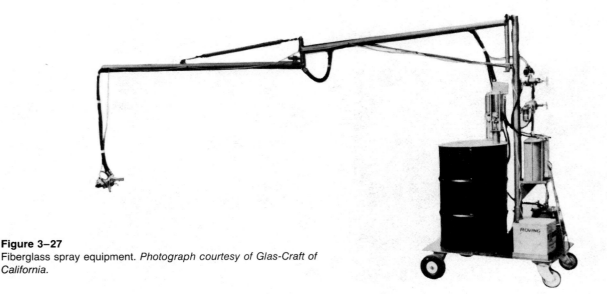

Figure 3–27
Fiberglass spray equipment. *Photograph courtesy of Glas-Craft of California.*

METAL CASTING

Metal casting (often referred to as founding) is one of the oldest popular metal crafts; nonferrous casting dates back to the Bronze Age (3000 to 5000 B.C.). Although casting and the related metallurgy are handled industrially with great precision today, the principles have remained essentially the same through the years. One of the best sources for information on all aspects of metal casting, including mold constructions, is *The Metalcaster's Bible* by C. W. Ammen. (Published by Tab Books Inc. Blueridge Summit, Pa.)

A mold is needed to receive the metal. The metal must be contained in a crucible, or the furnace itself, for melting; the furnace must be constructed from a refractory material. A fuel is needed to produce heat, and an air supply is needed to increase the rate of combustion and to elevate temperatures.

Molds, metals, and refractories must all be made of natural, earth materials. Early melting furnaces were constructed easily out of clay, stone, or fired ceramic blocks. Wood was used as a fuel, and simple bellows were used for delivering the air.

Metal for casting may be either ferrous or nonferrous. Ferrous metals, those primarily containing iron, are generally susceptible to corrosion. Nonferrous metals are more corrosion-resistant. We ordinarily think of copper-based alloys and aluminum as nonferrous metals. Zinc, lead, tin, nickel, silver, manganese, gold, platinum, and cadmium are also nonferrous materials. Many of these are used as additives or alloying agents to alter the properties of copper or aluminum.

Lead increases tensile strength and ductility in copper alloys. A small amount of lead actually exists in almost every alloy. Zinc improves fluidity and hardness. Nickel and silicon increase structural density,

strength, and corrosion resistance. Tin increases strength and hardness.

Today, hundreds of alloys meet specific performance needs in metal casting and fabrication. Few sculptors need to become overly involved in these

Aluminum	1225
Aluminum Alloys	900–1250
Anitmony	1160
Brasses	1550–1875
Bronzes	1300–1900
Cast Iron	2050–2200
Chromium Nickel Cast Iron	2100
Chromium	2925
Copper	1980
Cobalt	2690
Gold	1950
Hard Steel	2560
Iconel Metal	2475
Lead	625
Lead Alloys	150–650
Manganese	2300
Manganese Bronze	1590
Magnesium	1200
Magnesium Alloys	650–1200
Mild Steel	2725
Monel Metal	2475
Nickel	2650
Nickel Steel & Iron	2150–2775
Pure Iron	2800
Red Brass	1860
Silver	1760
Silicon	2580
Silicon Bronze	1850
Stainless Steel 12% Cr.	2760
Tin	450
Tin Alloys	375–650
Tobin Bronze	1640
Wrought Iron	2700–2900
Zinc	790

Figure 3–28
Melting points of metals (degrees Fahrenheit).

complexities because suitable alloys are readily available for casting and fabrication. Ordinarily, it is better to purchase new ingots for casting than to attempt to use scrap; this way, it is possible to know the precise characteristics of the metal being cast and the casting requirements. Suppliers should be able to supply specification sheets on their alloys. Figure 3–28 lists melting points of some metals. Descriptions of some of the most common metals follow.

Aluminum. Principal alloying elements are copper, magnesium, silicon, zinc, and tin in small percentages. In casting aluminum, use alloys specifically designed for casting.

Bronze. Tin is the principal alloy, with additives of zinc and lead. A typical bronze is 70 to 90 percent copper, 10 to 20 percent tin, and the remainder zinc and lead. However, traditional bronzes, such as "statuary bronze," "bell bronze," and "art bronze," are more likely to have close-to-equal portions of tin and zinc.

Commercial bronze. This is actually a brass, with 10 to 12 percent zinc as the alloying agent.

Muntz metal. This is a brass with about 40 percent zinc and 60 percent copper.

Silicon bronze. This alloy is 1 to 3 percent silicon, 94 to 98 percent copper, and 1 to 2 percent additives of aluminum or manganese.

Tobin bronze. This is 60 percent copper, about 39 percent zinc, and the remainder, tin.

Manganese bronze. This is 58 percent copper, about 39 percent zinc, 1 percent tin, and a fractional amount of manganese.

Aluminum bronze. This alloy is 82 to 95 percent copper, with the balance aluminum; some aluminum bronzes have fractional amounts of tin or manganese.

Brass. Any copper-based material that has zinc as its principal alloy is classified as brass. At times, these may be called "bronze," but metallurgically they should be classified as "brass." Brasses vary considerably as to zinc content. Copper content may be as high as 95 percent, and the zinc content may vary from 5 to 40 percent. Pure brass is a copper-zinc alloy. Leaded brasses make up a whole area of brasses; lead can be added in fractional amounts up to about 3 or 4 percent. Special brasses have fractional percentages of tin, lead, aluminum, phosphorous, or manganese.

Phosphor bronzes. These are up to 98 percent copper, with the balance in tin and a fractional amount of phosphorous. In some cases, 1 to 4 percent lead is included.

Pewter. This is comprised of lead and tin, or tin, copper and antimony; the percentage of tin is about 80 percent.

Nickel-bearing copper alloys. These are 45 to 65 percent copper, 17 to 42 percent zinc, and 10 to 18 percent nickel, with a fractional amount of manganese. At times they are referred to as German silver, monel, iconel, or nickel silver.

Low-melting-point alloys. These consist of cadmium, tin, bismuth, and lead, and melt at temperatures of 140 to 180 degrees. Lipowitz alloy consists of three parts cadmium, four parts tin, fifteen parts bismuth, and eight parts lead. It softens at 140 degrees and melts at 158 degrees. Woods metal consists of four parts lead, two parts tin, five to eight parts bismuth, and one to two parts cadmium. It melts at between 140 to 161 degrees.

Cast iron. This is the ferrous metal usually cast by sculptors. It has a reasonably low melting point of 2100 to 2200 degrees and melts readily in a cupola furnace.

Steel has enjoyed less aesthetic appeal than bronze and other nonferrous metals. Because it requires higher working temperatures and, subsequently, more costly equipment, steel is not frequently used as a casting material for sculptures.

Steel is available in a wide variety of alloys. The carbon content largely determines its physical properties because carbon lowers the melting point and the steel becomes harder, stronger, more brittle, and more wear-resistant. Other alloys such as nickel and manganese improve its toughness; tungsten and chromium carbide improve its wear resistance; chromium provides corrosion resistance, as in stainless steel; copper provides resistance to the atmosphere; and silicon acts as a deoxidizing agent and adds strength.

Principal factors involved in metal casting are the properties and characteristics of the metal being poured, the molds and dewaxing of the molds, the furnace and melting procedures, the pouring of the metal, mold removal, and final finishing of the casting.

FURNACES FOR MELTING METAL

A furnace is a heat-producing device that operates at temperatures above 1000 degrees. Furnaces for melting metal are classified according to the method of metal removal, the kind of heat energy, and the method of containing the metal during the melting process.

The metal can be melted either in a refractory crucible placed in the furnace or directly in the refractory-lined furnace. A major distinction exists between the two approaches: In the second, the melting metal often comes directly into contact with the combustion. The heat energy may be coke, coal, natural or butane gas, oil, or electrical energy.

Molten metal can be removed from a furnace by liftout, baleout, tapout, or tilting. Liftout is associated with the crucible furnace from which the crucible of molten metal is removed. Baleout means ladling or scooping out quantities of metal from a crucible- or other-type furnace. In tapout, a plug is removed from a tap hole, which allows the metal to flow out into a receiving ladle. Tilting furnaces tilt to discharge the metal into the ladle.

A blast furnace is used to produce iron from iron ore. The open-heart furnace processes the iron into steel. Reverberatory furnaces are used in producing copper.

The fuel-operated cupola furnace is used to produce cast iron and to melt large quantities of copper or copper alloys. It is a relatively simple device. Art-department foundries and sculptors doing large castings often use the cupola for melting bronze or cast iron. You can build a simple drop-bottom cupola furnace by welding 55-gallon steel drums together. (Figure 3–29)

The cupola furnace is essentially a refractory-lined, vertical-steel cylinder. The lining may be brick or a refractory that is stuccoed, troweled, or rammed in place. A drop door is located at the bottom of the

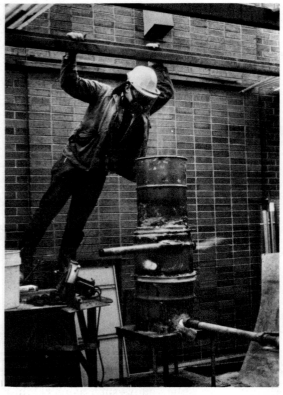

Figure 3–29
Small cupola constructed out of 30-gallon steel drums. Fire is being started with a gas burner.

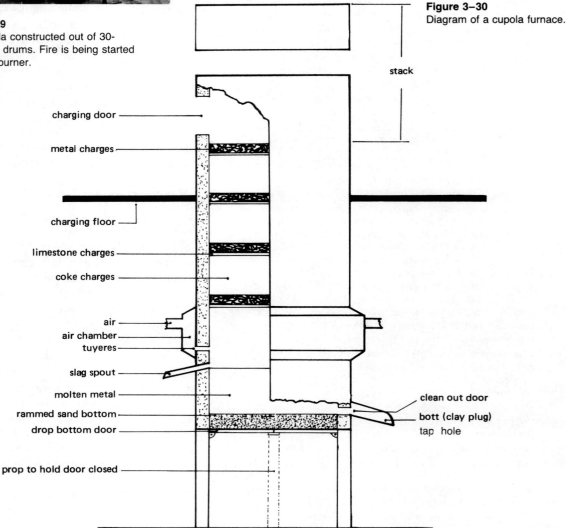

Figure 3–30
Diagram of a cupola furnace.

stack

charging door

metal charges

charging floor

limestone charges

coke charges

air

air chamber

tuyeres

slag spout

molten metal

rammed sand bottom

drop bottom door

prop to hold door closed

clean out door

bott (clay plug)
tap hole

furnace, in order to clean out ashes and unburned coke. The other parts of the furnace include a tap hole to discharge the metal, a slag spout to draw off slag, the tuyeres (or holes to introduce air into the furnace), a bell-shaped enclosure or air chamber around the tuyeres to direct the air, and a charging door. (Figure 3–30)

To operate a cupola furnace, the bottom is lined with green sand and a coke fire is built up to the level of the tuyeres. (The tuyeres may be anywhere from 12 to 48 inches from the bottom of the furnace, depending on the furnace size and on whether the metal is collected in the bottom of the furnace or is continuously discharged.) Blowers or gas burners may be used to start the fire. As soon as the coke fire is burning freely, the tap hole is plugged with a lump of earth clay; the fire is built up above the tuyeres. An initial charge of metal is placed on the fire and followed by alternating layers of metal, coke, and limestone. The initial charge could be anywhere from 100 to 150 pounds or more, depending on the size of the furnace. The proportion of metal to coke can vary from 7 to 10 pounds of metal per pound of coke. The limestone is added as a fluxing agent at the rate of about 20 to 30 percent. (Figure 3–31)

After the furnace has been charged through the charging door, the air is turned on and, as the coke burns, the metal melts and flows to the bottom of the cupola. Additional charges of material can be added as the charges burn and melt.

The metal is allowed to accumulate in the bottom of the furnace, or it is allowed to flow out continuously into receiving ladles as the melt proceeds. In a continuous melt, the tap hole would not be closed. If the metal is allowed to accumulate, the tap hole would be closed at the time the furnace door was closed. Another practice is to leave the tap hole open until the metal begins to run. This procedure is used as a safeguard to prevent the metal from freezing around the tap hole. To close the tap hole and stop the flow of metal, a clay lump is rammed into the hole with a bott stick. The bott stick is a steel rod with a small, flat metal disc on the end. The clay is fastened to the metal disc. (Figure 3–32)

Figure 3–31
Large cupola furnace being charged with coke.

Figure 3–32
Cast iron being transferred from furnace to pouring ladle. The worker to the left is holding a bott stick ready to push the cone shaped lump of clay into the tap hole to stop the flow of metal.

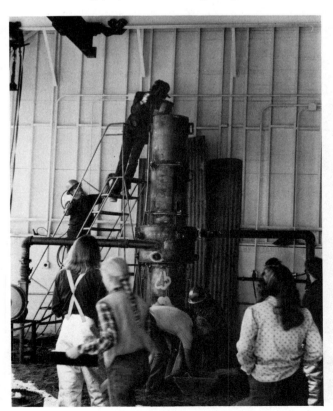

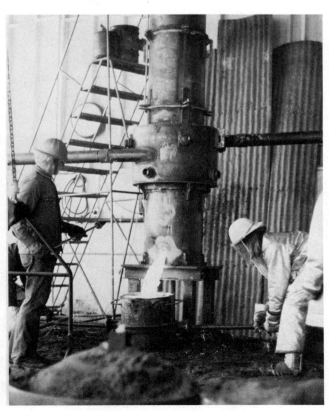

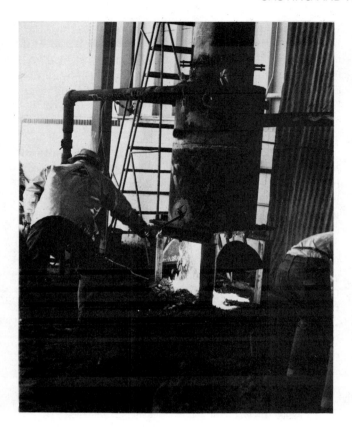

Figure 3–33
Slag and ashes being removed from furnace.
Photographs of facility and iron pour taken at the Art
Department, Cameron University, Lawton, Oklahoma.

Periodically, slag may need to be tapped off through the slag spout. This is accomplished by letting the molten metal build up to the level of the slag spout. At this point, the slag spout is unplugged and the slag flows off the top of the molten metal.

After completion of the melt, the ashes, slag and unburned coke are immediately removed from the furnace. (Figure 3–33)

Electric furnaces are most prevalent in steel foundries. Lack of contamination characterizes these furnaces, so the foundries are able to alloy and process metal with a great deal of precision using them. In electric-induction furnaces, current passes through coils surrounding the metal-charged crucible or furnace. Electric energy passing through the charge melts the metal. Several varieties of electric-arc furnaces also exist. The electrode may be submerged in the metal or it may be above the metal charge, so the arc occurs between the metal charge and the electrode; the arc may also be over the metal charge, between two electrodes.

The gas-fired, liftout-crucible furnace is the type most frequently used in sculpture departments and studios. Because its main purpose is to melt nonferrous metals, it is simple to build and operate. The flame enters at an angle at the bottom of the furnace and travels in a circular pattern around the crucible to a hole in the lid. This type of furnace either stands upright on the floor or is buried in the floor (pit furnace). Crucible furnaces may melt quantities of metal up to several thousand pounds. (Figures 3–34 and 3–35)

Figure 3–34
Small crucible furnace with controls. Note ingots being preheated on top
of furnace. (Other views of furnace in Figures 3–39 and 3–40.)

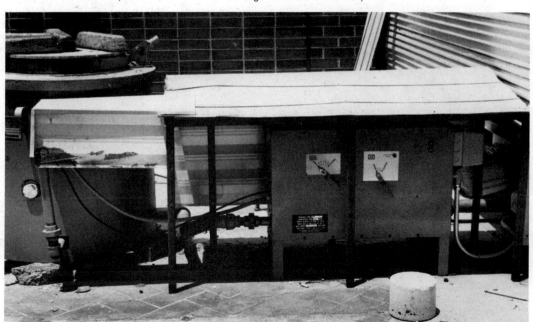

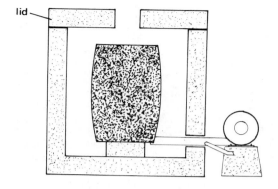

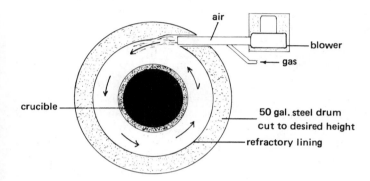

Figure 3–35
Simple crucible furnace.

Since most melting by students or sculptors is in crucible-type furnaces, further discussion of metal casting focus is on the techniques for using them. For the average sculpture studio, a furnace of 100 to 200

pounds capacity is more than adequate. Cast sections of that weight can be readily welded together. Some sculptors, however, prefer a single casting, and some techniques even require it. In this case, far larger melting and handling facilities are essential. Whenever possible, it is advisable to put such large casting jobs into the hands of competent art foundries.

The crucible from a small crucible furnace is lifted with a one- or two-person crucible tong. The tongs should be designed so that they can be adjusted to hold the crucible firmly without applying excessive pressure on it. Large crucibles are removed with a lifting tackle attached to an overhead hoist on a monorail. The pour may take place directly from the crucible, or the metal may be transferred to a pouring ladle. Large quantities are also bailed out, or, in the case of a tilting furnace, poured. For large amounts of metal, the ladle may be preheated, or heat from a ladle warmer may be directed on the ladle to maintain the temperature of the metal. A ladle warmer can be built in the same fashion as the burners shown in Figure 3–36.

Although commercial furnaces with manual or automatic controls are expensive, they are well worth the investment. Many sculptors construct their own melting furnaces by improvising or buying the necessary components. A simple, inexpensive furnace would consist of a refractory-lined steel container, a lid, a burner, and an air supply.

Refractories are available as bricks, preformed shapes, castable material, or material that can be stuccoed or rammed in place. These materials are readily

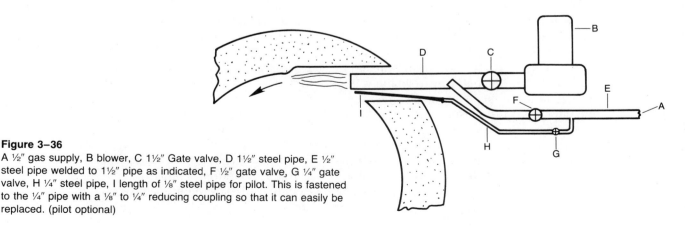

Figure 3–36
A ½″ gas supply, B blower, C 1½″ Gate valve, D 1½″ steel pipe, E ½″ steel pipe welded to 1½″ pipe as indicated, F ½″ gate valve, G ¼″ gate valve, H ¼″ steel pipe, I length of ⅛″ steel pipe for pilot. This is fastened to the ¼″ pipe with a ⅛″ to ¼″ reducing coupling so that it can easily be replaced. (pilot optional)

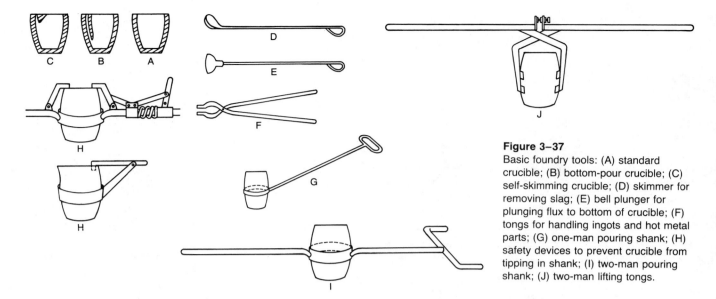

Figure 3–37
Basic foundry tools: (A) standard crucible; (B) bottom-pour crucible; (C) self-skimming crucible; (D) skimmer for removing slag; (E) bell plunger for plunging flux to bottom of crucible; (F) tongs for handling ingots and hot metal parts; (G) one-man pouring shank; (H) safety devices to prevent crucible from tipping in shank; (I) two-man pouring shank; (J) two-man lifting tongs.

available in any major city. The castable, or stucco, materials are less expensive than brick and are very adequate in studios where firing is only occasional. The lid for the furnace can be cast, or can be formed from properly shaped bricks held together with a steel band. Precast lids and furnace linings can also be purchased.

The burner can be as simple as a piece of steel pipe or it can be a complex arrangement with ceramic burner tips, pilot light, and safety controls. Figure 3–36 illustrates a simple burner-mixer that can be built readily out of steel pipe. The burner should be positioned in the furnace so that the flame impinges on the refractory wall and the wall produces a slight baffling action for the flame. The refractory will then rapidly develop a few red hot spots that will help keep the burner ignited. Because the melting furnace is not left unattended as the melt proceeds, safety controls are less important than with a burnout furnace. A simple, manually operated burner is often quite adequate.

The air supply can be an old vacuum-cleaner motor or an appropriate fan. Often it is advisable to buy a burner fan unit, which is available with all the components preassembled. Considerable savings are still realized if you build your own furnace.

The sizes of the burner and the blower are relative to the amount of heat desired. Heat is estimated in terms of b.t.u. per hour. It takes approximately 250,000 b.t.u.s per hour to melt approximately 90 pounds of bronze in a number-30 crucible. The size of the gas line depends on the distance the line must travel from the meter to the furnace. You usually need a 1½-inch gas line to deliver the desired amount of fuel. It is also important that the line from the street to the meter, the meter, and the pressure regulator be the right size. These requirements can be checked with your local utility company.

Crucibles are made of graphite or silicon carbide. Standard sizes run from 6 to 800. (The number indicates the approximate number of pounds of aluminum the crucible will hold. Multiplying the number by three gives the pounds of brass or bronze.) A new crucible should be heated slowly the first time to temper the refractory material. It should be kept dry and not subjected to rough handling. Metal should not be wedged, forced, or dropped into the crucible. The crucible is placed in the furnace on a base block.

The lighting procedure to start the furnace may vary with the manufacturer and the kind of controls. If an automatic ignition system is used, the starter button is pressed. As soon as the ignition strikes or sparks, the gas and air are turned on. After the mixture ignites, the burner is adjusted to the desired flame. Ignition is usually identified by a buzzing sound.

For manual lighting of a burner as in Fig. 3–36, the furnace lid is partially opened and gate valve GC and F are closed. A small piece of burning rag soaked in charcoal lighter fluid is placed in front of the burner and lighted. If a pilot light is being used, it is ignited. Next gate valve F is slowly opened until the gas ignites. This ignition can readily be determined by the flame in the furnace. At this point the blower is started and valve C is slowly opened until a flame with a blue tip is formed. Gas and air are then slowly increased until the desired flame is achieved. Keep a low flame and give the furnace and crucible a chance to preheat before increasing the flame to full. The preheating is important because sudden intense heat exposes the furnace and crucible to thermo shock and results in more rapid deterioration of the refractory materials.

It is advisable to seek the assistance of another sculptor or student familiar with burners when trying to light a furnace; lighting it and judging the proper amount of gas and air takes some experience. Above

all, care must be exercised, since a furnace that has accumulated a lot of gas can be explosive.

Keep the flame adjusted to a moderate-to-slight oxidizing atmosphere for bronze and a slight oxidizing atmosphere for aluminum. An oxidizing atmosphere is rich in air and lean in fuel; the flame should be a bluish to clear pale color. A reducing atmosphere is rich in fuel; its flame is yellow-tipped.

The crucible is usually charged with metal after the first preheating with the furnace on low heat or prior to lighting the furnace. Aluminum may be charged into the crucible at a higher furnace-crucible temperature to reduce gas entrapment.

The metal should be clean and free from moisture. Slightly preheating the metal is a good practice when possible. Metal added to melted metal in the crucible must also be moisture-free. For preheating, the pieces to be added can be placed on top of the furnace lid, around the opening. It is important to realize that moisture or contaminants on a cold piece of metal, or ingot dropped into a molten-metal mass, can cause spattering or violent reaction. The metal being added should be picked up with tongs and gently lowered into the crucible. Protective apron, goggles, and gloves should be worn.

If alloys are being added to the molten metal, they are added in order of their melting points with the lowest melting-point alloy being added last. For example, in adding tin or zinc to copper, the copper would be brought to a molten state before the addition of either alloy. Conversely, a higher-melting-point alloy, such as silicon, would be melted before the copper. In commercial foundries, alloying is a precise practice. For the sculptor or student, it is far more practical to buy ingots of the desired metal.

When the metal is charged into the crucible, or as the metal begins to melt, a flux may be sprinkled on the metal to act as a protective cover for the molten metal. This protective cover helps prevent oxidation and gas absorption, which are the result of the molten metal's being exposed to combustion and the moisture of the atmosphere of the furnace.

Many nonferrous metals, such as those with a high zinc content, produce a natural, oxide protective cover as they are melted. In this case, a flux may not be necessary. In fact, if clean, new metal is used, a flux is probably unnecessary for most copper alloys.

Fluxes also clean and remove unwanted agents and impurities by direct action with these particles in the molten mass. They may also act as degassing agents, removing and dispersing such gases as hydrogen. Multipurpose fluxes that combine to form protective covers, clean, and degas are readily available.

Fluxing oxidizing agents are frequently manganese dioxide or copper oxides; deoxidizing agents may be phosphor copper, silicon, boron, magnesium, and others. For aluminum, degassing is also accomplished by inserting a hollow metal tube attached to an appropriate nitrogen source and bubbling the nitrogen into the molten-metal mass prior to pouring. The nitrogen is available in a cylinder equipped with pressure gauge. Degassing agents may also be included in the initial flux, or they can be sprinkled and stirred into the molten-metal mass after it has been removed from the furnace and skimmed. A typical degassing would consist of stirring in 2 percent phosphor copper. This can be stirred in with a metal rod.

The metal should not be stirred during the melting, or the protective cover of oxides and flux will be broken. If the cover is broken during the addition of more metal to the crucible, it may be necessary to add a small quantity of flux.

When the metal reaches a molten state, the temperature should be checked with a pyrometer. A hand pyrometer (as in Figure 3–38) is a convenient method of checking temperature. The pouring temperature

Figure 3–38
Using a hand pyrometer to check metal temperature.

Figure 3–39
Crucible being lifted from the melting furnace.

Figure 3–40
Crucible being placed over pouring shanks.

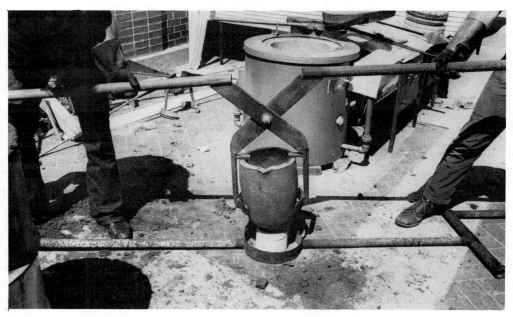

is 100 to 200 degrees above the melting point of the alloy. The temperature of the metal in the furnace should be about 100 degrees higher than the actual pouring temperature. This allows for the cooling of the metal that occurs between the removal of the crucible from the furnace and the actual pour. The pouring temperature varies according to the alloy. Sometimes, if the temperature is raised too far above the melting point, alloying agents can start to disintegrate. This happens readily in materials such as brass that have a high zinc content. The ideal pouring temperature is as close to the melting point as possible.

After the metal reaches the desired tempera-

ture, it should be removed immediately. The furnace is first turned off (gas first, then air); the crucible is lifted out of the furnace and placed in a pouring shank. (Figure 3–39 and 3–40) The two-man pouring shank is used, typically, for pouring by hand. It is placed on the floor with a few inches of dry sand around the shank opening; a refractory block is placed in the center of the shank to insulate the hot crucible from the floor.

At this point, slag and flux are skimmed off the top with a skimming bar or small hand ladle, and the metal is poured. The skimming bar is a small piece of perforated steel welded to a rod (as in Figure 3–

41). An assistant may also use the skimming bar and hold back any particles of flux and slag during the pour.

Pouring requires some skill. The pour must be continuous, steady, and even; metal must always be present in the pouring cup, to keep turbulence in the cup to a minimum.

Molten metal can be poured into sand, plaster, ceramic shell, or permanent metal molds. Molds are often placed in wood or metal flasks. Moist loam is rammed around plaster or sand molds; dry sand is used with ceramic shell. If the mold should crack during the pour, the sand or loam may prevent a runout and loss of the casting.

Adequate cooling time must be allowed after the pour. Breaking away the mold is simple; most mold materials readily fracture and fall off in large sections when tapped or struck with a metal hammer. Final investment material is carefully scraped off or removed with small chisels, wire brushes, and so on. Sandblasting can be used for cleaning; however, this may alter the surface appearance of the casting. (Figures 3–42 through 3–49)

After the removal of the mold materials, sprues, vents, and so on are sawed off. This can be accomplished with a hack saw, band saw, cutting air-arc, or

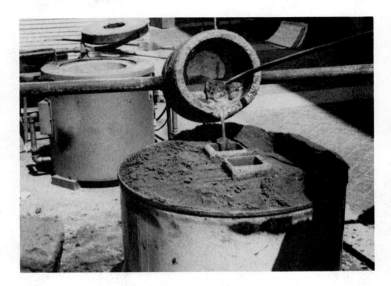

Figure 3–41
Metal being poured into the mold. Skimming bar is being used to hold back the slag as the metal is poured.

Figure 3–43
Moist sandy loam is being placed in the flask. It is being rammed or packed in place. Flasks are stacked until the top of the mold is reached. Note the cover over the pouring cup and the vent to prevent ramming material from getting into the mold. Note also that strips of wood, wire, and turn buckles were used to hold the mold together.

Figure 3–42
Sand mold ready for casting. The first flask has been placed around the mold.

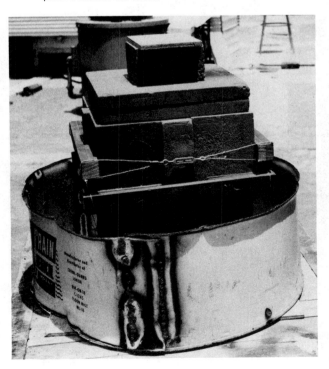

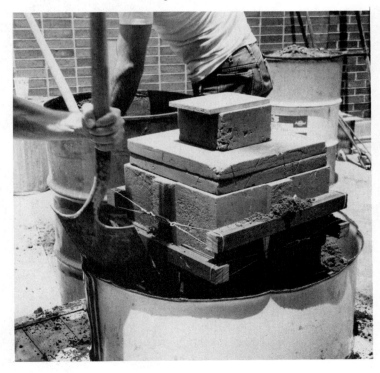

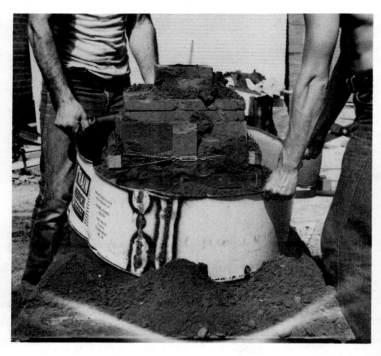

Figure 3–44
Flasks being removed from the mold.

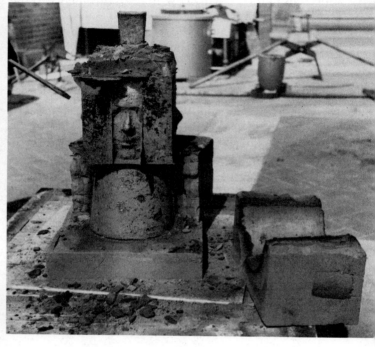

Figure 3–45
Mold has been partially removed revealing the completed casting.

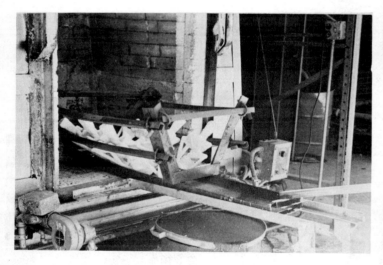

Figure 3–46
Ceramic shells of previously illustrated wax pattern (Figure 1–21) being removed from burnout furnace.

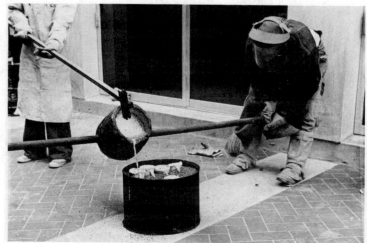

Figure 3–47
Ceramic shells packed with loose sand in flask being poured.

Figure 3–49
Breaking away shell molds. Spraying the molds with water after slight cooling helps the mold material break loose.

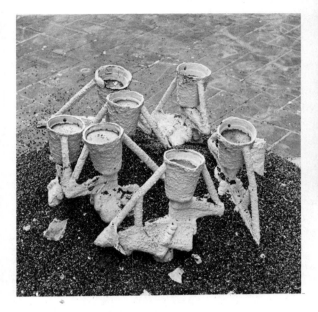

Figure 3–48
Flask removed showing cast shell molds.

abrasive cutoff wheels. Powder cutting or using a cutting bar are fast and efficient ways to remove sprues. Final finishing is accomplished with small cold chisels and punches for chasing. Abrasive coated belts and discs, grinders, and polishing wheels or buffs are used for final finishing.

Imperfections in the casting may result from any number of errors occurring during mold construction: the meltout in lost-wax molds, the melting of the metal, and the pour. Some common defects in metal castings and their causes are described next:

Flashings, runouts. These are caused by mold failures, improper materials, inadequate reinforcement, insufficient bulk to the mold, or poor mold design.

Porosity. Porous castings usually result if gases accumulate during the melting of the metal or if gases enter the molten metal in the mold. Proper degassing agents should be used during the melt or prior to pouring. Mold conditions such as the presence of excess moisture, gas-releasing agents in the mold, or turbulence in the pouring of the metal may produce porosity.

Pinholes. These are caused by moisture in the mold or gases that the molten metal absorbs during the pour. Better venting and mold permeability may remedy these problems.

Cold shut. This is usually observable as a thin hairline on the surface of the casting. It is caused when the metal is fed into the mold, or flows in several directions, and has cooled to the extent that the two meeting flows do not mingle or bond together. Variations in metal temperature, mold temperature, and

mold design (in terms of gates, sprues, etc.) are some of the causes. Insulated feeders may assist in maintaining metal temperature.

Blowholes. These are internal or external defects in the casting caused by trapped gases. They are caused by lack of mold permeability or inadequate venting.

Inclusions. These are slag, oxides, mold particles, or other materials present in the castings. They can result from careless assembling of the mold, careless handling, improper melting of the metal, inadequate removal of slag and flux, or poor mold materials or construction (resulting in sand or mold particles' breaking away from the mold as the metal is poured). Using bottom-pour crucibles can minimize slag or flux inclusions.

Hot tears and cold cracks. These are caused as the metal shrinks in cooling. They can be controlled by choosing the proper mold material and mold design. Too rigid a core or mold material may prevent the metal from shrinking without tearing. A core or mold material should tend to collapse as the metal shrinks.

Misruns. Poor pouring techniques, improper gating and spruing, poor mold design, and improper mold or metal temperature may result in defective or incomplete castings. In sculpture, if a misrun is not too severe, it can be repaired. Small holes and cracks are filled by welding. New patterns for missing sections can be cast and welded into place.

Warping. Uneven cooling and irregular thickness of wall or metal mass may cause distortion during cooling, particularly if the casting is cooled too fast. Mold design may also be a factor. Exercising care in designing of the wall thickness of the casting and allowing adequate, slow cooling can minimize this problem. Do not be in a hurry to remove the mold after the casting.

67

GLASS

In the past 10 years considerable attention has focused on glass as a sculpture media. Large-scale forms have been produced by blowing and altering glass shapes. Casting or blowing into molds seems to offer some of the best opportunities for innovative sculptural forms. The glass is essentially silica with soda ash added to lower its melting point and increase its fluidity. Hydrated lime, barium carbonate, dolomite, sodium nitrate, potash, barium carbonate, and other materials may also be added to alter its properties. Color is achieved by the addition of metallic oxides such as iron, copper, manganese, chromium, and so on.

You need several furnaces to work with glass: a glass-melting furnace, a furnace for heating and working the glass, and an annealing furnace. The melting furnace is either a horizontal tank type that melts the glass in its bottom or a pot type that melts the glass in crucibles. The furnace for working the glass is horizontal and has an end door on a track that can be opened partially or all the way to provide access to the work. (It is often referred to as "the glory hole"). (Figure 3–52) The annealing oven is a horizontal rectangular and has a top hinged door. (Figure 3–54) It is utilized to slowly anneal and reduce the temperature of the glass.

You blow or cast glass into molds you construct from a pattern or into direct molds such as those used to cast other materials. The investment materials used are often the same as those used in metal casting. A typical mixture might be something as simple as 50 percent 175 to 250 mesh sand to 50 percent plaster for molds into which you blow the glass. For molds that must withstand higher temperatures—such as those used to cast glass—it is better to use a refractory material in the mold. A mixture of equal parts sand, plaster, and a castable refractory such as Kaiser I.R.C. 22 is often used. The mold should be constructed with a funnel-shaped retaining well if it is to be used for casting glass. If glass is being melted in the mold, this can serve as a pouring cup or as a reservoir for extra material. First allow it to air dry for several days and then slowly dry in a kiln up to 600 degrees over a period of 4 to 5 hours. If a coarse surface is desired on the casting the mold can be used as is. If you want a smooth surface, coat the mold with powdered graphite mixed with oil or water.

There are two basic ways to cast glass. In one process the glass is poured into the mold. After slightly cooling to a solid the mold is quickly broken away and the work is immediately transferred to an annealing oven. The oven has been preheated to about 1200 degrees. The work is annealed for about an hour and then the temperature is slowly reduced. The rate at which the temperature is reduced depends on the size of the glass mass. Large forms may very well take 10 days or longer.

In the second process glass is placed in the mold including filling the retaining well. If the mold is relatively open, like a deep relief, a thick piece of glass may be placed over the opening and slumped into the mold. The mold is placed into the annealing oven and the temperature is slowly raised over a period of about 3 hours until the glass has melted. Melting temperature will vary depending on the glass used (plus or minus 1600 degrees). Being able to actually look into the mold through a small viewing hole in the top of the oven is the best way to check the glass to see if it has melted. Be certain always to wear a face shield during this procedure. Another way to check the glass is to momentarily open the door to view the mold. This is, by the way, the only way to check the glass if you are casting more than one mold. After the glass has melted, let it drop to annealing temperature (about 900 to 1000 degrees); this should take about an hour. It is held at that temperature for 1½ to 3 hours and then slowly reduce the temperature. The reduction time again depends on the size of the piece.

Another process for working with molds consists of blowing the glass into the mold to form a hollow casting. The glass is gathered and built in successive layers until a sufficient amount is gathered to blow into the mold. Molds in this case can be wood as well as plaster.

The tools for blowing and working with glass are quite simple. The blowpipe is needed to gather the glass. A punty rod is used to collect additional glass that might be added to the gather. The stanton is used to support the blowpipe or rod when the gather is being reheated or worked in the glory hole. The jacks are used to shape the glass and the shears are used for trimming it. Wet cherry wood blocks with spherical indentations and wet pads of newspaper are also used to form the glass. The forming of the glass takes place by rolling the blowpipe on the arms of the bench or rolling the gather on a flat steel marvering table. (Figures 3–51 and 3–53)

In building a gather the end of the blowpipe is heated to a dull red. It is inserted into the furnace and slowly rotated as it picks up its first glass. The rotation is continued and it is removed from the furnace. The worker then very quickly moves to the steel table and rolls it into a cylindrical shape (marvered) or moves over to the bench and, while rolling the blowpipe on the arms of the bench, shapes the gather with a wet, concave block of wood. Keep the blowpipe rolling with one hand while using the other to hold

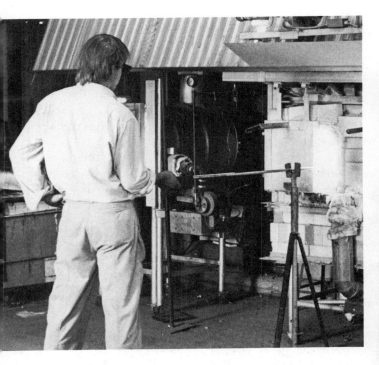

Figure 3–50
Sculptor Jeff Goodman gathering glass from the pot furnace.

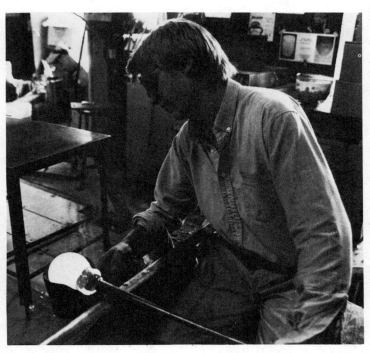

Figure 3–51
Forming glass gather with wood block while rolling blowpipe on bench arms.

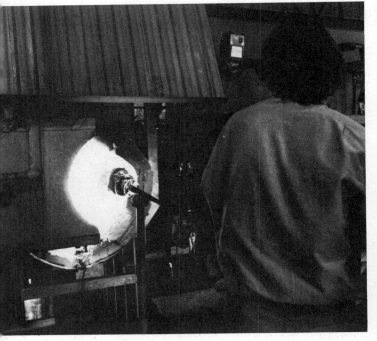

Figure 3–52
Reheating gather in glory hole.

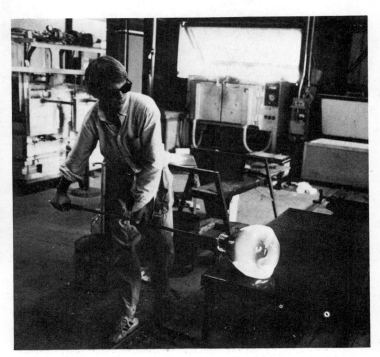

Figure 3–53
Shaping the gather on the steel marvering table.

69

the tool to shape the glass. In later gathers a pad of wet newspaper may also be used.

Working the molten glass cools it down enough to form a surface skin. At this point a small bubble is formed by blowing lightly on the pipe. The air is trapped into the pipe by covering the end of the pipe with your thumb. From here on the process is repeated until the gather is large enough for blowing into the mold.

In the gathering process, you can use several colors of glass. In fact, another worker can gather molten bits of glass with the punty and drop them on the gather for you to work into the surface. Shards of preheated glass may be picked up and formed on the surface of the gather, or the gather may be rolled in ground glass (Frit) or other materials to create varied surface effects.

After the glass has been blown into the mold, it is allowed to cool to the point of solidifying. The mold is then immediately removed and the work is transferred to the annealing oven. (Figures 3–50 through 3–58)

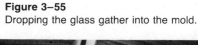

Figure 3–55
Dropping the glass gather into the mold.

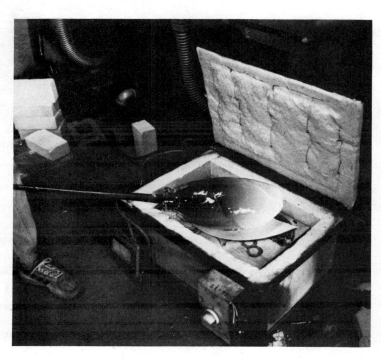

Figure 3–54
Picking up a shard of glass that has been pre-heated in an annealing oven and adding it to the glass gather.

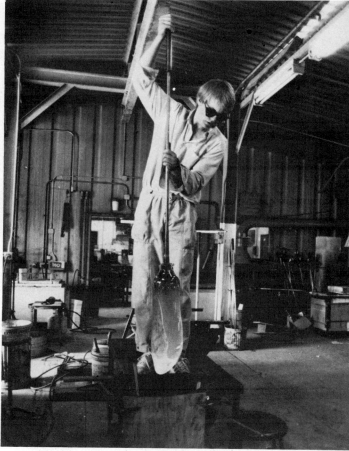

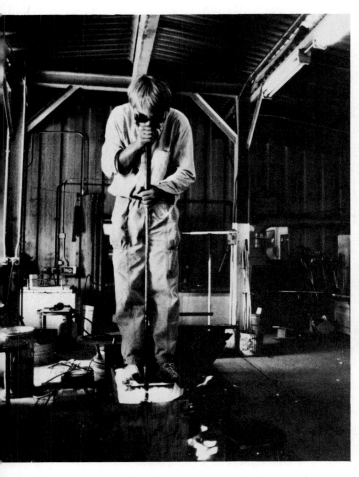

Figure 3–56
Blowing the glass gather into the wooden mold.

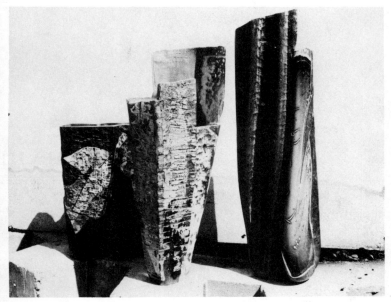

Figure 3–57
Glass forms after removal from the mold. By Jeff
Goodman. Glass casting demonstration courtesy of
Jeff Goodman and the glass program of William
Carlson, University of Illinois, Champaign-Urbana, Ill.
Photographs by Ronald Sterkel.

Figure 3–58
Basic glass-working tools, left to right. Wood block,
diamond shears, trimming shears, jack and wet
paper pad.

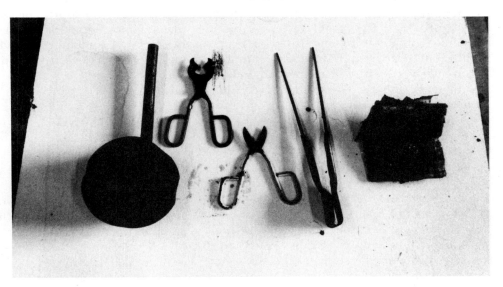

Carving

<div style="text-align: right;">

4

</div>

Carving is one of the oldest methods used to shape materials; simple stone tools and implements date back to primitive times. Ancient Egyptians, expert at wood and stone carving, possessed excellent metal carving tools.

The simple tools and techniques for carving are not much different today from those of ancient times. We have a greater variety and mechanical and electrical tools to make the task easier. However, the steps—from roughing out a wood or stone form to finishing it—remain essentially the same and can be accomplished with relatively few tools.

The materials for carving are still, basically, wood and stone. Some blocks of synthetic materials do have specialized usage for student projects and temporary patterns. In addition, some of the soft synthetic materials, such as blocks of foam or concrete, or plaster mixed with vermiculite or perlite, are excellent for beginning students. These materials are easy to carve and can rapidly acquaint the student with thinking subtractively and visualizing form in a mass of material. A few practice carvings from such materials can help considerably to build confidence and minimize error in subsequent wood or stone carvings.

In recent years, emphasis has been placed on the newer, industrial materials, but some sculptors do not favor carving techniques for contemporary sculp-

ture. For the young sculptor or student, however, exploring this traditional technique can produce worthy and satisfying results.

If carving is approached spontaneously and each material is explored for its own unique qualities, carving forms or combining carved forms with other materials can still have fresh and creative potential for you.

WOOD CARVING

Selecting a wood for carving is a matter of personal choice: Any wood can be suitable for carving. Some woods possess fine, even grains and are easier to carve than others; however, some woods that seem less desirable possess unusual grains and colorations that can result in works of great merit.

There is usually an adequate supply of native wood available in any geographic area. Sculptor James Surls, for example, collects much of his wood from sources in his own state. (Figures 4–1 and 4–2) Landscape and construction companies, park departments, and public utility companies are always busy trimming or removing trees. In the normal process of driving around a city, logs can be obtained from the work sites of such firms. It is also possible to find the city

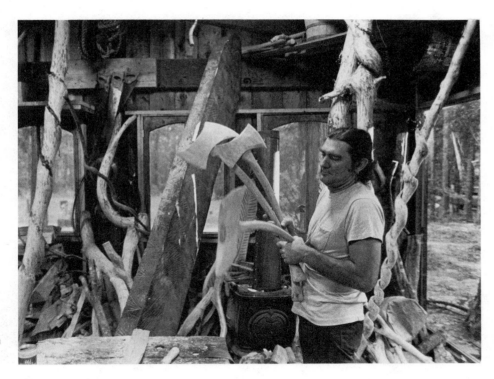

Figure 4–1
Sculptor James Surls in studio with carved wood forms used in his sculptures.

dumping area for these materials. Firms selling fire wood frequently have logs of fireplace length that can be used for small carvings. Exotic and uncommon woods can be obtained from wood suppliers. As a last

Figure 4–2
Completed wood sculpture *Cat Flower* oak, Ca. 1981 by James Surls. Photographs 4–1 and 4–2 by Frank Martin.

resort, dimensional lumber available at any lumber company can be laminated together.

Ideally, it is desirable to collect logs, seal the ends by painting them with oil paint, and dry or cure them in a dry, sheltered area. Curing can take several years for a large-diameter log. Uncured logs can be carved, but cracks or checks will develop. These can be filled with pigmented beeswax; after the log is completely dry, slivers of wood or wood fillers can be used instead.

First carvings can best be done in soft to medium-hard woods. Cedar, white pine, redwood, aspen, basswood, soft maple, cottonwood, spruce, cypress, and poplar are easy to carve. Birch, butterwood, olivewood, and fruitwoods such as apple, cherry, pear, and plum are good medium-hard woods for carving. Domestic medium-hard to hard woods are ash, beechwood, dogwood, elm, sycamore, maple, oak, walnut, and hickory. Excellent imported hardwoods are cocabola, ebony, koko, lemonwood, mahogany, rosewood, teakwood and *lignum vitae*.

Identifying woods is a matter of recognizing the texture and color of the bark, or the color of the wood and its grain configuration, in a rough or finished state. *Knowing Your Trees*, by G. H. Collingswood and Warren D. Brush, published by the American Forestry Association, Washington D.C. 1955, is an excellent reference guide to woods.

Carving generally undergoes three phases: the roughing-out, intermediate carving, and final-finishing stages. Some works may be carried to completion with roughing-out or intermediate carving as the final desired effects.

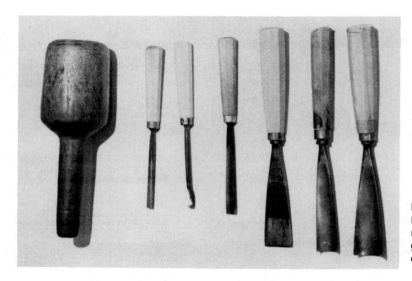

Figure 4-3
Hand tools for wood carving. Left to right: carving mallet, parting tool, bent gouge, straight gouge, straight flat carving chisel, straight gouges.

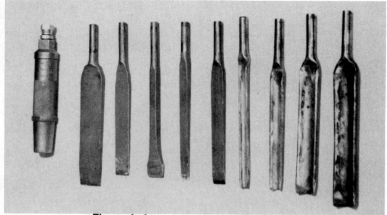

Figure 4-4
Pneumatic tools for wood carving.

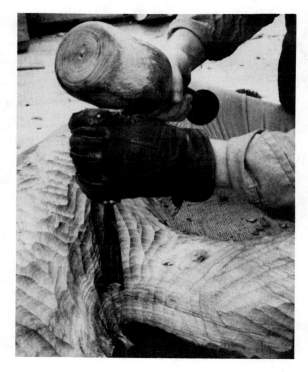

Figure 4-5
Roughing out a carving with a straight gouge.

Figures 4–3 and 4–4 illustrate some of the typical gouges, chisels, and other tools used for carving. Wood carving tools can be flat (chisels), slightly curved to half-round (gouges), or V-shaped (parting tools). Tools should be kept sharp while working. Chisels can be honed on a flat oil-stone, and gouges are sharpened with specially shaped slipstones.

Small logs or blocks of wood need to be held in a vice, bolted, or clamped to the table. Butting the end of the log or wood block against a 100-pound canvas bag of sand placed on the workbench works exceptionally well, because it allows you to turn the log and manipulate it easily as you develop the carving on all sides. Large logs are usually supported by their own weight.

To rough-out a moderate-sized work, strike a half-round gouge with a wooden mallet. The width and curvature of the gouge and the weight of the mallet (16 to 32 ounces) depend on the size of the log and your personal preference. The gouge is held at approximately 45 degrees and is struck with the mallet. (Figure 4–5) As the gouge bites into the wood, the angle of the chisel is decreased and a piece is gouged out of the material. Always carve in the direction of the grain, because working against the grain, or attempting to gouge out too large a piece, may result in your imbedding the chisel in the wood and breaking the tool.

Large sections can be sawed or chiseled out of a log; hand saws or chain saws can be used. (Figure

Figure 4–6
Sculptor Anne Wallace working with chainsaw on sculpture *The Rape of Europa*. 1980 Photograph by Alan Weiner.

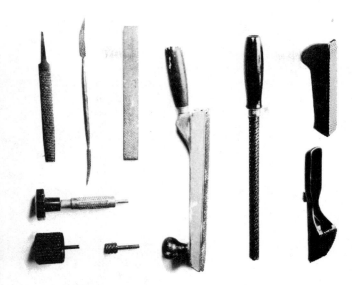

Figure 4–7
RASPS—upper left: half round, riffler, and flat rasps. Lower left: rotary rash planer (top) serrated drum and steel cylinder that fit an electric drill. Center to right: hand rasps with serrated surfaces.

4–6) Cavities or holes can be drilled and carved out. Hand axes and adzes are also used for roughing-out. Pneumatic hammers can be used to drive the gouges and accelerate the carving.

After the initial roughing-out is accomplished, a shallow or slightly curved gouge is used to cut down the ridges left by the gouge. Lighter-weight mallets are often used for the intermediate carving. The chisel is either struck with the mallet or pushed and tapped with the palm of your hand. After the gouge ridges have been reduced somewhat, flat chisels are used to further flatten the surface.

Surfaces can also be rasped or worked down with rifflers. In fact, having a good variety of rifflers (Figure 4–7) is essential for getting into otherwise inaccessible areas when finishing by hand. Mechanical rotary rasps can also be used instead of hand rasps. (Figure 4–7) These can be used in an electric or air drill, or on a flexible shaft. A flexible shaft or air drill is more compact and highly desirable for finishing in holes and negative spaces.

If you are going to give a carving a smooth finish, the normal abrasive-finishing procedures can be followed. Unusual-shaped sanding drums and discs can be used to finish the difficult-to-reach areas rapidly.

STONE CARVING

Stone for carving has fundamentally any of three geological origins. The very hard igneous rocks, such as granite and basalt, were formed by heat, volcanic action, and the subsequent cooling of the molten masses. The moderately soft materials, such as sandstone and limestone, are sedimentary rocks formed by layers (strata) of sediment resulting from erosion by chemical and physical action. Metamorphic rocks, such as quartzite, slate, shist, soapstone, marble, and gneiss, were formed through heat, pressure, and chemical action on igneous and sedimentary rocks.

Marble has been one of the most preferred materials for sculpture; granite, valued for permanence and weather resistance, has been used extensively for large monumental works. Porous rocks, less resistant to erosion, moisture, and freezing temperatures, should be treated with a sealer if permanency is desired.

Selection of stone is a personal matter, and the choice of stone is extensive. The ease with which stone can be carved varies from the soft materials, such as soapstone and alabaster (which, when wet, can be scraped and carved with a knife or coarse rasp), to granite (which requires sharp, well-tempered chisels

75

and a pulverizing action to break down the hard, granular material).

Because permanence, in the sense of a century or centuries, is of minimal concern to many sculptors today, any material is worthy of experiment. Every rock has its own unique form and structure. Traditionally, only well-formed, even-grained stones with minimum defects were considered suitable for stat-uary. Today, however, do not hesitate to explore previously unacceptable materials.

As in wood carving, a stone carving is developed by roughing out, intermediate carving, and final finishing. The final finish may be quite rough, revealing the chisel marks of the intermediate state, or it may be finished to a smooth or polished surface with abrasives.

Figure 4–8
Limestone sculpture *The Golden Age* 1984 by Sandy Stein.

Figure 4–9
Hand tools for stone carving. From top: hand hammer, bush hammer, hand set or pitching tool, hand tracer and hand point, hand plug drill, hand chipper, and hand chisel.

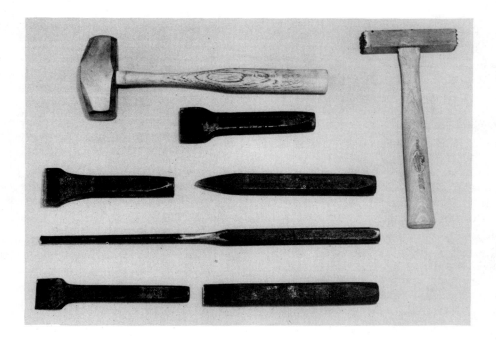

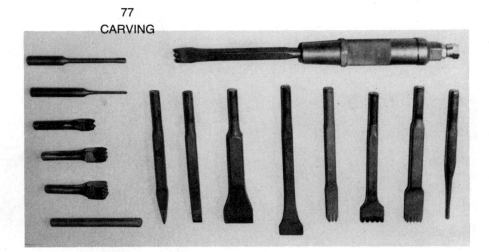

Figure 4–10
Pneumatic tools for carving. Top: pneumatic hammer and ripper. Left vertical row, top to bottom: two carvers drills, 4, 9, and 16-point chisel and carvers drill. Horizontal row, left to right: hand point, ½-inch clean-up chisel, marble cutting chisels, 3-tooth marble chisel, 5-tooth marble chisel, ripper and carvers drill.

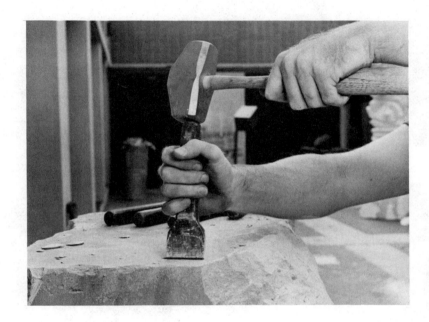

Figure 4–11
Using a hand set or pitching tool to break off edges in roughing out limestone.

During carving, you should place small blocks on sturdy wooden stands or on 50-gallon steel drums filled with sand. Large blocks of stone will support themselves. Large blocks of stone can be moved by hand or using rollers, levers, A-frames, or blocks and tackles. Use mechanical equipment, such as fork lifts and cranes, when available. (Figure 4–8)

Figures 4–9 and 4–10 illustrate basic tools and equipment for stone carving. Stone carving tools of the proper design, steel, and temper can best be purchased from a reliable supplier. These may be hand, pneumatic, or thermal tools. The tools should be kept sharp and in proper condition. Any mushrooming, or curling of edges, that occurs on the striking end of the chisel should be ground off immediately to avoid injury. Appropriate safety goggles and dust masks should be worn at all times.

In the roughing-out stage, it is important to visualize the general outline or essential, simple shape of the form to be carved. If the stone is a block of material, the first roughing out is accomplished by hand carving with a hand set or pitching tool. The rough corners and edges are broken off by striking the tool intensely with a relatively heavy striking hammer; the heavier the hammer you can handle, the easier this task will be. (Figure 4–11)

Large pieces can also be removed, or blocks can be split, by drilling a series of holes and driving wedges into them. Holes are drilled with an electric drill with carbide-tipped masonry bits or an air-hammer-driven carver's drill. To cut negative spaces or holes, it is simplest to drill into the stone, or cut with a carbide or diamond-tooth saw, and then chisel out the pieces. (Figure 4–12)

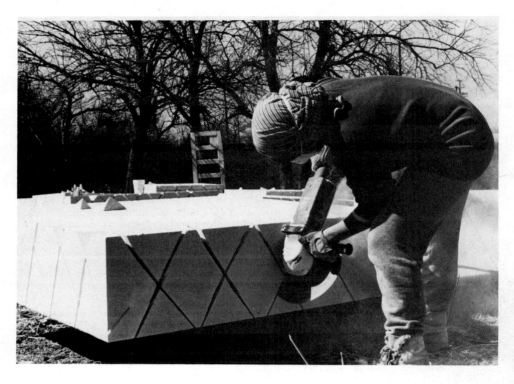

Figure 4-12
Sculptor Sandy Stein cutting with an abrasive saw to facilitate chiseling surface. Note that cutting blade should have a guard for optimum safe working procedure.

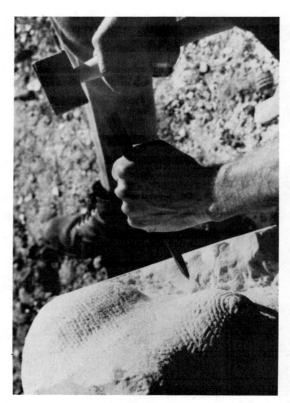

Figure 4-13
Sculptor Paul Aschenbach using a point to carve marble. *Photograph courtesy of Paul and June Aschenbach.*

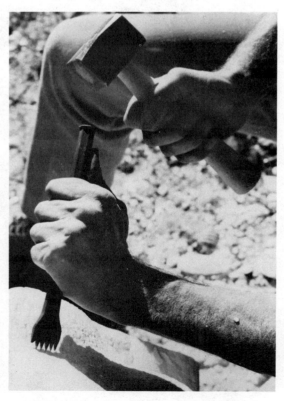

Figure 4-14
Hand finishing marble with a toothed chisel. *Photograph courtesy of Paul and June Aschenbach.*

After the initial roughing out, subsequent material is removed with the point. (Figure 4–13) The point for marble is rather slim and tapered, whereas the point for granite is rather blunt. The point is held at an angle and struck with the cutter's hammer. The point should not be buried in the stone. For carving soft stones such as sandstone and limestone, the hand tracer and chipper frequently work better than the point.

Intermediate carving is achieved with toothed or flat chisels. (Figure 4–14) Finish granite with a four- or nine-tooth chisel. Note that intermediate carving is best accomplished with machine-operated chisels; however, hand finishing, although tedious, is also possible and, in fact, is considered more desirable by some sculptors. In hand finishing granite, the bush hammer is often used in place of the four- and nine-tooth chisel at this stage. Because granite is granular, the action pulverizes the surface, wearing it down to within about ⅛ inch of the desired surface. (Figures 4–15 and 4–16)

If the stone is not to receive a polished finish, the final surface is usually achieved by working down with fine, sharp flat chisels. These chisels are struck lightly with light-weight hammers or, in the very final stages, pushed or tapped with your palm. A variety of smaller chisels is used to do fine detail and to get into difficult places. Although some sculptors object to the practice, machine-operated air or electric rasps and abrasive grinders can be used at this stage. This is really a matter of personal choice, as well as a matter of what you intend the final surface finish to be.

You may desire a smooth or polished finish rather than a tooled one. After working down with the flat

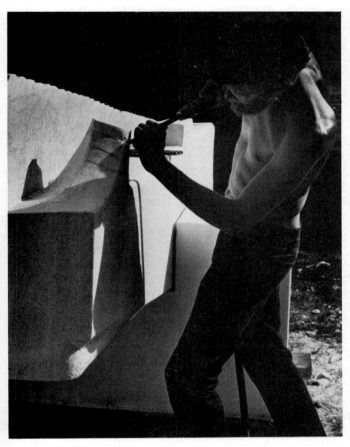

Figure 4–15
Sculptor Paul Aschenbach carving with a pneumatic hammer. *Photograph courtesy of Paul and June Aschenbach.*

Figure 4–16
Completed sculpture. *Proctor, Vermont Sculpture Symposium. Sculpture by Paul Aschenbach. 1968 Photograph courtesy of Paul and June Aschenbach.*

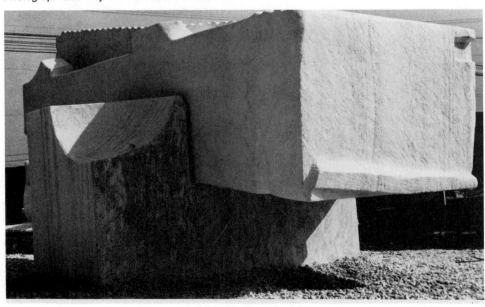

chisel, the surface can be finished abrasively in the same manner as other materials, by starting with a coarse grit of about 20 and working up to 200 or 300. Vitrified-bond, silicone-carbide cup wheels are best for flats and planes. Wet or dry silicone-carbide discs are recommended for curved and irregular shapes. Any of the variously shaped and coated abrasive wheels can be used for difficult-to-reach areas, some of which may require hand polishing. This can be accomplished by breaking off small pieces from abrasive wheels or by using pieces of hand bricks or other abrasives glued to desired shapes.

An air grinder is preferable for wet finishing. If an electric grinder is used, it should be properly grounded. Even then, I would hesitate to recommend its use for any wet-finishing operations. For dry abrasive finishing, a good fitting mask is absolutely essential, as stone dusts are hazardous.

If a polished surface is desired, the final buffing is accomplished mechanically with a felt buff, using tin oxide or cerium oxide buffing compound. Hand buffing is possible if mechanical equipment is not available.

Carving with thermal torches is a relatively new process for carving spallable stone such as granite. It involves spalling off thin layers of material by thermally induced expansion of the surface. The thermal torch employs a high-velocity flame produced by burning a mixture of oxygen and vaporized fuel such as kerosene. The flame size can be controlled by reducing the fuel flow. A jet of water alongside the flame washes away the spalled off material and gives the operator better control of the spalling action. The torch can be used for rapid removal of material and more delicate surface finishing. (Figure 4–17)

SYNTHETIC CARVING BLOCKS

Many materials can either be purchased in cast-block or slab form, or cast into blocks in the classroom or studio. I consider these synthetic blocks, as opposed to the natural blocks of wood or stone.

Besides their value for elementary carving, synthetic blocks can be used as patterns, as forms on which to build fiberglass, or, in some cases, as permanent media for interior or exterior work.

The usual procedure for casting blocks or slabs is to build a wooden box or frame the size of the desired form, or to pour the mixture into a corrugated cardboard box, which can be greased, lacquered, waxed, or lined with polyethylene film to make it waterproof.

Another interesting approach is to build the container to roughly approximate the shape of the desired piece. This reduces the amount of material and

somewhat eliminates the first roughing-out stages of the carving.

PLASTER

Plaster carving blocks have existed for some time. In recent years, perlite or vermiculite has been added to produce a softer material. A mixture of three parts vermiculite, one part plaster, and one and one-half parts water produces a soft block; these proportions can be varied to achieve softer or harder material. To prepare this mixture, the dry ingredients should be mixed and sprinkled into the water mix, and should keep on being added until the mixture reaches a firm, dough-like consistency. Adding too much water will produce an excessively soft material. Dry pigments or cement-coloring can be added for tinting and marble chips, sand, sawdust, or fine gravel can be added for texture, or these materials can be mixed with plaster, without vermiculite. The adding of these ingredients, or eliminating vermiculite, will produce harder blocks.

When vermiculite is added to the plaster, complete the rough carving within the first few days, while the block of material is relatively soft; after the block dries, it becomes harder, and finer detailing is possible.

The tools for carving plaster or plaster and vermiculite can be the regular plaster tools and rasps. If sand or other abrasive materials are added, stone-carving tools should be used.

The finished carved pieces can be sealed with a clear lacquer or masonry sealer.

PORTLAND CEMENT

Portland cement mixed with vermiculite in the ratio of three parts vermiculite, one part cement, and one and one-half parts water produces a block harder than does the plaster mixture just discussed. A distinct advantage of using cement instead of plaster is that the cement mixture allows far more time in preparing and pouring the mixture. In addition, if cement vermiculite carvings are treated with a clear sealer for concrete or masonry, the finished works can be displayed outdoors.

Generally, the same method is used for carving and mixing this material as is used for the plaster, but remember that the cement vermiculite material does harden more quickly; it is, therefore, advisable to do the first rough carving as soon as the mix has set. This is usually 12 to 24 hours after pouring the mixture.

Portland cement and sand- or gravel-aggregate mixtures can be carved immediately after they are set,

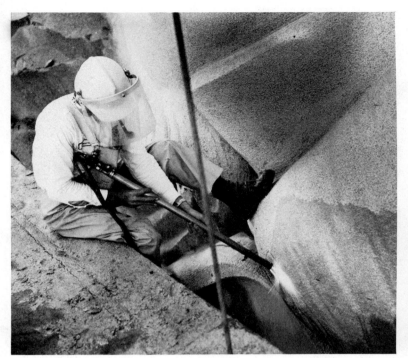

Figure 4–17
Cutting with a thermal torch. *Stone Mountain, Georgia.*
Photograph courtesy of Frank Rippetoe and Union Carbide Corporation, Linde Division.

Figure 4–18
Sculptor Roger Kotoske carving a cast polyester form using a rotary file, 1970.

or when cured and dry; this is, however, a difficult process that demands essentially the same tools and approaches as stone carving. One of the principal disadvantages is that the concrete does not fracture as does limestone or marble. You can, however, exploit its own unique chipping and fracturing qualities when your desired form is bold and direct.

Concrete mixtures are usually one part cement to three or four parts aggregate. The aggregates can be masonry, sand, graded silica, mixtures of sand and gravel, selected-size gravel, or crushed rock. A spontaneous and direct approach to concrete is to carve it immediately after it sets to the point at which the mass will support itself and the mold can be removed. As with plaster-block molds, it is preferable to design the mold in wood roughly approximating the desired form. If the mixture is poured in the late afternoon or early evening, it will reach a desirable carving condition by early the next morning. This allows a full day for the rough carving; subsequent finishing can take place as the material hardens and becomes more resistant to the tools.

FOAM

Blocks or slabs of polystyrene or polyurethane foam are easy to carve. The material can be purchased in densities ranging from 2 to 35 pounds per cubic foot.

Preformed blocks or slabs are available from plastic suppliers or marine supply houses, where they are sold as flotation billets. Several companies market blocks of high-density, colored foam for carving. The foam can also be purchased as a two-part mixture, which, when mixed and poured into a box or mold, forms a block.

An ordinary carpenter's hand saw or hot-wire cutters can be used. The material can be carved with ordinary wood-carving tools or can be cut down very rapidly with a coarse wood rasp. Finer rasps and sandpaper are used for finishing.

Usually, foam is used as practice material for students, or to make patterns to receive subsequent treatment (as described in Chapter 1). Specially formulated, colored, low- and high-density carving foams have, however, been used for finished sculpture in interior applications.

PLASTICS

Blocks of acrylic, polyester, or epoxy can be cut with ordinary woodworking saws, drills, rasps, and files. The process involves sawing, drilling, rasping, filing, and abrading, instead of chipping and gouging. If abrasive fillers are present in the plastic material, stone-carving tools and techniques should be used.

Sheets of acrylic up to three inches thick can be purchased and laminated into blocks. Blocks of polyester or epoxy can be cast clear or with fillers (following the casting procedures described in Chapter 3).

When possible, it is advisable to cast blocks in the approximate shape of your desired final form, because this reduces material cost and expedites carving. (Figure 4–18)

81

Direct
Modeling

5

Building directly with a dough-like or soft material, or applying it over a previously prepared armature is a spontaneous and satisfying method for creating some forms of sculpture. It is particularly useful for students wishing to experiment with form, without investing much time and/or expensive materials in a single work.

Direct sculpturing with clay has existed for centuries as a practical approach to pottery and statuary. Direct paper mache, plaster, and concrete have been used by sculptors for many years. Plastics such as polyester or epoxy resin mixed with sand, fine crushed rock, perlite, sawdust, metal powders, or fiberglass, have provided a new group of materials that possess greater strength and permanence than paper, plaster, or concrete.

Direct materials may be thought of in relation to their characteristics and the methods necessary to manipulate them; some materials can support themselves, whereas others require internal armatures for structural support.

Armatures may be constructed of metal lathe, screening, hardware cloth, wire, and rods. Figure 5–1 illustrates a typical large-scale armature being constructed out of concrete-reinforcing rod and hardware cloth. As a wire-mesh material for armatures,

hardware cloth is preferred; it can be cut and formed easily. Metal lathe is satisfactory for large, flat surfaces; it tends to be more rigid and gives more reinforcement support for the material. It is more difficult to shear, however, and its sharp-wire ends may cut your hands or fingers. Protective leather gloves should be worn when handling any wire mesh. (Figures 5–2, 5–3, and 5–4)

When twisted wire, concrete-reinforcing rod, welding rod, or metal piping is used for linear forms, it should be wrapped with a fine wire, string, or fiberglass strands to provide additional bond between the armature and the material.

For direct sculpture with plaster or concrete, the armature must be carefully planned and constructed. It should be built to the precise proportions of the piece, allowing reasonable space for the material that is going to be applied. Internal supports should be sufficiently rigid to carry the weight of the material and stresses developed within the form. An armature that is constructed too hastily—with the attitude that strength can be achieved simply by adding bulk to the work—results only in failure; the increased bulk merely increases the weight and often compounds the problem.

Polystyrene or polyurethane foam is an excellent armature material. It can be sawed, rasped, carved,

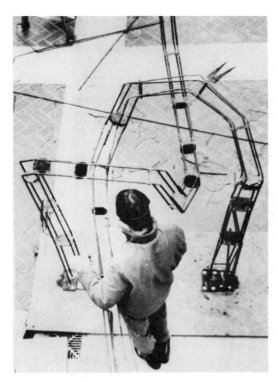

Figure 5–1
Armature for a plaster pattern being constructed out of reinforcing rod.

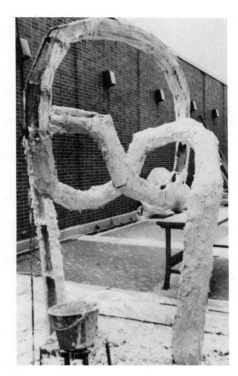

Figure 5–2
Plaster buildup of armature.

Figure 5–4
Completed plaster pattern by Charles Aberg, Ca. 1967.

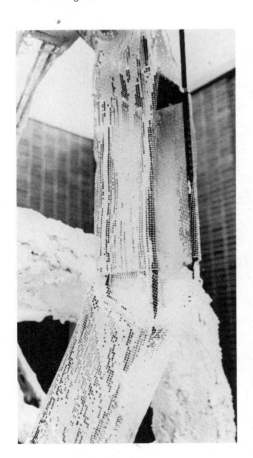

Figure 5–3
Detail showing wire mesh, steel armature, and applied plaster.

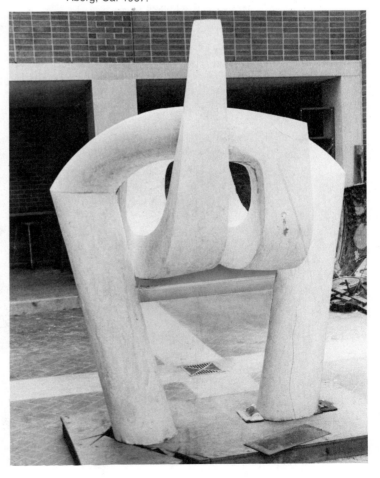

cf. p. 13

. sanded (as described in Chapter 1). For plaster a..d concrete, the foam armatures must be bulky enough to withstand the weight of the material. Wire mesh and steel are often applied over the foam to give additional support to the concrete or plaster. Foam armatures to receive fiberglass can be quite linear and delicate, because as soon as a thin layer of fiberglass and resin is applied, the surface becomes strong enough to support itself.

Wood frames with cardboard or stretched-muslin surfaces make suitable armatures for paper mache or fiberglass construction. For paper mache construction the armature should be waterproofed with lacquer or shellac.

There are several methods for applying materials directly over armatures. Putty-like materials are best applied with spatulas and trowels. Materials such as plaster and concrete are sometimes applied with the fingers for initial roughing out. Sometimes materials can be thinned for brush application. Specialized equipment has been developed for spraying plaster, concrete, plastics, and metal.

PLASTER

Because plaster does not possess much tensile strength, armatures must be well-constructed for direct-plaster techniques. Whereas linear forms can be constructed better in other materials, plaster is good for simple, massive, or bulky forms. For additional performance, high-strength plasters such as U. S. Gypsum Industrial Plaster PC or PCI with polymer and short fiberglass strands can be used. You can also use U. S. Gypsum HYDROCAL® and HYDRO-STONE®.

Although plaster is seldom thought of as a very exotic material, it is still one of the most versatile, most adaptable, and least expensive materials with which sculptors can work. It is highly suitable for direct modeling for patterns, or for interior works; students can quickly fashion direct models at very little expense. Plaster is simple to handle and requires very few tools.

To build up plaster directly, small quantities of plaster are mixed in plastic bowls and are applied with spatulas and other tools. The plaster is mixed in the same fashion used in building plaster molds. (See Chapter 2, page 13) On large works, the plaster is often applied with the fingers. Depending on your project, the plaster-water ratio of your mixture may vary. Using less water increases the strength of the plaster. If the surface of the work is to be sanded to a smooth finish, a soft surface may be desirable. In this case, the final application may be a plaster mixture with a higher water ratio. Conversely, if a hard surface is desired, the water ratio can be reduced. Any patching or additional buildup should be made with the water-plaster ratio remaining the same as that used in the surface coatings; patching with mixes of lower

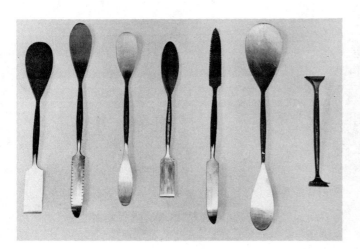

Figure 5–5
Plaster modeling tools.

Figure 5–6
Large plaster wall relief being constructed of plaster and burlap. *Student project, Southern Methodist University.*

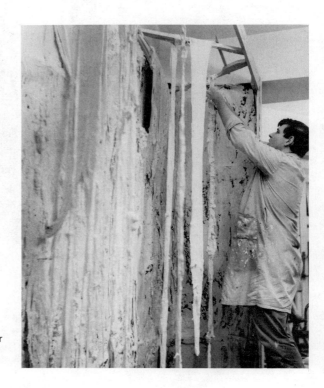

Figure 5–7
Figure composition out of plaster and burlap. *Student project, Southern Methodist University.*

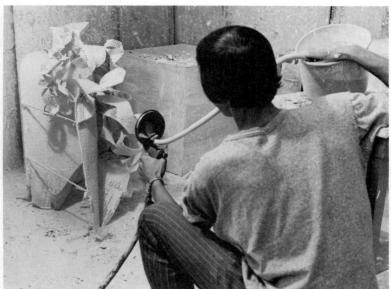

Figure 5–8
Plaster being sprayed with an R-2 spray gun using a siphon hose. *Student project, Southern Methodist University.*

Figure 5–9
R-2 spray gun with disposable container for spraying small batches of plaster, resins, and other materials.

water ratio results in hard spots, which often prevent sanding a surface to a smooth, homogeneous finish.

Whatever method of application is used, the work should be carefully developed. The layers of plaster should be applied evenly, allowing the form to progress slowly to completion. To assure bonding, each layer should be kept rough until the final layer is applied; surfaces that have dried should be moistened before applying new layers. The particular kind of final surface texture developed is a matter of personal choice; many sculptors have explored the rough, troweled look that goes with the hand application of material. A wide variety of tools is available for applying plaster and for producing surface finishes. (Figure 5–5)

Rather than applying plaster with a trowel or spatula, loose-textured, bold forms can be achieved by dipping burlap strips, hemp fiber, or strips of fiberglass mat into the plaster and applying the pieces over the armature. (Figures 5–6 and 5–7)

Plaster can also be applied directly over foam armatures. If the form has sufficient bulk, wire reinforcing may not be necessary; the first layer might be reinforced by mixing hemp fiber or other fibrous material with the plaster.

Plaster can be mixed thin and applied with a brush, which should be cleaned and rinsed in water quite frequently to prevent the plaster from setting in the brush. Another technique that can be used is the spraying of plaster with a spray gun (as illustrated in Figures 5–8 and 5–9).

For finishing, wet plaster is usually chiseled, scraped, sanded, and rasped. Ideally, if a work is developed carefully, chiseling should not be necessary; it is, in fact, undesirable, because chiseling off lumps and projections may fracture the work.

To produce decorative results, such fillers as marble dust, sand, marble chips, stone aggregates, vermiculite, glass spheres or nodules, and pigments can be added to the plaster before the final surface application. Sanding or wire brushing the surface to expose the filler, plaster can also be painted, coated with plastics, plated, or sprayed with metals.

CONCRETE

Direct application of Portland cement and aggregate mixtures on metal lathe have been used by the building industry for many years. Stucco and terrazzo surfaces are frequently built this way.

Making a direct sculpture with Portland cement and aggregate mixtures is fairly similar to working with plaster, as far as armature construction and method of application are concerned. As mentioned earlier, it is important that the armature be designed to carry the full load of the applied material; otherwise, cracks will result.

Cement and sand-aggregate mixtures do not stick as easily to an armature as does plaster; for flat surfaces use expanded metal lathe, rather than hardware cloth, because concrete mixtures adhere more readily to it. Another typical technique today is to dip pieces of ¾-ounce fiberglass mat or fiberglass mesh into a thin cement and fine sand mixture. It is applied over foam or wire mesh armatures. Several coats are built up this way to produce an exceptionally strong surface.

Marble dust, brick dust, marble chips, fine gravel, sand, and vermiculite are used as aggregates. A typical mixture of cement and aggregate would be one part cement, one or two parts masonry sand, and one or two parts aggregate, with a particle size of ⅛ to ¼ inch. Fine mixtures might be one part cement to one or two parts marble dust, masonry sand, or other fine material. A small amount of hydrated lime (5 to 10 percent of the weight of the cement) can be added to the mixture to increase its plasticity and to produce a mixture that sticks more readily to the armature. Fiberglass short fibers can also be added to the cement-aggregate mixture to increase strength. Commercially available mortar mixes with the appropriate proportions of ingredients can also be used.

Recently, polymer additives have been developed that give considerable strength to the cement.

These can often be found at local building-supply dealers who handle cement and plaster products. They should be especially considered when the forms are linear or flat planes and maximum strength is needed.

Of particular interest are recent polymer products called KellStone and KellGlaze developed for sculptural use by chemist-engineer Paul Kellert of Kellert Industries in Oklahoma. Kellert has had extensive experience in developing cement polymers for commercial use. Sculptor Chuck Tomlins has worked with this material with excellent results. The product is marketed exclusively by Rogers College Foundation, Claremore, Oklahoma 74017. KellStone is mixed utilizing three parts sand to one part cement. The KellStone polymer is mixed with water on a one-to-one basis and is added to the cement-sand mix until a workable putty-like mixture results. The ratio of KellStone to water can be as high as one to five parts water if maximum strength is not necessary. KellGlaze is applied to the finished work to further seal and harden the surface.

Design-cast 62 and 66 is another polymer-based material developed for sculpture that is excellent for direct modeling. It is a complex calcium aluminasilicate mixture and acrylic emulsion polymer. It is being used extensively by scuptors and has excellent strength and weather resistance. It can be obtained from sculpture supply sources or Design Cast Corp., P.O. Box 134, Princeton, N.J. 08540. High early-strength cements can be used if a fast curing of the material is desired. The description in Chapter 3 of the strength of cast concrete in relation to aggregate-particle size also pertains to directly applied cement-aggregate mixtures. Extremely coarse aggregate mixtures are seldom used in direct buildup, because the weight of the aggregate makes application of the material impossible on vertical surfaces. As in cast mixtures, the cement and aggregates are mixed dry prior to addition of the water. Concrete-coloring agents can be added to the mix.

In a typical application, the cement-aggregate mixture is applied with a spatula or trowel, working from the bottom up. A layer up to ½ inch thick is applied. It is kept comparatively rough in order to provide a mechanical bond for the subsequent layers. A good practice is to scrape or roughen the surface with a toothed tool, such as a piece of saw blade, after the cement has partially set and is firm enough to withstand the scraping. To reduce costs, the first coating can be a cement-sand-fine-gravel mixture. Because coarse mixtures are stronger than fine mixtures, as coarse a mix as is feasible should be used on the first coating. Generally, as the work develops, it should

proceed from a coarse layer to finer layers, with refinement of detail taking place in the second and third layers.

Total thickness need not be more than an inch, unless the work is extremely large. For large works or for extra strength, additional layers of metal lathe or hardware cloth can be used along with the layers of fine cement-aggregate mixture. Throughout the buildup, the work should be kept moist and covered with a plastic or other airtight cover. Surfaces that have been allowed to dry should be moistened with water before applying the next layer. Under ideal circumstances, the work should be completed as quickly as possible—about a layer a day.

Upon completion, the work should remain covered with moist cloths and a plastic or airtight cover for at least 2 weeks. This allows the concrete to cure and reach full strength. High early-strength cement would require less curing time.

When curing is completed, the work is ground and finished for smooth surfaces and to expose aggregates. For rough, exposed aggregate surfaces, the work may be lightly wire- or fiber-brushed after the final coating has partially set—to the point at which it can withstand the brushing. After the work has thoroughly dried, it is a good practice to treat the surface with a clear sealer for concrete or terrazzo.

Another process for working with concrete is a commercial spray technique called "gunite." Extensively used in building swimming pools, this process can be adapted to large-scale sculptural forms. (Figure 5–10) In this method, a cement-sand slurry is sprayed directly onto a wire mesh and reinforcing-rod surface.

The mixture is compacted by the pressure of the mixture hitting the surface. Some spray apparatuses use a dry mixture to which water is added at the nozzle; in others, the cement and sand are mixed before they reach the nozzle. A typical mixture consists of one part cement to four parts sand.

PLASTICS

Acrylic polymers or plastic resins such as polyester, epoxy, or other thermosetting resins can be mixed with fillers, or applied with other reinforcing materials, and built up over armatures. These materials have substantially more tensile strength than plaster or concrete, and can be applied in thinner layers to produce relatively light-weight sculpture.

Armatures may be clay, wire mesh, polystyrene or polyurethane foam, paper mache, earth, wood, cardboard, or plaster. If your form is such that the armature can be dug out, the plastic can be built over a clay form. Foam armatures are among the most desirable due to their light weight. When using polyester resins, polystyrene-foam armatures should be sealed with several coats of a water-based latex paint, an epoxy coating, or a layer of tissue paper and white glue. Although plaster armatures are quite common, their weight is a distinct disadvantage. Rough armatures of wood, cardboard, or foam can be built to more accurate dimensions by using plaster, wood fillers, or commercial spackling compounds. The fillers and reinforcement materials described in Chapter 3, page 51 can be used in these buildup processes.

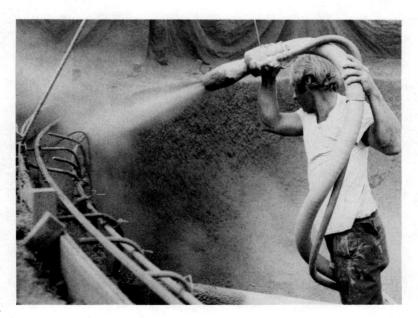

Figure 5–10
Concrete being sprayed for a pool structure. *Photograph courtesy of Travis "S" Gunite, Inc., Dallas, Texas.*

The reinforced plastic materials are applied to the armature in several different fashions, depending on the desired surface qualities and strength in the material, fillers and resins used. Small quantities of fine powders and granules can be mixed with a catalyzed resin to form putty-like modeling pastes. These can be applied with a trowel or spatula to determine the required amount of catalyst. With polyesters, the amount of filler must be considered as part of the total volume. The fillers may be added until a paste-like consistency is achieved. Some commercial putties have concentrations of filler to resin that reach 90 percent of the total volume. The amount of filler that a resin will take depends on the viscosity of the resin, the particle size of the filler, and the oil-absorption qualities of the filler. Low-viscosity resins with non-absorptive, maximum-dense particles allow for the largest amount of filler. Metallic powders from 150 to 300 mesh, such as aluminum, brass, steel, and copper, are often used as fillers to produce fine, durable, metallic-like surfaces. Glass nodules or perlite make excellent filler for bulk and light-weight buildup. Coloring agents can also be added to the mixtures.

Prepared modeling pastes of epoxy or polyester with metal or other fillers are available from sculpture supply houses. High-quality commercial plastics with metal fillers designed for repair are also available and are excellent for direct modeling. An excellent source for a wide variety of resins, fiberglass, fillers, and so on, is Industrial Arts Supply Co., 5724 West 36th Street, Minneapolis, Minnesota, 5541-2594.

Another method of working direct with plastic is to place pieces of reinforcing material on an armature. Saturate these pieces with acrylic polymer thinned with water or resin. A brush, roller, or spray gun can be used. Apply several layers of this thinned polymer, as in layup techniques, into molds. In this approach you must use an armature and form built to the finished dimensions. Foam is most typically used, although carefully built wire mesh or cardboard forms will also work. Reinforcing material can be gauze, cheesecloth, canvas, other fabric, fiberglass veil, matt, or mesh.

For interior use, non-linear forms can often simply be covered with gauze or cheesecloth saturated with acrylic polymer slightly thinned with water. The

Figure 5–11
Painted polyurethane sculpture, surface was reinforced with cheesecloth and polymer primer. By author 1985.

Figure 5–12
Sculptor Donald Beason working on gauze wrapped sculpture *Roaring Stallion* for installation 1982.

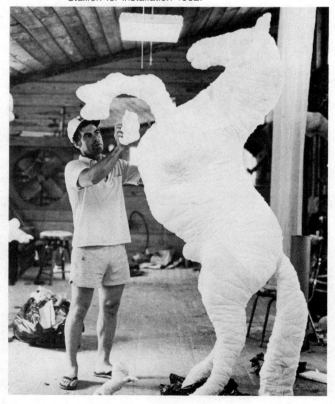

distinct advantage here is not using more toxic resin materials. Figure 5–11 shows a foam sculpture that was covered with cheesecloth. After the polymer dried it was simply painted with an exterior acrylic paint. Figure 5–12 shows a wood and wire mesh armature being built up and wrapped with gauze. After the buildup was completed, the form was saturated with an acrylic polymer and water solution, and it was painted when dry. (Figure 5–13)

For exterior use or stronger and more durable works, fiberglass reinforcement saturated with polyester or epoxy is more desirable. Figures 5–14 through

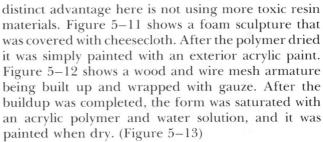

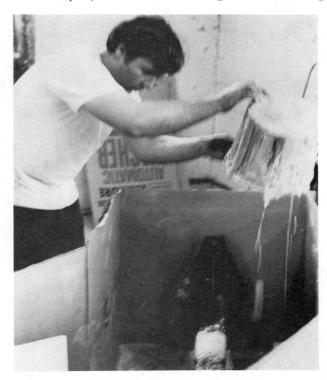

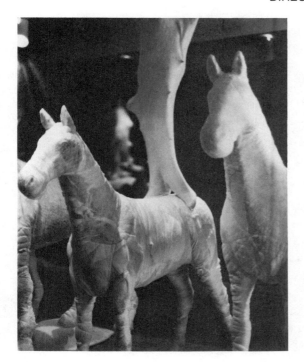

Figure 5–13
Segment of installation of *San Antonio Sun Screen,* "Off the Wall" exhibition, San Antonio Art Museum, San Antonio, Texas 1981. By Donald Beason.

Figure 5–14
Sculptor Mike Cunningham pouring foam into the mold.

Figure 5–15
Mold filled with foam. Note that some scraps of sheet have been used as additional fill material. *Figures 14 and 15 photograph by Don Schol.*

Figure 5–16
Foam shapes completed, assembled, and covered with dynel fabric and resin. Ca. 1970.

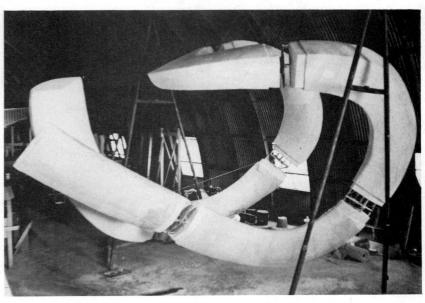

Figure 5–17
Epoxy resin being applied over the dynel fabric. Note use of protective mask and gloves. *Sculpture by Mike Cunningham.*

Figure 5–18
Plastic-reinforced fiberglass relief. *By Roger Kotoske, 1964.*

5–17 show the development of a urethane foam form and its covering of epoxy and dynel fabric.

Many sculptural techniques might combine modeling paste and fiberglass cloth or matt. When a form is built up with putty or paste, it may be desirable to include a layer of fiberglass-reinforced plastic for maximum strength. In a typical procedure, working with paste over a rough armature, it would be desirable to use a light-weight filler, such as perlite or glass nodules mixed with resin and Cab-O-Sil®, to build the form out to about ¼ inch less than the desired form. A layer of glass cloth or matt would next be applied and saturated with resin. The final surface would be putty with a fine-grade filler.

Another approach, which requires paper, fabric, fiberglass cloth, or matt, is to dip pieces into the resin and apply them over an armature, as in the plaster and burlap technique. Some sculptors place pieces flat on a nonabsorbent surface, saturate them with resin, and then shape them (as in Figure 5–18). This is a rather spontaneous approach that presupposes a certain amount of waste and modification as the work is developed.

There are several spray processes available for applying resin and fibrous reinforcing material. Industry uses a spray gun that sprays a mixture of resin

and chopped-glass fiber for the rapid buildup of fiberglass forms. This equipment is costly, however, so a more likely approach for a sculptor would be to build the armature and have an industrial firm apply the reinforced plastic. An inexpensive all-material spray gun can be used for spraying resins and slurries.

Another method uses an R-2 spray gun to spray a layer of resin and then a flocking gun to spray a layer of short aluminum or steel fibers. The alternating layers are repeated until the desired thickness is achieved. Pieces of fiber projecting after the final coat are removed by abrasive finishing.

Spraying urethane foam is another direct technique for creating spontaneous forms or for building up rough armatures. Although the equipment used (as with fiberglass) is costly, some art schools and individual sculptors are using it. Inexpensive spray-foam kits are now available that are practical for smaller works. (Figures 5–19 through 5–21) Some sculptors have worked directly with poured urethane foam to produce reliefs. The rough form can be poured and left as is, or it can be finished with carving techniques. The foam can also be contained with mold sections made out of cardboard or wood. The urethane foam is a two-component system. When the liquids are mixed in equal proportions, a reaction occurs that causes the

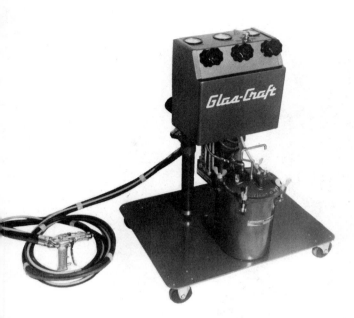

Figure 5–19
Spray equipment for foam. *Photograph courtesy of Glas-Craft of California.*

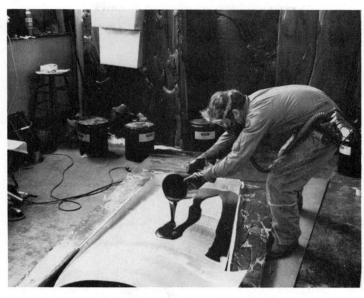

Figure 5–20
Sculptor Roger Bolomey pouring foam for a relief panel. *Photograph courtesy of Roger Bolomey.*

material to foam and increase in volume. Good ventilation or protective face masks should be used when working with this material.

Direct sculpture in plastic is most adaptable for spontaneous forms on which the surface is textural and minor irregularities are acceptable. To build a plastic form directly with the intention of producing a precise, highly finished surface is tedious and almost impossible. Filler and plastic often do not lend themselves to machining or abrasive finishing. As a rule, it is far less time-consuming to build a smooth clay or plaster pattern, to make a mold, and to use a molding technique.

CLAY

Today ceramicists build directly with clay to achieve dramatic sculptural results. Handling the materials for clay sculpture is fundamentally the same as constructing other ceramic objects. Wheel-thrown forms are no longer thought of as simple, cylindrical shapes, but are cut, distorted, or manipulated. Slabs can be cut and assembled, and rolls or pieces can be pinched together. Ceramic units can even be combined with welded metal, plastic, or cast metal to produce visual contrast between materials.

Figure 5–21
Hoboken Number 13, a completed foam relief. *By Roger Bolomey, 1964. Collection: University of California Museum of Art, Berkeley, California.*

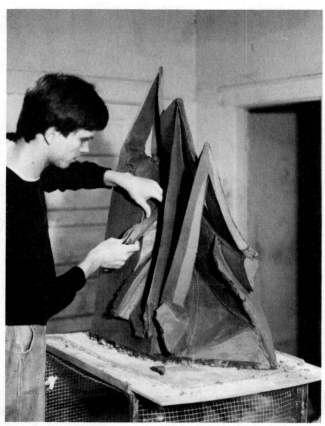

Figure 5–22
Sculptor Joseph Havel working on clay
slab sculpture.

Figure 5–23
Completed sculpture by Joseph Havel,
1985.

Assembling clay pieces may entail simply joining them with a slip mixture while they are still moist, or joining finished fired sections with adhesives or mechanical fasteners. The material and procedures for handling clay, firing, and glazing discussed in Chapter 3 relate as well to sculpturing using direct clay techniques. (Figures 5–22 and 5–23)

SPRAY METAL

Direct buildup can also be accomplished using the spray-metal equipment discussed in Chapter 9 (pages 175–176). Use armatures covered with fine screening, or material that will provide a good mechanical bond with the sprayed metal.

Wood
Fabrication

6

Visually, wood is diversely rich. Amidst the clamor for new materials, it is refreshing to see sculptors and students continue to explore the visual texture and forms that only wood can produce.

Wood carving is distinctive in itself. Wood offers perhaps greater diversity and spontaneity for producing sculpture than almost any other material. Readily cut and shaped with hand tools and inexpensive mechanical-shop equipment, wood pieces are easily assembled by bolting, gluing, and nailing.

In observing some different woods, we find that careful polishing, staining, or laminating reveals the beauty of the grains, the growth rings, and the inner structures. Weathered timber and planks bolted together boldly express the unusual structural nature of wood. Assembled boards and strips assume their own forms and attitudes. Band sawing readily produces a limitless variety of shapes and configurations. Massive monolithic forms are easily constructed out of plywood; properly coated or painted, they are even reasonably durable.

Imported and domestic woods are available in a wide variety of textures, colors, shapes, and sizes. Some woods left untreated are more weather-resistant and less susceptible to decay than others. Some possess better structural properties. Depending on the way a log is cut, the grain may affect the wood's structural properties, surface treatment, or paintability. Each species of wood has its own unique color and grain configuration. All these factors must be considered when a wood for your sculpture is being chosen.

A wide variety of used and weathered old lumber can be found in wrecking-company yards; two other principal sources for wood are lumberyards that deal in construction-grade materials, a few hardwoods, and specialty items, or lumber companies that specialize in fine grades of domestic or imported woods or plywoods.

Wood for fabrication may be classified as hardwood or softwood. This is a botanical distinction; some hardwoods are soft. Hardwoods are those woods produced from broadleaf-bearing trees. Needle-bearing trees, such as pine, produce soft woods.

Some ordinarily available soft woods are cedar, redwood, fir, cypress, hemlock, pine, and spruce. Some common hardwoods are basswood, beech, cherry, gumwood, hickory, mahogany, maple, oak, poplar, walnut, and willow. Lumberyards usually handle only soft woods for general construction and a few hardwoods such as oak and walnut. Some lumber companies specialize in a wide variety of domestic and imported hardwood boards and plywoods.

The grain in a piece of lumber depends on the way the log is cut in relation to its annual growth rings and the kind of growth rings they are. Growth rings

Figure 6–1
Growth rings on a Bois d-arc log.

Figure 6–2
Plain-sawed (A) and quarter-sawed (B) wood grain.

A B

may vary in thickness. (Figure 6–1) Each annual ring usually consists of a spring wood, with a soft, light-colored ring, and a summer wood, with a harder and darker ring. In some woods, there may be less distinction in hardness and color between the spring-wood and summer-wood rings. These factors, as well as the manner in which the wood is cut, determine the boldness of the grain and the machining and finishing characteristics of the wood.

If slabs are simply cut off a log, the grain is more open and wavy. This is called *plain sawed* or *slash grained.* Cutting into the log parallel to the radius produces a straight grain and is referred to as *quarter sawing.* Quarter-sawed lumber has less shrinkage, warpage, and grain rise. It is more paintable and does not surface check or split as much as does plain-sawed lumber. (Figure 6–2)

Plywood grain configurations also vary according to the method of cutting the veneer. If a log or half log is mounted on a lathe and revolved against the blade of a knife, the result is a rotary or half-round veneer. If the log is sawed into halves or sections and the sections are mounted on a slicer after having been softened by steaming, boiling, or soaking, a sliced veneer results. Rotary, half-round, and plain-sliced grains are often wavy and bold. Sliced plain-quartered grains are straight. Sometimes, veneers are sawed rather than sliced.

Selecting a piece of wood for sculpture is a matter of personal choice and common sense. Any surface or texture has aesthetic potential. However, if the wood is to be painted and you want a smooth, grainfree surface, boards or sheets should be *selected* with this application in mind.

Material for wood fabrication may be thought of in terms of *boards, planks, dimensional lumber, timbers, and sheets.* In rough dimensions, boards are usually cut to 1 inch or less in thickness and 4 inches or more in width. Narrower pieces would be classified as strips. Dimensional lumber may be 2 to 5 inches in thickness. Timbers are at least 5 inches. Sheets are plywood or pressed-wood products such as masonite and particle board.

Lumber is classified according to the degree of manufacturing at the sawmill, its use, and its quality. The degree of manufacture can be *rough, dressed,* or *worked.* Rough lumber is as it appears after being cut from the log, with the edges trimmed. The nominal size or rough-cut dimension is usually in increments of an inch. Rough-cut lumber can be readily identified by the presence of saw marks and its rough appearance. Dressed lumber is surfaced (planed smooth) on one or two sides, one or two edges, or all surfaces. Common boards and strips purchased at the lumber

yard are normally dressed thicknesses of ¼, ⅜, ½, ¾, or ¹³⁄₁₆ of an inch. When dimensional lumber is surfaced or dressed, it loses about ¼ to ⅜ of an inch of its original dimension. Timber loses about ½ inch. For example, if you order a 1 × 4 inch piece of lumber at a lumber yard, it will be ¾ to ²⁵⁄₃₂ inches thick and 3⅝ inches wide. An ordinary 2 × 4 piece of dimensional lumber would be 1⅝ inches thick and 3⅝ inches wide. Worked lumber receives additional milling after having been dressed. Tongue-and-groove lumber and moldings are typical of worked lumber.

Use classifications of lumber are *yard, factory, shop,* and *structural* grades. Most lumber yards stock yard lumber. Factory and shop grades are a better class of material, produced for wood-product manufacturing. Structural grades are large-sized pieces selected for their strength and durability.

Yard lumber is classified as *select* or *common.* Common lumber is graded from one to five. Grading is based on the number of knots, the soundness of the knots, pitch pockets, spots of decay, and other defects. Number one lumber has a few sound knots but is relatively clear. As the number becomes larger, the number of defects increases. Select lumber is a finer grade than common. It is classified *A, B, C,* or *D.* Grade *A* is clear and relatively free of all defects. Grade *B* is clear but permits minor defects. Grades *A* and *B* are used when a nearly perfect natural or stained finish is desired. Grades *C* and *D* are used for painted surfaces. Grade *C* is often used for molding and for other millwork.

Factory and shop lumber are graded on the basis that they are going to be cut into pieces that are clear and sound. They are supplied to manufacturers of furniture and other wood products. The grade of lumber, inspection agency, kind of lumber, and conditions of lumber (green or dry) can be identified by the grade mark on the end or surface of each board.

Structural lumber consists of dimensional lumber or timbers. Lumber yards normally stock dimensional lumber such as 2 × 4, 2 × 6, 2 × 8, 2 × 10, and 2 × 12. They also stock some 4-inch-thick material. Timbers are usually specially ordered from the sawmill.

When lumber is purchased, it is ordinarily measured in terms of board feet. A board foot is 12 × 12 inches by 1 inch thick. To compute board feet in inches, the thickness is multiplied by the width and then by the length; the resulting figure is then divided by 144. If the length is in feet, the thickness is multiplied by the width in inches, then multiplied by the number of feet and divided by 12. Normal lumber widths are 2, 4, 6, 8, 10, and 12 inches and from 4 to 20 feet in length in increments of 2 feet. Strips of lumber are purchased by the lineal foot. Boards and sheets are sold by the square foot.

Sheets of plywood are made from thin strips or sheets of veneer that are glued together with the grain of each layer running at right angles to the previous layer. This cross-laminating produces sheets with high strength in both directions. The number of layers in a sheet may vary from three to seven (called ply). We are most familiar with plywood as 4 × 8 sheets. However, ¼-inch plywood is available in sheets up to 12 feet in length, and ⅜-inch plywood can be obtained in lengths up to 16 feet. Plywood is available in thicknesses of ⅛ to 1³⁄₁₆ inches.

Two types of plywood are manufactured: ex-

Figure 6–3
Typical grade markings for plywood. *Courtesy of American Plywood Association.*

Figure 6–4
Decorative plywood textures: (A) rough sawn; (B) striated; (C) brushed; and (D) circular sawn. *Photographs courtesy of American Plywood Association.*

terior, with waterproof glue, and interior, with moisture-resistant glue. The grade of a veneer sheet is designated as *N*, *A*, *B*, *C*, or *D*. *N* grade is the best, and *D* is the poorest. Grades *N*, *A*, and *B* are used as the face of the plywood or on both sides when both sides are exposed. Grades *C* and *D* are used as inner layers or as backing when the back is not exposed. Besides the grade or quality of the veneer, the kind of wood used in the veneer is designated *1*, *2*, *3*, and *4*, with *1* being the most desirable.

The quality of a sheet of plywood can be recognized by the marks on the sheet and on the edge. (Figure 6–3 on page 95) Ordinarily you might go to a lumberyard and ask for a piece of plywood, interior or exterior, good on one side or good on both sides. If the plywood is to be stained or natural finished, it should ideally be *N* grade. If it is to be painted, and a smooth finish were desired, it should be grade *A* or a plywood with a special surface for painting.

A wide variety of plywoods is available in both exterior and interior forms. One group has a fine surface appearance. Another, used by construction and industry, has a less fine surface, because it is assumed that the surface is to be covered by another material, or that the plywood has been selected for its unusual structural or other properties.

The first group is perhaps of most interest to sculptors. Interior plywoods are available with various-grade surfaces, veneers, and decorations. Decorative textures result if the veneer has been brushed, scored, grooved, or rough sawed. (Figure 6–4) Interior plywoods are available with hardboard, plastic, or other precoatings. Of the exterior plywoods, the most weather resistant and most paintable have greatest sculptural appeal. Marine plywood is often used. High-density overlaid plywood and medium-density overlaid plywood with a fused resin-fiber overlay are particularly durable and paintable. The fiber overlay prevents grain raising and problems often associated with plywood and the deterioration of its coatings. The painted sculpture in Figure 6–6 was constructed of medium-density overlaid plywood. (Figures 6–5 through 6–8)

Sheets of pressed wood (masonite) or particle board are made by processing wood chips or fibers. For pressed wood, the chips are treated and expanded into fiber with steam; the fibers are then pressed together in heated hydraulic presses to form sheets. Pressed wood is available in tempered and untempered sheets. Tempered sheets are harder, more abrasive, and moisture-resistant. They are available in 4 × 8 foot sheets, ⅛, ³⁄₁₆, ¼, and ⁵⁄₁₆ inches thick.

Figure 6–5
Fabrication of a plywood sculpture with framework of
dimensional lumber.

Figure 6–6
Completed sculpture. *Denver Sculpture Symposium.
By author.* 1968.

Figure 6–7
Sculptor Wayne Amerine shaping plywood forms.
Photograph by Susan Lecky.

Figure 6–8
Completed painted sculpture. *Cows* at the 5th Texas Sculpture
Symposium, Dallas, Texas 1985 by Wayne Amerine.

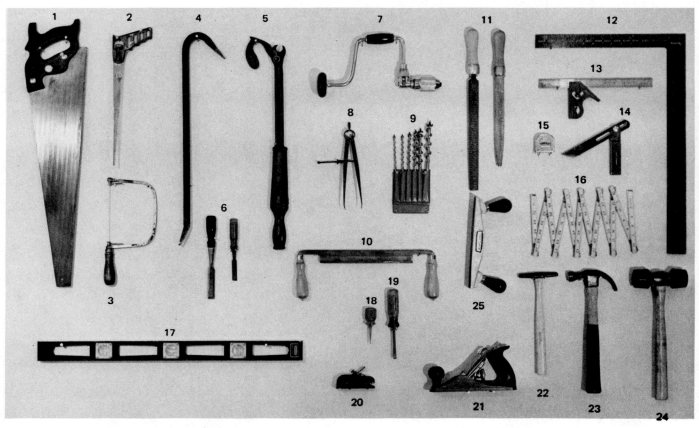

Figure 6-9
Basic woodworking hand tools: (1) handsaw; (2) keyhole saw; (3) coping saw; (4) wrecking bar; (5) nail puller; (6) chisels; (7) brace; (8) calipers; (9) bit set; (10) draw knife; (11) wood rasps; (12) rafter square; (13) combination square; (14) sliding T bevel; (15) steel measuring tape; (16) folding ruler; (17) level; (18) scratch awl; (19) flat blade screw driver; (20) bull nose rabbet plane; (21) bench plane; (22) tack hammer; (23) claw hammer; (24) rubber-tipped mallet; and (25) rasplane.

Figure 6-11
Level being used to check a vertical edge.

Figure 6-12
Detail of level showing air bubble between lines.

Figure 6-10
Marking lumber using a combination square.

Larger sheets are available, or they can be specially ordered.

Particle board is made from resin-impregnated wood chips that are pressed into sheets under high pressure. It is available in 4 × 8, 4 × 10, and 4 × 12 foot sheets, from ¼ to 1⅛ inches thick.

TOOLS

As stated earlier, lumber is easily fabricated with hand or power tools. In fact, a few hand tools can accomplish the majority of cutting and detailing operations that are achieved with power tools. The major distinction is in the time and effort involved. Some basic power tools are relatively inexpensive, however, so there would be very little merit or justification in using only hand tools for daily wood fabrication.

There are three basic groups of tools for wood fabrication: hand tools, portable air and electric tools, and stationary power tools. Having some tools in each of these categories is essential for making any complex wood fabrication.

HAND TOOLS

A few basic hand tools are essential for occasional work or for tasks that you cannot perform with power tools. These should be of good quality. Not only will good quality hand tools outlast inferior ones but they will make it easier for you to work with the wood. Some of the basic tools you need are as follows. (Figure 6–9)

Squares. Framing, try squares, and miter squares are used for drawing or checking angles of 45 to 90 degrees. The T-bevel square is used for angles other than 90 degrees, by setting the desired angle from a reading on a protractor.

Gauges. Marking gauges are used to mark off a specific width along the edge of a board. The sliding adjustable combination square can be used for this purpose by placing a pencil along the outside edge of the ruler as the square is moved along the board. (Figure 6–10)

Levels. Vertical and flat horizontal surfaces are checked for their accuracy with the level. When a level is placed on a flat or vertical surface, the air bubble in the liquid should be between the two lines in the glass indicator. (Figures 6–11 and 6–12)

Saws. Sometimes it becomes necessary to cut a piece of material with a handsaw. To cut across the grain, a cross-cut saw with eight teeth or points per inch is used. For fine-finish cuts, a saw with ten and a half points to an inch is preferable. To rip a piece of wood along the direction of the grain, a saw with five and a half points per inch is used. In handsawing, small pieces may be placed in a vise; large pieces are placed on a low table or on sawhorses and held in place with the knee. The saw is gripped with the right hand, with the thumb and index finger along the sides of the saw. The cut is made along the outside of the line, leaving a trace of the line as cutting proceeds. It is best to start with a few short strokes to get the cut started and then apply even, full strokes. If the wood binds the saw blade, drive a wooden wedge in the crack or kerf to slightly spread the wood and relieve the pressure. For cutting inside holes, a starting hole is drilled and a keyhole saw is used. For scroll work and odd contours, a coping saw may be used if an electric saber or jig saw is not available. When cutting with a coping saw, the blade is placed in the saw with the teeth pointing toward the handle. The cutting is done as the saw is pulled. The material being cut may be placed in a vise or clamped to a table. Coping-saw blades may have anywhere from ten to twenty teeth per inch; these are suitable for fine, delicate scroll work.

Clamps. Clamps are the principal holding devices in wood work. C-clamps are used to clamp stock a few inches in thickness. Bar clamps, designed to span greater distances, are for holding and gluing in the assembly of materials. The adjustable hand-screw clamp is designed for holding and exerting pressure on material, and the miter clamp for holding square-mitered corners while nailing and gluing. (A wide variety of miter clamps is available.) Spring clamps are particularly helpful to hold flat-sheet material while gluing it to wood frames or supports. (Figure 6–13)

Hammers. Having good-quality hammers is important. They should be well balanced and of good-grade, properly tempered steel. Their faces or striking surfaces, which should also be polished and hard-tempered, are not simply flat, but slightly convex. Keep the faces clean.

The claw hammer, the principal tool for driving, setting, or pulling nails, is available in weights from 5 to 20 ounces. For finishing and average work, use a 12- to 16-ounce hammer; 20-ounce hammers are used for heavy construction and for driving spikes or large nails.

Do not use a woodworking hammer for metalworking.

Hand plane. Use the hand plane for smoothing or beveling surfaces and edges if a power planer or jointer is not available. Many hobbyists use the bench plane, 8 or 9 inches long, for this operation. However, using a 22-inch jointer, 18-inch fore, or 14-inch jack plane is a more professional way to plane long surfaces or edges; it also produces better results. Ideally, you would use the jointer or fore plane for rough removal of wood, and then the jack plane for further finishing. You can use the jack plane as a general-purpose plane for both operations if another plane is not available.

The bench plane is normally used for finish planing short surfaces and edges. Standard blade angle for most planes is 45 degrees. Because the block plane has its cutting edge set at a less acute angle (20 degrees), you use it for planing end grain. Special-purpose planes are also available for cutting rabbets, planing concave and convex surfaces, dadoing, cut-

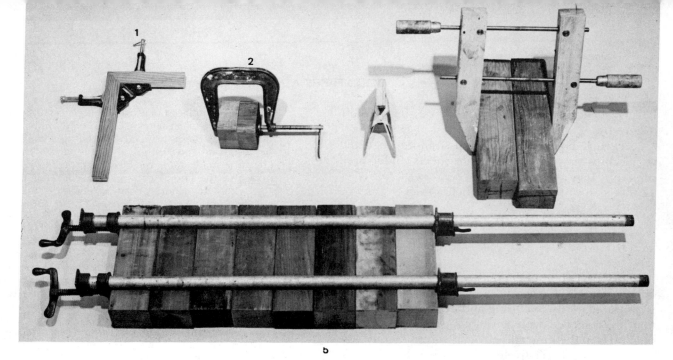

Figure 6–13
Clamps for working with wood and metal: (1) corner clamp; (2) C clamp; (3) gluing clamp; (4) spring clamp; and (5) pipe-gluing clamp.

ting tongues and grooves, scraping, and other shaping and finishing operations.

In planing, the depth of cut is controlled by adjusting the adjusting nut. Use the lateral adjustment lever to tilt or move the blade to adjust for a uniform cut. The depth of cut may vary, depending on the hardness of the wood and the amount of wood to be removed. For finishing, the plane is set to shave off slight amounts. All planing should be in the direction of the wood grain, to avoid tearing or gouging the wood. To plane end grain with the block plane, move the plane at a slight angle to the direction of travel. You should clamp the wood or hold it securely in a woodworking vise while planing. When you are planing flat surfaces, you can butt the wood up against a stop fastened to the work bench. For planing edges on strips, you can nail a V-shaped guide to the workbench as shown in Figure 6–14.

Planes should be stored with the blades adjusted so they are not protruding from the surfaces. The plane blades should be kept sharp by occasional honing. In planing old wood, care should be exercised to be certain all nails are removed. If the plane blade becomes nicked, it is necessary to grind it down on a bench grinder and resharpen or hone it on an oilstone.

Chisels. A variety of chisels exist for different purposes. A set of these is adequate for most work. Start with a firmer chisel, a rugged, general-purpose chisel. Then use a flat chisel for chopping or paring out dovetails, lap joints, and other details. Use a mortice chisel for morticing; butt chisel, with a short blade, for working in awkward places and for finishing; an offset chisel, for working close to a surface; and the paring chisel, for fine finishing. Chisel widths normally range from ¼ inch up to 2 inches. The blade lengths may run from 3 to 6 inches.

Chisels should be sharpened periodically on an oilstone, to maintain a good cutting edge. For chopping out wood, the chisel is struck with a wooden

Figure 6–14
Edge planing with the bench plane. (Note jig for holding lumber.)

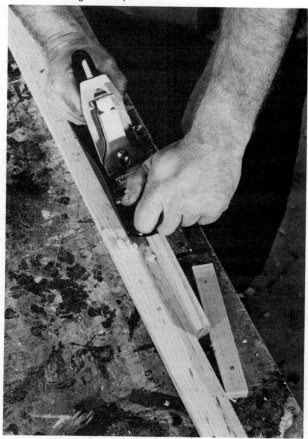

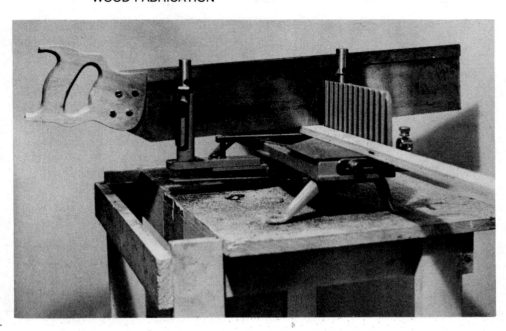

Figure 6–15
Miter box for cutting 45° and 90° cuts.

mallet. The wood should be securely clamped to a workbench or held in a vise, to free your hand for working the chisel. The usual position of the chisel is with the bevel down. For paring or finishing, it may be tapped with your palm or simply held firmly and pushed with a slight side-to-side motion.

Screwdriver. Woodworkers usually use slotted screws and the flat-tipped screwdriver as the principal tool for driving or removing them. Sometimes, they also use Phillips screws and Phillips screwdrivers.

The flat-tipped screwdriver is available in many sizes. Selecting the proper size is essential for working efficiently. In fact, having a good set of screwdrivers with sufficient variety in tip size is necessary to avoid damaging the wood, the screws, or the screwdriver. Avoid inexpensive screwdrivers, because their metal tips are usually inferior and they readily wear out and are damaged. The handles, moreover, are usually too small in diameter, which reduces the leverage and makes driving the screws more difficult.

Special-purpose screwdrivers are also available. The offset, stubby, and ratchet offset are used for driving screws in spaces inaccessible to the common screwdriver. The spiral ratchet screwdriver makes it possible to drive or remove screws more rapidly. Screwdriver bits that fit a bit brace, make it possible to apply more leverage and pressure. Electric and pneumatic screwdrivers are used for fast-production work.

Rasps and files. When the plane or chisel cannot be used, a rasp or file may be needed for shaping and finishing. Rasps and files are available in a variety of shapes and degrees of coarseness. A useful version of the rasp is the rasplane, which has an open-mesh, serrated, removable blade that cuts rapidly; it is also self-cleaning. A drum variety of this is available for use with an electric drill. Rotary files and rasps are also made to use with a drill. In handrasping and filing, the cutting is done on the forward stroke; pres-

sure should be released on the backstroke. Files can be kept clean with a wire brush called a "file card." Separate files should be used for wood and metal. All files should be fitted with proper handles, for ease of handling and proper manipulation of the tools.

Wood bits. Devices for cutting holes in wood are turned with the bit brace, the hand drill, or the electric drill. Today, the bit brace and the hand drill are used only when electric power is not available.

Twist auger bits, expansion bits for large holes, twist drills, and the countersinks are used with the bit brace. Small twist drills and countersinks are used with the hand drill. Twist drills, bits, countersinks, plug cutters, hole-cutting saws, and woodscrew bits are available for use with the electric drill. The woodscrew bits are designed to drill pilot holes and countersink or counterbore to the desired depth.

Miter box. The miter box is a device used for hand cutting 45 degree angles and for squaring the ends of wood pieces. Inexpensive wood miter boxes can be purchased or built; however, they wear out easily and lose their accuracy. A good-quality miter box consists of metal parts and adjusts from 0 to 45 degrees, right or left. It also adjusts for depth of cut. On the top edge, the saw has a rigid metal strip, which rides on two metal guides that support the saw blade. Miter clamps are available with saw guides, and bench-mounted miter clamps are used for framing and mitering strips. Miter attachments are designed to control the planing of bevelled edges using hand planes. (Figure 6–15)

Nail sets. In finished-wood fabrication, it is often necessary to drive the nail beyond the surface of the wood and fill the hole with wood putty, to conceal the nail. Because it is also desirable to avoid denting the wood with the hammer, the nail is driven into the wood, allowing it to protrude $1/16$ to $1/8$ of an inch. A nail set is placed with its point on the nail, and the nail is driven in the remainder of the way by striking the

Figure 6–16
Setting a nail with a nail set.

nail set with the hammer. Nail sets are available with point diameters of $\frac{1}{32}$ to $\frac{5}{32}$ of an inch. (Figure 6–16)

PORTABLE ELECTRIC TOOLS

Portable electric woodworking tools were designed to ease the workload normally associated with hand tools and to supplement stationary power tools. With a portable electric drill, plane, sander, portable circle saw, saber or jig saw, and router, it is possible for you to perform most of the tasks ordinarily carried out by large stationary equipment. Power equipment purchased should be of good quality. For an occasional job, an inexpensive power tool may be satisfactory; however, it is a better practice to purchase good-quality, sturdy, well-constructed equipment that has ample power to do the jobs you require. (Figure 6–17)

Dull drills, cutters, and saw blades should not be used. Besides doing an inferior job, they place an excessive load on the tool's power supply and shorten the life of the tool. Portable power tools can be extremely dangerous if improperly handled. All tools should be equipped with three-prong plugs that provide proper grounding. When changing drills, saw blades, and cutters, the tool should be unplugged from the extension cord or wall socket. This may seem troublesome, but many accidents have been caused by the accidental hitting of a switch while working on a power tool. The tool cord, fingers, and hands should be kept clear of the cutting edges of the tool. Goggles should be worn when operating all power tools.

Following are some details about specific portable electric tools you will need.

Drills. Electric drills are classified according to the size of the drill bit the chuck will accommodate. Standard chuck capacities are $\frac{1}{4}$, $\frac{3}{8}$, $\frac{1}{2}$, and $\frac{3}{4}$ inches. Larger industrial sizes are available up to $1\frac{1}{4}$ inches. The $\frac{3}{8}$-inch drill is the most popular for moderate and occasional heavy-duty jobs. The $\frac{1}{2}$-inch drill is used for heavy work. Motor size is rated by amperage. Typical amperage is from 2.4 amps, 115 volts, for a $\frac{1}{4}$-inch drill, to around 11 amps, 115 volts, for a $\frac{3}{4}$-inch drill. Drill speeds are rated on the basis of the drill's being run with or without a load. Small drills operate at higher speeds than large drills. A $\frac{1}{4}$-inch drill may have a load speed anywhere from 750 to 3300 r.p.m.; $\frac{3}{8}$- and $\frac{1}{2}$-inch drills run with load speeds between 300 and 700 r.p.m. The $\frac{3}{4}$-inch drill runs at a speed of 200 to 300 r.p.m. Variable speed drills are available with the speed varying from zero to the maximum speed of the motor. Some drill motors are reversible.

Attachments are available that can convert electric drills to other small woodworking tools. Saber saw, circle saw, drill press, sander, and router attachments are the most common. These may be satisfactory for extremely light work, but normally they are not capable of providing all that sculptors require of a tool.

Power Plane. The power plane is normally used in construction for planing and fitting wood doors, windows, and cabinet work. For the sculptor, it can be useful when a jointer is not available. As a shop or studio tool, a moderate-sized jointer, which costs no more than a power plane, is preferable; either one costs about $400. A good-quality power plane has a motor capacity of $\frac{3}{4}$ or 1 H.P., with plane speed of 18,000 to 23,000 r.p.m. The shoe or plane surface, adjustable for planing angles, is 16 to 24 inches long and 2 to $2\frac{1}{2}$ inches wide. Mounted on a workbench with bench brackets, it can serve as a jointer. Grinding arbor and attachments are also available. (Figure 3–21 showed a power plane planing the surfaces on an acrylic casting.)

Router. Use the router to cut and perform shaping and detailing otherwise accomplished with the shaper. It is pushed over the surface or along the edge of the board, which must be securely clamped or held with a bench vise, leaving the hands free to operate the router. Adjustable guides and the shape of the cutters determine the depth, width, and configuration of the cut. Cutter blades are designed for molding cuts, rabbets, inserts, dovetails, fluting, dados, grooves, and beading. Trim saws, grinding wheels, power planes, and other attachments are also available. Gouging and routing out for relief carving can be successfully accomplished with the router, followed by hand finishing. (Figure 6–18)

The size of the router is based on the horsepower or amperage and the diameter of the cutter shaft. For very light, delicate work a $\frac{1}{4}$-H.P. router is adequate, but for general studio work a $\frac{3}{4}$- or 1-H.P.

Figure 6–17
Left to right: portable jig saw, circle saw, and ⅜-inch drill.

router is more reasonable. For heavy-duty continuous work, 1¼-to 2½-H.P. routers should be used. Router speeds are normally from 18,000 to 27,000 r.p.m. To operate at these high speeds, blades must be kept sharp. Burn marks on the finish indicate that the blades are dull or that the travel speed for the router is too slow. The router can be mounted with special bench brackets to be used as a shaper.

Saber saw. As mentioned in Chapter 8 on metal working, the saber saw or portable jig saw is one of the most versatile tools in general use. Although not as accurate as bench-mounted equipment, it can do much of the work normally associated with the jig saw, band saw, circle saw, and radial-arm saw. The blade on the saber saw operates with a reciprocal action similar to that of the jig saw. A larger, all-purpose version of the saber saw, which takes blades up to 12 inches in length, can be used for rough cutting thick-dimension lumber and timber up to 8 or 10 inches thick. The normal saber saw blade is from 3 to 4 inches in length. A heavy-duty saber saw can cut 2-inch material and, with the proper oversized blade, can even do small amounts of cutting in thicknesses up to 4 inches.

Guides for ripping, mitering, and cross-cutting mount on the saw for greater accuracy. The saw tilts for 45-degree cuts and other angles. In some models, the saw motor and housing can be turned independently of the blade mechanism, for greater maneuverability. Variable-speed saws are available. Although these are not essential for wood, it is advisable to purchase a variable-speed saw, taking into account possible future needs for cutting other materials. Typical amperage ratings on a saber saw are 2.5 to 3 amps; all-purpose saws are rated at about 5 amps.

In operating the saber saw, a starting hole is usually drilled for inside cuts. For many saws it is possible to start a cut without drilling a hole: by tilting the saw and gradually bringing it into an upright position as the blade cuts into the wood. The saw should

Figure 6–18
Portable router. *Courtesy of Black & Decker Manufacturing Co.*

be pressed lightly against the surface of the wood as it is moved forward. Upon completion of the cut, the pressure should be maintained until the saw is stopped; blades are frequently broken when downward pressure is released before the saw has completely stopped.

Normal blades for cutting wood with a saber saw have from six to ten teeth per inch. The design and set of the teeth in the blade determine whether the saw is used for rough or finish cutting. Special blades are manufactured with fewer teeth for rough cutting dimensional lumber, for cutting at right angles to the normal position of the blade, and for leather cutting with a knife edge.

Circle saw (portable). The circle saw is classified according to blade size and motor capacity. Blade sizes

Figure 6–19
Portable circle saw cutting plywood.

are 6, 7, 8, 9, and 10 inches; motor capacity or amperage rate from 7 amps, 115 volts, for saws for home workshops and light construction, to 10 to 14 amps for saws for heavy-duty construction and fabrication.

The circle saw is equipped with a tilting surface for cutting angles, a rip gauge or guide for ripping, and an adjustment for depth of cut. The capacity or depth of cut depends upon the saw-blade sizes. At 90 degrees, a 10-inch saw will cut to a depth of about 4 inches. A sliding safety guard keeps the blade covered when the saw is not in use.

The material should be placed on a sawhorse or on a low cutting table. When cutting with the circle saw, the blade should be adjusted to extend about ¼ inch beyond the material. The saw should be grasped by the handle and front knob, held firmly, and moved with moderate forward pressure. As the saw is moved forward to start the cut, the guard is pushed back by the edge of the board. The saw should not be forced. Blades should be kept sharp.

Special-purpose blades for cutting materials other than wood, tables for converting a circle saw to a table saw, and other attachments are available. (Figure 6–19)

STATIONARY POWER TOOLS

Power tools ordinarily used in wood shops are the table circle saw, radial-arm saw, band saw, scroll or jig saw, jointer, planer, sander, lathe, and drill press. Stationary power tools are rated according to size of the blade, cutting capacity, and horsepower of the motor. Motors in excess of 1 H.P. should be operated at 220 volts, single or three-phase for maximum power and efficiency. They should be equipped with some form of overload switch or device to prevent overheating and burning out of the motor. To ensure the

tool's long life, motors, wheels, and shafts on the tools should have bearings instead of bushings. Equipment should be kept clean and oiled at required intervals. Manufacturer's instructions should be carefully studied and followed for required maintenance, operation, blade changing, and adjustment procedures. Recommended safety precautions should be followed.

Details about some stationary power tools follow.

Band saw. The wood-cutting band saw has a continuous steel blade mounted on two rubber-tire wheels. Adjustments are provided for centering the blade on the wheel. Adjustable guides hold the blade straight and support the back of the blade during working pressure. A typical blade speed is about 3000 surface feet per minute. The working table on the saw is designed to adjust for cutting various angles as well as cutting straight cuts. A slot in the work table allows you to use a miter-gauge guide to make straight cuts and angles. With the miter gauge and the table tilted, compound cuts are possible. Attachable guide bars for the table allow for the use of a rip fence for cutting strips. The table size is about the same width as the diameter of the wheels holding the blade.

Band saws come in many sizes. The size is based on the wheel size, which determines the approximate cutting capacity, or the distance between the cutting edge of the blade and the rear of the blade, minus about ¼ inch for the rear blade guard. For example, a saw with a 14-inch wheel would have clearance of 13½ inches for cutting a piece of wood. Wheel sizes are from 12 to 40 inches. A typical small-shop or studio band saw would be 14 inches and would cut wood up to 6 inches thick. Ideally, your studio should have a saw of at least 20 inches, which would allow you to cut thicknesses up to 13 inches. The motor size is usually ½ H.P. for a 14-inch saw and may be up to 2 H.P. for a 20-inch saw. Of particular interest is the three-wheel band saw, which has a cutting depth of larger machines but is far less expensive. (Figures 6–20 through 6–23)

The saw should always be kept in proper adjustment: Tension on the blade should be appropriate to blade size; blade guide pins should be adjusted so that they clear the blade by about the thickness of a heavy piece of paper. The saw teeth should project slightly in front of the guide pins. The back guide or blade support holds the blade in this position when working pressure is applied to the front of the blade.

Saw blades come in widths from ⅛ to ¾ inches. The ½-inch blade is a good, all-purpose width, unless you are doing fine scroll work. Standard and skip-tooth blades are most common in wood cutting with a raker or alternate set. (See Figure 8–37) The kind of blade you use and the number of teeth it should have depend on the cutting operation you will perform. For fine cutting and scroll work, a standard blade with a wavy or alternate set and six teeth to an inch might be used. For cutting through thick stock, a skip-tooth blade with a raker set would provide the widest possible kerf, freedom from binding, and the best cutting action.

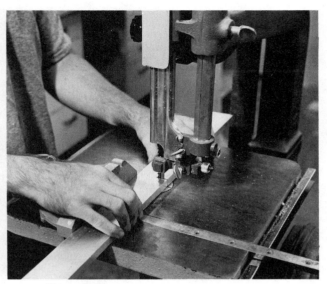

Figure 6–20
Cutting free forms on the band saw.

Figure 6–21
Cutting on the band saw using the miter gauge as a guide.

Figure 6–22
Large 20 inch wood-cutting band saw. Note extra height to allow cutting extra thick materials.

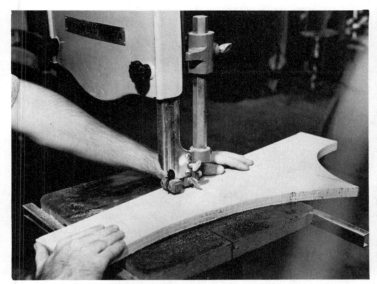

Figure 6–23
Three-wheel band saw with 24-inch depth-of-cut capacity. *Photograph courtesy of Laskowski Enterprises, Inc.*

In a wood shop, the band saw is primarily used for cutting curves. Straight cuts and ripping can be accomplished more efficiently and more accurately with a circle saw. Cutting on a band saw is relatively simple: Raise the upper guides to a height to just clear the material; feed the wood through the saw blade with moderate to light pressure. If excessive pressure seems necessary, the blade is probably dull, and it should be changed. In sawing, it is important to be aware of the position of your fingers: Keep them clear of the path of the blade. Be particularly careful when completing a cut.

When making complex cuts, it is often advisable to make several short cuts into the material or to rough out the material first. For duplicate pieces, the material can be stacked and tacked together and sawed at the same time. Rounds can be ripped by using a V-block or special jig. The rip fence can be used as a guide for sawing short lengths of dowels or other stock, ripping or resawing a thick board into two thin boards, diagonal cutting of square stock (from corner to corner), and cutting off corners of square stock for turning. Jigs can be constructed for cutting circles, rounding corners, kerfing, making arcs, tapering, and solving many other special problems.

Table circle saw. Table saws are classified by blade size. Blade sizes for shop and fabrication are 8, 10, 12, 14, and 16 inches. The 10-inch saw with a 2- to 3-H.P. motor is the most popular size; it can handle most shop and studio work. The standard motor for the 10-inch saw operates at about 3450 r.p.m., and has a cutting speed of about 9000 surface feet per minute. Its depth of cut is 3 inches, and it can easily handle boards, sheets, dimensional lumber, and so on, up to 2 inches thick. If the saw is expected to rip large quantities of dimensional lumber that are more than 2 inches thick, a 12- or 14-inch saw should be used with a 5- to 7½-H.P. motor. The small 8-inch saw may be all right for occasional light work, but it should not be considered for the classroom, shop, or professional studio. (Figure 6–24)

Inexpensive table saws are available with tilting tops. A saw with a stationary top and a tilting arbor is a better machine, however, because it is safer, easier to operate, and more accurate. A tilting arbor saw and a tilting top saw both adjust for 45 degrees and other kinds of angles.

Besides sawing, a table saw can dado and groove, using a dado head that consists of two outside blades and four inside cutters. By varying the number of inside cutters, or by using only one of the saw blades, grooves and dados can be cut from ⅛ to 13/16 inch wide. When equipped with a special molding head and appropriate blades, the table saw can function as a shaper and can cut a variety of molding shapes. Standard blades for the circle saw are the cross cut, rip, and combination. (Figure 6–25) The combination can be used for ripping and cross-cutting. Also, investing in a carbide-tipped combination saw blade, although initially expensive, is perhaps one of the best moves you can make to help your wood sawing. The initial high cost is soon offset by the fact that it seldom needs sharpening and the fact that only one blade is needed. The proper combination blade will cut plastic as well as wood.

In all sawing operations, the blade is raised to a height to project about ¼ inch above the surface of the material. (Figure 6–26) Higher settings are unnecessary and hazardous. Hands should be kept clear of the blade, and proper devices should be used to hold material that is close to the blade. Loose clothing, particularly partially rolled-up shirt sleeves, neckties, or hanging items, such as jewelry, should be avoided.

Ripping, grooving, and cutting molding involves cutting the board lengthwise. For this operation, the board is placed flat on the saw table and is guided by the rip fence, to maintain the proper width being cut. The rip fence slides along a front and rear guide. The front guide is calibrated in inches, to indicate the width of the cut. The fence is equipped with a front and rear locking device, to hold it parallel to the saw blade. When ripping strips narrower than 3 inches, a push stick should be used to complete pushing the material through the saw. (Figure 6–27) A common and safe practice is to pull the remaining material through the saw rather than to use a push stick. When the material being ripped is long, an extension table or other support should be provided for the material as it feeds off the saw table. Ideally the saw should be equipped with an antikickback device and a splitter for ripping; the splitter spreads the board, preventing it from binding on the saw blade.

The miter gauge is used as a guide for the material when the cut is made across the board. Attempting a crosscut without the support of the miter gauge is dangerous and should never be attempted. In a typical crosscut of strip material or boards, the wood is held against the miter gauge with one hand and is pushed across the table; it is not necessary to hold on to the free end with the other hand. If a wood facing is fastened to the miter gauge (as in Figure 6–28), cross-cutting operations are easier for long strips. Short pieces can be held down with a small block of wood, to avoid getting the fingers close to the blade.

A stop or the rip fence should never be used against the free end of the wood for measuring exact lengths. For measuring exact lengths, the safest method is to fasten a stop to the facing board on the miter gauge. With the miter gauge and saw set at an angle, compound angles can be cut. A wide variety of jigs can be constructed for sawing unusual details and joints.

Radial-arm circle saw. In the radial-arm saw, the saw is mounted on a track, over the work. For crosscutting, this has distinct advantages over a table saw, because the cutting operation and layout marks can be observed more easily. Woodworkers and fabricators often disagree over the merits of the radial-arm saw and the table saw. Ideally, it is desirable to have both—using the table saw for rippings and the radial-arm saw for cross-cutting, or using each saw according to which seems to provide the greatest ease, accuracy, and safety in the particular operation being performed. The distinct advantage of using the radial-arm saw for cross-cut operations is that the material remains in a stationary position while the saw is moved

Figure 6–24
Good quality stationary 10-inch table saw.

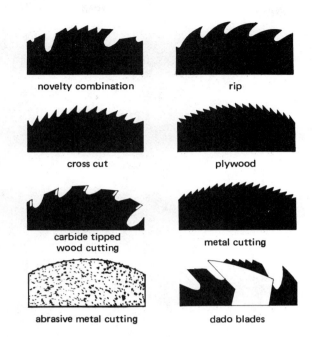

novelty combination · rip

cross cut · plywood

carbide tipped wood cutting · metal cutting

abrasive metal cutting · dado blades

Figure 6–25
Basic saw blades.

Figure 6–26
Ripping a piece of plywood on the table saw. Note saw blade height and position of fingers over the rip fence; these are precautions that prevent the hand from getting too close to the blade.

Figure 6–27
Using a push stick to guide material.

Figure 6–28
To cross-cut with the miter gauge, attach a wood facing to the miter gauge to help guide the material.

Figure 6–29
The 10-inch radial arm saw.

across the work to make the cut. If your studio or shop is to be equipped with one saw, it would be advisable to consider the radial-arm saw, which is also more versatile than the table saw; with attachments, it can be used for dadoing, molding, drilling, sanding, shaping, and routing. (Figure 6–29)

For cutting operations, the radial-arm saw is placed into the desired position in relation to the table and ripping fence. For normal ripping and cross-cutting operations, the saw should never be operated without the blade guard. For ripping, the saw is parallel to the rip fence. The guard is adjusted to just clear the material; This allows the sawdust to collect and be discharged away from you. For maximum cutting width, the rip fence can be moved all the way to the back of the table. A calibrated scale (in inches) on the overarm provides a convenient means of setting the width to be cut. An antikickback device on the guard prevents the material from being kicked back by the blade. This is adjusted to rest on the board. For ripping, the lumber is placed on the table against the rip fence and is pushed through the saw from the back side of the blade. Feeding from the front results in pulling the board into the blade, making the rate of feed difficult to control; moreover, front-feeding is dangerous, because, at the completion of the cut, the saw could easily pull your hand or fingers into the blade. When ripping, the same precautions should be observed as when cutting on a table saw. A push stick should be used for narrow cuts, or the work should be pulled through to complete the cut.

For cross-cutting, the rip fence is in a position in front of the blade. The wood is placed and held against the rip fence with the left hand. The saw is grasped with the right hand and is slowly pulled across the wood to execute the cut. Hold the right arm rather stiffly, and hold back on the saw slightly as the saw is moved slowly forward. An abrupt forward movement may cause the saw to jam. If the saw is held securely by the proper handle, and care is exercised in being certain that the left hand (holding the material) is not in the path of the blade, cross-cutting on a radial-arm saw can be safe and efficient. Material should never be cross cut unless it is held securely against the rip fence. For cross-cutting a number of strips the same length, it is a simple matter to clamp a stop on the rip fence. For cross-cutting 45-degree angles with the saw traveling at right angles to the rip fence, the saw is raised and tilted to a 45 degree setting. For a 45-degree angle from the rip fence, the overarm is moved 45 degrees. To execute compound angles, both adjustments are made. As well as for 90- or 45-degree cuts, the saw can be set for any other desired angle. The location for the adjustment knobs for making the settings on the saw will vary according to manufacturer. The manufacturer's instructions should be followed for making cutting adjustments and maintenance of the saw. (Figure 6–30)

Radial-arm saws, as table saws, are rated by blade sizes, which may run up to 20 inches for an average fabrication shop or studio. Larger blades are used industrially. Motor speeds are usually 3450 r.p.m., and surface feet per minute depend on the blade size. The average small shop or studio would use a 10- or 12-inch saw; the motor would be rated at 1 H.P. for the 10-inch and 3 H.P. for the 12-inch saw. Saw blades and recommendations would be the same as for the table saw.

If you remove the saw guard, the shaft is pointing down, and the saw is positioned behind the rip fence, the saw is in position for molding, routing, sanding, shaping, dadoing, and grooving along the edge and length of the material. With a drill-chuck attachment, it can be used as a vertical or horizontal

drill press. Cove cutting and many other special cuts and details can be accomplished with the proper techniques and the saw in the proper position.

Scroll saw. The scroll saw or jig saw is primarily used for cutting fine patterns and scroll work in thin stock. Intricate inside cuts can be made by drilling a hole through the sheet of wood, attaching the blade, and proceeding with the cutting. A principal advantage the scroll saw has over the band saw is its ability to make shorter-radius cuts, its being able to cut from the inside of the material and having clearance for making wider cuts. A 24-inch scroll saw is able to cut to the center of a 4-foot-wide piece of material.

The scroll saw operates on the basis of its blade moving up and down with a reciprocal action. Most saws are equipped with step pulleys or with a variable speed control to alter the speed from 600 to 1700 cutting strokes per minute. A ¼- or ⅓-H.P. motor is usually sufficient. In thickness the cutting capacity of the saw rarely exceeds 2 inches. The table of the saw tilts for bevel cuts. (Figure 6–31)

In cutting with the scroll saw, the upper guide (with the hold down) is lowered on the material. The spring tension of the hold down holds the material against the surface of the saw table. Feeding the work through the saw is a matter of moderate feed pressure.

There are two basic types of saw blades for the scroll saw: the jeweller blade and the saber blade. The jeweller blade is held from both ends; the saber blade is mounted in the lower mount. The blades are mounted with the teeth pointed downward, because the cutting takes place on the down stroke. Saber blades are used for making coarse cuts and for cutting larger radii. Jewellers blades are used for making fine and extremely intricate cuts. Using fine, spiral jewellers blades, with cutting surfaces on all sides, allows you to change the direction of the cut with minimum movement of the material.

Jointer. The jointer is used as a planing machine, primarily to surface edges and some flat work. Some models are also used for rabbeting. The jointer uses a rotary cutting head with three or four blades turning at about 4,000 r.p.m. The material is planed as it moves across the table surface of the jointer. Jointer tables and blades vary in width from 4 to 16 inches. A 6- or 8-inch model with a ¾- or 1-H.P. motor is usually sufficient for average wood shops and studios.

For planing, the jointer is set so that the rear half of the table is even with the highest point of the cutting knife. This is easily adjusted by placing a flat piece of wood flat on the rear half of the table extending over the blade. The blade is moved back and forth as the table is raised or lowered until the blade clears the strip of wood. All of the blades should be checked in this fashion. After the adjustment has been made, further adjustment should not be necessary until the knives are sharpened or appear to be out of alignment. The day-to-day adjustments for cutting depth are made by adjusting the front half of the table. The fence can be tilted for planing angles or for beveling.

In planing on the jointer, the wood is held firmly against the fence and the table. The right hand is placed to the rear of the board and is used for feeding; the left hand leads and guides the material. The wood is pushed slowly over the cutting head; the wood should be fed so that the blades cut with the grain and in the direction of the rotation of the cutters. The guard

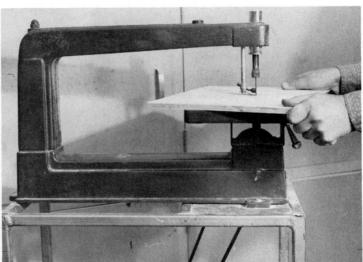

Figure 6–30
Cross-cutting with a radial-arm saw.

Figure 6–31
Sawing on a scroll saw.

Figure 6–32
Surfacing on a jointer using a push stick.

Figure 6–33
The 12-inch planer.

should always be in proper position, covering the cutting edges. Particular attention should be directed to the position of the right hand and fingers feeding the material. They should not be resting on the table surface as the cut is completed. This is the point at which accidents usually occur. Fingers of both hands should always be clear of the table surface. For planing small strips or flat pieces, a push stick as shown in Figure 6–32 should be used.

Planer. The planer is used to surface boards and dimensional lumber. There are two basic types of planers: They either surface one side at a time or both sides at once, as the material is fed through. Planer sizes range from small machines, which accommodate stock 4 inches thick by 12 inches wide, to large machines, which handle material 8 inches thick and 48 inches wide. Motor sizes start at 2 or 3 H.P. for the smaller machines, and correspondingly increase as the machines become larger.

To operate the planer, the machine is set for the desired depth of cut (about 1/16 inch or less) and the rate of feed. The board is fed into the machine so that the blades cut with the grain. An infeed roller grasps the board and feeds it through the machine. An outfeed roller carries the stock out. Friction rollers hold the board in alignment with the cutting head. (Figure 6–33)

Planers are relatively expensive in comparison to other shop equipment. For the shop or studio that does not wish to invest in a planer, lumber companies with mills, or shops doing commercial mill work; they often plane material for you for a modest cost.

Shaper. The shaper is used primarily to shape edges of boards in the production of molding or for cutting grooves, rabbets, and glue joints. When equipped with small sanding drums it can also be used for sanding edges for inside contours, and short-radius curves.

The shaper is essentially a machine with a vertically mounted spindle that can be raised and lowered. A cutter or cutting head with knives is attached to the spindle. It is equipped with a 3,450 r.p.m. motor. Power is transferred to the spindle by means of a belt and pulley. The ratio is usually three to one, which provides a spindle speed of about 10,000 r.p.m. The average shop shaper requires a 1- to 2-H.P. motor.

Straight stock is cut by running the stock along a fence, past the projecting cutter blades. Using a hold-down device to hold the material against the table and the fence is highly recommendable. For shaping ends of stock, a miter-gauge guide that fits into a slot on the table top is used. The stock is guided and pushed past the cutters. A sliding jig with miter gauge and hold-down clamps is a good device for this operation.

In shaping curves or material that cannot be guided against the fence, the wood is guided along a pin projecting from the table top and a collar on the spindle. Patterns can also be fashioned to act as guides. The material is clamped into the pattern guides and the pattern is guided along the guide pin and collar.

There are three basic types of cutters for the shaper: the three-lipped solid cutter, the open-face knife clamped between two slotted collars, and the three-knife cutter head with changeable blades. The three-lipped solid cutter is the safest and most convenient to use. (Figures 6–34 and 6–35)

Drill press. The drill press is primarily used for accurate drilling or sawing of holes, countersinking, circle cutting, plug cutting, and boring mortices. (Figures 6–36 and 6–37) With attachments and jigs, it can be used for contour sanding, routing, and shaping with the three-lip solid cutters. However, if you are planning to do a large quantity of this type of work, the

appropriate piece of equipment should be used. The drill-press shaft is not designed to take continuous heavy side loads, as are the router and shaper.

A particularly useful device for woodworking is the morticing attachment, which consists of a bit that cuts inside a square chisel. As pressure is applied, the drill cuts out most of the material and the chisel squares the corners.

The standard drill press is the single spindle, 14- or 15-inch model, powered by a ½- or ¾-H.P. motor. A variable-speed machine is desirable so that

it can be used for both wood and metal work. Typical speed ranges from 300 to 5000 r.p.m. Drill presses are classified in terms of the distance they will drill into the center of a circle. In other words, a 14-inch drill press will drill into the center of a 14-inch circle, and the center of the drill chuck would be 7 inches from the back-supporting column.

You often have to securely clamp the work to the drill press table for drilling. If you are holding the material and a drill binds or catches in it, the material can easily be pulled from your hand and

Figure 6–34
Shaper with three-knife cutting head. Note the hold-down device.

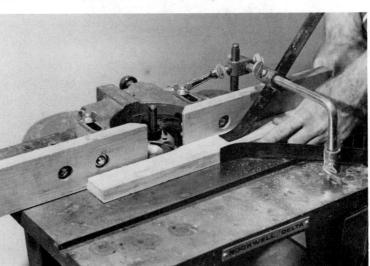

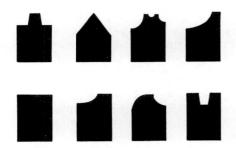

Figure 6–35
Some typical knife shapes for cutting molding and detailing edges.

Figure 6–36
Circle cutter on a drill press.

Figure 6–37
Hole cutting with a drill press.

Figure 6–38
The hold-down clamp for clamping work on the drill press.

injure you. Proper fences and jigs should be used for morticing, shaping, and so on. (Figure 6–38)

Lathe. Although many sculptors or students seldom find a lathe applicable to their work, it is an indispensable tool when round wood or spun-metal parts are needed. Turned wood parts can be used in wood constructions or as patterns for metal casting. Spun-metal parts are occasionally needed in metal fabrication. Buffing wheels, grinding wheels, sanding wheels, sanding attachments, and drill chucks for horizontal drilling can be used with the lathe. (Figure 6–39)

Wood turning is a relatively simple operation. For long turnings the piece of wood is placed between the spur center on the headstock spindle and the cup center on the tailstock spindle. The wood is first marked for the center on both ends by drawing two diagonal lines from corner to corner. A center hole is punched or drilled in the case of hard wood. Slight sawing of the crosslines on the band saw helps to position the spur center. The spur center is placed on the end of the material and is struck with a wood mallet, to seat it. Spur center and wood are then picked up and placed in the lathe. While holding the piece in position with one hand, the operator moves the tailstock up and locks it in place with the cup center pressing against the other end of the wood. The tailstock spindle handle is then turned, pressing the cup center slightly into the wood. A moderate amount of pressure is applied; then, back off about one-fourth turn and lock the tailstock spindle in place with the tailstock spindle clamp. The tool rest is then positioned to be about ¼ inch away from the work.

Figure 6–39
Wood-turning lathe with wood pattern: (1) headstock spindle; (2) spur center; (3) tailstock; (4) cup center; (5) tailstock spindle; (6) tailstock spindle handle; (7) tailstock spindle clamp; (8) tool rest; (9) speed control.

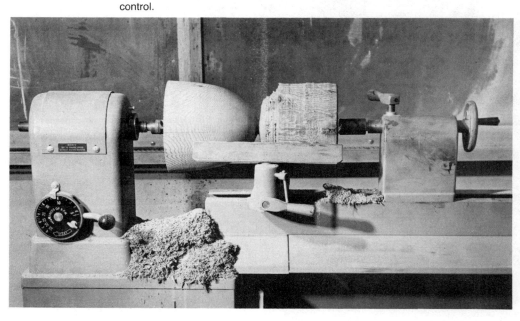

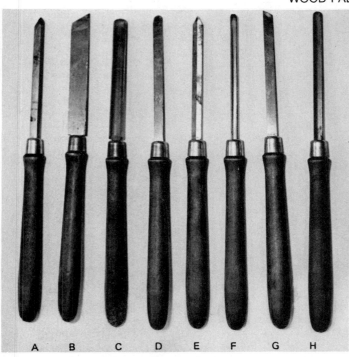

Figure 6–40
Wood-turning tools: (A) spear; (B) skew; (C) gouge;
(D) round nose; (E) parting; (F) gouge; (G) skew;
and (H) gouge.

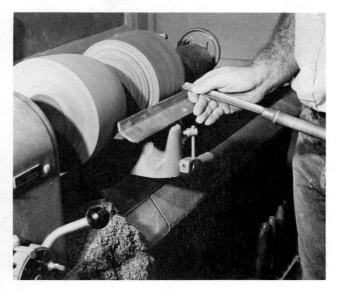

Figure 6–41
Wood turning a pattern for metal
casting. Note the position of the gouge.

Figure 6–40 illustrates the typical wood-turning tools. The gouge, used for gouging out, is the most common. The skew is used for smoothing, cutting shoulders, and making other details. The other chisels are used when their shapes suit the desired contour to be cut. There are two basic procedures in wood turning: if the chisel is held horizontally on the tool rest and moved straight in, it is a scraping position; if the handle is dropped 10 to 15 degrees, the chisel slightly turned toward the work and moved slowly in the direction of the cut, this is a shearing or cutting action. (Figure 6–41) The depth of cut should be slight—controlled by the forefinger of your left hand pressing against the tool rest, with the chisel being held between the thumb and forefinger. The tool handle is grasped with the right hand well to the rear of the handle, to provide maximum leverage and control during the roughing out. In later finishing, it may be desirable to take a shorter grip on the handle. The gouge is held with the curve resting on the tool rest and the concave surface pointing up.

For turning shapes that cannot be held between the two centers, the wood is mounted with screws or cemented on a face plate attached to the headstock spindle. Many lathes have an outside spindle to allow for turning larger than the normal inside capacity of the lathe. This turning technique always involves using the scraping position for the chisel; cutting or shearing would gouge into the wood. The tool rest is positioned on the center line of the piece being turned.

Normal turning speeds are 600 to 1000 r.p.m.,

for roughing out the cylinder; 1200 to 1600, for further shaping; and up to 2400, for final finishing and sanding.

The lathe size is determined by the maximum diameter of material it can turn. An average shop lathe would be an 11- or 12-inch machine with a ½- or ¾-H.P. motor. Limited variable speeds may be obtained on inexpensive models by a series of step pulleys. Higher-priced machines have more complex variable speed units, with speed choices anywhere between 300 to 3600 r.p.m.

WOOD JOINTS

The essential goal of any wood joint is to achieve maximum strength between two or more pieces of wood. If the wood structure is an internal frame to be covered with plywood or other material, wood or metal gussets, brackets, or glue blocks can often be used to achieve the desired results. If the wood structure is going to be exposed and joining occurs on finished surfaces, other means must be employed. There are four basic types of wood-joining problems: end to end, edge to edge, end to surface other than end, and surface to surface. (Figure 6–42)

The simplest end joint for end-to-end fabrication is the end butt joint. This may be satisfactory for internal structures with gussets or other bracing; however, when exposed, such a joint can readily separate, and the exposed-end grain is often objectionable. A plain miter on the joint improves the appearance, and because you nail it from both directions, it is less likely

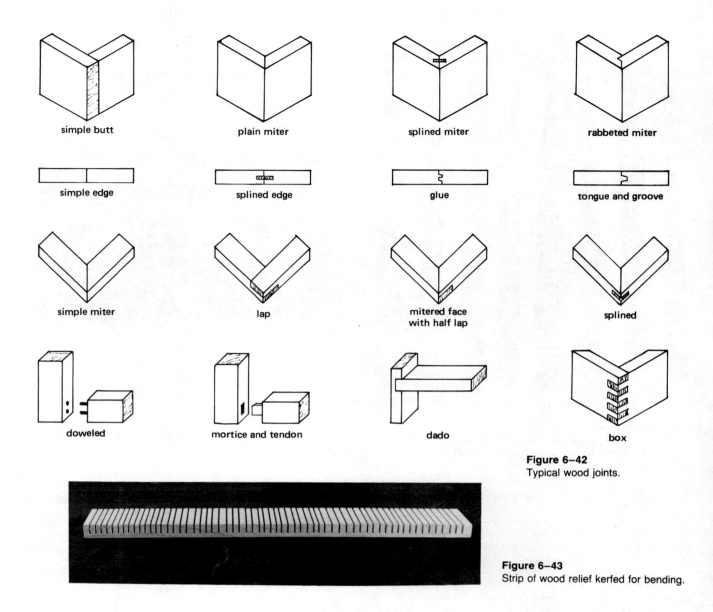

simple butt

plain miter

splined miter

rabbeted miter

simple edge

splined edge

glue

tongue and groove

simple miter

lap

mitered face with half lap

splined

doweled

mortice and tendon

dado

box

Figure 6–42
Typical wood joints.

Figure 6–43
Strip of wood relief kerfed for bending.

to separate. Ideally, for the best joint, the miter should be splined; if the end grain is not objectionable, it can be dovetailed or box jointed. If the corner joint is surface to surface, a simple end joint is the end lap joint. The end lap joint can also be handled as a miter, or the end joint can be mitered and splined. A mortice and tenon joint can also be used.

Edge-to-edge joints are often used when several boards need to be joined to form a wider board or surface. The tongue and groove, spline, or glue joint are the three usual methods of joining. Edge-to-edge corner joints can be joined at 45-degree angles, as just described for end-to-end stock. End-to-surface joints can be dado, half-lap, dovetail lap, or mortice and tenon.

All woodworking books illustrate many variations of these joints. Any joint can be fashioned using simple hand tools or appropriate stationary equipment.

BENDING

Wood can be bent by steaming, cutting relief kerfs, or laminating. Wood to be bent should be clear and free of knots or defects. The grain of the wood should run parallel to the length of the material.

To steam, the wood is placed in a steam vessel or container, such as a metal tank large enough to hold the part. The tank can be covered but should not be sealed to the extent that steam pressure is built up. The wood part is placed on supports in the tank so that it does not touch the water. Steaming time is approximately 1 hour per inch of thickness of the wood. After the wood has been steamed and becomes pliable, it is clamped in place, or in a jig, and bent to the desired shape. Always wear asbestos or leather gloves when handling hot wood parts.

One of the simplest methods of curving wood when maximum strength is not necessary is done very

Figure 6–44
Sculptor Steve Paulk bolting a section of his sculpture. *Photograph by Susan Lecky.*

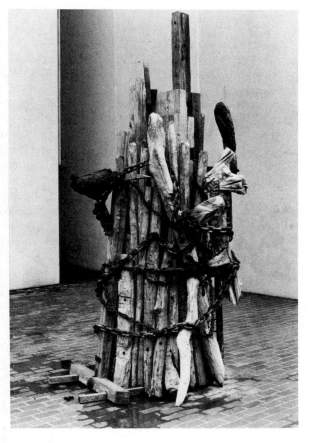

Figure 6–45
Completed sculpture by Steve Paulk at the 5th Texas Sculpture Symposium, Dallas, Texas 1985.

COUNTER SUNK COUNTER BORED

Figure 6–46
Countersunk and counterbored holes.

efficiently on the radial-arm saw. Cutting across the board to a depth of about three-fourths of the thickness of the wood allows the board to be bent. The closeness of number of cuts depends on the sharpness of the bend. Cuts or kerfs should be uniformly spaced if an even bend is expected. (Figure 6–43)

Laminating consists of clamping together thin strips of wood bent to the desired shape and clamping them in a jig, or holding them in place until the glue has set. Thin strips of plywood or veneers are readily shaped in this fashion.

FASTENERS

Nails, screws, bolts, and adhesives are the principal means used for fastening or holding wood parts together. Fasteners are often accompanied by adhesives for added strength and rigidity. In close-fitting joints, the adhesive and bonding of the surfaces may provide the major portion of the joint strength; the fastener would merely serve to hold the parts together during the curing or drying of the adhesive.

The kind of wood fasteners used depends entirely on joint design, performance required, and surface appearance. Exposed nails, bolts, and screws can add dramatic and effective detail on fabricated wood

sculpture. (Figure 6–44 and 6–45) If fasteners need to be concealed, nails may be driven below the surface with a nail set as discussed on page 101. Screws and bolts can be countersunk by drilling appropriate holes (as in Figure 6–46). Countersunk holes may be prepared with putty, or wood plugs can be used if the hole is counterbored. Wood plugs can be made with a plug drill. Epoxy paste is another excellent filler; a plastic filler can be made by thickening catalyzed polyester resin with Cab-O-Sil®. The specific kind of filler used depends on the hardness of the wood and on whether the wood grain will be exposed or painted.

NAILS

Nails used for wood fabrication are essentially round lengths of metal with heads and points. Although or-

115

dinarily made of steel, they may also be made of copper, aluminum, and other metals. Metallic coatings such as galvanizing are also applied to nails. Common nails and spikes have flat heads and are used in rough construction. Box nails are flat-headed nails made of a small diameter wire; they are less likely to split the wood than are common nails. Finishing nails have small, tapered heads designed to countersink into the wood. (Figure 6–47) Casing nails are similar to finishing nails, but they have slightly larger heads for more holding.

Common nails, finishing nails, box nails, and casing nails are all classified according to wire gauge and numbers. When ordering nails, it is good to remember that larger numbers indicate larger nails, both in diameter and in length. Figure 6–48 indicates common nail lengths. The small-wire nails and brads are ordered by length and gauge or diameter. Note that the wire nail has a flat head; the brad has a tapered head like the finishing nail's.

Figure 6–47
Some basic nails: (A) *right:* Oil-quenched hardened concrete nails—flat countersunk head, smooth shank, diamond point; *left:* Oil-quenched hardened masonry nails—flat countersunk head, fluted shank, diamond point; (B) perfect shingle nail—flat head, smooth shank, blunt point; (C) asbestos shingle nail —large flat head, barbed shank, long diamond point (usually galvanized); (D) duplex head nail—diamond point, smooth shank; (E) nonleak nail—large knobbed convex head, smooth shank, diamond point; (F) large-head barbed roofing nail—large flat head, barbed shank, diamond point; (G) checkered-head perfect roofing nail—large checkered head, smooth shank, diamond point; (H) scotch finishing nail— bead head, cupped scotch shank, diamond point; (I) scotch common—flat head, scotch shank, diamond point; (J) common nail—flat head, smooth shank, diamond point; (K) Common nail— flat head, smooth shank, diamond point; (L) finishing nail—brad head, cupped diamond point, smooth shank; and (M) barbed dowel pin nail—headless, cupped end, diamond point. *Photographs courtesy of Bethlehem Steel Corporation.*

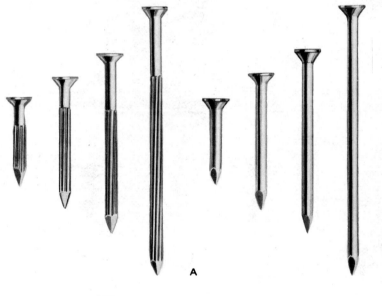

A

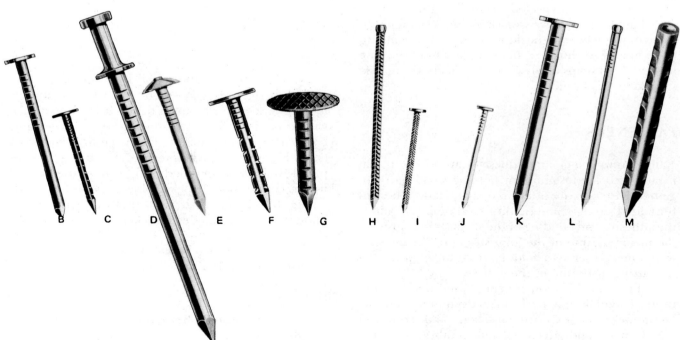

B C D E F G H I J K L M

Designation	Length, inches
2d	1
3d	1¼
4d	1½
5d	1¾
6d	2
8d	2½
10d	3
12d	3¼
16d	3½
20d	4
30d	4½
40d	5
50d	5½
60d	6

Figure 6–48
Basic nail lengths.

Figure 6–49
Different heads, shanks, and tips of nails.
Photograph courtesy of Bethlehem Steel Corporation.

Besides the nails just described, a variety of nails has been designed for special purposes. Nails with grooves, rough, or coated surfaces are designed for extra holding or mechanical bonding in wood. The ring-lock-scotch nail and grip-screw nail are typical examples of this form of fastener. On the ring-lock nail, the projecting ridges prevent the nail from being pulled out. Nails of this kind should be used for any large, permanent sculpture. Ring-lock nails were used to fasten the plywood to the wood frames on the wood sculpture at the Denver Sculpture Symposium.

Also note that nail points may vary in shape to provide easier driving, prevent wood splitting, and so on. Obviously, a fine-pointed nail will drive into the wood with less tearing and will have more holding quality than will a dull or blunt-pointed nail. Nail heads are available in many shapes to serve many purposes. (Figure 6–49) These are of particular interest to the sculptor wishing to use the head of a fastener as a decorative detail on the work; heads may be round, flat, oval, square, or diamond shaped, and they may vary in thickness. Diamond-headed boat spikes, drive spikes, track spikes, oval-headed beer-case nails, hoop fasteners, and duplex-headed nails are just a few of the unusual nails not ordinarily considered for woodworking.

If there is any possibility of your splitting the wood, pilot holes should be drilled before you drive in the nails. In driving finishing nails, the nail should be driven to about 1/16 to 1/8 inch from the surface; the driving and countersinking completed with a nail set.

WOOD SCREWS

Round, oval, and flat-headed, slotted wood screws are ordinarily used in wood fabrication. Assembling with screws is more costly and more time-consuming than nailing. However, it is preferred for many wood sculptures because it provides a permanent, positive method of fastening, with little possibility of the fastener's working loose (as is the case with nailing).

Screws are classified by thickness or by diameter and length. The diameter of the screw is ranged in size between 0 and 24. The 24-gauge is the largest size. (Figure 6–50)

To avoid splitting the wood, it is a good practice to drill a pilot hole for each screw. If the head is to be countersunk, the pilot hole must be drilled out with a countersink, or counterbore it. Using a set of drill bits that drills a pilot hole, extra diameter for the screw, shank, and countersinks or counterbores all in one operation is an efficient way of drilling holes for setting screws.

If the head is countersunk, a putty filler is used to cover the head, unless the head is to remain flush and exposed. If it is counterbored, a wood plug is used. Round- and oval-head screws are used where the head can be exposed as a decorative element in the fabricated work.

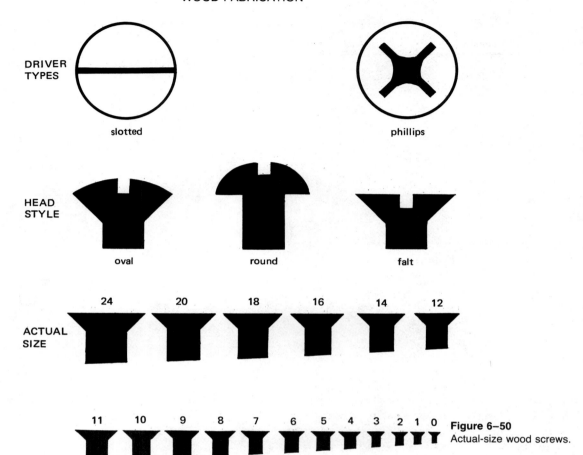

DRIVER TYPES

slotted phillips

HEAD STYLE

oval round falt

ACTUAL SIZE

24 20 18 16 14 12

11 10 9 8 7 6 5 4 3 2 1 0

Figure 6–50
Actual-size wood screws.

BOLTS

When assembling with bolts, appropriate holes need to be drilled in the wood to the same diameter as the bolts. The round, oval-head carriage bolts with square neck are generally used in wood-to-wood fabrication. The square neck of the bolt is seated in the previously drilled hole by striking the bolt with a hammer. The square neck prevents the bolt from turning while you are tightening the nut on the bolt. In the use of a lag bolt, a pilot hole is drilled. The lag bolt has a screw-like thread that is turned into the material in the same fashion as a wood screw. Machine bolts can also be used in wood-to-wood or metal-to-wood fabrication. Washers may be used with bolts to increase the surface contact between the bolts and the material. Bolts can be recessed by counterboring and plugging or filling the hole. (Figure 6–51).

Figure 6–51
Typical bolts: (A) carriage bolt; (B) lag bolt; and (C) machine bolt. *Photograph Courtesy of Bethlehem Steel Corporation.*

A B

C

Plastic
Fabrication

<div align="right">7</div>

Since 1950, plastic has gained increased recognition as a sculptural material. Originally, many of the prejudices against plastic held by industrial users extended to sculptors as well. Manufacturers, accustomed to metal and metal fabrication, or other materials, were reluctant to use plastics; because they often considered plastics to be cheap substitutes for metal and other materials, they failed to recognize the unique, and sometimes superior, qualities of the plastics themselves.

In many sculptural or industrial applications, plastics can, in fact, be superior to metal, as can plastic-fabrication to metal-fabrication techniques. However, the principal aesthetic merit of plastics in the arts, as in industry, is not only as a substitute for metal and other materials, but rather as a vast new array of materials suitable for many purposes.

For the sculptor, artist, and designer, plastic has opened the door to many forms not previously feasible. For the first time in history, sculptors have a selection of colored dimensional materials comparable to the painter's palette. Pigments and dyes added to plastic-sheet materials or resins to form coatings have given sculptors an acceptable and durable range of color with a high degree of permanency. Plastic has also contributed new dimensions in the scale, as well as the visual and tactile qualities, of the sculptural object. For example, building soft inflatable works is one of the many new approaches to sculpture made possible by plastic. (Figure 7–1)

This chapter is primarily a brief description of plastic materials and a discussion of the basic fabrication and forming techniques for sheet, film, tube, rod, and slab material. Further discussion relating plastics to other techniques are included in Chapters 2, 3, 4, 5, and 9, dealing with mold-making, casting, carving, direct modeling, and coating. Refer also to Chapter 15, which describes general safety procedures you should observe when handling plastics. Solvent fumes, resin and catalyst fumes, dusts, and fumes from plastic heated to a point of decomposition are often toxic.

Plastic-like materials, such as wax, clay, rubber, and glass, have existed for centuries in a natural state. Today, the materials we think of as plastic are synthetic and can be divided into two basic groups: thermoplastic and thermosetting. Thermoplastic materials can be remelted and reformed, whereas thermosetting materials cannot.

Relatively few chemical elements form plastics. Carbon is usually the principal element, along with such others as hydrogen, oxygen, nitrogen, chlorine,

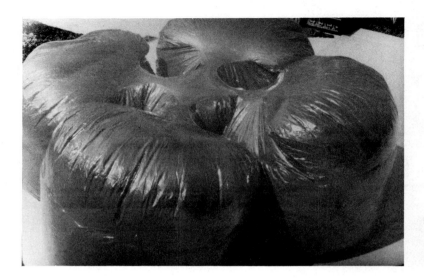

Figure 7–1
Inflatable sculpture. *Sculpture by Betty Voelker. Photograph courtesy of Betty Voelker. Ca. 1968.*

and fluorine; these are linked to the carbon atoms to form molecules. These molecules combine to form monomers, the primary combining units, or building blocks, in the formation of plastic. When subjected to heat, pressure, catalyzation, or a combination of these processes, polymerization occurs. The result is the finished material or object, which consists of complex groups of polymer molecules.

The final material can take on many forms. In other words, the arrangement of molecules can be such that a material is thermoplastic, thermosetting, hard, soft, flexible, brittle, dense, cellular (such as foams), adhesive, or nonadhesive (such as in mold-release agents).

Although it is not essential to be a chemist or to have a complex understanding of chemistry, to work with plastics, it is important to know that a chemical process is occurring. Polymerization of a plastic is often the result of specific conditions and is usually dependent on temperature, humidity, mixture proportions, and other working conditions.

Plastic is not as stable as metal; it has a higher degree of thermal expansion, a lower range of operating temperatures, and rigidity and fatigue strengths below that of metal. Materials with high degrees of thermal expansion often require special fabrication techniques. Lower range of operating temperature may render some materials useless in direct sunlight. In addition, degree of chemical resistance, moisture absorption, and resistance to abrasion may limit the suitability of a material for a particular use. Physical properties of plastics vary to such an extent that each material must be considered in relation to its use and expected performance. Specification sheets on individual materials can be obtained from suppliers. *Modern Plastics Encyclopedia*, published annually by McGraw-

Hill Book Company, Inc., is an excellent source for information of this kind.

Plastics as an industry is still developing at such a rate that each year brings new variations of plastics with improved physical properties. In fact, it might be safe to say that for any problem a sculptor or designer envisions, he or she can find a plastic that will do the job. Tensile strengths of plastic tend to increase each year. With glass reinforcement, polyester layups can reach strengths of 50,000 pounds per square inch. Other glass-reinforced resins can also reach high-performance levels. Development of exotic reinforcing fibers promises to dramatically increase tensile strength up to 250,000 p.s.i.

Impact strengths also increase each year; these can be varied by fillers and additives in plastic formulations. Although these factors are not of major concern for small works and wall reliefs, they do become of considerable concern for large-scale sculptures: play sculptures, works in parks and public places, and kinetic and environmental forms subject to impact. For example, temperatures concern sculptors working with materials exposed to sunlight and other special conditions, such as heat buildup in light sculptures. Ultraviolet stabilizers can be added to many plastic formulations to improve their properties under such conditions. Moisture and chemical conditions are perhaps of major concern to those sculpturing outdoor works or creating forms relying on fluids encased in plastics for visual effects.

Flammability can be another major concern for large-scale interior installations, particularly for environmental forms that surround the viewers. Many plastics are relatively slow burning or self-extinguishing; in addition, flame-resistant substances can be added to plastic formulations to make them even less flam-

mable. Machinability, primarily a concern for mass production, is not of great importance to sculptors in most instances.

Although plastics exist in great abundance, many forms of plastics are unavailable to sculptors or design students; small quantities are often unavailable from suppliers whose principal customers are large industrial formulators and fabricators. For the practicing sculptor who is serious about a material this is less of a problem; he or she is often prepared to buy such minimum quantities as 50-gallon barrels, 100- to 500-pound lots, full sheets, or large quantities of sheet, rod, or tube. In large cities, students can often find sympathetic formulators or fabricators who will sell them small quantities of the materials that are difficult to obtain.

Among the available plastics for sculpture are such materials as granules, pellets, powders, and flakes—usually used as molding materials in injection, extrusion, and other forms of molding. These can, however, also be melted and cast and used for mold materials, as fillers with resins, or in other experimental forms. Powders are also used in fluidizing bed, flocking, and other coating operations.

Filaments are most often used as continuous strands. They are machine-wound on a mandrel and treated with resins. After the resin is cured, the mandrel is removed or destroyed.

Resins are used to produce high-pressure and low-pressure laminated materials in sheet, rod, and tube form or finished products. Formica® is a common high-pressure formed material familiar to most of us. Fiberglass-reinforced polyester sheets and products are usually the result of low-pressure laminating. Resins combined with fillers are also popular as castable materials or adhesives. With the addition of colored pigments they become excellent coating materials.

Foams, too, are available to sculptors in a liquid form, such as urethane two-part systems; foam solids are available in blocks, sheets, and special shapes. Polyurethane and polystyrene materials are the most readily available foams. Sheets may be from 12 to 48 inches wide, up to 12 inches thick, and up to 12 feet long. Blocks may be up to 48 inches wide, 18 inches thick, and 12 feet long. (Figure 7–2) Foams, formulated in both rigid and flexible forms, may be as light as 1 pound or as dense as 50 pounds per cubic foot.

Films, sheets, rods, and tubes are available in an unlimited array of sizes, colors, and materials. (Figure 7–3) Films are usually heat-sealed, sewn, or cemented. Sheets, rods, and tubes may be rigid or flexible; thermoplastic forms may be heated and bent or thermoformed. They can be fabricated by adhesive bonding, solvent cementing, welding, or conventional fastening. They are available in a wide variety of sur-

Figure 7–2
Typical foam materials.

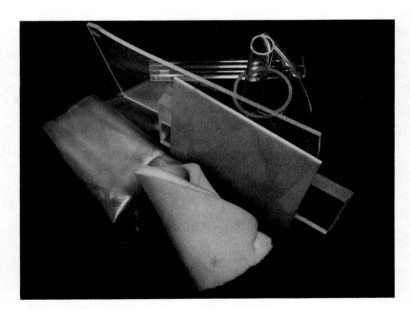

Figure 7–3
Some common plastic materials. From top: plastic rods, rigid plastic tube, flexible plastic tube, transparent acrylic sheet ¼ and 1 inch thick, opaque sheet, flexible foam, and vinyl film.

faces, textures, and decorative patterns. Films and thin sheets are often laminated to the backs of plastic, fabric, wood, metal, paper, and other materials. Many plastics are also available in a wide variety of custom shapes. Angles, tees, Ls, Us, and shapes common to metal come in plastic as well.

Special fabrication and forming techniques exist for all plastics; likewise, forms of adhesive bonding and methods for painting or plating most plastics also exist. Many thermoplastics can be welded with heat devices in techniques similar to welding metal.

There are fourteen major thermoplastics and seven thermosetting plastics. The thermoplastics are: ABS (acrylonitrile-butadiene-styrene), acetals, acrylics (polymethyl methacrylate), cellulosics (cellulose acetate, cellulose nitrate, cellulose acetate butyrate, cellulose propionate, and ethyl cellulose), chlorinated polyether, fluorocarbons (tetrafluorothylene, chlorotrifluoroethylene, and others), polyamides (nylon), polycarbonates, polyethylenes, polymides, polypropylenes, polystyrenes, urethanes, and vinyls. The thermosetting materials are: epoxides, furane, amino plastics, (melamines and ureas), phenolics, polyesters, and silicones. ABS, polyethylene, polystyrene, and vinyls are more recent and of more interest to sculptors. One of the newer plastics, ABS, is an alloy of a styrene-rubber combination. Where solid colors are used, ABS is less expensive to use than acrylics. It is also highly resistant to exposure to weather, although it is subject to slight yellowing and color changes.

THERMOPLASTICS

Acetals, high-strength, tough plastics of recent origin, are to some extent competitive with die-cast metals. At present, they are of limited interest sculpturally, because complex equipment is necessary for the forming process.

Acrylics—whether resins, pellets, powders, films, sheets, rods, tubes, or blocks—are clear or available in a wide range of colors; colorless acrylic is one of the clearest plastics available. Acrylic, whose major constituent is polymethyl methacrylate, is exceptionally stable against light discoloration and has good resistance to weather and chemicals.

Acrylic has enjoyed wide sculptural use for many years. Sheets have been fabricated into a wide variety of forms. It is easy to saw, cement, weld, finish, and thermoform. Some sculptors have cast resins into exceptionally optically clear castings. Rods have been used as light-transmitting devices. (Figure 7–4)

Cellulosics are some of the oldest of the plastic family; cellulose nitrate dates back to 1869 when it was patented as celluloid. Other cellulosics are cellulose acetate, cellulose acetate butyrate, ethyl cellulose, and cellulose proprionate. Cellulose nitrate has the disadvantages of being flammable and lacking stability in heat and light. Cellulose acetate butyrate, a weather-resistant material, has been used by sculptors in thermoforming. Although chemically resistant, cellulosics are not resistant to solvents such as alcohol, acetone, lacquer thinner, paint removers, and strong alkalis, and paints with similar solvents.

Polyether, particularly known for its excellent chemical, corrosion, and thermal stability, is chiefly used in corrosion-resistant pipes, valves, fittings, coatings, and linings for handling chemical materials. Coatings and linings are usually applied with a conventional spray apparatus, fluidizing-bed process, or flock coating. Commercial application of polyether coatings to sculptural fountain components, or to works demanding exceptional corrosion resistance, would have merit. Size limitations would relate to available commercial facilities.

Fluorocarbons, tough, nonflammable, high-temperature and chemical-resistant plastics, are used, for example, in the familiar Teflon® coating on cookware. Fluorocarbon coatings are available in spray cans as mold-release agents. Gasket materials, bearings, and coated parts may be useful in fountain construction and motorized assemblies. Coated wires are excellent as lead wires to ovens and heating devices, or in areas of heat buildup in such forms as light sculptures. Fortified with glass fiber, fluorocarbons are as tough as aluminum.

Polyamides are most common to us in the form of nylon-brush bristles and fabric. Films are utilized in food packaging. Gears, pulleys, noncorrosive fasteners, and coated wire should have sculptural application in mechanical and electrical forms. Nylon tubing is used as venting material in mold construction. Fluidized-bed coating may come into use. Fabrics coated or impregnated with nylon, or all-nylon fabric, can be sewed into forms and stuffed with shredded foam or stretched over rigid frames. Paper and other materials can also be impregnated or coated with nylon and laminated to rigid surfaces. These materials and techniques have been used in display design and sculpture.

Polycarbonates are relatively new; the first polycarbonate products were introduced about 1960. Polycarbonate, a high-performance, tough material, is transparent, with good optical qualities. Highly heat-resistant (up to 250 degrees), it should prove useful

Figure 7–4
Memorial sculpture made of acrylic plastic. *MACH PELAH Cemetery, Flint, Michigan. By sculptor Mon Levinson, 1969. Photograph courtesy of Mon Levinson.*

for light boxes and sculptures needing heat-resistant, transparent materials.

Polyethylene is one of the most familiar plastics in our day-to-day life; in excess of 3 billion pounds per year are used in the manufacture of industrial and household materials and products. Packaging containers, housewares, and toys are the most common items. Polyethylene has excellent weathering properties when treated with ultraviolet stabilizers and is available in both a flexible and rigid form. With good fatigue strength, it could be valuable in sculptures when flexing of a surface is desirable. Melted polyethylene pellets, powders, or molding compounds can be used in relief molds or they can be cast into conventional rigid and flexible molds. Sheets of polyethylene can be thermoformed, welded, and assembled with mechanical fasteners. Film can easily be heat sealed for inflatable or stuffed forms.

Polymides, developed to meet high-temperature requirements, can withstand temperatures up to 900 degrees for sustained periods of time. Resins, combined with glass fibers to produce high-strength components, are also used to produce heat-resisting adhesives. Polymides are not commonly available except from industrial suppliers.

Polypropylene, a result of the experimentation for a high-density polyethylene, is more heat-resistant and stronger than polyethylene. Fiber products such as yarn and rope, auto-upholstery material, ribbon, and piping may have sculptural possibilities. Polypropylene is a plastic that can be metal-plated easily if plating-grade resins are used. Sculptural suggestions for polyethylene also apply to polypropylene.

Polystyrene, although it has excellent potential as a sculptural material, has not enjoyed the popularity of acrylic. We are most familiar with polystyrene-foam

materials and products. Styrofoam®, a favorite for hobbyists and for small classroom projects, has been on the market for many years in small slabs, blocks, and other forms. It can be found in almost every home—as ice chests and in other applications.

In recent years, large blocks and sheets of polystyrene have been particularly popular with sculptors. The material is often carved, sealed, and coated with plaster, paint, or fiberglass. In another technique, the foam pattern is placed in dry or green sand, and is then cast in metal. The hot metal burns out the foam as the casting takes place.

Polystyrene is relatively inexpensive and is available in exceptionally diverse forms and in an unlimited range of colors. Its water-clear resins are castable. Glass-filled resins possess high strength. Medium-, high-, and extra-high-impact grades of sheet polystyrene can be thermoformed and fabricated with all common fabrication techniques. It does not, however, possess good weather resistance and tends to become brittle and to discolor under ultraviolet exposure. *Styrene-butadiene*, an elastomer available in pellet form, should be useful as a hot-pour mold material or in castings for which rubber-like properties are desired.

Urethane is the result of reacting polyester or polyether resins with isocyanates or diiocyanates, water, or fluorocarbon blowing agents. It is primarily available in resins, coatings, adhesives, rigid and flexible sheets or blocks, and shredded material. We are normally acquainted with foams of a light density, such as 1½ to 4 pounds per cubic foot. However, urethane can be formed into densities of 50 pounds or more per cubic foot.

In the past 15 years, there has been considerable sculptural application of polyurethane. Preformed sheets or blocks are carved or constructed into patterns and handled in the same manner as polystyrene foam. If the foam pattern is to be covered with polyester-reinforced fiberglass, urethane is preferred, as it does not react to the solvent nature of the polyester resin.

Castable urethane foams, usually in two-part liquid mixtures, can be formed into molds for flexible or rigid castings. Dyes can be added to tint and color the mixtures. Urethanes have been poured in a free-form technique to fashion sculptural reliefs or to build up textural surfaces. Prefabricated urethane building panels surfaced with thin-gauge metal or paper should be useful for fabricating large-scale sculptures.

Industrial spray applicators for foam can be used to construct large-scale sculpture. Recently, laminating thin layers of foam to other plastic sheet has resulted in thermoforming sheet material.

Although the toxicity of liquid-formed foams has been reduced considerably, always exercise caution when working with these materials.

Vinyls, the most versatile of the thermoplastics, can be compounded in an infinite number of ways. Vinyl chloride and vinyl acetate are the principal compounds in many formulations. Other materials are polyvinyl alcohol, polyvinyl acetals, and polyvinyl chloride acetate. We are familiar with vinyls as finished products in such commonplace items as fabric, film, floor covering, and house siding.

Flexible and rigid materials can be fabricated and formed by most known processes. Vinyl fabric, film, sheet and special shapes, building products, and coatings have been used sculpturally and show promise for further application. Melted-vinyl molding compounds are castable using certain mold techniques. Polyvinyl chloride should lend itself to hot-pour mold applications or slush molding for rigid or soft sculpture. However, like other plastics the fumes are toxic and molding should take place with proper fume removal and a protective respirator.

THERMOSETTING PLASTICS

Epoxides in many commercial forms have sculptural application, as they possess highly desirable physical properties for sculpture. In sculpture, as in industry, epoxy adhesives often make exceptional replacements for mechanical fasteners and weldments. Epoxy coatings are desirable on metal and other surfaces. Epoxy resins combined with fillers make outstanding castings with good weather resistance, as do epoxy-fiberglass laminates. Colored glass, epoxy bonded to glass, and glass set in epoxy-resin-sand mixtures have had extensive application in decorative, stained-glass windows.

Epoxies are usually two-part systems—mixtures of the resin and a catalyst or curing agent. Polymerization occurs at oven or room temperatures. Always take the normal precautions for handling toxic materials when working with epoxies.

Furane, through a complex formulation process, originated in furfuraldehyde and furfuryl alcohol, which are processed from vegetable wastes such as corn cobs and rice hulls. Sculpturally, its primary use has been as a no-bake binder added to sand in metal casting.

Amino plastics are usually melamine-formaldehyde or urea-formaldehyde formulations. Melamine-plastic dinnerware and high-pressure laminated melamine-phenolic-sheet material, such as Formica®, are most familiar to us. High-pressure, laminated-sheet

material such as Formica® has been used to make durable final surfaces on simple flat-surfaced sculpture. Urea-formaldehyde formulations have been used in electrical components for many years. Fabrics treated with amino formulations become permanently pressed.

Most amino-plastic products are formed by compression molding. Resins are combined with fillers and processed to form molding compounds. Products are formed under pressure and heat.

Phenolics were the first synthetic thermosetting resins to be developed. Dr. L. H. Baekeland discovered the first material in 1909, and the tradename Bakelite has been a household word for many years. The first application of this phenol-formaldehyde plastic was in the automotive and electrical industries.

Sculpturally useful would be phenolic resins that could be poured and heat-cured in inexpensive molds, resins mixed with fillers for molding compounds, resins for shell molds and foundry processes, laminated materials, and phenolic foams that could be carved with ordinary hand tools.

Polyesters are among the most promising of plastics to find application in the arts. Fiberglass-reinforced polyesters and cast polyesters are exceptionally useful to sculptors because they can be handled easily in a variety of molds and direct-buildup techniques. They also produce exceptionally strong and durable works. Resins with color additives and fillers have been used for textural paintings since 1950.

Industrially, polyester has been used since about 1942. Furniture, boats, car bodies, corrosion-resistant tanks, pipes, and containers are a few of the many products produced with reinforced plastics. Other applications are in such products as fabrics, coatings, corrugated and flat sheets, and castings. In reinforced plastic, fiberglass matting, cloth, or fiber is placed in a mold and saturated with catalyzed polyester resin. This may be a hand layup, spray, or match-dies-mold procedure.

In casting, the resin is catalyzed and poured into the mold. The resin may be clear, colored, or reinforced with fillers; the casting may be solid or hollow, utilizing a slush-mold technique. Catalyzing the resin is a simple matter of adding from 1 to 2 percent catalyst to the resin. The catalyst is usually MEKP (methyl ethyl ketone peroxide).

Polyester resins are as various as their uses: Laminating resins for hand layup, resins for match-die molding, resins for spray applications, and casting resins are all formulated to suit particular processes. Always take precautions pertinent to handling toxic materials when working with resins and catalysts.

Silicone is an inorganic plastic. When heated with carbon, sand is the basic raw material that produces the silicones that are compounded chemically to produce silicone formulations. These are usually in the form of liquids, oils, resins, and elastomers.

Silicone-rubber molding compounds and silicone mold-release agents are used extensively in sculpture and in industry. Castable-silicone elastomers could be used for flexible sculptural components. Coatings may be useful in situations in which high temperatures are required.

FABRICATION

Industrial fabrication of plastics may involve extremely simple techniques or complex and sophisticated machinery. Moreover, many wood- and metal-fabrication techniques can be adapted to plastic fabrication. Simple hand and electric tools can be used. Inexpensive versions of complex industrial machinery can be built, since the sculptor seldom needs the accuracy and high-production rate required by industry. Ovens and forming machines are easily built from simple materials and components.

Plastic fabrication falls into two basic categories: cold forming and thermoforming. In cold forming, the material is sawed, sheared, stamped, machined, and carved. Assembling is achieved through adhesive bonding, welding, bolting, riveting, or other mechanical means. In thermoforming, the material is heated until flexible, and then held in the desired form until cooled. At this point, the thermoplastic material retains the desired shape. Thermoformed parts can also be assembled using the techniques mentioned for cold forming. Plastic forms often combine cold-formed and thermoformed parts.

SAWING AND CUTTING

Because you usually deal primarily with flexible or rigid sheet, rod, tube, or custom shapes, your first concern would be to cut the material to the desired form. Plastic tends to be soft and to scratch easily, so the surface often needs protection. When you buy plastic, it often has a protective paper or film covering; when possible, leave these on the material during sawing and fabrication. If the material is purchased without a protective covering, surface paper can be taped onto sheets or rods, or wrap and tape it around tubes.

Small quantities of plastics can often be cut with simple hand tools. Tin shears or scissors can be used on film and thin materials. Thin, flexible material can often be cut with a razor blade in an appropriate

holder or with a linoleum knife. Paper cutters and sheet-metal foot-squaring shears can also be used on flexible and semiflexible material.

For handsawing, a handsaw, keyhole saw, hacksaw, or coping saw can be used. Teeth per inch in sawing is relative to the thickness of the material. Generally, two to three teeth should be in contact with the cutting surface. The handsaw should have 10 to 12 teeth per inch and moderate set. Eighteen teeth per inch is a fairly standard and desirable size for a keyhole saw and hacksaw. A coping saw should have from 15 to 20 teeth per inch.

To make straight cuts, sheet material should be clamped to a table and cut with the handsaw; the coping saw for curves and free forms. In fact, it is advisable to build a slotted table for clamping materials, if much cutting is to be done with hand and portable electric tools. Such a table is indispensable for hand cutting plastic, wood, or metal. (Figure 7–5) Rods, tubes, and other straight stock should be wrapped with cardboard, clamp in a vise, and cut with the hacksaw.

When sawing, use moderate pressure on the cutting stroke and ease up on the return. On hard, somewhat brittle plastics, side movement of the saw blade should be avoided as much as possible, as this can result in minor chipping or fracturing. The saw blades should be kept sharp and clean, to prevent excess friction and to ensure clean, smooth cutting action.

You can also cut appropriately clamped plastic materials with a hand electric jig or saber saw. Metal-cutting blades with 18 to 24 teeth per inch and a fairly wide set are usually recommended. When making straight cuts, a straight edge can be clamped to the plastic to guide the saw.

If the saw is a variable-speed saw, a slower speed, such as 1000 to 2000 strokes per minute, is advisable,

Figure 7–5
Slotted table for cutting materials.

to reduce friction and heat. In fact, cutting plastic with a portable jig saw, stationary jig saw, or band saw all have one thing in common: If the saw teeth are too fine or too dull, the set too narrow, and the speed too fast, heat can build up to the point of setting up undesirable stresses in the material. This is particularly true when you are working with acrylics or fairly rigid plastics that melt at relatively low temperatures. A partial remedy for this is to work with the fewest number of teeth and the lowest speed practicable. One thousand to 2000 strokes per minute for the portable and stationary jig saws and 3000 feet per minute for a band saw are reasonably acceptable speeds.

When cutting with the band saw, use metal-cutting blades. Materials over an inch thick can be cut with blades having three or four teeth per inch, with slight set.

The blade should be as wide as the nature of the cut will permit. One-half-inch wide is a good, all-purpose width for straight cuts and for cuts with large radii. Short-radius and intricate cuts call for blades ⅛ to ¼ inch wide. Spiral-edged blades can be used for exceptionally intricate cuts, because they can readily change direction of cut, with minimum movement of the material.

When the jig saw is being used for cutting, the hold-down should be set down on the plastic so that it exerts sufficient pressure to prevent vibration of the material. On the band saw, the upper guide should be set down to within about an inch of the material. Rollers and guides should be adjusted to as close a tolerance as possible.

The feed pressure on the material, when cutting with either the band saw, table saw, jig saw, or other power saws, should be moderate to light; it should be such that the cut proceed at a reasonable speed. The normal tendency when first cutting materials on a power saw is not to apply sufficient pressure; the result is usually excess friction, heat, and gumming of the blade. This can also occur if pressure, or rate of feed, is too fast. Proper rate of feed is gained by experience. It is possible to get manufacturers' recommendations on inches-per-minute recommended for a particular material under certain conditions, as a check for your cutting speed. If compressed air is available, a jet of air can be directed toward the cutting zone, to cool and remove dust. Industrially, liquid cooling is also used in production cutting. A small amount of wax on the blade can help reduce friction and prevent the blade from gumming. The blade can be cleaned with alcohol, mineral spirits, acetone, or other suitable solvents.

In cutting plastics on a table saw or with a skill or radial-arm saw, metal-cutting blades or carbide-

tipped blades should be used. Hollow-ground, 8- to 10-inch-diameter metal-cutting blades with six to eight teeth per inch are suitable for cutting thin material. Material over ½ inch thick requires blades with three to four teeth per inch. Some fabricators prefer a small amount of set in the teeth when cutting thick stock. On a table saw, the blade should be set up so that it barely projects above the material.

If a table saw, radial-arm saw, or skill saw is a permanent piece of your studio equipment, the best practice would be to equip it with an all-purpose, carbide-tipped blade suitable for cutting both plastic and wood.

The table saw and radial-arm saw can be used for straight cuts, grooves, miters, and all cuts normally associated with woodworking equipment. Special jigs can be constructed to hold pieces of rod, tube, or custom shapes while cutting.

In sawing or cutting plastics that have fillers added, carbide-tipped, diamond-tipped, or abrasive cutting wheels should be used. Glass and other filler materials are often so abrasive that they can ruin a metal saw blade in just a few cuts. For highly abrasive-filled materials, the abrasive cutoff wheel should be used.

To prevent scratches when ripping material with a table saw or with a radial-arm saw, the material should have a protective piece of paper on it. If cutting quantities of long, straight cuts is going to be a daily routine, it would be advisable to purchase a special traveling saw; because the plastic remains stationary while the saw blade moves, the danger of marring or scratching the material is eliminated.

MACHINING

To machine plastics, woodworking or metalworking equipment such as shapers, routers, jointers, lathes, drill presses, and milling machines, can be used. Because plastics are usually fairly abrasive, you should use carbide-tipped cutters, blades, and tools.

Using routers and shapers, shapes common to woodworking such as half-round, coves, corner beads, and others can be achieved. Spindle speed should be from 10,000 to 20,000 r.p.m. for cutters under 1½ inches in diameter. Edges can be planed on the jointer in the same way as you learned for wood in Chapter 6 (see page 110). Shapes can be turned on a lathe at surface speeds of about 500 feet per minute, with a moderate rate of feed. (Surface speed is circumference in inches multiplied by r.p.m. and divided by twelve.)

Drilling holes with portable drills or on the drill press can be accomplished with standard metal-cut-

small flat
on cutting
edge of drill

Figure 7–6
Modified twist drill for cutting holes in plastic.

ting twist drills. However, if fabrication of plastic is a usual studio procedure for you, it would be advisable to purchase a set of drills designed for drilling the desired kinds of plastic. Metal-cutting drills can be modified. Using a hand stone or fine grinder a small flat should be ground on the cutting edge of the drill. Because plastics are soft, the flat side on the cutting edge produces a scraping rather than a cutting action and prevents the drill from digging into the material. (Figure 7–6) Drill speed is about 3500 r.p.m. for ¹⁄₁₆-inch drills to 1000 r.p.m. for a ½-inch drill. Quarter-inch drills require 1800 r.p.m. and ⅝-inch drills run at 700 r.p.m. Precise recommended speeds and drills can be found in a source such as the *Plastic Engineering Handbook* (Allen F. Randolph, ed. New York: Reinhold Publishing Corp., 1960, 3rd ed.) or machining handbooks.

To drill, the plastic should be backed up with a piece of wood. Pressure should be eased up as the drill cuts through the material. When cutting deep holes, the drill should be backed out several times to remove chips, and a coolant should be used. The coolant can be simply a small amount of soapy water applied with an eye dropper, or a commercially prepared solution. A jet of air is one of the most desirable coolants.

Problems common to sawing also apply to machining operations. Cutting tools should always be sharp and clean; rate of feed should be moderate, and materials should be at room temperature. With a small amount of experience in handling plastic, the right technique to minimize heat and friction is soon developed. Stresses developed in plastic by sawing and machining can be removed by annealing the parts before assembling them.

TAPPING AND THREADING

Plastic rods can be threaded and tap holes can be tapped with dies and taps used for metal. For soft plastics, coarse threads are preferable. The tap or die can be lubricated with wax or soap to facilitate the cutting. The tap should be backed out frequently to remove chips. Also, making a slightly oversized hole is advisable to thread deep holes; this prevents the tap from binding or freezing in the hole. Self-threading screws that cut their own mating thread as they are inserted are also available. Refer to page 166 which deals with metal fabrication, for additional information on tapping and threading procedures.

SANDING AND POLISHING

Plastics can be sanded and polished by following the standard abrasive-finishing procedures outlined in Chapter 10.

ASSEMBLING

Plastic parts can be assembled using mechanical fasteners, adhesive bonds, solvent cementing, or welding.

Mechanical fasteners may be screws, bolts, or rivets. For plastics with a high rate of thermoexpansion, loose-fit arrangements are the most desirable. Tapped holes for threaded screws should be slightly oversized, and Class 1 taps should be used. In many cases, self-tapping screws can be used; special self-tapping screws for plastic are available. Plastic screws can be used in all plastic assemblies, or screws can be made from threaded dowel. On solvent, sensitive materials, pieces of threaded or unthreaded dowel can be inserted and permanently set, by touching the top of the insert with a drop of appropriate solvent. (Figure 7–7)

In setting screws into plastic, pressure on the screw should be moderate. In some cases, it may be necessary to back out the screw and start again. Soft plastic screws are particularly difficult to set and easy to break.

When fastening plastic to other materials, or bolting two pieces together, oversize the hole slightly to allow for expansion. The most ideal screw or bolt arrangement is round-headed, with a metal or rubber washer, or both, to distribute the pressure over a wider area of the material. From a decorative standpoint, this is often not desirable, however, and devices with less optimum results may be preferable.

Many kinds of rivets can be used on thermosetting plastics of high tensile strength and relatively low

Figure 7–7
Loose fit joint to allow for thermoexpansion of plastic to plastic or other material.

rates of thermoexpansion. Rivets are fairly ineffective in most soft materials unless washers are used to distribute the pressure over a larger area. Riveting is also less desirable on stress-sensitive materials such as acrylics. Pressures produced by rivets can produce stresses that craze or crack the material.

Blind riveting using the pop-rivet tool is one of the simplest riveting techniques and is acceptable in many decorative applications. It is preferable to use back-up washers on both sides to distribute the pressure. The holes should be slightly oversized. Squeeze the riveting tool handles together until the rivet has spread out and set. Do not continue to apply pressure until the mandrel pin is cut. Rather, release and remove the tool by spreading the handle, and cut off the mandrel pin with a wire cutter. This will minimize the pressure on the material.

Welding Many thermoplastics can be welded like metals. Using a welding torch containing a gas or electric heating unit, a jet of hot air is directed at the welding zone. As the plastic softens, a filler rod is pressed and melted into the softened zone. (Figure 7–8)

Joint designs are first beveled as shown in Figure 8–26 for metal fabrication. On thick material, multiple passes with the welding torch are made into deep bevels. Pieces can be tacked together and then welded as in metal fabrication. Rate of feed from the rod and speed of welding will depend on the plastic being welded. As in any welding technique, some practice on scrap material is essential; it is also the most appropriate way to learn and establish the desired technique for a specific material.

Another version of welding involves having the metal tip of the welding tool come into contact with, and melt and fuse, the material. A filler rod can be used for added fill.

An unusual, not-too-common welding process is spin welding, which is applicable only to small, round parts that can be placed in the chuck of a lathe or drill

Figure 7–8
One of several plastic-welding techniques.

Figure 7–9
Dielectric heat sealing vinyl film for an inflatable sculpture. Note curved die between the two platens. Dies are designed to meet the seam configuration of the individual sculpture.

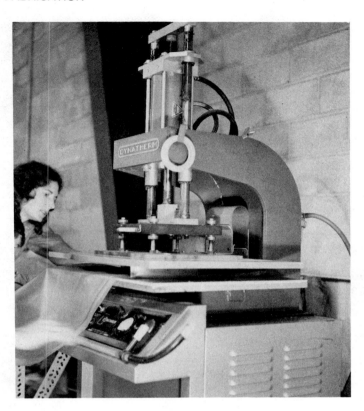

Figure 7–10
Completed inflatable sculpture. *By Betty Voelker*, Ca. 1968.

press. In this process, the piece is rotated at a high speed against the desired weld spot on the material. Friction builds up heat until the plastic softens enough to bond to the part. At the fusion temperature of the material, the drill press or lathe should be stopped as quickly as possible. To stop the chuck quickly, grasp the chuck with a gloved hand, and slowly apply pressure.

Welding fumes from heated plastic can be toxic. Knowledge of toxicity levels and required safety procedures should be obtained prior to welding a plastic.

Heat sealing Heat sealing is another form of welding thermoplastic together. Industrially, the four basic methods are dielectric, induction, ultrasonic, and thermal sealing.

In dielectric sealing, a radio frequency produces molecular disturbance at the point at which the die contacts the plastic. Here, it produces heat. This results in softening and bonding of the material. (Figures 7–9 and 7–10) Dielectric sealing is most satisfactory if a superior, leakproof seam is needed in such works as inflatable sculptures. Because the equipment is extremely expensive, the most practical approach is to work with a commercial plastic-fabricator who has sealing equipment.

Induction heat sealing involves placing metal membranes or powders in the plastic material at the point of bonding. The metal carries the necessary energy to produce heat and bond the material.

In ultrasonic welding the bond is accomplished through high-frequency vibration and the resulting friction between the two surfaces to be bonded. Using this process, plastic can be bonded to dissimilar material.

Thermal sealing is a process by which a thin film or sheet is melted together by directly applied heat. Thermal sealing is simple, and the equipment is not expensive. The process involves pressing the surface or surfaces of the heated die or tool against the material itself until the points of material contact, melt, and bond together.

THERMOFORMING

Thermoforming is a simple process of heating thermoplastic sheets to their softening temperatures and forming them while they are in these soft, flexible conditions. When the plastics cool, they retain the molded shapes.

The common thermoforming methods utilize air-blowing, vacuum, or mechanical pressures to shape the softened sheets. Plastic bottles, signs and letters, skylight bubbles, toys, and many household bowls and containers are formed in this manner.

Equipment for forming plastic in the studio or classroom need not be expensive or complex, if the forms are moderately sized and the artists are concerned with one-of-a-kind or limited production. The essential components for thermoforming are a heat source and air compressor for pressure or vacuum. For small works, an ordinary household oven can be used to soften the plastic, and a vacuum cleaner can be used as an air supply. This equipment, however, is quite inadequate for anything more than a few small experiments; serious sculptors or art students obviously need larger-capacity machines.

There are many variations in thermoforming, depending on the desired configuration and its size. For thin material (up to about ⅛ inch), it is best to heat the plastic in place and minimize the handling time. The plastic can be heated from one side with radiant heat. Thicker materials retain their heat longer and should be heated from both sides to ensure uniform temperature of the material. This is usually accomplished in a circulating-air oven that is either gas or electrically heated. The material is either hung in the oven or placed on metal trays that have drill-cloth or flannel coverings. An oven can be built easily out of cement asbestos board and angle iron. Kaowool® blanket insulation can be used to insulate the inside of the oven. Simple gas or electric burners can be used as a heat source. The metal casing from an old electric dryer or washer is easily converted into a small oven. Temperature controls can be salvaged from old ovens, or they can be purchased new.

One of the simplest techniques for thermoforming has sculptural appeal but little commercial value —free forming. In this approach, the previously cut and oven-heated parts are formed by hand and held in the desired position until cool. Insulated gloves must be worn to protect the hands. The parts can be assembled by adhesive bonding or mechanical means.

Figure 7–11 illustrates another relatively simple

Figure 7–11
Free-blowing technique for plastic.

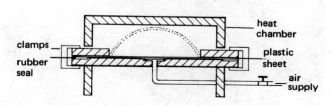

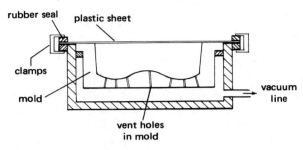

Figure 7–12
Simple vacuum-forming technique.

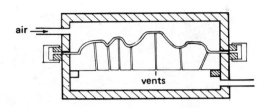

Figure 7–13
Air-pressure forming technique.

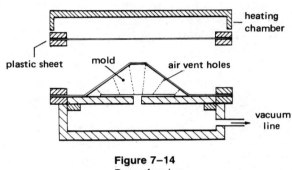

Figure 7–14
Drape forming.

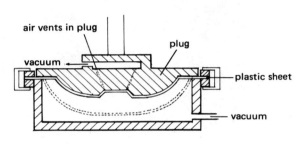

Figure 7–15
Vacuum-snapback technique.

technique. Here, the plastic and a template are clamped to a board having an inlet for air, and the shape is free-blown. This is the process ordinarily used for forming skylight bubbles. Thin plastic can be clamped in place and heated with a radiant heater from one side; thick material may need to be heated in an oven and then clamped and formed. Formed shapes can be further modified by heating selective areas with a heat gun; or air pressure can be applied to flat sheets and selective areas can be formed in this fashion. In addition to free blowing, forms can be free vacuumed into a suitable vacuum chamber.

From simple free forming and free blowing, thermoforming techniques become more complex and often require positive or negative molds or plugs. Figure 7–12 illustrates typical vacuum forming into a negative mold. In this case, the plastic is placed in the forming position and is heated from the top. As it softens, it will partially drape into the cavity. When the desired temperature is reached, the vacuum is applied and the material is drawn into the mold. In

another version of this technique, the top is sealed and air pressure forces the plastic against the mold walls. Mold walls must be smoothly finished as imperfections may transfer to the soft plastic.

Drape forming is an application in which the plastic is draped over a positive mold and vacuum is applied from the bottom, or air pressure is applied from the top. (Figure 7–13) In some simple forms, the weight of the plastic is sufficient for the plastic to conform to the mold shape and vacuum or air pressure is not needed. A desirable aspect of this approach is that the exposed surface of the finished work does not come into contact with the mold surface. (Figure 7–14)

In another forming process, a plug is used to press the soft plastic into shape. A variation of this approach is vacuum snapback, in which the plastic is vacuum-drawn into a bubble, the plug is lowered into place, and the cooling plastic snaps back and forms around the configuration of the plug. (Figure 7–15) Match dies and mechanical pins or rams can also be

Figure 7–16
Vacuum-formed sculpture 1968. *By Steve Wilder.*

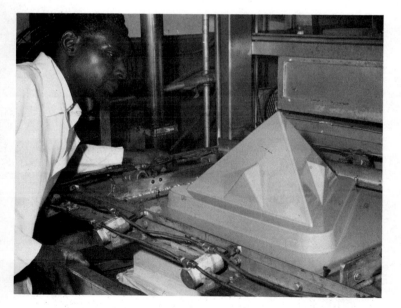

Figure 7–17
Drape forming on an industrial forming machine. *Photograph courtesy of Samsonite Corporation.*

used to force the soft plastic into the desired shape. (Figure 7–16)

The amount of time it takes for a piece of plastic to reach its forming temperature depends on the thickness of the material and the intensity of the heat source. Several experiments with scrap material are advisable to gain experience in estimating time requirements. Estimating proper forming time is also partially visual. If the plastic is hanging free in a frame over a positive or negative mold, the softness of the plastic can be judged by the extent to which the material sags as it softens.

Visual qualities, such as a change in the surface appearance of the material, also indicate temperature. If the material is to be heated in a thermostatically controlled oven, the oven can be set to hold the desired temperature; obtaining the proper temperature will therefore not be a problem. Most plastics for thermoforming soften at about 300 to 400 degrees.

You may want to preheat a mold for a complex mold configuration to about 125 to 150 degrees to prevent the plastic from chilling too quickly as it comes into contact with the mold surface. Preheating can be done in an oven, or, if a radiant heat-source is used, the heat can be directed on the mold prior to insertion of the sheet of plastic. After the plastic has been formed, fans can be used to blow air on the formed part to accelerate cooling.

The design of a simple thermoforming machine can vary considerably. Figures 7–11 through 7–14 indicate the basic principles, the application of which is often a matter of your personal needs and objectives. If a large quantity of pieces is needed, as in a modular design, it may be desirable to have them formed commercially. Figures 7–17, and 7–18 illustrate excellent examples of this approach. Sculptor Roger Kotoske, who visualized a sculptural module that could be arranged in many configurations, collaborated with the Samsonite Corporation to commercially produce 700 pieces in 5 hours. However, design and engineering time far exceeded this production time. Often, what appear to be simple shapes require complex engineering in order to be vacuum-formed.

Bending thermoplastic simply requires placing a strip heater between strips of asbestos board, as shown in Figure 7–19. The sheet of plastic should be turned several times to thoroughly heat the area to be bent. After the sheet is heated and bent over a simple form, as shown in Figure 7–20, it is clamped in place until the plastic has cooled.

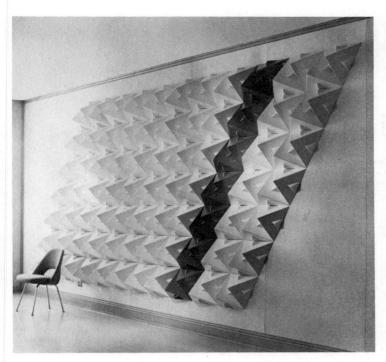

Figure 7–18
Completed sculpture of drape-formed modules. 1969. By Roger Kotoske. *Photograph courtesy of Samsonite Corporation.*

Figure 7–19
Basic design for a strip heater.

Figure 7–20
Forming plastic over a pattern or jig.

Metal
Fabrication

8

Metal-fabrication techniques, such as riveting, forge welding, and other simple mechanical devices, are ancient. Egyptian statuary of riveted sheet copper dates back to 2300 B.C. Sumerian craftspeople working around 2500 B.C. were particularly skilled in many forms of metal work.

Most fastening or fabrication devices used today are products of the last 100 years. Both welding (which started around 1900) and adhesive bonding developed considerably during and immediately after World War II; high-performance requirements in rocket design and space travel resulted in new and more sophisticated metal-fabrication techniques. The evolution of these processes has contributed significantly to the development of materials and techniques for sculpture and three-dimensional design.

Among twentieth-century industrial techniques, using the welding torch undoubtedly offered the greatest challenge and fascination. Direct, spontaneous manipulation of metal suited sculptors, just as direct, spontaneous application of paint suited abstract expressionist painters.

Properly conceived and manipulated, industrial materials and techniques can produce striking visual effects. Rich surface qualities are achieved with brazing and bronze welding. Bolting devices can take on

an honest and dramatic effect. The welded beads can produce strong visual surfaces (as in Figure 8–1). A striking example is David Smith's cubi series, for which he successfully exploited the noncorrosive qualities and appearance of stainless steel. (Figure 8–2) Indeed, monumental sculpture has become possible for many sculptors who wish to do their own fabrication. (Figures 8–3 through 8–7) Moreover, although complex processes are usually prohibitively expensive for sculpture and, usually, simpler approaches are sufficient for the sculptor, who seldom needs the high-performance fabrication processes demanded, for example, by the aerospace industry.

Three basic methods of metal fabrication exist: fabrication with fastening devices, adhesives, and welding. Selecting the proper fabrication technique depends on the nature of the form and the equipment available. Although, ideally, it is always desirable to select the best process, this is not always feasible for sculptors, who may have to choose techniques according to the tools and equipment available.

For example, to make a large-scale metal sculpture with thick material or large parts, an arc-welding process would be the most desirable in terms of cost, time involved, and quality of the weld. If arc-welding equipment were not available, the work could be ac-

Figure 8–1
Welded steel sculpture. 1965. *By Robert Mangold.*

Figure 8–2
Cubi VIII. 1962. Sculpture by David Smith. *Collection of Elizabeth Meadows Sculpture Garden, Southern Methodist University, Dallas, Texas.*

complished with oxyacetylene welding, but that process would be more difficult, more time-consuming, and more costly.

A similar dilemma can arise in the use of adhesives; some techniques involving pressure and heat curing can produce results that approach or surpass the strength of welding. These procedures are, however, usually inaccessible to sculptors because they require special ovens and precise temperature control. Consequently, sculptors would probably use adhesives that require air drying or room-temperature chemical curing.

Although welding does offer the most possibilities for metal fabrication, it is often overused because of the ease with which it solves many problems. Technically and aesthetically, an adhesive or fastening device would often meet particular needs more satisfactorily.

Welding also has some disadvantages: The problem of thermoexpansion and the possibility of

distortion due to heat input in the weld zone are ever-present; undesirable stresses may be set up in the metal; change in color and appearance of the metal may be unacceptable. Prefinished metallic or plastic-coated steel or aluminum usually require other fabrication techniques, as well, because the coatings would be damaged next to the weld zone.

Ordinarily, oxyacetylene welding is used on lightweight steel and for brazing nonferrous metals to each other or to steel. Other welding processes prove more satisfactory for welding thick sections of steel or matching alloys in nonferrous metals. The higher heat input of the electric arc makes it particularly desirable for welding large volumes of metal or metal such as copper or copper alloys that possess a higher rate of thermal conductivity. Nonferrous metals are easiest to weld using shielded-arc processes, because the inert-gas shield protects the welding zone from oxidation as the metal fuses together.

Figure 8–3
Mystic Raven welded steel sculpture by David Deming, First City Centre, Austin, Texas, 1983.

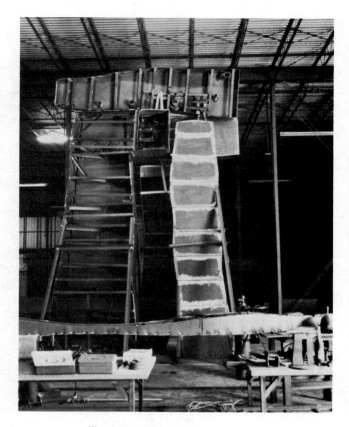

Figure 8–4
Welded steel sculpture in process in studio.

Figure 8–5
Sculpture being removed from truck.

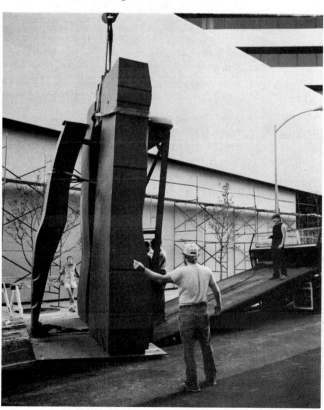

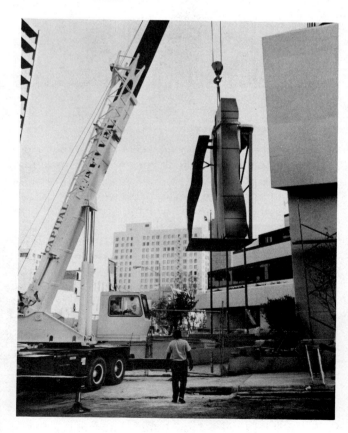

Figure 8–6
Sculpture being moved to site.

136

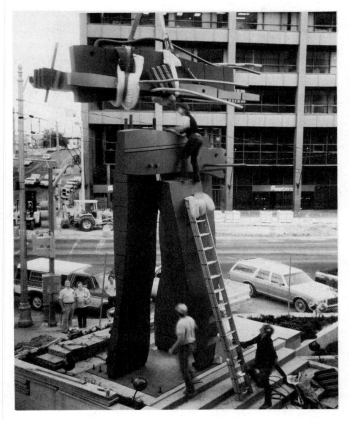

Figure 8–7
Assembling sculpture on site.
Photographs (Figures 8–3 through 8–7)
by Vicki Bohannon.

WELDING METALS

Following are brief descriptions of some metals you can use for welding.

Steel. Steels may be classified as hot rolled or cold rolled. Hot-rolled steel is easily identified by the oxide scale present on its surface; cold-rolled steel has the scale removed prior to its being rolled to its finished size. Rolled steel up to ⅛ inch thick is referred to as "sheet." Thicknesses over ⅛ inch are called "plate." Further classification is based on the alloying element. Plain carbon steels are identified as "low," "medium," and "high" in carbon content. Low-carbon steel is ordinarily about .15 percent carbon and is easily weldable with oxyacetylene or arc-welding processes. Most common varieties of steel sheet and shapes are low carbon. As the carbon content increases, the metal becomes less weldable. Other alloying elements are used to increase the toughness and strength. Nickel and manganese improve toughness; tungsten and chromium carbide improve wear resistance. Chromium provides corrosion resistance; molybdenum provides hardness; and copper provides atmosphere resistance. Low-alloy steels alloyed with chrome-molybdenum, nickel-chrome-molybdenum, and manganese-chrome-nickel can be welded by oxyacetylene or shielded arc. Tool steels alloyed with tungsten, molybdenum, or cobalt require special welding techniques. Cast steels such as cast or gray iron can be welded with oxyacetylene or arc techniques. Low-carbon steels and cast iron are most often used by sculptors. Copper-alloyed steel, which has been used on exposed architectural components and sculpture, acquires a deep brown protective patination in several years.

Stainless steel. Shielded-arc-welding processes are preferred for welding stainless steel, although coated electrodes can also be used. Of the high-alloy steels, stainless steel is perhaps of most interest to sculptors because of its high corrosion resistance. Stainless steels are heavier than carbon steels, and some have up to a 30 percent higher rate of expansion. Its thermal conductivity is lower. Low-carbon chromium-nickel stainless steel possesses the greatest corrosion resistance; although it is more difficult to weld, it should be considered for exterior works. Carbon-chromium steels can be identified by A.I.S.I. (American Iron and Steel Institute) numbers in the 400 series; chromium-nickel steels are identified with 200- or 300-series numbers.

Copper and copper alloys. These materials can readily be brazed with the use of a bronze rod and an oxyacetylene torch. Fusion welding is best accomplished with the shielded arc, although a few alloys are easily fusion-welded with oxyacetylene or the carbon arc. Generally, copper alloys are used instead of copper; the alloys are easier to weld and possess far less thermal conductivity. Brasses with relatively high zinc content, bronzes alloyed with zinc and tin, phosphor, aluminum, silicon, or nickel are usually used. High-zinc-content materials are easy to braze; they can also be fusion-welded with the oxyacetylene torch. They are difficult to weld with arc-welding procedures, because the high temperature of the arc and low melting point of the zinc cause rapid decomposition of the zinc and excessive zinc fumes. It is important not to be misled by the term bronze; sometimes a brass with a high zinc content is called "bronze." Brasses called "commercial bronze" have a low zinc content, whereas brasses called "architectural bronze," "tobin bronze," or "manganese bronze" have high zinc contents.

Silicon bronze, which is particularly weldable, consists primarily of copper alloyed with 1 to 3 percent silicon. It has a very low rate of thermal conductivity and requires far less heat input than many of the other alloys or pure copper. It can easily be welded with the oxyacetylene torch or with the carbon arc using direct current. A silicon-bronze welding rod would be used as the filler material. Nickel-alloyed copper can be easily brazed of fusion-welded with the oxyacetylene torch. Phosphor and aluminum bronzes are best welded with shielded-arc processes.

Aluminum. Rapid oxidation, high thermal conductivity, and no color change during heating make welding aluminum with conventional arc and oxyacetylene torch difficult. However, with the use of shielded-arc processes, these conditions are easily controlled. If shielded-arc welding is not available, aluminum can be oxyacetylene welded, using an appropriate flux with the aluminum rod; because heat input is slower, the heat is distributed over a wider area and there is a greater tendency toward distortion or slumping of the metal. A backup plate should be used on the back side of the weld joint to prevent slumping and provide support for the soft metal around the weld zone. Flux-coated electrodes are available for use with the conventional arc welder. Some aluminum can be soldered with special aluminum solders.

Aluminum consists of a whole group of aluminum alloys, some of which are more weldable than others. Alloys 1100, 3003, 5050, 6053, 6061, 6062, and 6063 can be welded with all welding processes; they can also be soldered. Alloys 5050, 6062, and 6063 are more difficult to solder. Alloys 2011, 2014, 2017, 2024, and 7075 are not very weldable. A few casting alloys that are easy to weld are 43, 355, A355, and 356.

OXYACETYLENE WELDING

This process is based on the principle that an acetylene flame combined with oxygen will burn at a temperature sufficiently hot to melt almost any metal. The temperature of the flame depends on the mixture of oxygen and acetylene. An excess acetylene flame is a maximum temperature of 5550 to 5700 degrees; a neutral flame is 5850 and an oxidizing flame is 6000 to 6200 degrees. Essentially, the oxyacetylene process is used to join or cut metal. As a heat source, it is also used to bend, forge, form, remove, scale and rust, and perform other metal preparations. The decision to use, and desirability of using, the oxyacetylene process with some metals depends, of course, on the nature of the material and on the other joining processes available for that material.

Using a wide variety of welding rods and fluxes, most metals can be joined with the oxyacetylene process. These metals would include cast iron, wrought iron, carbon steel, alloy steel, stainless steel, copper, brass, bronze, aluminum alloys, nickel, nickel alloys, and magnesium alloys.

The oxyacetylene equipment consists of a cylinder of oxygen, a cylinder of acetylene, regulating gauges, hoses, torch body, welding tips, cutting tip, cutting attachment, gloves, goggles, and friction lighter. Figure 8–8 illustrates a portable setup with large cylinders. The short cylinder holds approximately 300 cubic feet of acetylene. The taller cylinder holds approximately 244 cubic feet of oxygen. Smaller cylinders would hold 100 or 60 cubic feet of acetylene and 122 or 80 cubic feet of oxygen. If you do not intend

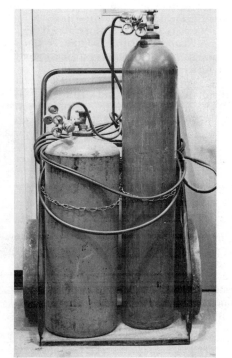

Figure 8–8
Oxyacetylene portable welder.

Figure 8–9
(A) Acetylene torch adjusting knob; (B) oxygen torch adjusting knob; (C) friction lighter; and (D) tip cleaners.

to do large work, the smaller sizes might prove adequate. Smaller portable units are also available that use acetylene-oxygen or propane-oxygen. These might be quite adequate if you only intend to work on small sculpture intermittently.

Figure 8–9 illustrates a typical torch body that is designed to take welding tips and the cutting attachment. Of particular interest recently is the Dillon torch with a pistol grip. It apparently has a new flame design that has some advantages for cutting and welding aluminum and stainless steel. Sculptors also like the pistol grip; they claim it to be less fatiguing when welding for long periods of time. (Figure 8–10)

To avoid any possible error in assembling the equipment, the acetylene fittings are equipped with left-hand threads and the oxygen fittings are equipped with right-hand threads. The acetylene is further identifiable by a red hose and the oxygen by a green hose.

To assemble the equipment, before attaching gauges, the oxygen and acetylene tanks are turned on one-quarter turn, one at a time, momentarily (on and immediately off) to blow out dust or dirt that may have accumulated in the valve seat. Never look at the tank valve or stand in the stream of released oxygen or acetylene. Examine gauge fittings for dust, dirt, or grease before attaching them to the cylinder. Because they are highly combustible and explosive, oil or grease must never come into contact with oxygen or oxygen fittings. After gauges are attached to cylinders, hoses are attached to gauges and torch body, the desired-size tip is attached, the equipment is ready to be turned on.

Figure 8–11 illustrates a typical oxyacetylene regulator setup. The first step is to be certain that the

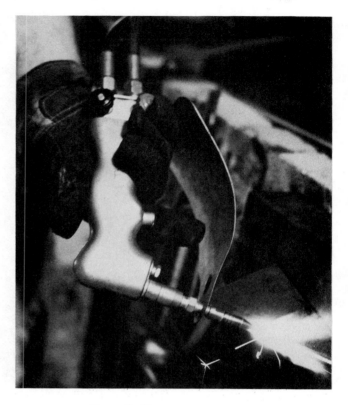

Figure 8–10
Dillon torch being used for fusion of metal.

pressure-adjusting screws (*A* and *B*) are turned out counterclockwise until loose. The remainder of the procedure is as follows:

1. Turn on oxygen valve (*C*) counterclockwise, opening valve all the way. Gauge (*E*) indicates tank contents.

Figure 8–11
Oxyacetylene pressure regulators: (A) acetylene adjusting screw; (B) oxygen adjusting screw; (C) oxygen tank valve; (D) acetylene tank valve; (E) oxygen tank pressure gauge; (F) acetylene tank pressure gauge; (G) oxygen working pressure gauge; and (H) acetylene working pressure gauge.

2. Turn on acetylene value (*D*) counterclockwise one-fourth to one-half turn. Gauge (*F*) indicates tank contents.
3. Turn in oxygen pressure-adjusting screw (*B*) until oxygen gauge (*G*) reads desired pressure—generally around 7 to 10 pounds for moderate work, higher readings for large tips and cutting, lower readings for very small tips.
4. Turn in acetylene pressure-adjusting screw (*A*) until acetylene gauge (*H*) reads desired pressure—generally around 5 to 7 pounds for moderate work, higher readings (not exceeding 15 pounds) for large tips and heavy cutting, lower readings for very small tips. (Refer to pressure settings and tip sizes recommended by the manufacturers of specific equipment, for more precise settings in relation to metal thickness.)

To turn on the torch, open the acetylene knob (*A*) (Figure 8–9) on the torch body counterclockwise one-eighth turn to one-quarter turn and the oxygen knob (*B*) (Figure 8–9) counterclockwise about one-quarter turn. Light the torch with the friction lighter (*C*) (Figure 8–9), and adjust to a neutral flame. A simpler approach (perhaps preferable until you are familiar with the equipment) is to open the acetylene knob one-eighth to one-quarter turn, light the acetylene, and adjust it until the flame stops smoking or shows a tendency to leave the end of the tip; then, open the oxygen knob slowly and adjust until the excess acetylene cone (*A*) (Figure 8–12) disappears, and you have a "neutral flame," with a pale blue inner cone (*B*) (Figure 8–12). If the oxygen is further increased—with a slightly shorter inner cone—the flame becomes an excess oxygen flame. (Figure 8–12) The principal disadvantage of this method of igniting first the acetylene, then the oxygen is that the smoke

from the burning acetylene is dirty and settles on work and shop equipment. When lighting the torch, be certain it is not pointed toward the cylinder, other workers, or flammable material.

To turn off the torch, turn off the acetylene torch body knob and then the oxygen. If work has been completed for the day, turn off the acetylene tank valve and then the oxygen. Then, bleed the system by turning on the acetylene torch body valve; this releases the acetylene in the system. When released, turn off the acetylene valve and repeat the same procedure for the oxygen. To complete the procedure, turn out the acetylene and oxygen gauges' adjusting screws until they are loose.

Good work habits and safety practices should be of continuous concern while welding: Always wear proper goggles—available in light, medium, or dark shades; always wear leather gloves and other protective clothing when cutting and when welding on large work requiring large amounts of heat; keep the work area clean and clear of flammables; never exceed recommended working pressures, and periodically check equipment for leaks with soap suds; always be alert to metal properties for toxicity of fumes during welding—good ventilation is essential.

The three common methods for joining metal using oxyacetylene welding, are fusion, fusion with a filler rod, and brazing. In fusion, the metal is melted and the molten metal flows to join the two parts. When a filler rod is used, a rod of metal similar to the metal being welded is added to the weld as it is being developed. In brazing, a nonferrous metal (usually bronze) is used to join-materials.

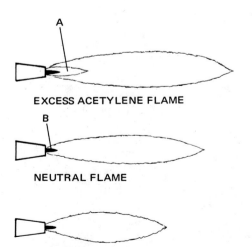

EXCESS ACETYLENE FLAME

NEUTRAL FLAME

EXCESS OXYGEN FLAME

Figure 8–12
Acetylene flames.

FUSION WELDING

Most welding operations require a neutral flame. In fusion welding, the tip of the neutral flame is directed at the joint to be welded. As the edges of the metal start to melt, the tip of the flame is moved in a series of overlapping ovals (Figure 8–13), allowing a molten puddle to form; this joins the two pieces. If a filler metal is added to the weld, the filler rod is directed at the edge of the molten puddle in front of the flame, working from right to left, melting off small amounts of rod as the weld proceeds. This is referred to as a "forehand technique" (Figure 8–14), and is the most common method. When you feed the rod behind the flame, working from left to right, the procedure is referred to as a "backhand technique."

A number of very common problems occur when welding is first attempted. If the tip of the flame (inner cone) is not close enough to the metal, it may be dif-

Figure 8–13
Oval welding pattern for torch movement.

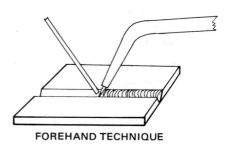

FOREHAND TECHNIQUE

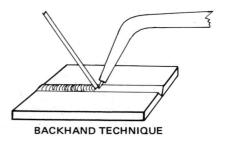

BACKHAND TECHNIQUE

Figure 8–14
Basic oxyacetylene welding techniques.

Figure 8–15
Typical welding bead and welding faults: (A) good bead; (B) overheating welding zone; and (C) insufficient heat, rod applied too soon with very little fusion of the base metal.

A B C

ficult to get the metal to a melting point; when the melting point is reached (particularly on thin sheet metal), the heat is distributed over too large an area, and the molten metal will separate and form a hole in the metal. To confine the heat to the weld area, it is essential to work with the tip of the flame next to the metal; there should be about 1/16- to 1/8-inch gap between the tip of the flame and the metal.

Selecting proper tip size is also important. If the tip of the flame is being directed properly at the metal and the molten puddle does not readily form, the tip may be too small. If the puddle separates and holes appear, the tip may be too large, or you may not be using the overlapping or oval motion to assist the formation of the puddle.

Another common problem involves feeding the filler rod in too soon. This results in deposits of metal before the molten puddle has formed. These deposits tend to overheat and burn; the result is a porous and brittle weld. (Figure 8–15)

In welding an edge of a material to the center of a piece of metal, or a small piece to a large piece, the small piece or edge may tend to melt away. Here, it is necessary to direct the heat to the largest amount of material or area, first, until a molten spot starts to form; then, by moving back and forth in the overlapping, oval pattern, favoring the thicker or larger section, you can complete the weld.

Overheating the weld can also be a problem. Because metal will chemically change to an oxide in the presence of air or oxygen, and heat and oxygen accelerate this process, overheating the weld results in a porous and brittle weld. The speed at which the torch is moved and the weld developed, as well as learning to recognize the shiny, molten puddle, are important.

Dirty tips can also cause problems; tips should be kept clean with a proper tip cleaner. Figure 8–9 illustrates standard tip cleaners. The proper-sized cleaner is moved back and forth in the tip opening and is not twisted or turned.

BRAZING

Brazing or bronze welding generally involves using a nonferrous filler metal with a melting point above 1000 degrees but lower than the melting point of the metal to be joined.

The bronze welding rod is used principally in the fabrication of copper or copper alloys, or in the joining of dissimilar metals, such as copper or bronze to steel. The brazing technique is also used extensively to produce decorative surfaces on copper, brass, bronze, and steel; bronze rod is used for these effects, because it produces a golden brass-like surface that can be oxidized to a variety of colors. Silver colors can be

achieved using nickel-silver rod. Eutectic Corporation produces a variety of rods with distinct variations in color due to the varied alloys.

In bronze welding, if the metal is properly cleaned and the proper rod and flux are used, bronze welds with excellent tensile strength can be achieved. The metal can be cleaned with solvents, steam, sand blasting, wirebrushing, or abrasives as discussed in Chapter 9 and Chapter 10.

The welding procedure consists of heating the base metal from dull to cherry red, at which point bits of bronze rod are melted and fused to the base metal, forming a bead, as in fusion welding. Care must be exercised in letting the base metal reach the proper temperature; if the temperature is too low, the weld will not be properly bonded to the base metal; if it is too high, the bronze will burn and fume, producing an improper weld.

In using the brazing technique to develop textural surfaces, a small area about the size of a half-dollar is heated to a dull red, at which point the rod is introduced into the weld area. The tip of the flame is directed to the rod, melting off a small portion which flows over the preheated area. As the torch is moved from rod to metal, the brazing continues. If more heat is directed to the rod, the texture becomes rather thick and bumpy; if more heat is directed to the metal, the bronze will flow out and produce a thin surface texture. Figure 8–16 illustrates a studio assistant applying bronze to a brass piece for a large metal relief.

In bronze welding or brazing, a proper flux must be used. The rod end is slightly heated and dipped into the flux. As the rod is melted, the flux flows over the metal and protects the metal from oxidation as the weld develops. Flux-coated rods, obtainable at a slightly higher cost, are far more convenient to use and assure that the proper amount of flux is present on the rod. Especially for large quantities of brazing, considerable time is saved with the coated rod.

In most instances, the surface brazing of metal is performed prior to assembly of the pieces. The distortion that occurs during brazing can be removed by hammering and forming. Figures 8–17 and 8–18 illustrate the assembling and final detailing of a relief being finished in a studio.

Good ventilation should be provided when bronze welding or brazing, as the zinc fumes from bronze can be irritating.

SOLDERING

Soldering consists of using a nonferrous, low-melting-point metal to join metal to metal. Solder is a tin-lead mixture with a melting point of about 420 degrees. The mixtures are from 40 to 60 percent tin to lead. Larger amounts of tin result in a lower melting point. Hard solders consisting of silver alloys can be used where greater strength is required. These are classified as *easy flow*, with a flow temperature of 1300 degrees; *medium*, with a flow temperature of 1360 degrees; and *hard*, with a flow temperature of 1460 degrees. Aluminum solders are also available for soldering aluminum.

With proper conditions, soldering is a simple process. Normally, a soldering iron, electric soldering gun, or flame produced by air-acetylene or air-propane, is used as a heat source. (Figure 8–19) With silver solder, an air-acetylene torch or oxyacetylene torch is usually used because of the higher melting temperature of the material. It is important that the metal be clean. Steel wool, emery paper, or sandpaper are usual cleaning tools. After the metal has been cleaned, its surface is coated thinly with an appropriate flux. The metal is heated to a temperature that will melt the solder, at which point the solder is introduced into the solder area. The solder should melt

Figure 8–16
Texturing brass sheet with the brazing process.

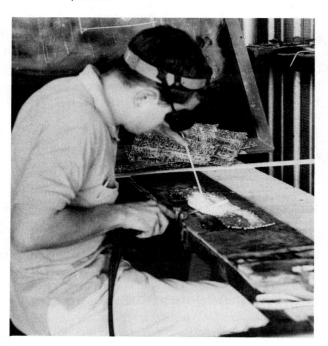

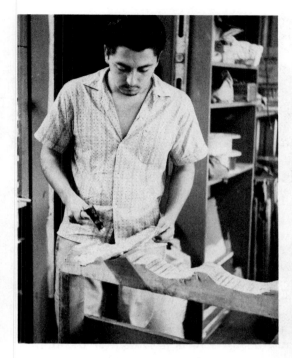

Figure 8–17
Pieces being assembled into sections
to form a wall relief.

Figure 8–18
Final detailing of relief panels.

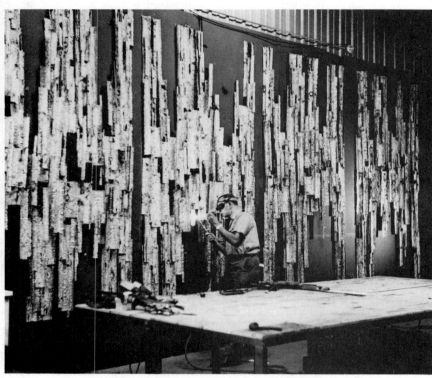

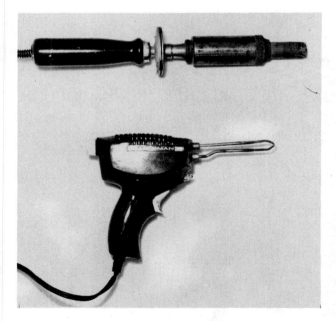

Figure 8–19
Soldering iron, top. Electric soldering
gun, bottom.

when it is touching the heated metal. In soldering parts like copper fittings for fountains, the solder will draw into the space between the parts by capillary action, if the parts are clean and have been properly fluxed.

Because flux is often corrosive, it should be cleaned from the metal with soap and water or other suitable cleaners. Care should be exercised in preventing flux and solder from splattering into the eyes; wearing protective goggles can ensure this. Lead fumes from solder (particularly if it is overheated) can be toxic. Silver solder fumes can be also, particularly if the alloying element is cadmium. Use good ventilation when soldering any appreciable amount.

ARC WELDING

Arc welding is essentially a process using heat formed by electrical energy—produced by a short circuit, as electrons meet resistance in the circuit and travel from rod to work piece or the reverse. Both alternating current (A.C.) and direct current (D.C.) are used.

There are virtually dozens of welding proce-

dures using electrical or other forms of energy; the electron beam, the plasma arc, the laser beam, and atomic hydrogen welding are all processes used today by industry. In most cases, the equipment is expensive, highly sophisticated, and not practical as studio equipment. If you have a welding problem that cannot be solved with conventional welding equipment, you should seek the advice of a large industrial fabrication shop which has more specialized equipment. You can also lease or rent moderately priced equipment (such as MIG and TIG), that is still too expensive for your small studio, from welding suppliers.

The principal advantage of arc welding is in the high rate of heat input, which not only results in considerable savings in fabrication time, but also minimizes distortion and makes welding thick or large metal sections more feasible.

Three of the most useful electric welders available today are: metal arc with consumable electrode, tungsten-inert-gas welder (TIG), and metal-inert-gas welder (MIG). Virtually any welding problem the sculptor encounters can be solved with these three pieces of equipment.

METAL ARC (CONSUMABLE ELECTRODE)

Undoubtedly the first electric welder the average sculptor purchases will be a simple arc-welding machine, consisting of the power supply, cables, ground clamp, and electrode holder (Figures 8–20 and 8–21). Protective leather gloves, a helmet with appropriate lens (about number ten), and a protective apron or jacket are also necessary equipment.

For the studio a good first welder capable of handling considerable work would be a 180-amp, combination A.C. and D.C. welder. The power supply required for a machine this size would be a single phase, 230-volt, 50-amp. circuit—the standard power service supplied by utility companies. Larger machines ideally operate off three-phase, 220 or 440 volts. This is more efficient but usually available only in commercial or industrial locations.

Selecting the A.C.-D.C. machine offers a wider choice of welding processes. Because the inexpensive, smaller A.C. welding machines seldom have sufficient duty cycles for sustained operations, they should not be considered unless welding needs do not go beyond an occasional small welding job.

The duty cycle is the amount of time a machine can operate efficiently at a particular amperage. A machine rated at 40 percent duty cycle at 180 amps. could be operated for 4 minutes out of every 10. As the amperage decreases, the performance factors increase, so that a machine with 40 percent rating would have around 90 percent duty cycle at 100 amps., or it could be operated 9 out of 10 minutes of time.

The 40 percent rating is reasonably adequate for small shops and the studio. In general fabrication, the

Figure 8–20
Electrode holder, left. Ground clamp, right.

Figure 8–21
180-amp. A.C.-D.C. electric arc-welding machine. Cables are plugged into the receptacles for welding.

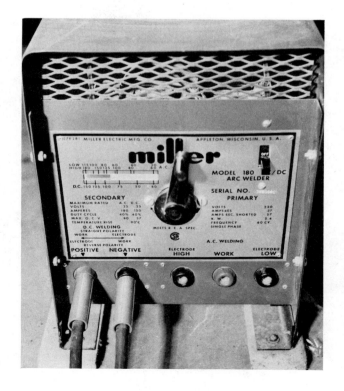

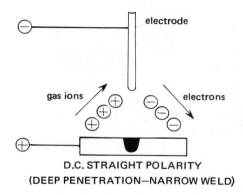

D.C. STRAIGHT POLARITY
(DEEP PENETRATION—NARROW WELD)

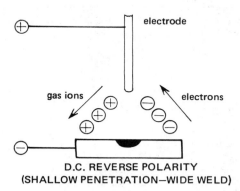

D.C. REVERSE POLARITY
(SHALLOW PENETRATION—WIDE WELD)

Figure 8–22
Straight and reverse polarity.

ELECTRODE DIAMETER	AMPERAGE	
	min.	max.
5/64	20	50
3/32	40	80
1/8	65	125
5/32	90	160
3/16	120	180

Figure 8–23
Current requirement for mild steel electrodes.

4 out of 10 minutes is seldom exceeded. Surface texturing of metals for sculpture requires high-duty cycles. However, amperages are usually low enough so that the machine can stand the near-to-continuous operation needed.

In many welding operations with the consumable stick electrode, direct current is preferred, because it provides more stable and precise current and a far wider choice of electrodes and welding procedures. However, many A.C. rods available are of equal merit.

In arc welding, two common terms are important: "direct current (D.C.) straight polarity" and "direct current (D.C.) reverse polarity." (Figure 8–22) In straight polarity, the electrons flow from the electrode to the work; the heat is concentrated on the work and penetration into the metal being welded is deep. In reverse polarity, the concentration is on the electrode. It is consumed at a greater rate and penetration is shallow. Obviously, the selection of polarity would depend on the kind of metal, the type of weld, and the thickness of the metal. For example, in welding rather thin sheet metal, reverse polarity would be used in order to prevent burning holes in the metal.

Operation of the welder is relatively simple: the machine is plugged into a proper wall receptacle and the cables are plugged into the proper jack-plug receptacle to select the process desired—D.C.-straight

polarity, A.C., or D.C.-reverse polarity. The proper amperage is selected and the machine is ready for operation. The amperage you should select depends on the rod size and the thickness of the metal. Figure 8–23 indicates some typical amperage settings in relation to rod size when welding steel. Figure 8–21 illustrates a typical machine. Machine designs vary with the manufacturers; refer to their instructions at all times.

After the amperage has been set, the ground clamp is fastened to the worktable or work piece, and the rod is placed in the electrode holder, generally at right angles to the holder. The power is turned on, and the welding is ready to proceed. The rod is positioned a few inches from the work; the helmet is lowered, and the arc is started.

The arc is started with a motion like striking a match or with a slight tapping-like motion. If the rod

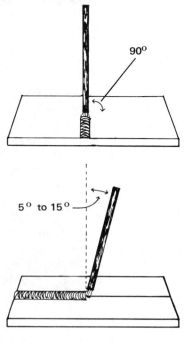

Figure 8–24
Proper rod position.

145

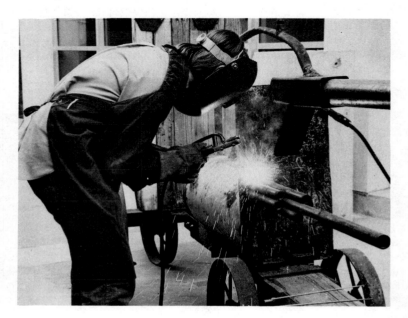

Figure 8–25
Rod movement pattern in arc welding.

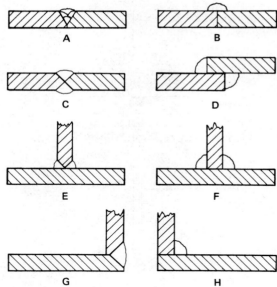

Figure 8–26
Typical weld joints: (A) butt joint V grooved from one side and filled with multiple passes; (B) simple butt joint welded from one side; (C) butt joint V grooved and welded from both sides; (D) lap joint welded from both sides; (E) T joint V grooved and welded from both sides; (F) simple T joint welded from both sides; (G) V grooved corner joint; and (H) simple corner joint welded from one side.

Figure 8–27
Arc-welding sculpture. *Student project, Southern Methodist University.*

is not lifted quickly, it will stick or freeze to the metal. The distance between the end of the rod and the metal is generally about the diameter of the rod. The position of the rod as the weld develops depends on the type of weld being executed; generally, the rod should be at a 90-degree angle with the direction of the weld seam and about 5 to 15 degrees from the direction of travel. (Figure 8–24) As the rod is moved in the direction of the weld, it is usually manipulated in a zigzag, sideward, or semicircular fashion. (Figure 8–25)

When welding thick metal and optimum strength is desired, the joint to be welded is "V"-grooved and multiple passes are made to fill the joint. The flux must be cleaned off each welded bead prior to application of the next bead. (Figures 8–26 and 8–27)

With direct current, a carbon electrode can be used for welding with a carbon arc. In this case, the electrode is not consumed but simply provides an arc for melting the metal. A rod is fed into the weld zone, as when welding with an oxyacetylene flame. This process is used in welding some nonferrous metals; silicon bronze is particularly easy to weld with this technique.

Two problems typical of learning to weld are a travel speed that is too fast and an arc too long. With a reasonable amount of practice on scrap material, you can usually control these in a short time.

The arc-welding procedure is relatively simple. However, what occurs metallurgically in the forming of a weld is complex. Any serious student of welding should read and own a good reference book on arc welding and metallurgy.

As outlined for oxyacetylene welding, safety precautions concerning metal, protective helmet and clothing, and general shop practice should be observed. Eyes should never be exposed to even a flash

of the arc. Any exposed skin will burn after a few minutes of exposure and continued exposure can result in severe burns.

Arc-welding rods. Rods are available for a wide variety of applications for both ferrous and nonferrous metals. Rods should be selected on the basis of the metal to be welded, the degree of penetration desired, the profile of the welding bead, the welding position, the deposit rate, and any special problems such as thin material or filling in around poorly fitting parts.

Although welding rods vary to some extent in terms of alloys that comprise them, some of the greatest differences are in the flux employed. The flux on the rod protects the weld zone by cleaning away oxides and providing inert atmospheres. Alloying and special elements added to the flux provide special welding conditions.

Rods are identified by the manufacturer as to their special purposes and characteristics. American Welding Society classifies carbon-steel rods by a four-digit system: The first two digits indicate the tensile strength; the third digit indicates rod position, and the fourth indicates a variety of rod characteristics such as power supply, coating, and type of penetration. As an example, in a rod numbered 6011, 60 would indicate a tensile strength of 60,000 p.s.i.; the first 1 would indicate all positions, and the second 1 would indicate deep penetration. Number E6010 is an all-position, heavily covered, mild steel rod, D.C. reverse polarity, but it is particularly suited to vertical and overhead welds. E6011 is primarily an all-position A.C. rod, but it can also be used on D.C. E6012 is an all-position, A.C. or D.C. straight or reverse polarity rod that is excellent for horizontal welds. It has good fill-up ability for any gaps that exist in the joint to be welded. E6013 is an all-position, A.C./D.C. straight polarity rod that is similar to E6012, but its slag removal is better. Also, its arc can be established and maintained more readily. These rods are used on mild steel. Number 7010 is an all-position D.C. reverse polarity rod for welding alloys and high-strength steel.

Note that color codes on rods indicate the type of rod and enhance quick identification.

TIG WELDING

Tungsten-inert-gas welding (TIG) is somewhat similar to oxyacetylene fusion welding or fusion and use of a filler rod. A tungsten electrode, which is not consumed, is used to form an arc for the heat source, and the metal is fused or a filler rod is added to the weld.

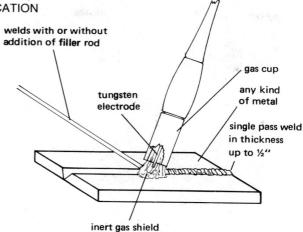

Figure 8–28
TIG welding process.

The principal advantage of the TIG process is in welding such nonferrous metals as stainless steel, copper and copper alloys, nickel, magnesium, and aluminum. Welding these metals has always been difficult because of the rapid formation of protective oxides when these metals are exposed to the atmosphere. In TIG welding, a protective wall of inert gas (usually argon) around the arc and the weld zone protects the weld being formed from the atmosphere, and thus prevents oxides from forming. The end result is a sound, clean weld, without the danger of flux, slag, or oxide entrapment that can occur with the simple arc or oxyacetylene processes. (Figure 8–28 illustrates TIG welding.) Contrary to popular opinion, then, welding aluminum or other nonferrous metals is not difficult. If the metal alloy is properly identified and the right rod is used, these metals can be welded quite easily.

The power unit for the TIG torch is a precision piece of equipment (Figure 8–29) designed to provide a wide range of welding currents, current control, and shielding-gas control. The power-unit settings are predetermined according to the metal being welded; if manufacturer's recommendations are followed, TIG welding can be mastered easily. (Figures 8–30 and 8–31)

Typical manufacturer's recommendations include kind of gas, rate of gas flow, type of current (A.C., D.C. reverse polarity or D.C. straight polarity), setting, amperage, electrode size, welding speed, welding rod, and gas-cup size.

The TIG torch is compact and easy to handle. (Figure 8–32) When changing electrode sizes, it is necessary to change the gas cup and the collet and collet body inside the torch. Power should be off when changing or adjusting the electrode. The torch is cooled with a water supply system.

Figure 8–29
TIG welding machine. Note the water cooler on top of the machine; the pump circulates water through the torch to keep it cool. An argon tank with pressure control regulator in the foreground.

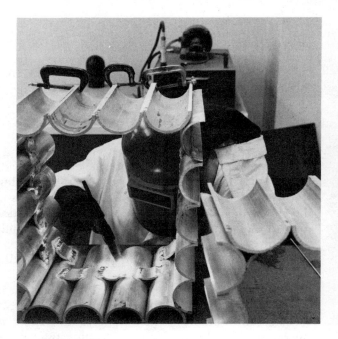

Figure 8–30
TIG welding aluminum. *Student project, Southern Methodist University.*

Figure 8–31
Completed aluminum sculpture. *Student project, Southern Methodist University.*

Figure 8–32
TIG torch.

Unlike a consumable electrode, you do not have to strike an arc with the TIG torch. The high-frequency current jumps the gap between the torch and the work, and the torch can simply be lowered to the right arc length.

MIG WELDING

Metal-inert-gas welding (MIG) is similar to TIG welding in that it utilizes a gas shield to protect the welding zone. In the MIG process, the electrode is in the form of wire which is fed from a spool mounted on the machine when the torch switch is pressed. The wire emerges through the torch body and is fed into the weld zone at a predetermined rate of speed. The process utilizes a special D.C. power supply. Most welding is done with reverse polarity. Steel, aluminum, stainless steel, and bronze can be welded, using wire similar to the metal being welded. One of the principal advantages in MIG welding steel rather than using coated electrodes is that the result is a high-quality, clean weld that does not require postcleaning (Figures 8–33 and 8–34)

A standard welding helmet and other protective clothing should be worn, and safety procedures should be observed with both TIG and MIG welding.

METAL CUTTING

A wide variety of cutting procedures exit for metal fabrication. Selecting the proper one often not only saves considerable time, but improves the quality of the final product. For example, the rough cut of an acetylene torch might suit one job, but a saw or shear cut might be preferable in another, especially if a close fit or finished edge is required.

The basic cutting techniques practical for sculptors and generally used by industry fall into two categories: flame cutting—using the oxyacetylene process or arc process—and cutting by mechanical means—including sawing, shearing, and friction cutting.

FLAME CUTTING (OXYACETYLENE)

Flame cutting is based on the fact that metal in the presence of air changes chemically to an oxide. This

Figure 8–33
MIG torch. Note torch switch and wire protruding out of gas cup.

Figure 8–34
MIG welding machine.

process can be accelerated with the use of heat and oxygen. An oxyacetylene cutting torch attached to a torch body is normally used; other fuels, such as propane or natural gas, can also be used with the proper torches.

Oxyacetylene cutting, although commercially considered costly, provides sculptors with a simple, portable means of cutting steel when fine finishes are not necessary. (Figure 8–35) In fact, sculptors often prefer some of the rough qualities of cuts that are not too expertly done.

Any thickness of steel can be cut with oxyacetylene cutting. Industry uses large cutting machines to produce precision-cut parts. These machines could be useful to sculptors who need large quantities of similar parts.

In the oxyacetylene process, the metal is heated to an ignition temperature with the preheating flames, at which point a stream of oxygen is introduced; the iron and oxygen combine to form iron oxide and are blown away from the flame, thus forming a narrow kerf, or slit, in the steel.

This process, limited principally to low-alloy steel, is not possible with stainless steel or nonferrous metals such as copper or aluminum. However, the makers of the Dillon torch claim that it will cut both aluminum and stainless steel successfully.

In flame cutting, the first step is to adjust the

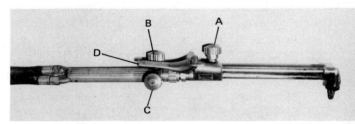

Figure 8–36
Oxyacetylene cutting torch: (A) cutting torch oxygen adjusting valve; (B) torch body acetylene valve; (C) torch body oxygen valve; and (D) cutting torch oxygen valve to increase oxygen for cutting.

acetylene and oxygen pressures. For routine cutting of plate up to ⅜ inch thick, the acetylene pressure would be 3 to 5 pounds, and the oxygen pressure would be 20 to 30 pounds. Pressure and tip sizes would increase with increased metal thickness.

The oxygen pressure is considerably higher than in welding, to provide the necessary oxygen for the cutting process. It is possible to cut a range of thicknesses with a smaller number of tips. In fact, most acetylene-equipment sets come with a limited number of cutting tips that are adequate for the average cutting done by the sculptors, especially if clear, precision cuts are unnecessary. For optimum results, manufacturer's recommendations should be followed as to tip size and pressure required.

Figure 8–36 illustrates a typical cutting-torch attachment. To light the cutting torch, open the oxygen valve (C) on the torch body all the way. Open the acetylene valve (B) one-eighth turn and light the torch with the friction lighter. Increase the acetylene until the flame stops smoking. Then, turn on the oxygen valve (A) until a neutral flame is obtained. Press down on lever (D), and, if excess acetylene appears, readjust the flame by increasing oxygen or decreasing acetylene until a neutral flame is achieved.

To proceed with cutting, heat the edge of the metal with the preheating flames (with the tip of the flames not quite touching the metal). As soon as a bright red spot appears, depress the lever (D) and slowly move the torch in the direction of the cut. It will take some practice to develop proper cutting speed, which will depend on the thickness of the metal.

Although the position of the cutting torch is usually perpendicular to the metal, thin material may prove easier to cut if the torch is angled slightly away from the direction of the cut. This is particularly necessary if your supply of cutting tips is limited and you are trying to cut with a larger tip than would normally be used.

Figure 8–35
Cutting with the oxyacetylene cutting torch.

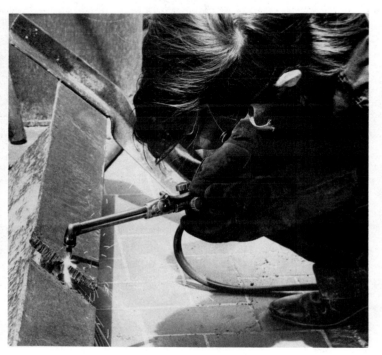

In cutting, if the travel speed is too slow, the tip too large, or the torch held too far from the metal, the metal will tend to melt and fuse together after the cut has been completed. If travel speed is too fast or the tip is too small, the cut will be incomplete.

Flame powder cutting. Another flame-cutting procedure, which is less commonly known and more expensive, is powder cutting. In this process, air pressure introduces a stream of iron or other metallic powder into the cutting zone. The powder fluxes the metal oxides in the cut and lowers the melting temperature of the oxide mixture; this makes the cutting possible.

One of the few practical ways of cutting thick stainless steel when a clean precise cut is needed, powder cutting is also used to cut aluminum, copper, brass, nickel, cast iron, and other nonferrous metals, as well as concrete and ceramic materials.

Arc cutting. Steel can be cut with an ordinary steel stick electrode or cutting rod designed for the purpose. For an occasional cut, an ordinary steel rod, operating at amperage higher than welding ranges, will suffice. However, in most cases, it would be advisable to purchase rods for the specific purpose.

The principal disadvantages of cutting with the arc are the rougher cut produced and the need for higher volumes of air removal because smoke and fumes are produced in the cutting operation. In some instances, the decorative quality of the rough arc cut is desirable and useful to a sculptor.

Cutting rods have also been developed to cut cast iron and nonferrous metals. These rods are usually for either A.C. or D.C. operation.

Cutting with the arc is relatively simple. The machine is set at the recommended amperage, an arc is started at the edge of the metal, and a cut produced by moving the rod up and down through the kerf in a sawing action. Typical amperage setting for ⅛-inch rod would be 250 to 350 amps.; for 5/32-inch rod, 300 to 400 amps.; and for 3/16-inch rod, 350 to 500 amps. Special air-arc cutting torches are available; these use compressed air to blow the metal slag out of the kerf as the cut is developed. These are particularly useful to cut nonferrous metals.

If the MIG process is available, you can use it to cut nonferrous metals. In this technique, the wire speed is such that it penetrates to the bottom side of the metal to be cut. The starting position is about ¼ inch from the edge of the metal, with the wire protruding slightly beyond the bottom edge of the metal. Shielding gases are helium, argon, or special mixtures. The TIG welder can also be adapted to cutting by using a thoriated tungsten electrode and direct current.

SAWING

Sawing metal is usually accomplished by hand hacksaw, power hacksaw, band saw, jig saw, or circle saw. It is better than flame cutting when precise fits and angles are required; it also normally distorts the metal less than does shearing or flame cutting. Moreover, it is one of the easiest and most preferred methods for cutting soft, nonferrous metals.

Saw blades are manufactured to cut almost any metal. The most important factors for successful cutting of metals are blade speed, number of teeth, tooth design, and rate of cut. The blade speed is determined by strokes or feet per minute; the rate of cut, by inches or feet per minute.

The tooth design in a cutting blade is usually alternate, raker, or wavy. (Figure 8–37) The set in the tooth depends on the material to be cut. Alternate set, with one tooth left and one tooth right, is common for wood-cutting blades. A straight tooth between each left and right tooth is a raker set, which is used for coarse and precision-cutting band saw blades. The wavy set has two or more teeth alternately bent to the left or right at a graduated degree. This set is common to hacksaw blades and blades for band sawing thin metal, thin tubing, and thin structural shapes.

Hacksaw cutting. A wide variety of hacksaws is available for hand cutting. Besides the standard hacksaw, keyhole saws—for working in close quarters— and shallow-frame saws—for precision hand cutting of pipe and bar stock—are available. (Figure 8–38)

Because hand hacksaw cutting is tedious and time-

Figure 8–37
Three basic saw-tooth settings.

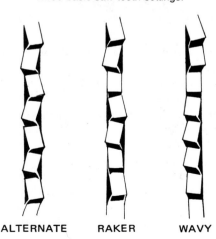

ALTERNATE RAKER WAVY

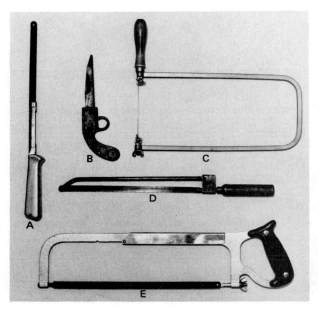

Figure 8–38
Handsaws for cutting metal: (A) close-quarter saw;
(B) keyhole saw; (C) jeweller's scroll saw; (D)
shallow-frame hacksaw; and (E) standard hacksaw.

Figure 8–39
Power hacksaw for cutting pipes,
angles, bars and flat stock.

Figure 8–40
Industrial horizontal cutting bandsaw.
*Courtesy of Dake, Division of JSJ
Corporation.*

consuming, it is inadvisable, except for occasional cuts. However, if no other cutting tool is available, hand sawing can be simplified with the proper cutting techniques.

Of prime importance is a good-quality blade with the right number of teeth. A poor-quality blade will be dull after a few strokes and, from that point on, cutting is possible but is tiresome and difficult.

The common blades are the standard semiflexible, generally used for maintenance work, and for home utility; the standard flexible, for working in awkward positions and for work that cannot be held

firmly; and the standard all-hard blade, for work held in a vise and for hard-alloy steels. The premium flexible blade, all-hard molybdenum, and all-hard tungsten are higher-quality blades used for considerable cutting of hard materials.

The number of teeth per inch depends on the thickness of the material—thicker materials need fewer teeth per inch. Approximate requirements for hand hacksawing most materials would be fourteen teeth per inch for materials ½ inch and thicker, fourteen to eighteen teeth per inch for 7/16- to ¼-inch material, eighteen to twenty-four teeth per inch for ¼- to ⅛-

inch material, and twenty-four to thirty-two teeth per inch for materials ⅛-inch or thinner. Softer materials such as aluminum and copper require fewer teeth per inch.

Mount the saw blade on the hacksaw frame with the teeth pointing forward. The blade tension should be set so that the blade feels tight.

A moderate pressure is applied on the forward stroke when sawing. Relieve pressure on the back stroke, as it is the most common cause of tooth wear. The rate of speed for hand cutting is about 45 to 60 strokes per minute.

If frequent hacksawing is to be done, it is advisable to invest in a moderately-sized power hacksaw, or horizontal cutting bandsaw which is inexpensive and performs many cutting chores. (Figures 8–39 and 8–40)

If occasional thick sections need to be cross-cut, metal shops with heavy-duty equipment often will perform this service at reasonable prices.

Band-saw cutting. For the sculptor, the variable-speed band saw is one of the most useful pieces of equipment. (Figure 8–41) This versatile machine, properly used, is indispensable for cutting metal, plastic, and wood. It can be used to cut both ferrous and nonferrous metal.

Cuts can be produced with speed and precision if the machine is properly adjusted and the right blade is used. The blade tension, support, and guides must be properly adjusted. Manufacturers' instructions should be followed to make blade changes and adjustments.

Band-saw blades are usually raker or wavy-toothed; raker teeth are preferred for general use and for thick material. Band-saw blades also come in several tooth patterns: standard, skip, and hook. (Figure 8–42) The standard blade is used on hard materials, whereas the skip and hook are used on soft materials such as aluminum.

Proper blade-speed (feet per minute) and rate of feed (inches per minute) is of utmost importance; when cutting ferrous metal, using excessive blade speed can ruin a blade in a single cut. In fact, when using a band saw, always examine the saw for proper blade adjustment and speed, because the previous operator may have been using the saw for a different material than you intend to cut. Figure 8–43 lists blade and saw requirements for various metals.

In the rate of feed, the pressure on the material being fed into the saw should be moderate to light. Excess pressure will produce friction, heating, and subsequent blade wear. If excess pressure is needed, chances are that the blade speed is too slow or is worn

Figure 8–41
Variable speed band saw. (Note pulley arrangement for changing speed.)

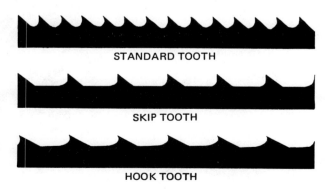

STANDARD TOOTH

SKIP TOOTH

HOOK TOOTH

Figure 8–42
Basic tooth design for band-saw blades.

REGULAR BLADES						
	under 1/2 inch		1/2 to 3/4 inch		over 1 inch	
	teeth per inch	feet per minute	teeth per inch	feet per minute	teeth per inch	feet per minute
Angle iron	24	160	14	160	10	40
Carbon steel	24	85	14	60	14	40
Cold rolled steel	18	220	14	220	14	160
Machinery steel	18	160	14	160	14	160
Stainless steel	24	40	14	40	10	40
Structural steel	24	160	14	160	14	115
Cast iron	18	115	14	80	10	16
Bronze, brass & copper alloys	18	300	14	250	10	200
SKIP-TOOTH BLADES						
Aluminum	3	3000	3	3000	3	3000
Copper	6	3000	4	3000	4	3000

Figure 8–43
Band saw blade speeds for cutting metal.

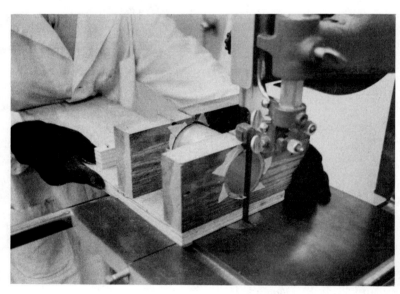

Figure 8–44
Special jig being used to cut pieces of aluminum tubing.

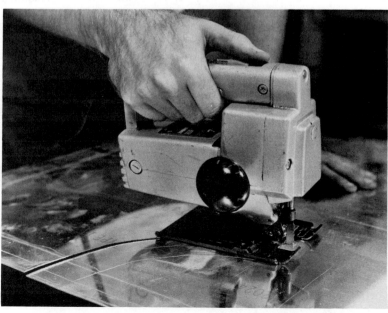

Figure 8–45
Portable jig saw cutting aluminum sheet.

and in need of replacement. A wax lubricant can be used on the blade to facilitate the cutting.

Blades are available in widths from ⅛ inch to 1 inch. The narrowest blade is primarily used for scroll work or for cutting short radii. The widest blade practical should always be used on a job. A ½-inch blade is a good, all-purpose width for general shop work.

Straight cuts on a band saw should be guided by a rip fence. Pipes and bar stock should be clamped and guided with a miter gauge. Special jigs are often designed for unusual cutting operations. (Figure 8–44)

Safety precautions for operating a band saw are few: protective goggles should be worn at all times; fingers and hands should be kept out of the path of the blade; the saw should be unplugged from the wall receptacle when changing blades.

The most common accident results from putting excess pressure on the blade as a cut is completed; in this case, the workpiece moves suddenly, and pulls fingers or hands in the path of the cut.

Scroll or jig-saw cutting. The scroll saw or jig saw is available as a table model, or as a portable model called a "saber saw" or portable jig saw.

The scroll saw differs from the band saw in that the blade has a reciprocal action rather than a continuous one. It is an excellent tool for making fine, intricate cuts and curves in wood, plastic, or sheet metal.

The saber saw or portable jig saw, which should be one of the first pieces of equipment you acquire (Figure 8–45), should be a heavy-duty, variable-speed model of good quality; it can do much of the work, on a limited basis, that stationary band and scroll saws can do when the production needs are light and low in volume.

Even when stationary equipment is available, the saber saw performs chores that the band and scroll saw cannot accommodate—especially cutting into centers of large pieces of material. For example, the cutting clearance on a moderate-sized band saw is 14 inches; if wider clearances are needed, a saber saw can be used.

To cut metal, it is essential to use reduced speeds; under high-speed reciprocal action, a blade simply will not stand the excess friction. Therefore, only variable-speed saws should be considered as permanent pieces of shop equipment.

In sawing, the saber saw should be held firmly against the material. Travel-speed, as with a band saw, can be determined on the basis of a moderated for-

ward pressure. When possible, the material should be clamped to the workbench or cutting table.

Saw-blade selection, as with the band saw, should be fine blades for thin material and coarser blades for thick. Blades are usually packaged with recommended usage provided by the manufacturer.

A hand version of the scroll saw is the coping saw or jeweler's scroll saw (Figure 8–38), which is useful for occasional work or for a cut in an area inaccessible to the power tool. In handsawing on small pieces, the work is usually clamped in a vise or clamped to a worktable.

Circle-saw cutting. Circle-saw blades for cutting metal, available for table saws or radial-arm saws, are usually a friction-cutting type or fine-toothed hard steel. (Figure 6–25)

A steel-slicer blade, not used on nonferrous metals, cuts steel with friction; other friction-cutting blades consist of abrasive materials embedded in fiber discs. Nonferrous metals generally cut better with fine-toothed steel blades.

The material is generally handled on a table saw in the same fashion as wood—ripping by guiding against the rip fence, and cross-cutting by using the miter guide. For cross-cut work, it is a good practice to have a miter guide with a hold-down device. Goggles should always be worn and a blade guard should be used when cutting with abrasive wheels. If the saw being used is used in wood work, all sawdust must be cleaned up around the equipment, since sparks from the blade can ignite the sawdust. A small amount of lubricant (either a tallow candle or a wax stick designed specifically for the purpose) should be used on metal-cutting blades.

SHEARING

One of the simplest and most economical methods of cutting metal is by shearing. We are all familiar with the hand shears used to cut tin or sheet metal. The most common shearing devices are foot-squaring shears, which are foot-operated. Other, less familiar, types are motor-operated shears and punch presses operated by industry.

Hand shears, available in a variety of designs, are versatile and very adequate in the fabrication of light-weight sheet material. They are designed for straight, left-hand, or right-hand cuts. Blade designs are also available that will accomplish all three cutting operations, and special shears are available with compound leverage for cutting thick and difficult mate-

Figure 8–46
Metal-working tools: top row, left to right: compound action tin shears, aviation pattern shears, straight pattern shears, dividers. Bottom, left to right: hole-cutting saw, cold chisel, center punch, rivet or pin punch, two high-speed drills, countersink; top, wire and sheet-metal gauge, drill gauge, and scratch awl.

Figure 8–47
Portable electric metal cutting shears.

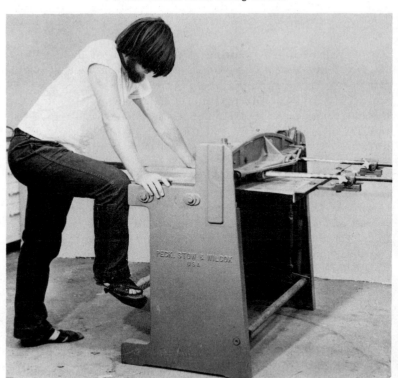

Figure 8–48
Foot-squaring shears.

rials or difficult angles. Figure 8–46 illustrates a variety of hand shears which are commonly used in metal shops and which are of possible use to sculptors or designers. Electric hand shears are also available. (Figure 8–47)

Foot-squaring shears (Figure 8–48), used primarily for shearing light-gauge materials, are partic- ularly useful when a quantity of similar-sized pieces is needed. The principal advantage over hand shear- ing is the ease with which the cutting can be accom- plished, moreover, there is less distortion of the metal.

Power shearing or stamping is normally used for large quantities of cuts and for cutting thick metal when manual shearing is not possible. Usually expen-

sive, power shears are used only by large metal suppliers or fabricators.

If a quantity of shearing is needed, the firm supplying the metal will usually be able to shear to your specifications at a reasonable cost. For example, the 8,000 lbs. of Everdur® silicon bronze for the fountain in Figure 13–17 was supplied in presheared strips, shown in Figure 13–18.

Metal stamping is a cutting process using a hydraulic press and cutting dies. Many shapes are available from standard dies that a metal-stamping firm would have in stock. To have a die custom-designed is, of course, expensive; sculptors or industrial designers usually limit their use of such shapes, therefore, to precontracted work.

EXPLOSION FORMING

New to industry is the process of forming metal with explosives. In this technique, the mold, metal, and explosives are submerged in a tank of water. A vacuum is drawn on the mold and the explosive charge is released, forcing the metal into the mold contour. In many cases, the metal will be partially constructed by a fabrication technique such as welding and completed with explosion forming. The amount and kind of explosives, distribution, and distance from the sheet are all important. Expert engineering advice is needed before attempting to use this process.

For industry, explosion forming has proven to be highly successful for pieces too large to handle in conventional forming processes. Sculpturally, variations of the process have been used.

COLD FORMING

Cold forming involves shaping sheet, bar, or strip metal using dies, punches, forming blocks, bending brakes, and rollers. Both ferrous and nonferrous metal can be cold-formed.

One of the simplest methods of cold forming is to bend metal strips, small bars, or rods in a bench vise. Hammering sheet metal over or into wood-forming blocks, forming it over steel stakes, or bending it over the edge of a workbench are other examples. (Figure 8–49) Bent-wire sculpture is a simple and typical example of cold forming.

Beyond simply bending materials mechanically, hand-or power-operated tools have been designed to produce almost any configuration imaginable. Angles of any degree, circles, zigzags, folds, and bends are all mechanically possible to make in thin-to-thick steel plate.

One of the simplest devices for bending tube, bar, angle, and strap is a universal iron bender. (Figure 8–50) Using a variety of forming dies, this hand-operated or hydraulically operated machine can perform a wide variety of bends. It is typically used in

Figure 8–49
Steel-forming stakes for working sheet metal.

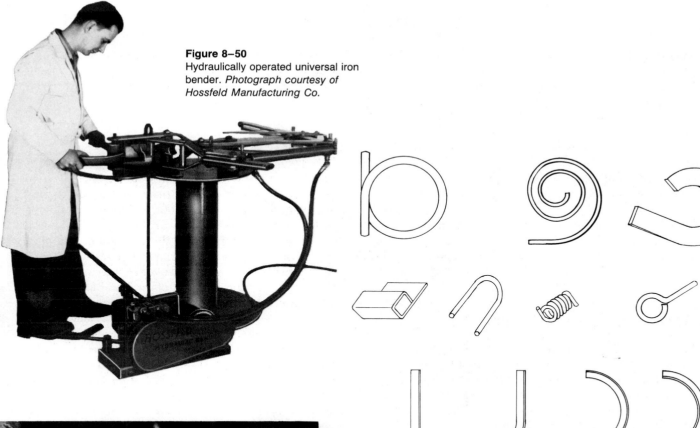

Figure 8–50
Hydraulically operated universal iron bender. *Photograph courtesy of Hossfeld Manufacturing Co.*

Figure 8–51
Typical bends made with a universal iron bender. *Adapted from Hossfeld Manufacturing Co. literature.*

Figure 8–53
Heating and bending metal using a Dillon torch.

Figure 8–52
Bending brakes bending sheet metal.

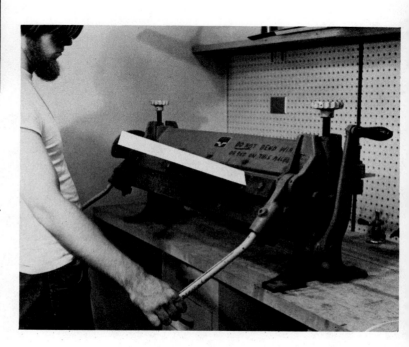

decorative wrought-iron work but has potential use for the sculptor who needs bending. (Figure 8–51) In addition, bending a flat sheet can be performed readily on a bending brake, and cylinders can be formed on roll-forming machines. (Figure 8–52)

Versions of the typical sheet-metal shop equipment exist on a large scale in industrial fabrication shops. Bending, folding, and rolling, feasible for monumental sculptural works, can be performed by these shops.

Metal forming using pinch presses, draw presses, and roll forming has sculptural possibilities for modular sculptural designs. A sculptural commission with a large number of modular units could conceivably merit the cost of using a punch- and die-forming operation.

FORGING

Heating and forming metal through forging dates as far back into history as many other metal fabrication techniques. The Egyptians and Sumerians (2300 to 2500 B.C.) mentioned earlier utilized forging. The blacksmiths of the fourteenth and fifteenth centuries made tools and decorative metal forms. The armourers of that time produced weapons and armour. Sheet metal was hammered and forged out of spongy lumps of hot metal called blooms. Essentially, forging is still the same process although industry uses mechanical means to shape or hammer the metal and controls the heating of the metal more precisely for forging and during annealing or tempering.

Sculptors today are more concerned with hand forging as a method of shaping metal. Metal can be heated with the oxyacetylene torch. Rods, pipes, bars, and strap material can be easily bent by heating the piece of material with a torch to a bright red at the point at which the bend is to be made.

Sculptor Jerry Dodd uses this technique to form, wrap, and bend metal in his work. (Figures 8–53 and 5–54) However, if forging is to be a regular part of your fabrication process it would be advisable to build a gas or coal-fired forge. Coal firing is preferable as a gas flame tends to oxidize the metal more than coal.

A simple forge is not complex to build. A refractory-lined metal basin is needed to hold the coal. A small blower is needed for an air supply. (This can be as simple as an old hair dryer or small vacuum cleaner blower.) The blower needs to have a foot-controlled damper or speed control. A hood is needed over the forge to remove smoke and fumes. (Figures 8–55 and 8–56)

For pieces of carbon steel that are to be hammered and shaped the metal is heated to a bright yellow. It is heated as rapidly as possible to prevent the grain of the metal from becoming too coarse. Heating the metal softens it; as it is hammered the grain becomes fine and the metal becomes harder and more brittle. The carbon content of the steel also affects its hardness; more carbon means a harder steel. The metal is held with tongs and hammered on an

Figure 8–54
Steel sculpture *Bound Barricade* 1983 by Jerry Dodd. Note: the bending and wrapping was achieved by heating the metal with a torch.

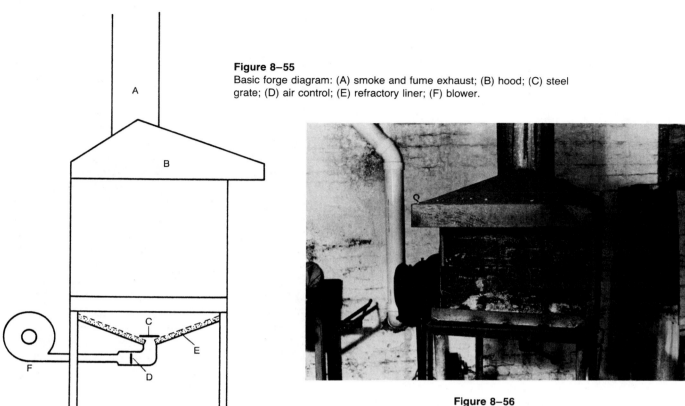

Figure 8–55
Basic forge diagram: (A) smoke and fume exhaust; (B) hood; (C) steel grate; (D) air control; (E) refractory liner; (F) blower.

Figure 8–56
Coal-fired forge.

anvil using a 30 to 40 ounce ball peen hammer. The metal is hammered until it becomes a dull red. If more shaping is necessary the metal is reheated and the process continues until the desired form is achieved.

If you do a lot of forging you will probably want to build your own collection of tools and form jigs to suit your own needs. (Figure 8–57) In many cases vise grip pliers, rather than the more traditional tongs, will do an excellent job of holding material. Hammers should have a slight convex surface with rounded edges. A power hammer is also useful for doing a large quantity of work or for forging parts that might otherwise require a two-person operation. (Figure 8–58) A quenching tank is also needed to cool or temper forged parts. A dipper with small holes in the bottom is used for dampening the coal or other quenching activities. The forge, rack of tools, quenching tank, dipper, and anvil should all be located in easy reach of each other so that the part to be forged can be handled as quickly as possible. (Figure 8–59) An excellent source for information on all aspects of forging is *The Modern Blacksmith* by Alexander G. Weygers, published by Van Nostrand Reinhold Company.

In forging or hammering cold metal such as copper or bronze, the metal is hammered on blocks of pitch or on bags of sand. The metal is heated to a dull red and allowed to cool slowly prior to the hammering. Heating metal and cooling slowly (annealing) softens it; cooling rapidly (tempering) hardens it. Copper is easier to hammer and shape than bronze. If the metal starts to become brittle because of the hammering it can be heated and softened again as the work progresses.

Sometimes, it may be desirable to restore the temper in tools—for example, in those used for stone carving. To temper a chisel, the cutting end is heated to a cherry red and then quenched in cold water. The tool end is then polished with a piece of emery paper and reheated to a temperature that will produce the desired temper. By polishing the steel it is possible to distinguish various color changes as the metal is heated. The desired temper can be achieved by quenching the tool in cool water when the desired color is reached. Tools for granite are heated to a straw yellow (400 to 425 degrees) tools for marble are heated to a bluish-violet (550 degrees).

Figure 8–57
Tools for forging.

Figure 8–58
The power hammer.

Figure 8–59
Lummox. Wood and forged iron
sculpture 1984 by Douglas Mclean.
Note: Figures 54, 55, and 56 are in the
studio of Douglas Mclean.

HAND TOOLS

In addition to the various metal-working techniques described so far, a variety of hand tools is basic to enhance your metal-working projects. For example, hand finishing may involve using hand or rotary files for working down edges or surfaces and reaching areas inaccessible to grinding or abrasive finishing. A hand file should be used as a hacksaw with pressure being applied on the forward motion of the stroke and released on the back stroke. A file card is used to clean the file. Special files are designed for special needs: saw files, machinists' files, pattern files, and silversmith riflers. Pattern files and riflers are excellent for fine detail work and for finishing in small areas. Rotary files are used with electric drills, drill presses, and with the flexible shaft. Small rotary files on a small flexible shaft can get into extremely small cavities and areas inaccessible to other finishing tools. (Figure 8–60)

Metal sculpture involves many typical mechanical devices and tools: To hammer on metal, plastic or rubber mallets are used to prevent marring the material. Hammering for forming or chasing is done with a ball peen hammer or with special metal-working hammers, nippers and diagonal cutting pliers are used for cutting wire, and pliers for holding material, twisting wire, or holding round stock, nuts, and bolts. Nuts and bolts are more appropriately held and fastened with proper fitting socket, open-end, adjustable, and box wrenches. Pipe wrenches are used for holding pipe and round stock, flat or phillips screwdrivers are used for driving machine screws, and offset screwdrivers for working in close quarters. Select the proper-sized screwdriver for the job to be done; the tip should be as wide as the screw slot and should fit in the slot snugly; working with an undersized screwdriver can damage the screwdriver or the screw. Allen wrenches are used to drive allen screws, which have a hexagon-shaped, recessed hole. (Figures 8–61 through 8–64)

Figure 8–46 illustrates a variety of other tools useful to metal working. The dividers measure diameters and widths. Hole-cutting saws cut holes through sheet metal. The cold chisel, used for cutting off metal burrs and projections, can also be used to clean up metal castings. A center punch is used for making a center indentation in metal for starting a drill in the desired spot. Rivet or pin punches drive out rivets and pins. The countersink reams out a hole that is to receive a screw with a countersinking head. Wire and sheet-metal gauges are indispensable for making quick, accurate estimations of wire size and

Figure 8–60
Hand and rotary files.

HAND FILE SHAPES

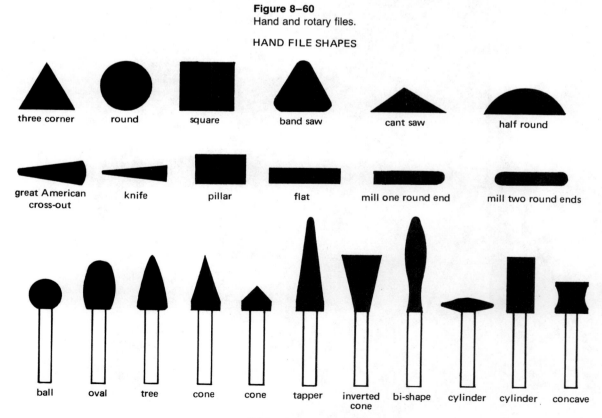

three corner round square band saw cant saw half round

great American cross-out knife pillar flat mill one round end mill two round ends

ball oval tree cone cone tapper inverted cone bi-shape cylinder cylinder concave

ROTARY FILE SHAPES

Figure 8–61
Hammers. From left to right: rubber mallet, ball peen, metal working, metal chasing. Phillips screwdriver bottom left; flat blade screwdriver, bottom right.

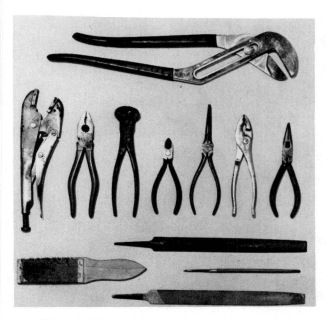

Figure 8–63
Top: arch joint pliers. Middle row, left to right: vise-grip pliers, lineman's pliers, nippers, diagonal cutting pliers, extra long-nose pliers, regular nose pliers, and long-nose pliers. Bottom left: file card. From top right: half-round, round, and flat files.

Figure 8–64
Top center down: socket driver speed handle, ratchet reversible socket wrench, adjustable wrench, and offset screwdriver. Left to right bottom row: pipe wrench, allen wrenches, socket driver, open-end and box-end wrench, open-end wrench, and adjustable wrench.

Figure 8–62
Visegrip pliers designed for welding.

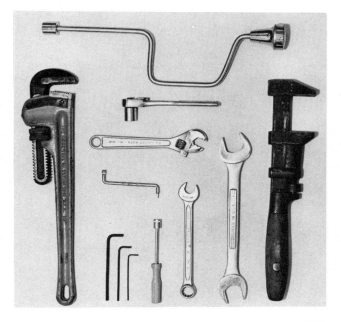

metal thickness. Drill gauges check screw and drill sizes when drilling holes that are to be threaded. The scratch awl marks metal accurately. High-speed twist drills are used to drill holes in metal. Use small drills up to ¼ inch at 600 to 800 revolutions per minute. As the drill size increases, decrease the speed. Use about 250 revolutions per minute with a ½-inch drill. Hard metals, like tool steel, need much slower speeds than soft, nonferrous metals.

Most clamps that are used on wood (Figure 6–13) also prove useful for metal. Vise-grip pliers designed as welding clamps, illustrated in Figure 8–62, are particularly useful.

FASTENERS

Sometimes, it may be desirable to fabricate metal using fasteners instead of welding or adhesive bonding. Rivets, bolts, or screws would be used in these circumstances. Rivets are either solid, semitubular, or tubular, split; they have either flat, round, or oval-shaped heads. (Figure 8–65) To fasten with solid rivets, hold a rivet bar against the head of the rivet, and strike the rivet with a riveting hammer on the opposite end. Use a punch to spread the walls of semitubular and tubular rivets. The drive-pin rivet is struck on the pin to cause the rivet to spread. Pneumatic hammers are used for setting rivets in production work. The drive-pin rivet is one of several forms of blind rivets that can be installed working from one side of the material; another with that advantage is the pop rivet, which is excellent for joining sheet metal. As the handle of the pop-rivet tool is squeezed, it pulls up a pin that causes the hollow rivet to spread out and flatten against the back side of the metal. The pin is sheared off with the tool after the rivet has flattened. (Figure 8–66)

Screw-type fasteners are either machine thread-forming or thread-cutting screws. (Figure 8–67) A

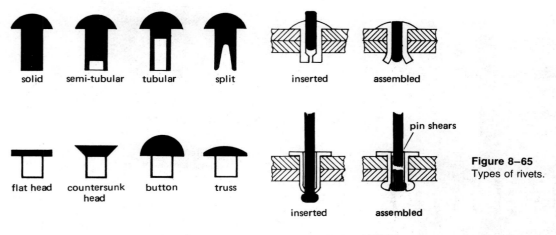

solid semi-tubular tubular split inserted assembled

flat head countersunk head button truss inserted assembled

POP RIVETS

Figure 8–65
Types of rivets.

Figure 8–66
Using the pop-rivet tool.

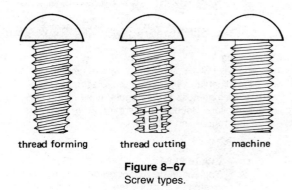

thread forming thread cutting machine

Figure 8–67
Screw types.

ACTUAL SIZE MACHINE SCREWS

3/8-16 5/16-18 ¼-20 12-24 10-24 8-32 6-32 5-40 4-40 3-48 2-56

flat round oval flat fillister oval fillister oval binding hexagon round washer pan knurled acorn

TYPICAL HEAD STYLES
(STANDARD AND NONSTANDARD)

Figure 8–68
Screws (actual size) and typical screwheads.

screw is normally thought of as a small bolt used in a threaded hole without a nut. Machine screws require cutting a mating thread to match the screw thread. Thread-forming or thread-cutting, self-tapping screws are used to join two pieces of thin sheet metal or are used in soft metals such as copper or aluminum. The pilot hole for the self-tapping screw must be drilled to the proper diameter to receive the screw. Typical screw heads are designed to accommodate a flat or Phillips screwdriver or hexagon allen wrench. Screw threads are classified as Unified National coarse (U.N.C.), Unified National fine (U.N.F.), and Unified National extra fine (U.N.E.F.). Threads per inch decrease as the diameter of the screw increases. Screws are identified as *2, 3, 4, 5, 6, 8, 10,* and *12* up to ¼ inch in diameter; number 2 is the smallest. From ¼ inch on they are identified by inches or fractions of an inch. The second number in screw identification designates the number of threads per inch. For example, a screw identified as 8–32 would have thirty-two threads per inch; a ¼-20 would have twenty threads per inch. (Figure 8–68)

A bolt is a threaded device that can be inserted through a hole in two or more pieces of material to hold the material together. A threaded square or hexagon nut is used on the opposite end of the bolt. Thread sizes are classified in the same manner as screws; a further classification designates the fit between the bolt and the nut; bolts are classified *A* and nuts are classified *B*; 1A and 1B designates a loose fit; as the

numbers increase up to 5, the fit becomes tighter. Besides standard machine bolts and stove bolts found in most hardware stores, a variety of bolts designed for the construction industry is available from special suppliers dealing solely in fasteners. The 6–32, 8–32, ¼-20 and ⅜-16 screws and bolts are readily found and ordinarily meet most sculptors' needs.

FASTENERS FOR INSTALLATION

Mounting or installing metalwork often requires special fasteners other than screws or bolts. If a wall consists of wood panelling, lag or wood screws can be used to fasten mounting brackets; the wooden framework or studs behind the paneling can often be located for additional support. For plaster walls, Molly® bolts or toggle bolts can be used, which spread out and hold from the backside of the wall surface. For concrete walls or floors, an appropriate-sized hole is drilled in the concrete with a masonry bit, and expansion-type fasteners are inserted into the holes; machine screws or lag screws turn into the fasteners and expand the fasteners to fit tightly into the holes. Threaded studs can also be driven into concrete using a special gun with an explosive charge. Studs can also be anchored into concrete by cementing with epoxy or other adhesives. Fasteners used for mounting metalworks are also appropriate for works in other material. Figure 8–69 illustrates some basic mounting techniques for walls and bases.

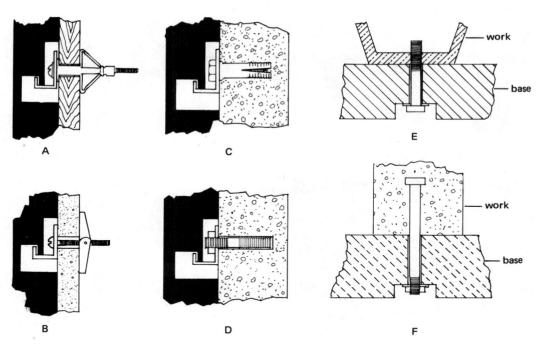

Figure 8–69
Methods of mounting for walls and bases: (A) Molly® fastener used on a
wood panel wall; (B) toggle fastener through a plaster wall; (C)
expansion anchor in concrete; (D) stud cemented into a concrete wall;
(E) metal sculpture mounted on a base using a threaded hole in the work
(if the work were wood, a lag screw could be used); and (F) threaded
bolt cast into the work.

THREAD CUTTING

Thread cutting is often required to install sculpture, mount it on a base, join sections, or screw pieces together. Dies are used to cut threads on round stock; taps are used to cut threads into holes. They are available in thread sizes corresponding to nuts and bolts. Taps, which are needed and used more often than dies, are available in three basic types: taper, plug, and bottoming. The taper, easiest to start, is best used when threading through a piece of material; when threading into a hole with a bottom, a bottoming tap should be used.

In cutting a thread with a tap, the proper-sized hole is first drilled. The proper size is easily determined by reading the drill gauge illustrated in Figure 8–46, which gives the drill size in relation to the hole needed for the threaded portion of the bolt (tap size) and the unthreaded portion (body size). Taps also have the required drill size indicated in fine lettering on the upper portion of the tap. Drills are sometimes also marked. Otherwise, the size is checked by in-

serting the drill into the proper hole on the drill gauge. For example, the ¼-20 screw requires a number 7 drill. Pick out a number 7 drill or, if the drill is not marked, select a size that you think will correspond to the number 7 hole in the gauge. If the drill fits the number 7 hole but not the number 8, it would be the proper size. The screw size, when not known, can also be determined by simply inserting it into the holes until the proper size is found and then reading the tap-size list of figures on the drill gauge (Figure 8–70)

After the hole has been drilled, a small amount of thread-cutting oil or wax is placed on the tap to provide a better cutting action. The tap must be started straight. It is turned several turns until the turning becomes difficult. Then back up about a half turn and proceed again. In tapping into a bottom hole, it may be necessary to remove the tap several times and remove the fine metal cuttings. It might also be advisable to tap the hole first with a tapered tap, followed with a plug tap, and completed with a bottoming tap. (Figure 8–71)

Figure 8–70
Left: thread-cutting tool with tap mounted in tool. Top row, left to right: tapered tap and bottoming tap. Center row: thread-cutting dies. Bottom: die tool.

Figure 8–71
Cutting a thread using a tap.

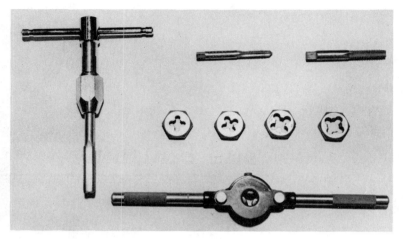

Coating
and Finishing

9

Conveniently, just as experimentation with mixed materials and colors for outdoor sculpture has increased the sculptor's need for coating materials, so has industry produced a wide variety of coating materials and techniques adaptable to sculpture.

A coating material can serve more than one function; its purpose, especially if it is a clear finish, may be solely to protect the finish and surface appearance of a material; or it may be to protect, color, or alter the surface using pigmented enamels, lacquers, and metallic surfaces.

Historically, coating dates back at least to ancient Egypt; as early as 1000 B.C. the Egyptians possessed a form of varnish, probably developed from the resin extracted from the sandarac tree. Still earlier, the paint used in early cave painting was a kind of coating. Ancient Greeks and Cretians made extensive use of pigments and such binders as glue, egg albumin, and natural resins. Venetian turpentine was used as a thinner. Ancient warriors used protective coatings of olive oil, linseed oil, or natural fats on weapons and armor.

Four types of organic and inorganic coatings are of principal interest to today's sculptors: Paint coatings, metallic coatings, powder coatings, and conversion coatings. Although some of these materials are available to sculptors and are easy for them to apply, others must be applied commercially.

The coating and metal-finishing industry is expanding rapidly, and new materials and processes are being developed each year. At best, this chapter can present only a sketchy view of the diverse methods that exist in so comprehensive an area. Two of the best sources of detailed current information are the monthly *Metal Finishing Magazine* (Nathaniel Hall, ed., Westwood, N.J.: Metals and Plastic Publications, Inc.), and the *Metal Finishing Guidebook and Directory*. The *Guidebook*, which presents about 900 pages of information on all aspects of metal finishing, can be obtained free of charge by subscribing to *Metal Finishing Magazine*; it is an indispensable reference for solving finishing problems.

Sculpturally, the use of coated materials depends on the desired degree of permanency for the work as well as on its surface appearance. For interior locations, the majority of coatings have an adequate life span and can be used with little concern. For exterior applications, however, the choice becomes narrower and limited performance of the coating must be taken into account.

Another factor to consider is that if a coating material can be replaced easily, and if the life span of the coating is reasonable, refinishing is not a major factor. Organic painted surfaces vary considerably. The life expectancy of painted films for wood or ma-

sonry may be from 5 to 25 years. Zinc or red lead organic primers on aluminum or steel are considered to have exceedingly long service. Zinc-powdered organic coatings to date have histories of at least 30 years. Nonorganic coatings, such as porcelain enamel, have indeterminate life expectancies.

PAINT COATINGS

This area of coating materials is undoubtedly the most familiar, because all of us have worked with some form of paint since early childhood. These organic and inorganic coatings are clear or pigmented; the essential difference between a clear varnish and a pigmented paint or enamel is the addition of a pigment to the latter. A paint coating consists simply of a binder (or vehicle), a thinner, and other additives, such as pigment for color, dryers or catalysts to accelerate drying, and fillers to thicken.

Modern coatings consist of complex combinations of resins, solvents, and additives, mixed to produce particularly desired results. Formulations may be directed toward flexibility; stability under temperature change; drying time; methods of application; appearance; resistance to corrosion, acid, moisture, sunlight, abrasion, and impact.

Early organic binders consisted of natural materials such as glue, egg albumin, and resins from plants and trees; linseed and tung oil were used next; inorganic binders are the most recent in origin. The majority of resins or binders used today are inorganic. The patenting of nitrocellulose in 1869, and its development in the lacquer industry, paved the way for a wide range of inorganic resins. Some modern paint formulations consist of cellulose acetate, ethyl cellulose, acrylic, vinyl, alkyd, phenolic resins, epoxies, styrene, polyesters, urethanes, and silicones. Early solvents were water and turpentine. Today, although a wide variety of solvents is used in relation to particular binder formulations, the most common solvents are still water, turpentine, alcohol, mineral spirits, acetone, and lacquer thinner. Coatings using water as a solvent have been particularly popular in recent years, because they eliminate the complex and undesirable process of cleaning equipment with flammable solvents.

The drying process in early organic coatings such as oil paints and lacquers was relatively simple: The thinner or solvent evaporated and the binder material oxidized to form a film. New, inorganic resins involve more complex systems of polymerization resulting in the change from a liquid to a solid film. During polymerization, chemical reactions occur not only within the coating material but also in relation to the surface on which the application is made.

In paint or coating formulations, critical concerns are as follows: the method of application, the solvent or thinner and the quantity used, the quantity of catalyst or proportion of total mixtures used, the temperatures at which coating is applied, the temperature of the coating material, and the condition of the surface on which the coating is applied. Remember that the films or residue from cleaning or finishing may not be compatible with the coating material.

Reliable manufacturers usually base their formulations on the results of extensive testing. Strict adherence should be given to specific directions for the preparation of surfaces, use of primers, and method of application as recommended by manufacturers. Buy coatings from a reputable paint dealer who represents a major paint or coating manufacturer. If permanence is desired, use the finest grade of materials offered. Always check the ingredients of the paint. They should be listed on the can, or the dealer should be able to supply them. As an example, a reasonably good acrylic white paint might have about 35% pigment and 65% vehicle. The pigment would be 15 to 20% titanium dioxide and 15 to 20% silicate fillers. The vehicle would be about 40% Acrylic resin and 25% water. Always look for the highest percentage of color pigment and resin. The pigment provides coverage and the resin provides durability.

CLEAR COATINGS

A wide variety of clear coatings is available for finishing or sealing wood, metal, concrete, and other materials for interior and exterior applications. Applying clear finish on sculpture poses no problem when the work is to remain indoors. For exterior use, however, although great advances have been made, a totally permanent coating still does not exist. Refinishing or periodically renewing the coating remains inevitable.

Some readily available clear-finishing materials are as follows:

Shellac. The purified resinous material from which shellac flakes are made is obtained from lac. Lac is a resinous substance obtained from southern Asia. It is deposited on the twigs of certain trees by the lac insect. The flakes are dissolved in alcohol, most often at the rate of 3 or 4 pounds to a gallon (commonly referred to as a 3- or 4-pound cut). In its simplest and least expensive form, it is known as orange shellac; when bleached, it is called white shellac.

Orange shellac is an excellent, inexpensive sealer for plaster molds, wood, modeling boards, wood armatures, and applications in which surface appearance is not a consideration.

White shellac is preferable as a finishing material. It is an excellent sealer for stained wood or plaster. Because it is not highly stain- or moisture-resistant, however, it is usually used as an intermediate sealer; the final finish can be lacquer, varnish, or wax. White, pigmented shellac is available today as a sealer-primer for wood and other surfaces when the surface is to be painted.

Lacquer. When spray equipment is available, lacquer sealers and finishes are still the best for finishing wood and metal for interior and exterior use. Lacquer produces a good, highly durable film. Of the clear coating systems, lacquer films tend to be the least prone to yellowing or discoloration. It is available as a finishing material in gloss, semigloss, and flat. Small quantities are available in pressurized spray cans.

Nitrocellulose resins were originally the first synthetic resins used in lacquer. Most lacquers today, however, are a blend of resins; many contain alkyds, vinyl, acrylic, or rubber derivatives. Lacquer sealers tend to have better sanding characteristics and are often preferable to shellac.

Varnishes. Originally, natural resins from trees were dissolved in turpentine or other solvents to produce varnishes. Later, binders became linseed oil, chinawood oil, and others. Today, inorganic resins, which are beginning to dominate the market, have been developed to minimize some of the problems of early varnishes. The life span of organic resin varnish as an exterior material had always been limited; discoloration of the varnish film upon aging also proved undesirable. Inorganic varnishes today equal or surpass lacquers and natural-resin materials. Although urethane-resin varnishes are proving to be some of the most reliable coatings for exterior and interior use, discoloration or yellowing in sunlight is still a problem with them.

Waxes. Natural waxes, such as beeswax, and inorganic wax, such as paraffin thinned with turpentine or mineral spirits, can be used to seal or protect surfaces. Brushing-wax solutions are prepared by first melting the wax in a double boiler; which is removed from the stove after the wax has melted, and the solvent is added; it is then placed back on the stove and warmed until the wax and solvent have blended. Proportions of one part wax to five to eight parts solvent can be used to seal plaster, concrete, or vermiculite, as well as plaster or concrete mixtures. Be careful when warming solvent-based materials: It is best to heat the solutions in a double boiler on an electric stove that has a sealed heating element. Commercial paste waxes and liquids can also be used to protect varnished, lacquered, and painted surfaces. Wax can also be used to dull the shine on surfaces. Oxidized surfaces can be protected with paste waxes.

Epoxy. Clear epoxy resins for coating are continuously being developed. As a metal coating these are sometimes considered to be superior to urethane. The principal disadvantage is that they have a tendency to chalk after prolonged exposure to sunlight and atmosphere.

PIGMENTED COATINGS

Pigmented coatings can be classified in two categories: primer and finish coatings.

Primer coatings. These are usually designed to act as an intermediate coat. They may act as a sealer or be used to increase or maintain the mechanical bond and render the surface more susceptible to finishing and final application. In the latter case, the appearance of the surface is of little concern, and pigment is selected in terms of other properties that are desired. This coating is of utmost important because it determines the effectiveness of the final finish or top coating.

If the primary function of the primer is to seal the surface and reduce porosity, a pigmented oil, shellac, lacquer, vinyl, or alkyd primer is used. These will serve the purpose on plaster, wood, or concrete. Some pigmented primers also contain fillers to help fill pores in the material. Preparatory to developing a fine finish, lacquer-based primers often prove most sandable. Use acrylic-based lacquer primers on fiberglass surfaces.

White primers are used by sculptors who desire a translucent finished coating. If the coating is to be opaque, colored pigmented primers can be used to help hide surface grain or blemishes. Tinting the white primer with a universal coloring agent is a common practice.

In addition to performing some of the functions just discussed, primers on metal have a further role in preventing corrosion. Addition of some pigments to a suitable binder inhibits electrochemical reaction, or corrosion, on the surface of the metal. This form of primer is absolutely essential if a coating is expected to adhere to and have a reasonable life span on ferrous metal.

Red-lead primers have been recognized for many years as superior protection for steel. Zinc-chromate primers, equally effective on steel, are used also on zinc, magnesium, and aluminum. Metallic zinc dust, in organic or inorganic vehicles, provides protective coatings for steel that have extremely long life spans.

Finishing coatings. In finish or top coatings, appearance is often as important as the performance factors of the pigments and binders. Binders and thinners are essentially the same as those used in clear finishes. However, a greater variety exist and formulation is different; today inorganic resins are predominant in pigmented coatings.

Some common formulations are alkyd resins, straight and modified, which produce excellent finishes with quick-drying and setting qualities. These, as well as vinyl and latex coatings, are used extensively in household and industrial finishes. Phenolic resins, which adhere well to metal, are some of the most durable for exterior use. Cellulose esters, and ethers used in lacquers modified with other resins, are extensively used on automobile finishes.

Heavy-duty coatings based on polyvinyl, epoxy, urethane, polyester, coal-tar epoxy, chlorinated rub-

ber, acrylic, and alkyd have been developed for long life and extensive service.

Although requirements for interior and exterior finishes are similar, exterior coatings must obviously withstand more rigid conditions. A coating must possess elasticity, because it must accommodate temperature change, and subsequent thermoexpansion and contraction, of the material onto which it is applied. It should resist atmosphere moisture, chemicals, and abrasion. In some cases, the top coating may be dense and highly moisture-resistant; yet it may have breathing characteristics to allow moisture to escape, as in formulations for masonry and wood.

Pigments used in coatings are organic and inorganic. In addition to imparting color, pigments help exclude ultraviolet light and retard deterioration of the binder. The hiding power of a coating may be due to the color, density, or particle size of the pigment. At times, pigments or fillers are also added to give body to the coating. The ratio of pigment to vehicles is usually about 25 to 35 percent by volume.

A wide variety of the pigmented coatings produced for household and, particularly, for industrial use are of interest to sculptors. Vinyl and latex exterior paints with water solvents designed for wood and masonry should prove effective on wood and concrete sculpture. (Figure 9–1) Epoxy, polyurethane, vinyl, and phenolic-resin coatings designed for ship hulls, bridges, and steel structures (where the corrosive salt-water and salt-air environments are factors) should prove effective on metal sculpture. These resins are also used in exterior paints for woods and masonry. Some epoxy paints are excellent on fiberglass.

Automobile lacquers, utilizing nitrocellulose combined with alkyd or melamine resins and acrylic lacquers, are excellent for finishing metal and fiberglass. Pigmented gel-coating polyester resins are available for fiberglass fabrication; resin-based paints are available for wood, metal, and masonry. Polyvinyl coatings such as those applied to dish-drain racks, and so on, could have excellent sculptural application, if a commercial source for applying the material were available. Zinc-powder-filling coatings would provide long-life corrosion protection on steel, if their limited color is not a problem; they can also be used as primers. Chlorinated-rubber coating materials, available in a limited range of colors, could be serviceable on outdoor sculpture of wood or metal.

POWDER COATINGS

Fine-powdered inorganic plastic, metallic, and ceramic coatings can be applied to metal or other surfaces. In this procedure, the metal or material is heated to a temperature slightly higher than the melting point of the powder. As the powder is applied, it sticks to the surface. Postheating is used to fuse the particles into a coating, which can be built up to a thickness of 30 millimeters.

Figure 9–1
Painted plywood sculpture. *By Roger Kotoske. 1968. Denver Sculpture Symposium.*

There are several methods for applying powder. Moderate-sized objects may be suspended in a fluidizing bed, which is essentially a container in which the powdered particles are suspended by a cushion of low-pressurized air. (Figure 9–2) Flocking guns can be used to spray the powder on the article; electrostatic powder spraying negatively charges the powder particle, which is attracted to the grounded object by electrostatic force. In some applications, the material does not have to be preheated for electrostatic spraying. The electrostatic process is also used in some powder applications using the fluidizing bed. In another process, a thermospray gun is used to spray powdered metals and ceramics.

Figure 9–2
Fluidizing bed coating technique.

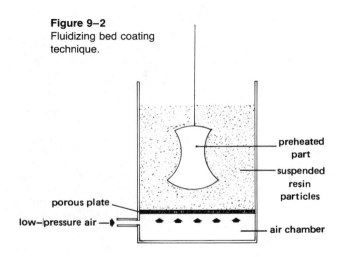

preheated part

suspended resin particles

porous plate

low-pressure air →

air chamber

Surface preparation of the materials to be powder-coated is the same as in other coating systems. In some cases, such as in spraying vinyls, an adhesion-promoting primer is needed.

Sculpturally, powder coating could produce highly durable coatings on moderate-sized work. Because the equipment is expensive and some experience is required to apply the coatings, however, it is advisable to find a commercial firm to do the powder coating.

METALLIC COATINGS

Materials with metallic inorganic coatings can be classified in two ways: materials coated prior to fabrication and objects coated after fabrication. Although the latter is of the greatest interest to sculptors, the possibility of fabricating sculpture from prefinished or coated material should not be ignored.

The most common metallic-coating processes for metal are cladding, hot dipping, electroplating, electroless plating, metalizing, and vacuum metalizing.

Metal cladding. This process consists of bonding two layers of metal together under heat and pressure, or casting the cladding material around the core material, and subsequently rolling it into strips, sheets, or bars. Although other core materials are used, the most common form of cladding consists of applying a layer of nonferrous metal to one or both sides of a mild-steel core. Aluminum, copper, stainless steel, nickel, lead, and other alloys are used. The finished clad sheet is usually considered to have the corrosive-resistant qualities of the cladding material.

Sculpturally, the most practical use of clad sheets of steel would be in metal fabrication, when the fabrication technique is riveting, bolting, or adhesive bonding. Welding clad steel is possible; however, it is a problem to find a coating for the welded area that will match the clad surface.

Hot dipping. In this process, the clean metal material or object is dipped into a container of molten metal; a coating is thus deposited on the dipped article. Industrial application of these coatings becomes quite complex on large quantities of sheet or other forms. Low-melting-point metals such as zinc, lead, and aluminum are used, with steel as the base metal. Most familiar, perhaps, is the long-established practice of galvanizing or zinc-coating steel sheet and objects to render them corrosion-resistant.

In recent years, the steel industry has developed a complex dip procedure to aluminum-coat steel sheeting. Highly recommended for metal buildings and numerous other applications, the aluminum coat contains about 8 percent silicon, and is considered to be four times more corrosion-resistant than zinc coatings.

Zinc-, aluminum-, and other-coated materials could be used in fabricated sculpture, for the visual properties or for corrosion resistance. These coated materials can be left in their natural colors, modified with mild chemical oxidation, or used as undercoatings for painted surfaces. Fabrication techniques would be similar to those suggested for clad materials. Spray-can or brush-applied aluminum and zinc organic coatings are available to cover welds in welded fabrications.

Hot zinc dipping, readily available in most major cities, should be particularly useful to sculptors desiring a silvery, noncorrosive finish on steel works. In this case, the work is simply sandblasted to produce a clean mechanical surface and is then dipped in the molten metal. The resulting zinc finish can be preserved with a clear finish or chemically colored. A natural dark gray results as zinc is exposed to the atmosphere.

Electroplating. Electroplating deposits a coating of metal onto metal or other material. The object to be coated is suspended in a solution related to the desired coating process. An anode of the plating metal is attached to the positive side of the current and the work is attached to the negative side. As the current passes through the solution, metal is deposited on the workpiece. (Figure 9–3)

The kind of solution, the rate of current, the time submerged, the position of the anode, the temperature, and the shape of the object all determine the density, thickness, and uniformity of the coating. Cadmium, zinc, silver, gold, tin, copper, nickel, chromium, and their alloys are used as plating materials.

Nonmetallic materials require special surface preparation prior to plating. Platable plastics are available. Wood, plaster, or other nonmetallic materials can be coated with conductive paints. Porous materials must be thoroughly sealed. The conductive paint consists of a lacquer or varnish heavily pigmented with a graphite, copper, or silver. The piece can then be plated in conventional plating solutions.

Plating on metal often involves applying several dissimilar coatings to achieve the desired results. For example, chrome coatings usually have undercoats of copper, nickel, or cadmium. Cadmium, chromium, and zinc platings are the most corrosion-resistant, but

Figure 9–3
The electroplating process.

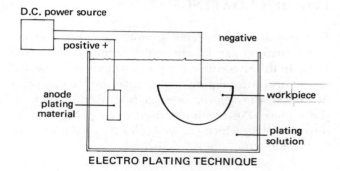

ELECTRO PLATING TECHNIQUE

do not perform as well as some of the dipped zinc and aluminum coatings. Copper or copper-alloy coatings on steel are generally not very satisfactory for corrosion resistance because of their particular electrical-chemical reactions with steel.

The plating processes can be performed for sculptors at fairly reasonable costs. Modern electroplating plants have both cleaning and plating facilities, and can offer advice on the most desirable process and the necessary thickness of the coating. It is usually advisable to determine the tank size of the plating facilities in your area. If need be, a work can be designed in sections to accommodate the tank size and assembled later.

An electroplating process that has been used by some sculptors is brush plating. In this process, one lead from the plating rectifier or power pack is connected to the metal part; the other lead is attached to a stylus anode wrapped with a cotton swab; the swab is dipped into the plating solution and is swabbed on the metal part. Brush plating produces dense deposits that are equal, or superior to, bath-plating solutions. The distinct advantage of this system is that it makes occasional plating possible without having to maintain large tanks of plating solutions. Also, sculpture too large for plating tanks can be plated, and deposits can be made on irregular forms that would not take uniform deposits in conventional bath-plating solutions. Nonmetallic surfaces can be coated with a conductive coating and then brush-plated. Cadmium, zinc, copper, nickel, gold, silver, and other metals can be deposited with this process. Commercial equipment and special solutions are available. (Figures 9–4 and 9–5)

Electroless plating. Deposits of cadmium, brass, copper, gold, lead, nickel, palladium, platinum, rhodium, silver, and tin can be formed on aluminum, zinc, copper alloys, iron, and steel by immersion in chem-

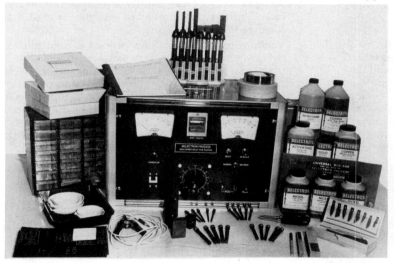

Figure 9–4
Brush plating: A typical selective plating installation, which includes a power pack, solutions, anodes, styli, and accessories, can be used for plating any conductive surface regardless of shape or size. *Photograph courtesy of Selectron, Ltd.*

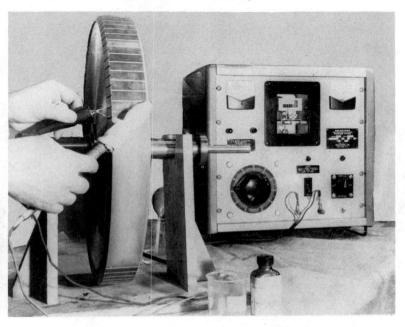

Figure 9–5
Gold plating a component with the Selectron process of high-speed selective plating. One lead from the power pack (on the right) is attached to the component and the other lead is attached to the plating tool (stylus), which is then dipped in the gold solution and brought into contact with the work. This completes the circuit and plates the component. *Photograph courtesy of Selectron, Ltd.*

ical solutions. These solutions consist of metallic sulfates, chlorides, oxides, and nitrates combined with other chemicals. Solution temperatures vary from room temperature to 255 degrees. Commercially prepared solutions are available.

Metallizing (flame spraying). Metallizing with a flame spray is the process of spraying molten metal on the surface of another material. The metals sprayed can be aluminum, bronze, brass, copper, lead, stainless steel, steel, zinc, cadmium, and nickel.

The process utilizes a spray gun attached to a supply of wire, air, and oxyacetylene. As the wire feeds through the gun, an oxyacetylene flame melts the wire. A jet of air blows the molten metal out of the gun and over the surface being sprayed. The spray gun and a proper-sized air compressor are quite expensive and would not ordinarily be purchased by a sculptor unless he or she intended to do extensive experimentation with the process. For occasional coating, metallizing shops that do individual work can be found in most major cities.

Zinc, cadmium, and aluminum are the only practical coatings for exterior steel work; coatings such as copper, brass, nickel, and silver on steel would deteriorate rapidly because of the galvanic action between the metals. Zinc or aluminum coatings provide a corrosion-resistant surface on steel that has an exceptionally long life. Surface preparation for metallizing on metal surfaces consists of grit-blasting or sandblasting prior to application of the coating.

Many coatings not suitable for steel are potentially useful for wood, plastic, ceramic, plaster, and fabric. Low-melting-point alloys such as aluminum or zinc are the most practical on cloth. For higher-melting-point alloys such as copper or bronze, wood and plastic forms are first coated with a lower-melting-point alloy such as tin, zinc, lead, or aluminum. Plastic and wood surfaces must be clean and completely dry. Resinous woods such as yellow pine or cypress should not be used. Hard plasters such as HYDRO-STONE® or HYDROCAL® should be sand-blasted slightly with a fine sand. Apply metal coatings on ceramics to a hot surface, or grit-blast the surface to provide a bond.

Metal coatings are possible on such plastics as fiberglass-reinforced plastic; however, the surface should be sandblasted prior to application of the coating. Fiberglass surfaces must be dense and completely free of air bubbles or pits will appear in the surface as a result of the sandblasting. Although flame-sprayed surfaces have a matt, sandblasted appearance, they can be buffed and polished to a bright surface finish. (Figures 9–6 and 9–7)

Vacuum metallizing. This process is used particularly on small plastic parts, which are primed with an undercoat and placed in a vacuum chamber. In the vacuum, it is possible to evaporate metal from an electrically heated tungsten-element coil without the metal's oxidizing. The metal evaporates from the coils and gathers on the plastic object. The resulting finish is usually a bright aluminum surface; this is rather fragile but it can be protected with a clear topcoat.

Figure 9–6
Metallizing shop truck. Note cylinders of oxygen and acetylene, control gauges, spool of wire, and spray gun. *Photograph courtesy of Metco, Inc.*

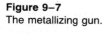

Figure 9–7
The metallizing gun.

CONVERSION COATINGS

These coatings are formed by chemically converting the surface of the material; this conversion may result in a thin, inorganic film that suitably resists corrosion by itself, or that acts as a primer surface for subsequent coating applications. Conversion processes can provide phosphate, chromate, oxide, and anodic coatings.

Phosphate coatings. Phosphate coatings consist of iron, zinc, and manganese formulations, which produce corrosion-resistant films on steel. Paint adheres well to these coatings, which can also be used to produce more paintable surfaces on zinc and aluminum.

Industrially, these solutions are used extensively in dip or spray operations. Phosphate solutions are readily available on the market and can easily be applied by the sculptor with a hand brush or with a spray applicator. Grease and oil should not be present on the metal. Some solutions can be applied over rust; designed to neutralize and destroy rust-producing agents, these solutions leave a rust-inhibiting film, which also promotes better adhesion for subsequent coatings. For optimum results in coating steel a phosphate process should precede applications of a primer. Zinc and aluminum should also be surface-treated by phosphate or other processes if good adhesion of the coating is expected.

In addition to serving as a preparation surface for painting on iron, steel, and zinc-coated steel, the silvery, gray-to-black color is aesthetically rather pleasing, and is worthy of consideration as a final color. If used as a final finish, it should be sealed with a good-quality, clear surface finish.

Chromate coatings. Chromate coatings are used for corrosion resistance or to render surfaces more paintable. In this process, chromium solutions are applied to cadmium, zinc, aluminum, copper, silver, or magnesium surfaces. Color can be achieved by immersing a surface in a dye solution, following the chromate treatment.

Oxide finishes. Oxide finishes have been used by sculptors and industry for a considerable number of years. Although an infinite number of color variations is possible, many of the processes require immersing and heating the solution above room temperature. This is impractical, except for small work; consequently, sculptors are limited to solutions that can be brushed, swabbed, or sprayed onto the metal surface.

The oxide finish is a result of oxides or salts formed on the metal surface because of reaction with the chemical solution. Solutions that are too concentrated may produce brittle films that lack surface adherence. Oxide surfaces are normally not permanent unless protected with coatings of wax, oil, or lacquer. Commercial paste waxes or clear lacquers can be used. Protective oil films can be deposited by rubbing the surfaces with linseed or lemon oil. The surfaces of exterior sculpture are sometimes not coated—particularly fountains, because water would rapidly deteriorate any form of protective coating. The chemical oxide finish is simply used to start patination; natural chemicals in the air are allowed to continue the process.

In most applications, the surface must be clean in order to produce the desired effect. Typical solvent or detergent cleaning processes may be used. For some finishes, the cleaning is followed by sandblasting, abrasive finishing, wire brushing, and so on. For other finishes, buffing, wire brushing, rubbing with a water-based pumice paste, or buffing with greaseless compounds may follow the application of the oxide surface. This removes surface oxides and adds a translucent or transparent quality to the surface coating that allows highlights of the metal to show through the oxide film.

Most swab, spray, or brush applications result in black, green, brown, or gray surfaces. Although, in the past, sculptors have formulated their own oxidizing solutions, I recommend using commercial formulations when they are available. Birchwood Casey has excellent solutions for obtaining black on steel, aluminum, zinc, copper, and copper alloys. Jax Chemical Company, Inc. also has blackening, antique green, and rust coloring solutions.

Blacks and browns can be obtained on copper and copper alloys by using a solution of 4 to 8 ounces of ammonium sulphide or potassium sulphide to 1 gallon of water. This can be applied at room temperature, and may take more than one application. Green on bronze and copper alloys can be obtained in several simple ways. Stippling or spraying the metal with a solution of 2 to 4 ounces of ammonium chloride per quart of water will produce a pale blue to green finish. Allow each coating to dry before applying the next coat; it may take four or more applications to achieve the desired results. Stippling or spraying the metal with repeated coats of 5 or 6 ounces of copper nitrate per quart of water will produce brownish tones that take on a blue-green tone. Applying a final coat of the ammonium chloride solution will turn the metal greener. Applying a final coating of the copper nitrate solution over the pale blue produced by the ammonium chloride solution will turn the pale blue a greener tone. It is also possible to first darken the metal with the ammonium or potassium solution to give the metal a darker tone before applying the green. By heating the metal slightly with an oxyacetylene torch as the solution is applied, a pale green can be achieved very quickly with the copper nitrate solution. As the patination develops, the surface can be spattered occasionally with the ammonium sulphide solution, if additional dark spots are desired.

It is a good practice to experiment on sample strips of metal with variations of these solutions to become acquainted with the colors that can be produced. The metal should be clean, although interesting results can be achieved by applying the solutions over welded copper, brass, or cast bronze without removing the existing oxides. The metal can be sandblasted or cleaned by swabbing with a solution of one part nitric acid to eight parts water, followed by a water rinse. Grease or oil should be cleaned off the metal with a detergent prior to the application of the

acid solution. Sandblasted surfaces react to the chemical solutions more quickly than surfaces cleaned by other means. When solutions are applied, different reactions and results may be produced. For example, copper alloys with a high percentage of zinc would react differently to a given formula than if the zinc content were very low.

Besides greens, blacks, and browns, other colors can be produced on metal with oxidizing solutions. A wide variety of formulas for these solutions can be found in books dealing with sculpture or metal finishing and metal coloring.

Anodic coatings. Anodizing of aluminum and magnesium, which is readily available at plating companies, involves both electrical and chemical processes: the piece of work becomes the anode and is submerged in a sulfuric or chromic acid and water solution. As the current passes, a rather soft oxide is formed. This film is hardened and sealed by subsequent immersion in boiling water or by exposure to steam. Prior to this final treatment, the soft film is rather absorptive and is easily treated with colored dyes. The final sealed surface is a hard, highly permanent, noncorrosive surface similar to the natural, protective surface oxide that forms.

Anodizing sculpture is relatively practical: Large anodizing tanks for anodizing architectural components are readily available and adaptable to sculptural needs. If aluminum sculpture is to be anodized, attention should be given to the alloy being used, because some alloys receive anodic surface and dye more readily. Alloys number 5005, 5050, and 6063 are excellent for this process; 6063 is often used for architectural components that are to be anodized.

In welded aluminum sculpture, care should be given in matching the weld alloy with the material alloy. Because the composition of the weld zone is inclined to be different from that of the base metal, difficulty can be encountered in achieving uniform color and texture.

STAINING

At times it may be desirable to alter the color of a material slightly, or considerably, and yet retain some of the color or characteristics of the original material. Staining with a transparent media containing colored pigments or dyes is a common procedure for achieving these results on many materials.

A stain usually consists of three basic ingredients: the pigment or dye, for coloring; the vehicle or media, which acts as a binder and holds the particles of pigment or dye together or in suspension; and a thinner, to reduce the stain to the desired consistency. The most common binder is linseed oil, but it can be any resinous material, such as shellac, varnish, gum arabic, acrylic, or other synthetic materials with suitable thinners, such as alcohol, turpentine, mineral spirits, lacquer thinner, acetone, methanol, or toluol. Japan drier, or other drying agents, are sometimes added to accelerate the drying. Wood, metal, fabric, plastic, concrete, stone, plaster, and paper are all susceptible to staining techniques.

Generally, a stain tends to be impermanent, unless treated with a transparent sealer or finish coating. Permanency of the stain also depends on the degree of penetration into the material and on the amount and kind of binder present.

There are three basic techniques for staining sculpture. In one, the stain is applied and is allowed to penetrate and dry. If it is applied on a nonabsorbent material, it dries on the surface. In the second, the stain is applied and allowed to penetrate or dry partially, and the excess material is wiped off. In the third, the staining pigment or dye is added to a sealer or clear finishing material and is applied as a finish coating.

Commercially prepared stains are available for woods. Any paint supplier can provide a wide variety of stains, which are usually pigmented-oil, penetrating stains; pigmented-oil, wiping stains; and varnish stains, for one coat finishes. Available also are many synthetic stains utilizing synthetic aniline dyes, resins, and thinners. Although aniline dyes are not as permanent as most pigments, they do possess brilliance and staining qualities that frequently surpass pigmented stains. Water stains are available but tend to raise the grain when staining wood; specially formulated nongrain-raising stains are available for wood finishing.

A simple way to test the degree of transparency of a stain is to make a pencil line on a scrap piece of material and brush a small amount of stain over the line. The extent to which you can see the pencil line through the stain indicates the density of the stain. It is also advisable to check the stain on a scrap piece of material, to judge its appearance. Experiment with the scrap material, and take note of the different results achieved by using the three methods of application described earlier.

Many interesting effects are achieved by using two or more stains in order to obtain antique or variegated appearances. Stippling, wiping, spattering, dry brushing, wet in wet (brushing a stain into the wet surface of a previously applied stain), and sponging are common methods of application. Dark, transparent stains can be used as undercoats. Lighter, opaque highlights can be stippled or spattered on the dark undercoat with a brush, sponge, or crumpled paper. This produces depth of coloring and is the usual technique for assimilating bronze, antique green, and brown effects on plaster or other materials.

Most of the simple coating materials in the classroom or studio can be used for staining, if a suitable commercial stain cannot be found. Only a small amount of coloring material is needed, with binders or thinner, to produce the desired stain.

By coloring water with tempera paints, water colors, water-soluble aniline dyes, acrylic, or any water-based commercial paints, water stains can be produced that can be used on wood, paper, fabric, plaster, and concrete.

Universal colorants, commercial oil paints, lacquers thinned with an appropriate thinner, or tube oil colors thinned with linseed oil and turpentine can be used on wood, fabric, paper, plaster, and concrete. Many of these stains have sufficient binders so that sealers are unnecessary for interior use. If a color tends to rub off, it can be lightly waxed with a paste wax.

Finely ground powdered pigments added to linseed oil, shellac, varnish, or lacquer thinned with appropriate thinner can be used in the same fashion as oil colors. The pigment should be mixed in a small amount of the media to form a thin paste before adding it to the thinned shellac, varnish, or lacquer.

Pigmenting paste wax is an excellent way to tint a surface with a dull finish. Liquid or paste shoe polish can also be used to finish and tint wood, plaster, concrete, and fiberglass. However, sometimes a final coat of clear wax is needed to prevent the finish from rubbing off.

Commercially produced fabric dyes can also be used as water stains although they tend to fade rather rapidly in sunlight. Acrylic plastic can be tinted by being submerged in a boiling solution of water and fabric dye. Subtle stains have been produced on plaster and concrete castings using water tinted with natural, colored clays.

SPRAY PAINTING

If surfaces are properly prepared, professional results in spray painting with enamels, lacquers, and plastics are not difficult to achieve.

For small items and touch-ups, pressurized aerosol cans of paint are popular, and successful results can be achieved if manufacturers' recommendations are followed. Handling such spray cans is similar to working with spray guns. Proper distance from the work and speed (or rate of pass over material) need to be controlled to avoid sagging, running, and missing areas.

A spray gun, spray booth, and air supply are essential to spray paint large items. Selecting one of the wide variety of spray outfits on the market depends on individual needs. If your works are very large and your spray needs are frequent, a high-capacity spray setup is recommended. (Figure 9–8) Occasional painting of large works can be done at a professional paint shop rather than investing in the proper equipment.

Performance of a spray gun depends upon its design and the capabilities of the air supply. Cubic feet per minute (c.f.m.) and pressure in terms of pounds

Figure 9–8
A large-capacity 10 H.P. air compressor used for operating spray painting, sandblasting, and metallizing equipment.

Figure 9–9
A small compact spray-painting outfit.

Figure 9–10
Dual air filter for controlling air and
removing dust and moisture.

per square inch (p.s.i.) determine the amount of spray a gun can deliver with the paint mixture at its proper consistency.

For example, a small, inexpensive spray outfit might need 1.2 c.f.m. of air at 20 p.s.i. for its spray pattern to fan out 5 inches. A moderate-sized outfit would need 3.2 c.f.m. at 35 to 50 p.s.i. for its spray pattern to fan out 7 inches. Larger-production spray

Figure 9–11
The proper movements for the spray gun in spray painting.

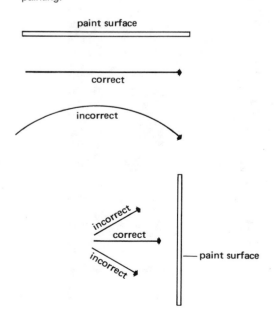

setups require expensive air supplies capable of 5 to 10 c.f.m. and 40 to 85 p.s.i. or larger, for spray areas to fan out from 10 to 15 inches. If a large air supply is not available, the moderate-sized gun will be adequate; it is reasonably priced and has a compactly designed portable air supply. (Figure 9–9) For optimum results, the air supply should be equipped with an adequate pressure regulator and an air filter to remove dust and moisture from the air. (Figure 9–10)

In the usual spray application, the gun is held 6 to 10 inches from the surface and is moved horizontally, at a right angle to the surface. (Figure 9–11) Pointing the spray up or down produces uneven results. Irregular sculpture forms make it impossible to maintain ideal spray-gun position. Building up the surface with thin coatings of quick-drying lacquer, instead of slower-drying enamels, is the most practical solution to this problem.

Adjusting the nozzle according to atomization or air-to-paint relationships is accomplished by the adjusting screws. (Figure 9–12) Too much air produces a misty spray or small particles, which, with lacquer, dry before hitting the surface. Large particles indicate insufficient amounts of air.

Manufacturers' recommendations concerning the consistency of the paint mixture and the thinner to be used should be followed. Paint should be strained through cheesecloth or some other suitable strainer to assure removal of any foreign particles. Running, sagging, and uneven application are often the result of the speed at which the spray gun is moved, the distance the spray gun is from the surface being

sprayed, the viscosity of the paint, excessive overlapping, spray-gun position, or mechanical problems with the equipment. The equipment should be cleaned thoroughly after each use; poorly cleaned equipment may cause spattering and uneven discharge of paint or air leaks due to improper sealing of valves or the paint tank.

All spray-painting operations should be confined to a specific area, and some form of air removal should be provided. For small and moderate-sized works, a spray booth can be fashioned in a corner of a room with a proper explosion-proof fan. If spray painting is done on a regular basis, some method of controlling overspray and paint particles must be developed. Ideally, a commercial spray booth should be used. Essentially, there are three forms of spray booths: dry baffle, paint arrestor, and water wash. The dry baffle is least efficient in removing paint particles from the exhausted air. The paint arrestor uses a filter to trap some of the paint particles. Passing the exhausted air through a curtain of water is the most efficient method for cleaning exhausted air. The type of spray booth to use and where to locate it depend on the amount of contaminants that can be exhausted into the atmosphere. (Figures 9–13, 9–14, and 9–15)

AIRLESS SPRAY PAINTING

A more recent development in spray painting involves airless painting equipment. In this process the paint is pressurized and atomizes as it leaves the spray gun. Generally, the paint particles are larger than those from other spray equipment, and the system works best for rapidly painting large areas. Small airless paint sprayers are readily available from hardware stores and building supply centers.

Figure 9–12
Typical spray gun: (A) air control; and (B) fluid control.

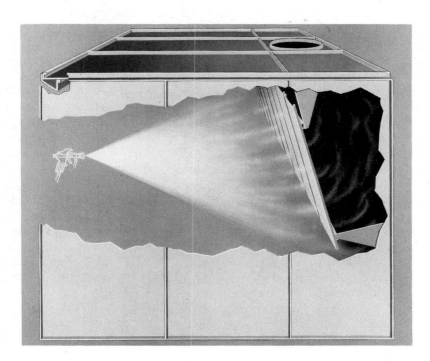

Figure 9–13
Baffle-type paint booth. *Photograph courtesy of Devilbiss Company.*

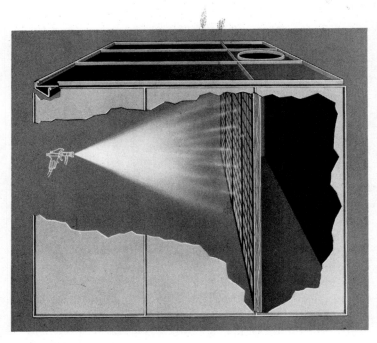

Figure 9–14
Paint-arrestor-type paint booth.
Photograph courtesy of Devilbiss

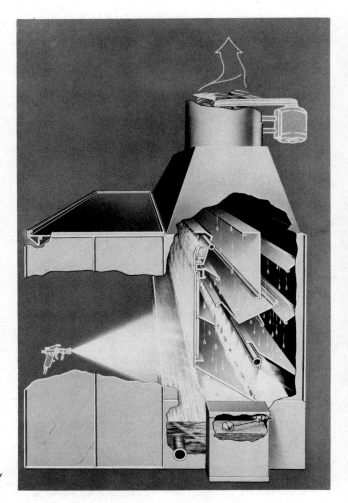

Figure 9–15
Water-wash-type paint booth. *Photograph courtesy of Devilbiss Company.*

SURFACE PREPARATION OF MATERIAL FOR COATING AND FINISHING

Prior to putting on a coating, two conditions are essential: The surface must be clean and it must possess the desired surface qualities necessary for the bonding characteristics of the coating and finish desired.

Cleaning, which is usually done with soaps, solvents, detergents, chemicals, or abrasives, chemically or mechanically removes undesirable dirt, oil, rust, and scale. Hand application or mechanical processes, such as steam cleaning, sand- or gritblasting, dipping in chemical solutions, and power sanding, buffing, and grinding, can be used. Sandblasting, sanding, or grinding with abrasives are used when the surface needs a rough finish to assure bonding of a coating. When the surface needs a smooth finish, sanding with fine abrasives, polishing, and buffing may be used.

A wide variety of commercial cleaning compounds is available, designed specifically for cleaning metal or other materials. The cleaners are a combination of materials formulated to produce specific cleaning results. Degreasing cleaners for metal often consist of several alkaline compounds, such as sodium hydroxides, silicates, and carbonates, along with wetting and dispersing agents. A local source for appropriate cleaning compounds should be found. Good cleaning compounds must be able to dissolve and disperse oil, grease, dirt, and soot; they must be such that after a water rinse they do not leave surface film or residue.

Paste cleaning compounds, available as nonacid cleaners, should be particularly useful to sculptors; many are harmless to the skin and easy to use. They are brushed or wiped on the surface of the metal; after having time to react, they are washed off with water, leaving a clean surface. For heavy deposits of dirt or contaminants, two applications may be necessary.

Many tallow soaps or ordinary soaps are unfit for cleaning because they tend to leave oily or fatty residue. From moderately contaminated material, spots can be removed by hand scrubbing with a water-soluble cleaner. Abrasive cleaners such as BAB-O® or Ajax® are reasonably satisfactory.

A good test for cleanliness is to hold the material at a slight angle and pour some clean water on the surface: if the water readily covers a large surface, the material is clean; if it beads and separates, oil still remains. Excessive films of oil, grease, and dirt on

material usually need stronger abrasive or solvent action. Industrially, this is easily accomplished by soaking in proper solvents or solutions. Other means might be spraying, vapor degreasing, and electrolytic or electrosonic cleaning. Since these processes are usually not practical or feasible for sculptors, they are often limited to hand operations. Excess oil, grease, and so on, can usually be removed quickly with solvents such as mineral spirits, kerosene, acetone, methyl alcohol, or nonvolatile solvent (such as trichloroethylene) formulated for cleaning purposes. The solvent is usually applied to a rag and wiped onto the surface of the material; rags should be changed frequently as they become saturated with grease and oil. Solvent cleansing should be followed by further cleaning with a commercial alkaline cleaner, or detergent and a water rinse.

Automotive supply houses are a good source for small quantities of degreasing materials. Solvent emulsions, frequently available in pressurized cans, can be easily sprayed on and rinsed off after dissolving the grease and oil. Solvent wiping is fairly practical for cleaning small parts, material for fabrication, small areas for bonding, or sculpture with simple, flat surfaces; complex forms and textural surfaces require a dip, vapor, or steam-cleaning process.

Special cleaners for cleaning and polishing plastics are available, many of which incorporate a destaticizing material; such cleaners leave a thin, antistatic film of wax on the surface, which repels dust and lint. When plastics are being cleaned or surfaces are being coated, care must be exercised to be sure that the solvent does not dissolve the material.

Old paint and organic coatings can be removed quickly with nonflammable paint remover, which is brushed on, allowed to remain until the old coatings are dissolved, and then scraped off with a spatula.

Steam cleaning is one of the best ways to clean many materials. (Figure 9–16) In fact, if a large quantity of material needs to be cleaned and you do not own a steam cleaner, it is advisable to hire someone with a portable unit, or to haul the material to a steam-cleaning service. Steam-cleaning solutions have been formulated that will dissolve almost any oily or greasy film. Steam cleaning, which is also practically the only satisfactory way to remove flux remaining on metal as a result of brazing and bronze welding, is, in fact, the simplest and most economical way to clean complex works of any size.

If surface deposits are insoluble solids (for instance, scale and heavy rust), more radical methods, such as strong chemicals or abrasives, are needed for their removal. Metal-plating and finishing firms provide chemical removal of solid, insoluble surface deposits, which is usually impractical for studios and classrooms; Oxidation, rust, and mill scale are chemically removed by pickling the material in sulfuric or hydrochloric solutions of 10 to 20 percent acid to water; the solutions are often heated to accelerate the cleaning action. Light acid dips are also used to brighten and deoxidize materials such as copper, zinc, and aluminum.

Hand applications of mild acid solutions (one part acid to ten or fifteen parts water) with a cloth swab or bristle brush is practical. Small pieces can be handled in a sink; large pieces need to be treated over a floor drain or outdoors. The work can be rinsed with water from a garden hose. It should then be swabbed with a mild, neutralizing alkaline solution, such as 1 ounce of sodium hydroxide to 1 gallon water, and then water rinsed again.

Inexpensive pressure cleaners, which fasten to an air supply and have a syphon hose for applying cleaning solutions, also work in many cases. The sy-

Figure 9–16
Steam cleaning a welded sculpture prior to painting.

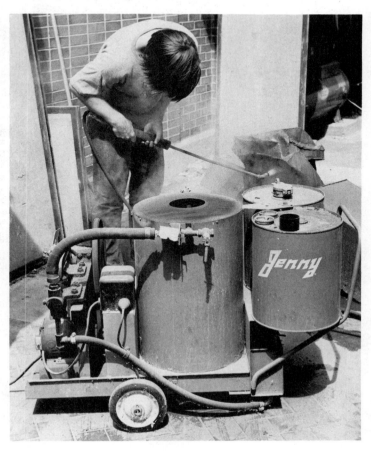

Figure 9–17
Pressure cleaner.

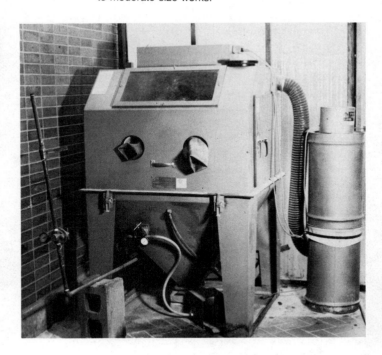

Figure 9–19
Sandblasting cabinet for cleaning small
to moderate-size works.

Figure 9–18
Small portable sandblaster being used
to clean a bronze casting.

phon hose can be removed and it can be fastened to
a garden hose and your regular water supply for rins-
ing and light cleaning. (Figure 9–17)

Whatever cleaning method is used, it is good
practice to wear old clothing, rubber gloves, and pro-

tective goggles. Hand-applying solutions on irregular
sculpture inevitably results in uncontrolled spatters
that can hurt your eyes, skin, or clothing.

If chemical cleaning is impractical or unavaila-
ble, abrasive cleaning may be the best way to remove

mill scale and oxidation. Sandblasting, one of the most practical ways to rapidly remove heavy rust or scale, old paint, and dirt, leaves a good surface for receiving paint. (Figures 9–18 and 9–19) Hand sanding or steel wooling is practical but tedious. Abrasive wheels, sanding discs, steel-wire wheels to fit electric drills, flexible shafts and portable grinders are commonly used, as well as belt and disc sanders. These tools are further discussed in Chapter 10.

An abrasive cleaning should be followed by further cleaning to remove dust or other contaminants. Superficial dust can be wiped or blown off with clean, compressed air, although it may be better to wash with a mild detergent or solvent.

Selecting the right method of cleaning ultimately depends on the availability of cleaning compounds and services, the material being cleaned, the kind of contamination present, as well as the final coating, finish, or bonding the material will receive, the performance desired, personal preference, and the manufacturers' recommendations. As previously mentioned, students or sculptors are usually limited to simple manual-cleaning operations using water-based detergents, solvents, abrasives, or mild chemical solutions.

In a sense, each method has its advantages and disadvantages. Although the hand application of water-based detergent solutions is inexpensive and simple, it is usually limited to nonporous materials and moderately contaminated surfaces; drying time is prolonged and metallic surfaces are likely to corrode unless they can be force-air dried. Hand solvent cleaning can remove greater deposits of grease and oil; rapid evaporation and drying is an advantage, although the toxicity and volatility of most solvent fumes necessitate some form of ventilation. In solvent wiping, there is also always some question as to whether minor oily deposits are still present.

Abrasive cleaning and abrading have the advantage of leaving a better bonding surface. On soft material, there is always the possibility of in-beading contaminants into the surface (particularly by sandblasting), and the rough surface is more difficult to further clean. Abrading, however, is advantageous for most opaque coating, and is usually an acceptable procedure for adhesive bonding.

Abrasive Finishing

10

Materials used as abrasives for sanding, grinding, and cutting are, in order of hardness, diamonds, silicon carbide, aluminum oxide, emery, garnet, and flint. Industrial diamonds are either natural or synthetic; silicon carbide and aluminum oxide are synthetics; the other abrasives are natural materials. Tripoli, pumice, rottenstone, and rouge are used for polishing.

Abrasives are used in varying grain or grit sizes, which are determined by the number of particles per lineal inch (particles are separated by screening and other methods). In other words, sixteen grit would mean that the particles are approximately $1/16$ inch in length and width. Grit sizes are from number 4 to 800.

The cutting ability of an abrasive grit is determined by the shape of the particle, its position on the abrasive wheel or surface, toughness, hardness, and resistance to attrition. Hardness and attrition are related according to how readily the grain will wear down; toughness is concerned with how well the grain withstands fracturing. Particle shapes are oblong or polyhedral.

Devices for abrasive finishing are either grinding and cutoff wheels, sanding or abrading sheets, belts, discs, and polishing wheels, and the compounds applied to wheels, buffs, or pads.

GRINDING AND CUTOFF WHEELS

Grinding wheels are used primarily for rough grinding and finishing of metal, removing metal stock, grinding down welding beads, grinding off rough spots on castings, and sharpening tools. (Figure 10–1) Grinding wheels are manufactured by bonding together the abrasive particles into wheels of varying hardness and particle density. The wheel characteristics are identified by the kind of abrasive, the grit size, grain combination, grade, structure, and bond. (Figure 10–2)

Aluminum oxide and silicone carbide are the only abrasives that are tough enough for grinding hard materials. Grit sizes run from 12 to 600. Grade refers to hardness of the wheel and is related to the bond. Bonds are: vitrified bonds consisting of various ceramic materials, resinous bonds utilizing phenol formaldehyde resins, and rubber bonds. Structure is a matter of the grit density or the spaces between the particles of the grit. Number 1 indicates the most dense and 12, the most open structure.

The selection of a grinding wheel depends on the material being finished and on some personal experimentation. Vitrified bonds are usually used for grinding, whereas resinous bonds are used on cutoff wheels and high-speed grinding. Rubber bonds are

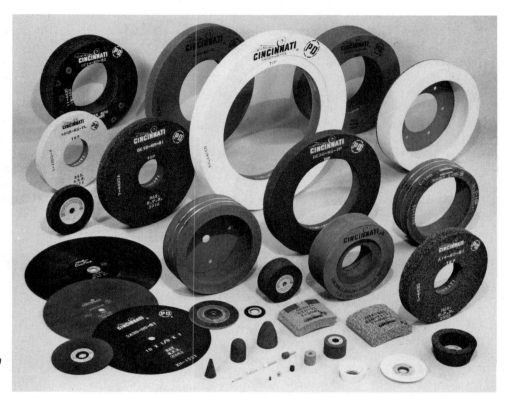

Figure 10–1
Typical grinding wheels. *Photograph courtesy of Products Division, Cincinnati Milacron, Inc.*

Figure 10–2
Wheel markings. *Courtesy of Products Division, Cincinnati Milacron, Inc.*

| Cincinnati Grinding Wheels | MARKING CHART | PD |

ABRASIVE SYMBOL	GRIT SIZE	GRAIN COMBINATION	GRADE	STRUCTURE	BONDS VITRIFIED
A—Tough Aluminum Oxide	Coarse Med. Fine	1	Soft Med. Hard	Dense Med. Open	VFM VSC
2A—Semi-Friable	12 36 90	2	E J O	1 5 9	VL V5
97A—	14 46 100	3	F K P	2 6 10	VL2 V6
3A— Friable	16 54 120	4	G L Q	3 7 11	VP V7
4A—	20 60 150	5	H M R	4 8 12	VP2 VS
12 A—	24 70 180	6	I N S		VC
9A—Very Friable (White)	30 80 220	7	T		
5C—Green Silicon Carbide	240		U		**RESINOID**
6C—Black Silicon Carbide	280		V		B1 BB
CA— Mixed Aluminum	320		W		B2 BF
C2A— Oxide and	400		X		BX BG
C4A— Silicon Carbide	500		Y		BXP BFA
C9A—			Z		BXK BFL
7C—Mixed Silicon Carbide					
					RUBBER
					R
					RP
					RS
					BWE1

Typical Marking: **2A 60 1 - K 4 - VFM**

often used for fine-finishing shapes, drums, and wheels. Aluminum oxide is used for grinding materials of high tensile strength, whereas silicon carbide is used on low-tensile-strength material.

Steel and hard materials are ground with fine-grit wheels with a soft bonding material that would break away, because the grit dulls rapidly. Soft materials, such as aluminum, copper, and many copper alloys, are ground with a coarse-grit wheel with a hard bonding material, as the abrasive grit does not dull as rapidly. To prevent glazing of the abrasive surface, space between grit is essential. Thus, grinding soft materials requires more space between the grit than grinding hard material. Large grit with wide spacing produces coarse finishes; small grit with close spacing produces fine finishes. A 60-grit, 4- to 7-inch wheel is fairly satisfactory for general-purpose work. For rough grinding and fast removal of stock, grit as coarse as 16 might be used.

The speed of the wheel must also be considered. Vitrified-bonded wheels can be run at up to 6500 surface feet per minute. Resin-bonded wheels should be used for higher speeds. A 7-inch wheel on a bench grinder running at 3450 revolutions per minute would have a surface speed for the wheel of approximately 6500 feet per minute, which is adequate for most grinding and sharpening.

Flanges should always be used to hold the grinding wheels on the arbor or shaft. A disc of clean blotter

Figure 10–3
Wheel dresser for a bench-mounted grinding wheel.

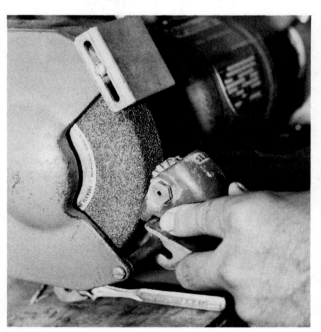

paper, which is usually supplied with the wheel, should be between the flange and the wheel. The nut should be tightened enough to hold the wheel; if it is excessively tight, it may crack the wheel.

For high-speed grinding or cutoff with a portable grinder, resinoid or rubber-raised hub wheels should be used. These wheels are fiber-reinforced to withstand high speed and can be rigid or semiflexible. A typical 7-inch wheel would be ⅛, 3⁄16, ¼, or ⅜ inch thick, in a grit size from 16 to 120.

Wheels can be equipped with a discard mount, or they can be mounted on the threaded shaft of the grinder with a mounting kit. Five-eighths inch is a typical shaft size. The resinoid wheel is used in sculpture for cutting and grinding off sprues in casting, grinding surfaces of castings, or grinding down beads and surfaces in welded sculpture. Wheels up to 16 inches in diameter are available for stationary cutoff equipment. Flat wheels can be used on table or radial-arm saws.

When wheels become worn, they require dressing to restore their original shapes. For bench- or pedestal-mounted grinders a hand dresser is held on the tool rest and is pressed against the wheel. For grinding wheels or portable tools, the wheel is held against the bench-mounted dresser. (Figure 10–3)

Grinding tools are either stationary and mounted or portable. Although stationary grinders are primarily used by industry, good-quality stationary grinders can be used by sculptors for tool sharpening and occasional grinding of parts. Of greater use is portable equipment, such as an ordinary electric drill fitted with small grinding wheels, air or electric grinders, and flexible-shaft machines.

STATIONARY GRINDERS

A stationary grinder consists of a power source and a grinding wheel mounted on a shaft. Also necessary are proper protective guards, eye shields, and a guide on which to rest the material. Although stationary grinders are produced in a wide variety of designs for industry, pedestal or bench models meet most sculptors' needs. (Figure 10–4) The typical pedestal or bench grinder accommodates a 6-, or 7-, or 10-inch wheel and is powered by ⅓ to 1 horsepower electric motor. It is a compact machine that will accommodate a wheel mounted on either side of the motor. The motor speeds are usually 1725 or 3450 r.p.m. If your sculptural needs are primarily tool sharpening and occasional light grinding, the smaller model would probably be adequate. However, if heavy

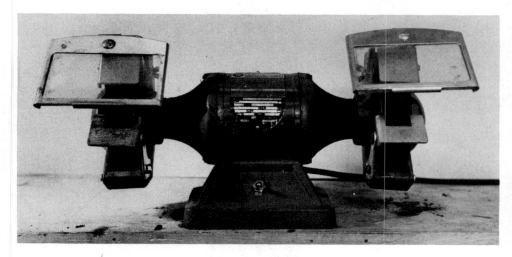

Figure 10–4
Bench-mounted grinder.

Figure 10–5
Air-angle grinder.

grinding is anticipated, the larger model should be used. The grinder is usually equipped with a coarse wheel (36 grit), for rough grinding on one shaft, and a medium (60 grit), for sharpening and fine grinding on the other.

PORTABLE GRINDERS

Portable tools including electric grinders, air grinders, and electric flexible-shaft grinders, are available with arbors that are either horizontal or at a 90-degree angle to the machine. Horizontal grinders use flat wheels or cylindrical attachments; angle grinders are usually equipped with cup-shaped wheels. The grinders are designed for specific-sized wheels. Particular attention should be given so as not to exceed the speed recommendations for wheels in relation to the grinder. Also, grinding wheels on portable grinders should always be covered with adequate protective guards.

Electric grinders operate at speeds from 4000 to 5000 r.p.m., at about ½ to 1 H.P. They use vitrified or resinoid wheels from 4 to 7 inches.

Air grinders are often preferable when an adequate air supply is available. They can be operated with greater safety, particularly for wet grinding in areas with wet floors or with wet material present. They are also more compact and lighter than electric grinders. Small air grinders are available to accommodate small grinding attachments. These may operate at speeds as high as 25,000 r.p.m. Large grinders using 4-, 5-, 6-, or 8-inch wheels would operate at speeds from 3000 to 6000 r.p.m. Air grinders are often equipped with speed controls or governors to prevent them from exceeding their rated speeds. (Figures 10–5 through 10–10)

The flexible-shaft machine, which can be variable or single speed, consists of a mounted motor and

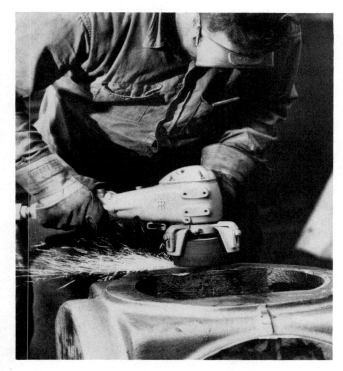

a flexible shaft. A typical variable-speed machine operates at speeds of 2275, 3000, 4000, and 5325 r.p.m., at ⅓ to ¾ H.P. The variable speed allows for the use of a greater variety of wheels and sizes. The flexible shaft has a threaded end. Wheels or chucks for small attachments are fastened to arbors that fit the threaded end of the shaft. An angle head can also be attached for cup wheels and discs. The flexible shaft is exceptionally useful for grinding in areas that are inaccessible to larger air or electric grinders. (Figures 10–11 through 10–13)

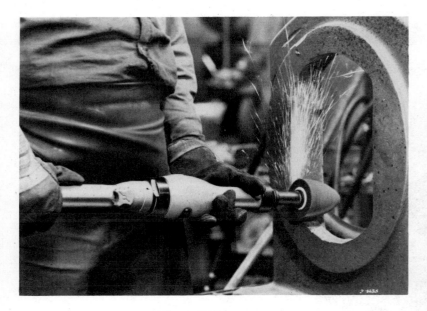

Figure 10–6
Air-cone wheel grinder.

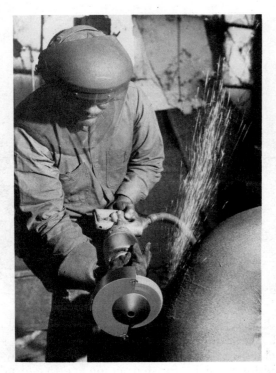

Figure 10–7
Horizontal air grinder.

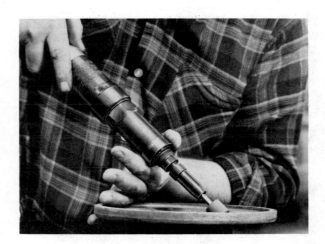

Figure 10–8
Light-weight air grinder.

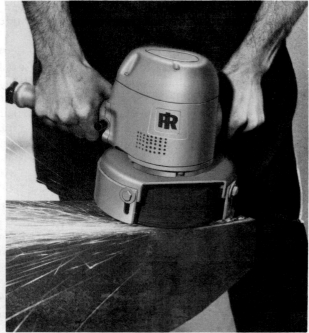

Figure 10–9
Surface air grinder. *Photographs in Figures 10–5 through 10–9 courtesy of Ingersoll-Rand.*

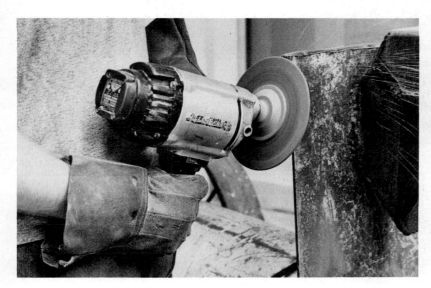

Figure 10–10
Electric grinder with a depressed center disc. Note: grinder should have guard as in Figure 10–7 for optimum safe usage.

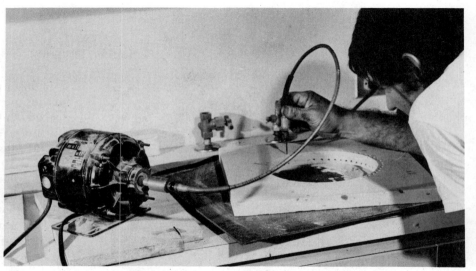

Figure 10–12
Small flexible shaft and motor being used to drill holes in a direct sand mold.

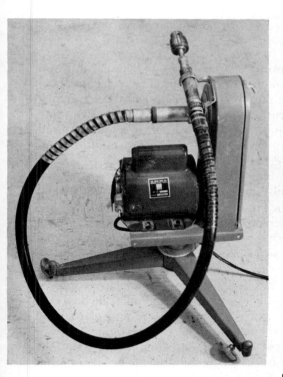

Figure 10–11
Flexible-shaft machine.

Figure 10–13
Chart on surface feet per minute.

r.p.m.	2″	4″	6″	8″	10″	Wheel Diameter
1,725	900	1,800	2,700	3,600	4,500	Surface feet
3,400	1,800	3,600	5,400	7,200	9,000	per minute

SANDING OR ABRADING

Sanding or abrading involves using abrasives bonded to paper or cloth sheets, belts, discs, drums, and special shapes. In industry these are referred to as "coated abrasives." The abrasives may be made of flint, emery, garnet, aluminum oxide, or silicon carbide. Because of their tough wear-resistant qualities, aluminum oxide and silicon carbide are usually used for finishing operations. The backings are either paper, cloth, fiber, or a combination of either paper and cloth or fiber and cloth. Paper backings are designated as A-, C-, D- and E-weight paper; C and D are intermediate-weight paper, and E is a heavy paper backing. Lightweight cloth is designated as J, and heavy, durable backing, as X. The fiber, made from multiple layers of rag stock, is used to produce tough, relatively hard backing for discs and drums.

The adhesive used to bond the abrasive grain to the paper consists of a bond coat applied to the backing and a size coat applied after the grain has been applied to the first coating. Adhesives are classified as *glue, glue and filler, resin over glue, resin over resin,* and *waterproof.* Resin coatings are the toughest and most heat-resistant. Papers with waterproof adhesives are used in wet sanding.

Abrasive grit, available in sizes from 12 to 600, is applied to the backing by a gravity or electrocoat process. In the gravity process, the grit is dropped or sprinkled on the adhesive-coated backing. Polyhedral-shaped grains are used. In the electrocoating process, the coating backing and grain pass through an electrostatic field. Oblong grains are used. As the grains are attracted to the backing, they adhere in such a manner that the maximum amount of cutting surface is exposed. This results in a coated abrasive with a cutting surface superior to the gravity-applied surfaces. Most abrasives today are electrostatically coated.

There are two distinct types of coatings: *closed coat* and *open coat.* The terms refer to the density of the grain: In closed coat, the grains are as close as possible, whereas in open coat, spaces exist between the grains. In open coat, surface coverage may run from 50 to 70 percent. (Figure 10–14)

Coated abrasives are identified on the back side as to paper weight, cloth, type of bond, and size of grain. Garnet, aluminum oxide, and silicon carbide are identified numerically as to grain size, running from 16 to 600. Flint and emery are simply marked *Extra Coarse, Coarse, Medium, Fine,* or *Extra Fine.* (Figure 10–15)

Some individual experimentation is essential for

189

Figure 10–14
Closed-coat (left) and open-coat (right) abrasive paper.

you to determine preferred finishing methods. Fundamentally, finishing procedures are the same for all materials: starting with coarse grains and working progressively with reduced grain sizes until the desired surface is achieved. The starting grain size depends on the condition of the material. (Figure 10–16)

Aluminum oxide can be used for most materials; silicon carbide is used on extremely hard surfaces, such as glass, ceramic, or stone; on lacquered and enameled surfaces; and for finish sanding. It is also sometimes preferred for abrading plastics and nonferrous metals. Some woodworkers still prefer garnet instead of aluminum oxide for wood finishing. In fact, if a slower cutting action is desired in the final, fine, or extra-fine phases of finishing, it might be used. Emery is sometimes used for final phases of finishing and polishing metals. Open-coat abrasives should be used for finishing soft materials such as wood, plastic, or soft metals; close coat on hard materials such as steel, ceramic, and so on. Closed coat might be used for final finishing phases on some soft materials. For materials such as stone, glass, and ceramic, a wet sanding process with silicon-carbide abrasive may be used for fine and extra-fine abrading.

Extra-coarse and coarse grades are especially good for removing old finishes, rust and mill scale on metal, chisel marks, saw marks from wood and plastic, and beads from welding. They are also recommended for final shaping of wood and soft-stone carvings, for final shaping of casts and direct-modeled forms in plaster or synthetic materials, and for working down rough spots in castings.

Use medium and fine grades to remove scratches from the previous finishing process and to prepare surfaces for the final finishing or the application of lacquers, paints, or varnishes. For the final fine finishing of coatings, porous materials are sealed; metals and nonporous materials are primed. In typical finishing, the dry-sealed or primed surface would be dry-sanded with about 80 to 120 grit. In applying varnish, enamels, and lacquers, the next coating would be wet- or dry-sanded with 120 to 150 grit, until the gloss is

Figure 10–15
Comparative grit sizes.

	Extra Coarse	Coarse	Medium	Fine	Extra Fine
Flint	36	50	80	120	220
Emery	30	40	60	120	
Garnet	16–36	40–50	60–100	120–180	220–280
Aluminum oxide	16–36	40–50	60–100	120–180	220–600
Silicon carbide					

Material	Abrasive	Rough	Intermediate	Fine	Extra Fine
Wood	Aluminum oxide or garnet	30–60	80–120	120–150	160–300
Plastic	Aluminum oxide or silicon carbide	50–80	120–180	180–240	240–600
Aluminum	Aluminum oxide	40–60	80–100	100–150	160–240
Copper	Aluminum oxide	40–60	60–100	100–150	160–240
Bronze	Aluminum oxide or silicon carbide	40–60	80–100	100–150	160–240
Steel	Aluminum oxide	20–50	60–80	80–120	120–240
Glass	Silicon carbide	50–60	80–120	120–200	220–320
Ceramic	Silicon carbide	50–60	80–120	120–200	220–320
Paint	Aluminum oxide or silicon carbide		120–150	150–300	300–400

Figure 10–16
Grit selection for finishing.

removed and the surface is smooth. If additional intermediate coats are applied, they are wet-sanded with 150 to 300 grit. For fine varnish and lacquer surfaces, the final surface is wet-sanded with 400 grit and then hand rubbed or buffed with a compound to restore the lustre. Final enamel coats are not sanded. Each layer of a coating should be allowed ample time to dry prior to sanding. Twenty-four hours is usually sufficient for primers and intermediate coats. The final coat usually needs 48 hours. Fine finishes require a minimum of four or five coats. On wood surfaces, sand in the direction of the grain.

SANDING AND ABRADING EQUIPMENT

As with grinding, sanding and abrading equipment can be stationary or portable. Originally, this equipment was used primarily for finishing wood and soft materials. However, with the development of synthetic abrasives and improvements in bonding, abrasive finishing of metals and hard materials became possible. Various types of sanding and abrading equipment exist: belt, drum, disc, or orbital. The use of portable machines has virtually eliminated the need for tedious hand sanding and finishing of surfaces.

STATIONARY SANDERS

Bench- or floor-mounted sanders fall into three basic categories, depending on whether they accommodate flat, circular discs, continuous belts, or cylindrical tubes that mount on drums. The combination 12-inch disc and 4- to 6-inch wide horizontal belt machine is one of the most popular pieces of shop equipment. Its motor should be ¾ to 1 H.P. (Figures 10–17 and 10–18)

Disc sanders range in size from 8 to 18 inches. As stated, the 12-inch size is most often found in wood shops. The sanding disc is cemented to the metal surface of the machine. A layer of cement is applied to the machine backup disc by moving a stick of cement back and forth across the metal disc while the machine is running. Additional cement is smeared on the back of the sandpaper disc before it is applied on the backup disc. In recent years, adhesive-backed discs have become available. Although they are slightly more expensive, they are well worth the additional cost, because they bond more satisfactorily to the backup disc and are far more convenient to use.

The disc sander is used primarily to sand edges and curves. Its tilting table and slotted top allow a miter gauge to be used to sand the ends on straight

Figure 10–17
Stationary combination belt and disc sander.

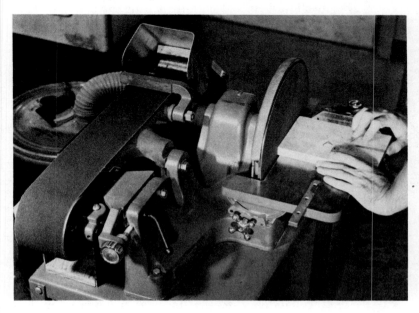

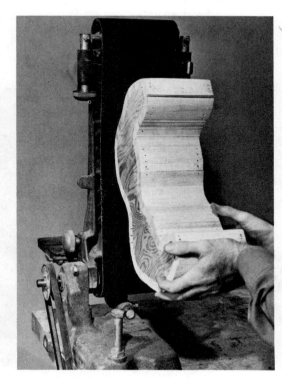

Figure 10–18
Stationary vertical belt sander.

stock. The tilting table also permits accurate sanding of angles.

The horizontal belt sander is used primarily for sanding flat surfaces. A backstop holds short stock on the machine; for long stock, the backstop is removed. With the end guard removed, inside contours can be sanded on the idler drum. Vertical belt sanders with tilting tables are used for contour and edge sanding in a fashion similar to the disc sanding. When operating the belt sander, from time to time, the belt may need adjustment so it remains in line with rollers and the platen or work surface. This is usually accomplished by turning the outside adjustment knobs on the idler wheel. Both adjustment knobs are turned to adjust belt tension. It is important that the belt alignment be maintained. If the machine is operated with the edge of the belt rubbing against the belt guard or machine parts, damage can readily result. Belt sanders are equipped with ¾ or 1 H.P. motors.

Narrow-belt vertical sanders are available for sanding difficult inside areas. On some machines, the belt is flexible and will follow curved contours.

Drum sanders are used for inside sanding of circles or convex contours. Drums range in sizes up to 3 inches in diameter and 6 inches in length. Larger diameters and lengths are used industrially. The typical small drum sander is like a shaper, with the drum mounted vertically on a spindle. The abrasive sleeve slides onto the rubber drum. If drum sanding is not frequently necessary in sculpture studios; instead of buying a drum sander, you can perform drum-sanding

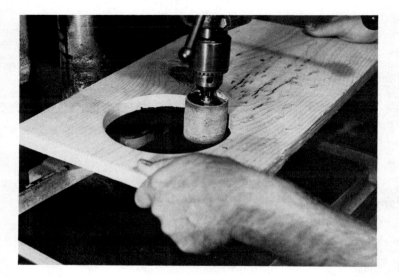

Figure 10–19
Drum sander on a drill press being used to sand an inside contour.

operations using a sanding attachment on a drill press, shaper, lathe, or radial-arm saw. (Figure 10–19)

PORTABLE SANDERS

Orbital, belt, disc, and drum sanders can also be portable. Air-operated sanders are available, as are the more common electric ones. Electric sanders are power-rated by amperage; ratings range from 2.5 amps, 115 volts for orbital sanders up to 8 amps for belt sanders, and up to 12 amps for heavy duty disc sanders. (Figure 10–20)

The orbital sander is used primarily for finish work. The sanding surface of the machine moves at a high speed in a circular fashion. The normal sanding-disc surface is designed to use one-third or one-half of a standard 9- × 11-inch sheet of sandpaper. The orbital sander is moved slowly back and forth across the surface of the board. The pressure should be moderate to light; excess pressure may overload the machine and cause the sandpaper to dig excessively into the wood. (Figure 10–21)

The belt sander is used either for coarse, moderate, or semifinish work. The belt moves in one continuous direction. Standard belt sizes are approximately 3 × 21, 3 × 24 and 4 × 24, depending on the manufacturer. When operating a belt sander, it is important to periodically check the belt to be certain that it is tracking properly. If it is allowed to track against the sander housing, it can cut into the metal and ruin the machine. A screw adjustment on the side of the machine is turned slightly to bring the belt into alignment. Follow manufacturers' recommendations for changing and adjusting belts. As with the orbital sander, excess pressure should not be necessary. Special, narrow belt sanders are available for working in narrow spaces. (Figures 10–22 and 10–23)

Disc sanders are used primarily for rough sanding or for sanding in contours and areas inaccessible to the orbital or belt sander. The right-angle, air-operated disc sander with a low profile is particularly useful and easy to handle. Standard disc sizes are 6, 7, and 9 inches. The disc sander must be handled carefully or the sanding disc will cut and gouge into the material being sanded. Power and performance of electric disc sanders are also rated by amperage or H.P. Satisfactory amperages would be 2.5 to 5 amps for light work, 5 to 8 amps for general studio work and 8 to 12 amps for heavy and continuous work. (Figures 10–24 and 10–25)

Sanding discs may be rigid or flexible, but flexible ones are usually used. The sandpaper disc is held

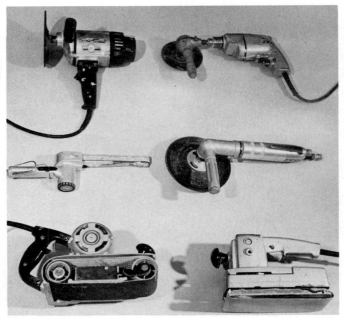

Figure 10–20
Portable machines for abrasive
finishing. Top left: horizontal electric
disc sander. Top right: small right-angle
sander mounted on an electric drill.
Middle left: narrow-belt air sander.
Middle right: right-angle air disc sander.
Bottom left: 4-inch electric belt sander.
Bottom right: orbital sander.

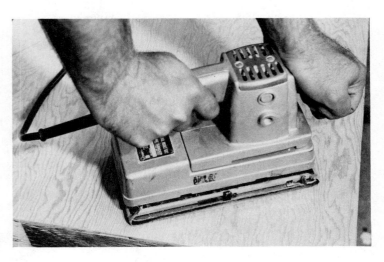

Figure 10–21
Orbital sander being used to finish a flat
surface.

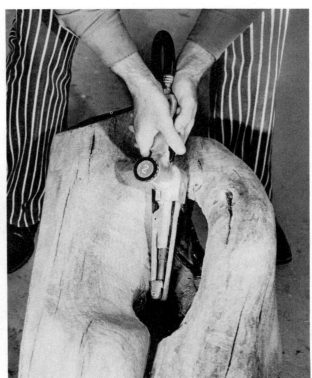

Figure 10–23
Narrow belt sander being used to sand inside
contours and hard-to-reach areas on a wood carving.

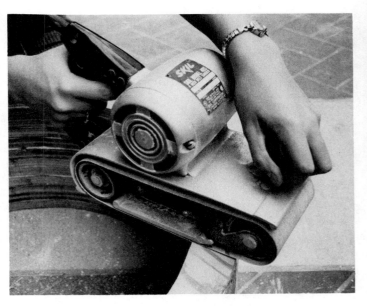

Figure 10–22
Belt sander finishing the edge of a
wood laminate.

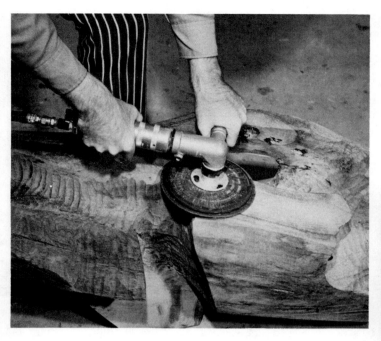

Figure 10–24
Disc sander with a flexible back being used to finish outside contours on a wood carving.

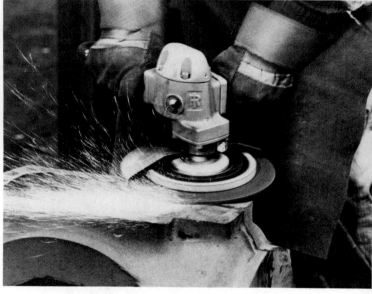

Figure 10–25
Disc sander on a heavy-duty operation, finishing a casting. *Photograph courtesy of Ingersoll-Rand.*

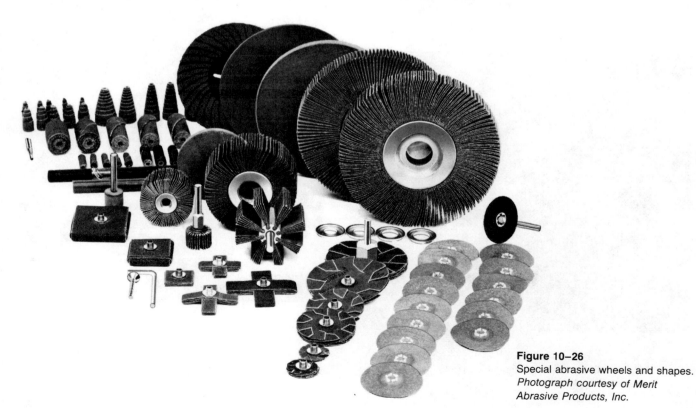

Figure 10–26
Special abrasive wheels and shapes. *Photograph courtesy of Merit Abrasive Products, Inc.*

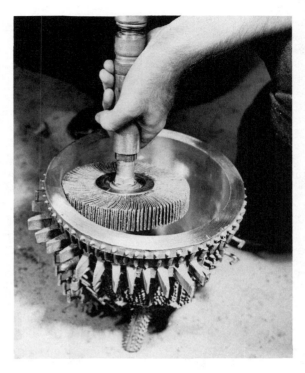

Figure 10—27
Flap wheel on a flexible shaft. It is being used to rough finish the inside of a cast bronze bowl.

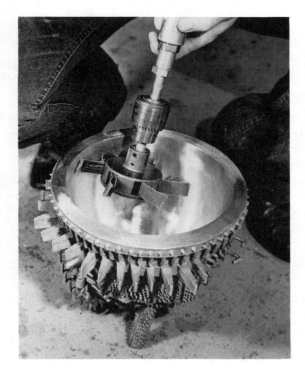

Figure 10—28
The Sand-O-Flex® wheel being used for intermediate finishing.

on the flexible rubber disc by means of a recessed tapered friction screw on the shaft of the sander. On rigid discs, the sandpaper is usually cemented or backed with adhesive. If sanding discs tear or become damaged, they should be removed and replaced immediately.

Drum sanders, used as attachments to air- or electric-drill motors or motor-mounted flexible shafts, consist of circular sanding belts or bands mounted on rubber drums. Sizes range from ¼ to 3 inches in diameter and ½ to 3 inches in width. Cones and other special shapes are also available. (Figure 10—26) Small-diameter sanding drums can be made by gluing fine sandpaper on wood dowels. For finishing sculpture, special-shaped sanding devices are exceptionally useful on portable equipment. Strips of sandpaper mounted on drums called "flap wheels," slotted discs, squares, and cross pads are used for sanding contours. The Sand-O-Flex® Wheel, manufactured by Merit Abrasive Products, Inc., is also excellent for this purpose; it is inexpensive and accommodates a variety of grit-sized rolls that are interchangeable. Small, rolled sandpaper cones and discs or abrasive rubber wheels are good for cavities and for hard-to-reach spaces. (Figures 10—27 and 10—28)

POLISHING AND BUFFING

Often, it is desirable to finish a material—particularly one with curved and irregular surfaces—with abrasives that are not on rigid or semirigid backing. In this case, polishing and buffing devices coated with suitable abrasives are used. The appearance of the final surface depends on the kind of abrasive selected, the grit size, the kind of binder (grease or greaseless), and the kind of buff used.

Although "polishing" and "buffing" are often thought of as interchangeable, "polishing" as used here means removing material but perhaps leaving lines or scratches on the surface; "buffing" means removing visible scratches to produce a final satin or high, mirror-like finish. Industrially, this is referred to as "coloring" or "color buffing." Polished finishes are produced with abrasive grit sizes from 80 to 220. Buffed surfaces require abrasives from 220 to 600, and special powdered compounds for mirror-like finishes. Polished surfaces tend to be satin or matt, or to possess a lustre, depending on the material and the abrasive used. Architectural metal work, hardware, and metal furniture often appear to have a fine line-scratched surface still present in the finish.

Material	Polish	Surface Feet per Minute	Buffing	Surface Feet per Minute
Aluminum	80–220 Aluminum oxide	4000–6000	Red rouge, tripoli, unfused aluminum oxide	6000–8000
Brass	80–220 Aluminum oxide	5000–7000	Tripoli, red rouge, silica, unfused aluminum oxide	5000–8000
Chrome	80–220 Silicon carbide	4000–5000	Unfused aluminum oxide	5000–6000
Copper and Copper Alloys	80–220 Aluminum oxide	5000–7000	Red rouge, tripoli, silica, unfused aluminum oxide	5000–7000
Plastic	220–600 Silicon carbide	3000–4000	Tripoli, silica, red or green rouge	3000–4000
Steel	80–220 Aluminum oxide	6500–8500	Tripoli, green rouge, unfused aluminum oxide	7000–9000
Stainless	80–220 Silicon carbide	6500–8500	Unfused aluminum oxide, pumice	7000–9000
Nickel	80–220 Aluminum oxide	5000–7000	Green rouge, tripoli, unfused aluminum oxide	5000–7000

Figure 10–29
Buffing and polishing chart.

Figure 10–30
Basic methods for sewing buffs.

sun ray buff

concentric sewed buff

square sewed buff

spiral sewed buff

curved tangent buff

loose type full disc buff

Figure 10–31
Some common buffs. From top, left to right: sewed buff, loose buff, sewed buff, sheepskin buff for disc grinder, cone buff, nylon abrasive buff, round buff.

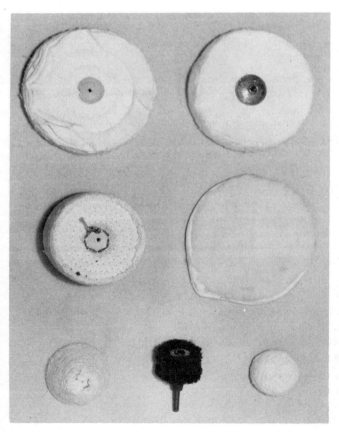

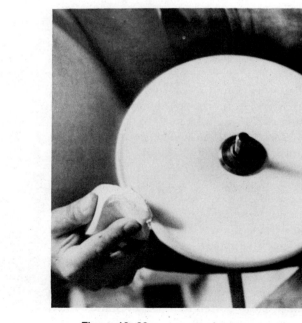

Figure 10–32
Compound being applied to a loose buff. *Courtesy of Roger Kotoske.*

Abrasives used in finishing are aluminum oxide, silicon carbide, emery, and fine powders of white silica, unfused aluminum oxide, chromium oxide, and tripoli. These abrasives are available in bar or powder form. The bars are formed by adding grease-like binders of fats or waxes, or greaseless water-soluble emulsions to the abrasives. Greaseless bars are often preferred today in manufacturing procedures. (Figure 10–29)

Buffs are produced in felt, sisal, sheepskin, or in a variety of fabrics, such as cotton, denim, flannel, and wool. The surface, density, and hardness of the cloth buff depends largely on the manner in which it is sewed: Close stitching results in harder buffs; radial and square sewing results in buffs with more pockets to hold compounds. (Figures 10–30 and 10–31) Hard buffs are used for polishing harder materials. Buffs with fewer stitches and made of lighter cloth are used on softer metals and on plastics. Loose buffs, with sewing only around the arbor hole, are used for coloring or for producing the final mirror-like finish. For polishing, use a felt or sewed buff; for buffing,

use a loose or ventilated buff. Sisal buffs can often be used without compounds to combine polishing and buffing operations. Ventilated or air-cooled cloth buffs are also excellent for final finishing. The most recent line of buffs on the market are synthetic fibered-nylon buffs that have aluminum oxide, silicon carbide, or flint bonded in the web-like material. These are used for coarse or fine satin finishes.

Buffing wheels, belts, and pads can be used on most sanding or abrading equipment, lathes, and drill presses; small wheels can be used with electric drills. (Figures 10–32 through 10–34) Hard materials, such as steel, can withstand higher buff speeds. Soft materials, such as plastic, require lower speeds.

BRUSHING

Besides polishing and buffing, another abrasive method is brushing. Brushes, which can be used for removing burrs, cleaning, surface finishing, and roughening, are available as wheels, cups, and special shapes for

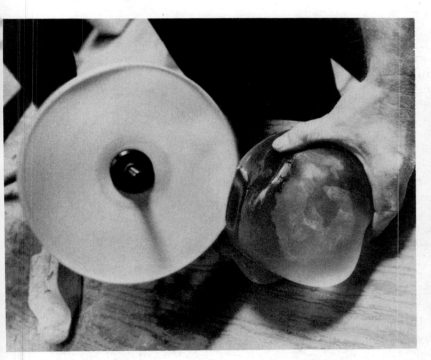

Figure 10–33
Cast plastic sculpture being buffed with a loose buff.
Courtesy of Roger Kotoske.

Figure 10–34
Buffing plastic with a spiral-sewn buff
mounted on a drill press.

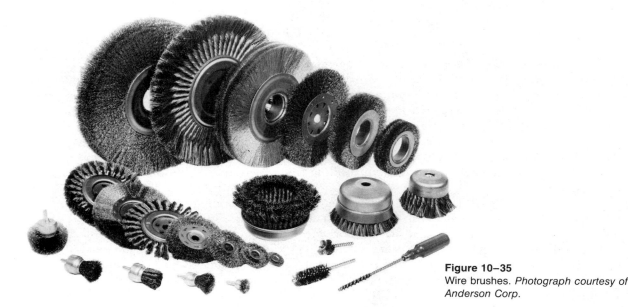

Figure 10–35
Wire brushes. *Photograph courtesy of Anderson Corp.*

getting into confined areas. Brushes can be made of steel, stainless steel, brass, bronze, beryllium copper, nickel silver, aluminum wire, tampico, or synthetic fibers. Brushes with wire diameters of .008 to .035 are used for removing burrs, rust, dirt, scale, and flashings on steel. Brushes from .005 to .014 are used on aluminum, brass, bronze, and copper. The wires can either be crimped (wavy) or straight. Crimped wire provides a softer continuous action; straight wire provides a more severe action. For fine finishing and buffing, tampico or synthetic-fiber brushes would be used with appropriate abrasives or buffing compounds. This is a good approach for buffing a textural surface whose surface cracks and crevices could not be reached with other abrasives. Buffing speeds are relatively low, averaging around 1700 to 3600 surface feet per minute. Wire-brush finishes on metal resemble line-scratch finishes produced by other abrasive methods. For final wire-brush finishing on nonferrous metals, stainless steel or nonferrous brushes should be used to avoid after-rust.

Brush speeds for finishing vary considerably. Surface-polishing speed is approximately 7200 surface feet per minute. Other speeds are: buffing, 7200; dry cleaning, 3600 to 5400; wet cleaning, 3600; removing rust, scale, burrs, and dirt, 5400 to 7200. Some of these approximate speed ranges can be achieved by using other different-sized brushes for slower or faster surface feet per minute or appropriate variable-speed equipment should be used. A motor equipped with a flexible shaft is versatile and can meet many finishing needs. Brushes can be mounted on most of the other abrasive-finishing equipment. Brush speeds should be close to the maximum recommendation. The pressure of the brush on the work should be

fairly light; excess pressure reduces the cutting action of the brush, accelerates breakdown, and reduces the life of the brush. Periodically rotating the brush resharpens the wire ends and maintains the efficiency of the brush.

In addition to wire brushes, steel wool is often used for hand finishing. It ranges in grades as follows: *3, 2, 1, 0, 00, 000, 0000.* Use the coarse grade 3 to remove rust, old paint, and scale; fine grades can be used for a line finish on metal; 0000 produces a satin finish on lacquer surfaces. (Figures 10–35 and 10–36)

Figure 10–36
Mounted wire cup brush being used in finishing. *Photograph courtesy of Ingersoll-Rand.*

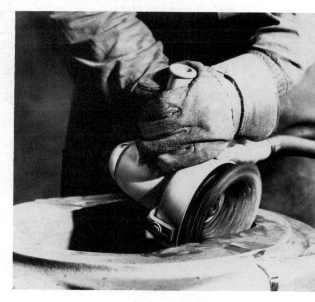

SHARPENING TOOLS

Maintaining sharp edges on cutting tools requires using abrasives, wheels, and stones. If a chisel, plane blade, or knife has become nicked or damaged, or if it has lost the proper angle, it is necessary to grind the tool to restore the flat cutting edge or bevel.

An aluminum-oxide, 60-grit hard wheel can be used on a bench- or pedestal grinder. The wheel surface should be flat. The tool rest is adjusted to a horizontal position; the flat chisel is pressed straight against the wheel and is moved back and forth to remove metal until a flat edge is restored. The tool rest is next set at a 30-degree angle, and the chisel is brought down onto the wheel with the flat blade pointed against the direction of rotation. Chisels and plane blades are normally beveled at a 30-degree angle. As the grinding progresses, the chisel may be dipped periodically in water to keep the metal cool and to avoid losing the temper. If a blue or black edge starts to appear on the edge, temper is being lost and the tool should be cooled more often.

Chisels and plane blades normally are hollow-ground. In other words, the bevel surface is slightly concave as a result of being grounded on the curved edge of the wheel. Wood-turning tools, most wood-carving tools, stone-carving chisels, axes, adzes, and plaster chisels are not hollow-ground. The bevel angles may also vary, depending on the particular tool. The simplest approach is to maintain the existing bevel angle. Flat chisels that are not hollow-ground are ground on the side of the grinding wheel. Gouges are ground on the face surface of the wheel by holding the gouge at an angle to the wheel, with the gouge resting on the tool rest. The beveled angle is rolled back and forth against the revolving wheel.

If the cutting edge is nicked on gouges or other tools, it is first ground flat as with chisel and plane blades. Except for a few double-edged chisels, all chisels are beveled from one side only. The other surface is kept perfectly flat. The grinding of the bevel continues until a burr forms on the chisel edge. At this point the chisel is ready to be honed on an appropriate oilstone.

To sharpen chisels without major nicks or faults, grinding is unnecessary, and abrasive stones can be used instead. As with other abrasive devices, abrasive stones can be made of either natural or synthetic materials such as aluminum oxide or silicon carbide. (Figure 10–37) The synthetic stones are fast-cutting and are used to develop preliminary edges. For most sharpening purposes, combination stones, with a coarse surface on one side and a fine surface on the other, are adequate. Stones are periodically lubricated with

Figure 10–37
Sharpening stones. Left to right: combination stone, gouge slip stone, round-edge slip stone.

thin oil during sharpening. This increases the cutting action of the stone and prevents the stone from becoming clogged with metal particles.

In sharpening a typical flat chisel, the chisel is held vertical to the coarse surface of the oilstone; it is moved back and forth a number of times to remove minor nicks. If the nonbeveled side of the blade has any burrs or nicks, the blade is placed flat on the stone and is moved in a circular fashion to remove them. Next, the beveled side of the chisel is placed on the stone at an angle so that the back side of the bevel just clears the stone. The chisel is grasped with one

Figure 10–38
Sharpening a chisel on a combination stone.

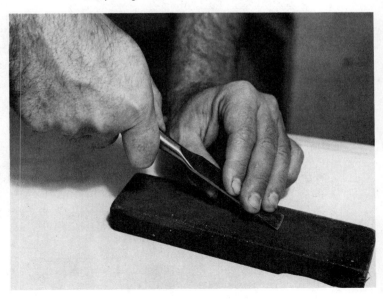

Figure 10–39
Sharpening a gouge on a gouge slipstone.

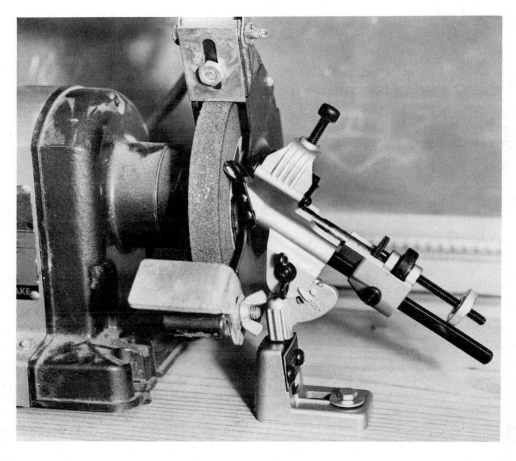

Figure 10–40
Grinder attachment for sharpening drill bits.

hand, while the fingers of the other hand rest on the chisel to apply pressure. (Figure 10–38) With the wrists rigid, the chisel is moved in a figure-eight or oval pattern. The sharpening continues until a fine wire edge is developed. The fine wire edge can be broken off by rubbing the chisel back and forth several times across a hardwood block. If a chisel had been machine-ground to this point, the wire edge would be broken off in the same fashion. It might be honed slightly on the coarse side of the stone prior to the final honing. For the final honing, use the fine side of the stone and apply fairly light pressure. With the bevel edge resting on the stone in the same fashion as previously described, move the chisel in a figure-eight or oval pattern. After light honing, turn the chisel over, with the nonbeveled side flat on the stone, and hone slightly. Keep repeating these two steps until the desired edge is achieved. The standard test for sharpness is to place the nonbeveled side against your thumb nail at a slight angle and push up; if the blade

readily slides off the nail, it does not have a truly sharp edge. It should bite slightly into the nail.

Most other flat chisels are sharpened in the same fashion, but gouges are honed differently: a gouge slipstone, concave on one side and round on the other, is used; the beveled edge is rocked back and forth on the concave side; the fine burr is cut off by placing the round edge of the narrow end on the stone, flat on the inside metal surface, and rocking it back and forth. (Figure 10–39) Axes, hatchets, and adzes are sharpened by holding the stone in your hand and stroking the edges. A wide variety of gouge slipstones and special shapes are available for sharpening auger bits, countersinks, knives, axes, shears, drill bits, and other tools. Special grinding wheels and grinder attachments are useful for drill bits. Although saws and blades can be hand-sharpened or filed, it is advisable to have this done at a saw-filing shop. (Figure 10–40)

Adhesive
Bonding

11

Although sculptors are generally skeptical of using adhesive bonds to connect metal to metal or metal to other material, such bonds are often stronger and more suitable than those made with other joining methods.

There are distinct advantages to using adhesives: Dissimilar materials and thin materials are easy to join; joints require less finishing; the load is bonded and distributed over a larger area; and the process is far simpler than welding or other joining methods. Adhesives can be formulated as pastes, liquids, tapes, or powders. Physically, they can be hard or soft, brittle or flexible enough to withstand a wide range of expansion (for example, when dissimilar materials are bonded).

Modern adhesive technology must be capable of the kind of performances required by the aircraft and aerospace industries. Numerous adhesives are available with sheer strengths as high as 3000 to 6000 pounds per square inch; some even exceed these figures. Obviously, serviceable adhesives and bonding techniques are available for sculptors as well.

In the past 10 years, the adhesive industry has developed at a tremendous rate. In fact, it is possible to find an adhesive for any material, or combination of materials, on the market today. Epoxies exist, for

example, that can be used on almost any material with excellent results. Although special fabrication problems may necessitate the use of other adhesives, epoxy formulations meet a wide range of adhesive needs; suitable for glass, brick, concrete, ceramic, wood, stone, plaster, and paper, they can be used to bond metal to metal or to bond metal or plastic to other materials. Such plastics as acrylic, polyethylene, or vinyl require special solvent-based cement to bond plastic to plastic. (Figure 11–1) Rubber is usually bonded with flexible urethane or rubber-based adhesives. Special adhesives for fabric, leather, felt, cork, and paper are also produced. Besides epoxy, silicones, polyurethanes, polyesters, acrylics, polysulfide rubber, cyanoacrylate, and neoprene phenolic are used in adhesive formulation.

Generally, readily available, room-temperature-cure epoxy should serve most of your needs. Epoxy has good adhesion to a wide variety of materials, is resistant to moisture and solvents, and can withstand varied temperatures, depending on the formulation; some are capable of withstanding short-term temperatures up to 1000 degrees. The epoxy adhesive is usually a two-component system. When the two materials are mixed, a chemical action called polymerization occurs. This can occur at room temperature or

Figure 11–1
This inflatable sculpture is a vinyl and
air experience, ca. 1968. Its seams
were joined with a heavy-bodied solvent
adhesive. *By Betty Voelker.*

at elevated temperatures attained by oven-heating the
article to be bonded. Curing time can be controlled
in the formulations to meet both rapid and slow as-
sembly problems.

Most hardware stores, department stores, and
so on, stock a reasonable line of epoxies and other
adhesives in small quantities. If they are manufac-
tured by such major material formulators as Devcon,
Bostik, or 3M, they are undoubtedly reliable. How-
ever, inexpensive substitutes should be avoided, be-
cause they may contain cheap ingredients and fillers.
If adhesives are regularly used, it is advisable to seek
a good industrial supplier or manufacturer who can
supply accurate data on the adhesive, its application,
performance, and required material preparation.

Any failure of an adhesive can usually be attrib-
uted to some fault in selecting it, preparing the ma-
terial being bonded, or applying the adhesive.

A few basic concerns essential to satisfactory
bonding are as follows:

1. Pay strict attention to manufacturers' instructions re-
 garding usage of the adhesive and surface prepara-
 tion of the material.
2. Do not vary recommended proportions of two-part
 systems.
3. Be aware that temperature is critical in many systems,
 if polymerization of the adhesive is to take place. Tem-
 peratures above room temperature (70 to 75 degrees)
 are not a problem, and merely accelerate curing.
 However, temperatures below room temperature may
 retard or affect completion of polymerization. (Infra
 heat lamps can be used to provide heat for curing if

necessary.) Some adhesives are designed for appli-
cations below 70 degrees; these utilize larger amounts
of catalyst or hardener.

4. The adhesive and material being bonded must also
 be at room temperature.
5. Use clean containers in all mixing operations; any
 contamination of the adhesive mixture may render it
 useless.
6. Observe safety procedures required for working with
 toxic materials. (See Chapter 15.)
7. For optimum results, surfaces being bonded must be
 cleaned. There are a few adhesives designed to stick
 to oily surfaces, but there is probably little reason for
 using them sculpturally.
8. The surface being bonded must be thoroughly dry.
 Solvents used in cleaning must be completely evap-
 orated.
9. The adhesive must thoroughly wet the surface, pen-
 etrating into the most minute pores of the material;
 this is essential to achieve the intermolecular contact
 between the surface being bonded and the adhesive.
10. Ensure that an adequate surface area exists; otherwise
 the bond will not be effective.
11. Temperature of the material in service must be con-
 sidered. This would be a concern for sculptors pro-
 ducing outdoor sculpture, for example, because
 sunlight can build up considerable temperatures on
 metal.
12. In industrial use of adhesives, the cleaning process of
 the material may become quite complex. The surface
 to be bonded should not be touched with your fingers
 after cleaning; oily fingerprints can seriously affect
 the performance of the bond.

The most typical cleaning processes involve a
solvent or detergent cleaning, followed by some form

of abrading, and then a final solvent or detergent cleaning. This seems to be adequate for many materials; however, in some cases, chemical etching and treatment are necessary to obtain optimum results. Final rinsing operations usually use distilled water because tap water contains some forms of contaminants.

Complex cleaning procedures are often not possible in the classroom or studio, so as a sculptor or student you have two alternatives. If you need optimum performance in the bond, you may need to have the cleaning or both the cleaning and the bonding performed by an industrial firm. If you do not require optimum performance, as is often the case, you can settle for a less complicated and practical approach. Reasonably good bonds can be obtained without chemical etching, which is often considered unnecessary for optimum results.

Solvent wiping or degreasing is essential to provide a grease- and oil-free surface for subsequent sandblasting or abrading. Abrading an oily surface would only result in the oil contaminants' becoming more embedded in the surface of the material. In solvent wiping, clean, white cotton cloths should be used. The cloths should be changed frequently to assure maximum cleaning of the surface.

Sand- or gritblasting should involve a clean, filtered air supply; oil or moisture in the air supply could contaminate the surface. Clean sand or grit should be used. In abrading surfaces, new sandpaper or emery paper should be used. The grit size of the paper is a matter of personal judgment; it depends on the material being bonded. The purpose of sandblasting or abrading is to improve the adhesive grip; the ridges and depressions formed increase the surface area and provide optimum intermolecular contact between the adhesive and the surface.

Solvent wiping or degreasing processes following sandblasting or abrading is a matter of removing any remaining contaminants and loose material particles from the surface. If vapor degreasing with trichlorethylene is possible, this is probably preferable. If the material is solvent wiped, it is conceivable that, unless you use extreme care and change cloths frequently, you might contaminate the surface more.

Wood surfaces to be glued should be dry and clean. On used material, old paint or other films must be removed to expose the raw wood fiber. The surface should be slightly roughed, sanded with fine sandpaper, or planed. To bond well-fitted joints, a white glue can be used, if the glue joint does not have to be waterproof. For waterproof gluing, resorcinal formaldehyde or epoxy glue can be used. In poorly fitting joints, an adhesive that has the ability to fill cracks and voids should be used; an epoxy paste or putty would be suitable. For large surface-to-surface areas, contact cements are often used. A good surface-to-surface joint which has adequate surface contact should be as strong as the wood, if it is properly cleaned, clamped, and allowed sufficient drying time.

Plaster and porous materials such as stone, brick, and concrete can be bonded with epoxy adhesives. The material must be clean. Abrading with sandpaper, wire brushing, or sandblasting is acceptable. Dust should be blown off with an air hose. For coarse, highly porous materials a fairly heavy-bodied adhesive should be used.

Before bonding smooth, nonmetallic surfaces, such as glass or ceramic, should be degreased with a detergent or solvent, dried and sandblasted or abraded with emery or silicon carbide paper. All dust should be wiped or blown off the surface. More complex processes, from which optimum results are desired, often use solvent wiping or degreasing after the sandblasting or abrading. For glass, the surface can be etched by dipping in a solution of one part chromium trioxide by weight to four parts distilled water. The glass is then washed with distilled water, dried, and heated at 210 degrees for 30 minutes. The adhesive is applied while the glass is hot.

Rubber can be wiped with toluene or naphtha, or it can be etched by immersion in concentrated sulfuric acid for 5 or 10 minutes. It should be thoroughly washed and dried. The material should be flexed prior to application of the adhesive. Epoxy, flexible polyurethane, rubber, or other proprietary adhesives can be used.

Metals with adequate surface area for bonding can be bonded with epoxy adhesives. Steel, zinc, tin, nickel, lead, cast iron, silver, copper, and copper alloys can be degreased or solvent-wiped, sandblasted, or abraded with emery paper; they can then be degreased or solvent-wiped again and bonded after being dried thoroughly. Vapor degreasing in trichloroethylene is preferred. However, if this process is not available, the material can be solvent-wiped with trichloroethylene, or acetone. For optimum results, copper and copper alloys are often immersed in concentrated nitric acid (thirty parts acid by weight) and water solution for a few seconds. The metal must be thoroughly rinsed and dried. Stainless steel or aluminum can be epoxy-bonded after having been sandblasted with a fine abrasive. Adhesive bonding of plastic is achieved by using heavy-bodied adhesives that bond the two materials together, or solvents that dissolve the surfaces of the materials, causing them to bond. A wide variety of adhesives is available for specific plastics.

Surface preparation is always important. Plastic

should be solvent-wiped, abraded, and again solvent-wiped, and then the adhesive can be applied. The solvent should be allowed to evaporate fully prior to adhesive application. Nylon, epoxy, reinforced plastics, melamine, formaldehyde, furane, formica, and phenolics plastics can be solvent wiped with acetone and sanded with medium grit emery paper, followed by a final solvent wipe. Acrylic, polyethylene, tetraphthalate, polystyrene, polycarbonates, and cellulose plastics are solvent wiped with methyl alcohol and abraded with fine emery paper, followed by a final wipe with solvent. Fluorocarbons, such as Teflon®, require special etching solutions.

For bonding plastic to wood, metal, or other surfaces, an epoxy adhesive can be used; or, sometimes, adhesives related to the plastic to be bonded can provide better bond. Special heavy-bodied adhesives for vinyl or polyethylene and polystyrene foam are also available.

SOLVENT CEMENTING

Solvent cementing is a bonding process unique to solvent-sensitive materials such as plastics. In many cases, it is one of the most preferable fabricating techniques. The common methods of solvent cementing are joining by capillary action, dipping, soaking, and sponging or brushing the solvent onto the material. In this process, the solvent softens and dissolves the surface of the two areas to be joined, which makes it possible to cement them together. Good-fitting joints are needed for this process, particularly if the cementing is by capillary action. If joints are not well fitted, there are viscous solvent cements consisting of a mixture of the material and the solvent. These help make slight fills in the joint to ensure optimum strength. Viscous solvent cements can be made by dissolving filings or scrapings of plastic into its solvent.

The toxic level of a solvent should be determined prior to its use, and appropriate working conditions should be arranged.

When joining parts by capillary action, the parts are placed in the desired position and a drop of solvent is deposited at the edge of both sides of the joint with a small brush or hypodermic syringe. The solvent flows into the seam by capillary action. (Figure 11–2) Special cement-resisting tape can be used along the edges of the joint to prevent the solvent from bleeding out onto the finished surface. Capillary cementing is ideal for fast assembly. However, to achieve good, permanent joints on material such as clear plastic is often difficult: Excess heat on cut edges during sawing can set up stresses that later produce crazing, and

excess humidity can produce cloudy effects; in addition, prolonged exposure to weather, crystallization can occur if ethylene dichloride or methylene chloride is used as a solvent. Cementing at temperatures below 70 degrees can result in weak and ineffective bonds. Special cements to minimize these problems can be obtained.

For dip or soak cementing, about ⅛ inch of solvent is placed in the bottom of a glass, stainless steel, aluminum, or galvanized metal tray. Place some lengths of ¹⁄₁₆-inch stainless steel or aluminum welding rod across the bottom of the tray to support the edge of the plastic and to keep it from touching the bottom of the tray. The piece of plastic can be held upright in the tray, using a wooden jig, as in solvent cementing. (Figure 11–3) As soon as the edge is softened, it is lightly pressed and held in place. The soft edge will have a softening effect on the surface to which it is being bonded. Weights and jigs can be used to hold the piece in place until the joints have set. Soak cementing should be used if high strength is desired and the piece is to be placed out of doors.

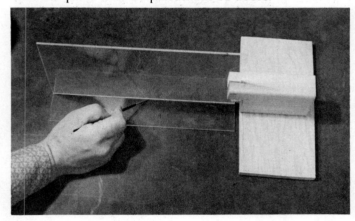

Figure 11–2
Solvent cementing acrylic by capillary action.

Figure 11–3
Dipping or soaking plastic for cementing.

Figure 11–4
Holding plastic at an angle with metal strips and clamps.

When working with acrylic, strength and quality of a cemented joint can be improved by annealing, which should take place after the work has been completely assembled and finished. A circulating-air oven with temperature control is needed for annealing, although a kitchen oven can be used for small parts. A simple annealing oven can be built out of insulation board or an old washer, dryer, or refrigerator case.

The safest approach is to anneal at a low temperature for a long period of time. Materials up to 1½ inches thick can be annealed for 24 hours at 160 degrees. Slightly higher temperatures, such as 175 to 180 degrees, will reduce annealing time to 8 hours for thinner materials and to 12 hours for materials

from 1 to 1½ inches thick. Although annealing can be accomplished at higher temperatures over a short period of time, deformation of the part may occur; sample runs are recommended before attempting high-temperature annealing.

Solvents can also be applied to the edge of the material with a small brush; the solvent is repeatedly applied until the edge has softened and has a good wet appearance; at this point it is then set into place and supported until dry.

Any bonding operation requires procedures for holding the material in place while the bond cures. For thick, stacked materials such as wood lamination, use bar clamps. C-clamps and spring clamps can be used for clamping strips and edges. Flat pieces of material can be held in place with weights. To hold materials vertical, as in solvent-cementing plastics, special jigs or clamps often need to be developed. Flat pieces can be held upright using wooden jigs, as in Figure 11–2. When necessary, parts can be weighted down with cloth bags filled with metal washers, nuts, bolts, or steel shots. Flat pieces of sheet metal can be bent and held with spring clamps or cloth pins to keep pieces of material at an angle. (Figure 11–4)

Joint design is important when working with adhesives. Adequate surface area must be provided for the bond. Most joints are similar to wood joints or modified joints to produce maximum amounts of surface area. Joints that produce stresses at an angle should be avoided; they should be designed to put a uniform load on the bonded areas. The load should be tensile or shear. Cleavage and peal stresses should be minimized or avoided. (Figures 11–5 and 11–6)

Figure 11–5
Basic structural conditions for adhesive bonding.

Figure 11–6
Common joint designs for metal.

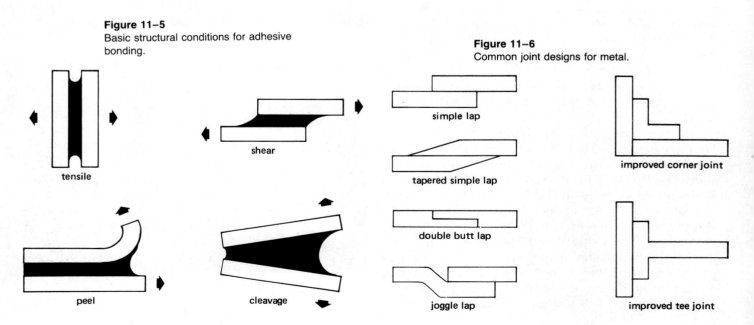

tensile

shear

peel

cleavage

simple lap

tapered simple lap

double butt lap

joggle lap

improved corner joint

improved tee joint

Electrical Devices

12

Sculpture of the past few decades has been characterized by experimentation with new material; other technological influences have been present as well. In particular, electrical and mechanical devices normally associated with industry have, in recent years, found sculptural application. Energies produced by materials have also been investigated. Experimentation with air, water, light, magnetic forces, fire, explosives, smoke, soap suds, dissimilar liquids, heat, and solar energy have extended the sculptor's horizons to include any device or material with a potential to provide visual effects.

Consequently, sculptors need information and techniques not ordinarily associated with sculpture. The extent to which they become involved in these new areas is, of course, relative to the sculptural problems they are trying to solve. These may vary from simple problems involved in constructing light, mobile, or fountain sculpture, to complex problems requiring mechanical or electrical engineers, chemists, physicists, mathematicians, or other specialists. In fact, the sculptors' concepts may be such that they cannot be realized without collaboration with other specialists. Organizations such as Experiments in Art and Technology, Inc. (E.A.T.), in New York, and the Centre for Advanced Study of Science in Art, in London,

were formed to meet these needs. Today, many artists throughout the country are working with specialists in industry to solve their problems.

Primarily, this chapter presents basic electrical and mechanical information that should help sculptors solve simple problems; simplified books on technology designed for the hobbyist and amateur provide further information that may help sculptors communicate with specialists in technical areas.

A basic understanding of the principles of electricity is almost essential, because many light, water, or kinetic forms use electric power as their source of energy. In working with electrical energy, *volts, amperes, Ohms,* and *watts* are the four terms encountered most often.

Voltage is the force of the energy being applied, like the pressure that is applied to water in order to force it through a pipe. Typical voltage in homes, shops, galleries, and buildings is usually 115–230 volt, single-phase alternating current (A.C.), 60 cycle; in this case, each wire alternates polarity, being positive sixty times per second and negative sixty times per second. In other words there would be current in the circuit 120 times per second. In alternating current (A.C.), three phase, the circuit would have three cycles of 120. Higher voltage, such as 220 or 440, three-

phase, might be used on large fountains, motors, or devices requiring large quantities of power. Lower voltage might be used for smaller systems using motors, pumps, and other electrical devices when higher voltage is not considered safe or desirable. Lower-voltage systems are provided with batteries or transformers that reduce the 115-volt system to the desired voltage. Typical low-voltage systems might supply 6, 12, or 24 volts. In D.C. or direct current, one wire is always positive, and the other is always negative; the current flows in one direction. Batteries and battery-operated devices are D.C. In purchasing electrical motors or other components, it is essential that they be designed for the kind of current to be used.

Amperage, the measure of power or current being used, is like the amount of water flowing through a pipe when a given amount of pressure is applied. One ampere per second passing a given point is the current strength produced by 1 volt acting through a resistance of 1 Ohm. An Ohm, the unit of resistance produced as the current passes through the wire or conductor, is like the resistance in a water line due to friction and the diameter of the pipe.

If two of these three factors are known, the third can be calculated: Amps can be computed by dividing the voltage by the Ohms; voltage can be determined by multiplying amps and Ohms; Ohms can be determined by dividing amps into the voltage. The total amount of electrical energy is normally described in watts, which are found by multiplying the volts times the amps. Or, if watts and voltage are known, amps can be determined by dividing volts into watts.

Some common concerns in working with electric power are:

1. The voltage of the system and whether the system is A.C. or D.C.
2. The total amperage or watts of the system and individual circuits.
3. Utilizing proper wire size in relation to amperage and the distance that the wire must travel.
4. Ensuring that switches and control devices are attached to the proper colored wires in the circuit.
5. Ensuring proper color coding of the system.

Concern for the voltage of the system is a matter of efficiency and safety. Large motors and devices are more efficiently operated at higher voltages; lower-voltage systems are often desirable to eliminate the hazard of electrical shock. Although A.C. is normally used, sometimes it is desirable to use D.C. with a battery-operated system or a rectifier to convert A.C. to D.C. In this case, it is important that the motors or devices are designed for D.C. operation.

Computing the total amperage or watts of a system is important, because it is essential to providing electrical power for the system. In commissioned work with permanent installation, the electrical contractor must have this information in order to provide proper conduit, wire, switches, and fuses. The typical gallery or household circuit has a 15- or 20-amp capacity. It would be pointless to design a light box or other electrical device with high amperage requirements if it were intended for general exhibition or sale where it would be plugged into a standard 15- or 20-amp circuit.

WIRING

Wire size is also important because it is concerned with the amount of current and the efficiency with which the current can travel along the wire. Excess amperage in relation to wire size results in inefficient flow of current; it is also hazardous. Although protective fuses are present in circuits, without proper fusing an overloaded wire can become hot enough to burn and start a fire. Motors cannot operate efficiently on undersized wire; they may overheat and burn out unless protected by thermooverload switches. Besides the size of the wire, the distance the wire has to travel is important; wire size should increase as distance becomes greater. Figure 12–1 shows some approximate wire sizes in relation to distance. (Figure 12–2) In addition to selecting the right wire size, the color of the insulation of the wire must be considered: a white wire indicates the neutral ground; a black wire indicates the hot wire in the circuit (at times this may be another color such as red); a green wire, used for grounding the device to prevent electrical shock in the event that a short or malfunction occurs in the system, should always be used whenever an electrical circuit is near materials that can conduct electricity (such as lighting or motors on metal sculpture and submersible pumps or lights); the ground wire is connected to the metal housing of the object.

Single-pole switches or devices that break the circuit are fastened to the black or hot side of the circuit; double-pole switches are attached to both wires. Terminals on electrical switches and receptacles are often chrome or brass in color. White wires are attached to the chrome terminals, whereas the black or hot wires are attached to the brass. In designing sculpture with complex circuits, some color-coding system should be devised. A diagram of the wiring should accompany the work so that an electrician could service the sculpture if necessary.

Amperage	Distance in Feet						
	50	100	150	200	250	300	
10	14	10	8	6	6	4	Wire size
15	12	8	6	4	4	4	
20	10	8	6	4	2	2	
30	8	6	4	2	2	1/0	

Figure 12–1
Chart of wire sizes in relation to distance for 115 volts.

Wire Size	Ampacity
14	15
12	20
10	30
8	40
6	55
4	70
2	95
1/0	125
2/0	145
3/0	165

Figure 12–2
The ampacity for various wire sizes.

Figure 12–3
Typical conductors: (A) three-wire motor cord with rubber insulation; (B) heat-resistant stranded wire, teflon coated, asbestos fire-resistant insulation; (C) flexible heater cord, stranded wire, rubber inner insulation, asbestos outer insulation with outer fabric cover; (D) lamp cord, stranded wire with plastic insulation; (E) small-gauge solid-wire, low-voltage, plastic insulation; (F) armored cable, two number 14 wires, plastic insulation with paper wrapping; (G) type N.M. three wire, two plastic-insulated and one paper-wrapped ground wire with an outer layer of plastic; (H) lamp cord, fabric-wrapped stranded wire; and (I) two-wire motor cord, stranded wire with rubber insulation, paper-wrapped with rubber outer insulation.

Standard electrical components that can often be used in sculpture are conductors, connectors, conduit for the wiring, switch and outlet boxes, switches, plugs and receptacles, lamp sockets, terminals, solderless connectors, sensors, transformers, programmers, and timers. Conductors normally consist of insulated copper wire. Typical wire gauge runs from 18 to 0000; 18 is the smallest diameter and has about a 3-amp capacity; the 0000 has about a 225-amp capacity. Much smaller gauges and wires, normally used in the electronic industry, are also available. Conductors may be solid or stranded for more flexibility. Insulation on the wire, which is usually rubber or plastic, can also be paper, asbestos, glass, cloth, or woven-glass cloth; often, combinations of these materials are used. The kind of insulation and wire to use depends on the voltage and the application; for example, a standard wire with a rubber inner insulation and a fabric outer insulation might be used in close quarters in metal housings. Conductors with asbestos or other heat-resistant material would be used in heating devices. Conductors with an inner rubber insulation wrapped with jute and an outer rubber insulation would be used in damp places. Cables, or wire ordinarily used for wiring buildings, when a lot of current will be used. The most commonly used wire is type T, which has a plastic insulation over a copper wire. Cables are nonmetallic-sheathed or armored. Nonmetallic-sheathed cables have three type-T wires, each individually wrapped with paper over the insulation, and all three enclosed in a moisture- and fire-resistant, braided fabric; spaces between the wrapped wires are filled with jute or cord. Armored cables consist of three insulated wires wrapped in paper inside a flexible spiral-steel covering. (Figure 12–3) Connectors are used to fasten heavy wires together and to fasten cables or conduit to switches and junction boxes.

Conduit, normally used when the wire or cable needs protection against possible damage, is classified as *rigid*, *thin-wall*, or *flexible*. The flexible conduit is similar to armored cable. Conduit is ordinarily made of steel with a rust-resistant coating, but bronze conduit and fittings, used in moist or wet surroundings, are also available. Bronze sculpture or fountains with built-in lighting would use this material. Submersible,

bronze light-fixture junction boxes and other fittings are used in pools. Steel conduit would be used in wood, steel, or concrete sculpture containing built-in lighting or other electrical features. Another form of metal covering is a raceway, which is a metal strip used to protect surface wiring. Special elbows, tees, switch boxes, and outlet boxes are designed to be used with raceway stripping.

Metal switch boxes, outlet boxes, box covers, and fittings are used with conduits to produce a completely metal-enclosed electrical system. (Figure 12–4) These metal boxes have punch-out holes to accommodate conduit fittings or connectors. Bronze waterproof boxes have threaded holes to produce water-tight fittings between the threaded pipe and the box.

Switches, used to open and close circuits, are either single pole or double pole. As stated earlier, single-pole switches are attached to the black or hot wire in the circuit; double-pole switches, to both wires. A switch is selected on the basis of the amperage load it is expected to carry, and is marked with its amp capacity. In addition to the typical toggle switches we see on walls for control of lights, there are push-button, rotary, and feed-through switches; the pendant is another form of push button; knife switches, which have hinged blades that clip between two contacts and are enclosed in a metal box, are ordinarily used to turn complete circuits off and on.

The relay switch is operated by an electromagnet controlled by a manually operated switch. When the magnet is energized, the magnetic force closes the contact points on the relay. Relays can handle greater amperages and voltages than the typical manual switches. Locating a relay close to a device requiring high amperage or voltage allows the device to be turned off and on from a remote point. Because the amperage required to operate the relay is a fraction of the amperage required for the device, the wiring from the relay to the manual control switch can be much smaller. Relays are also used as overload-protection devices on motors. (Figure 12–5)

The standard plug for 110 volts has either two or three prongs. The three-pronged plug, used when a ground is necessary, consists of two parallel flat prongs and a U-shaped prong. Prongs are positioned differently on plugs for a 220-volt circuit. In fact, the wide variety of different sizes of prongs and plug configurations ensures that an electrical device cannot be plugged into an inappropriate circuit. Also available are twist-lock plugs that lock into the receptacle to prevent accidental removal of the plug. The plug receptacle is designed with holes to receive the appropriate plug. The configuration of the holes denotes the ampere capacity and the volts of the circuit. Multiple-pronged plugs and corresponding receptacles may be used in electrical components when disconnection of complex circuits is required. (Figures 12–6 and 12–7)

Light-bulb sockets designed to receive screw, bi-post, or bayonet-type bulbs are available in a variety of sizes that correspond to the sizes of bulb bases. Some may have switches as an integral part of the

Figure 12–5
Switches. Top row, left to right: typical toggle switch, knife-blade switch, rotary switch. Bottom, left to right: push-button switch, feed-through switch, toggle switch.

Figure 12–4
Metal fixtures for enclosed circuits. Left to right: box cover, conduit, elbow, outlet box, connector to fasten conduit to box, coupling to join two pieces of conduit.

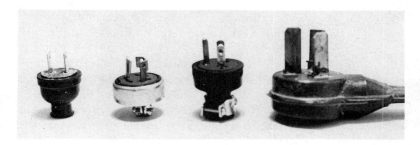

Figure 12–6
Plugs. Left to right: two-prong straight-blade plug; twist-lock three-prong 115-volt plug; three-prong straight-blade, 115-volt plug; three-prong straight-blade, 230-volt plug.

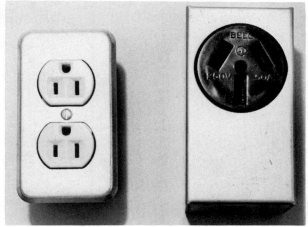

Figure 12–7
Typical receptacles. Left: three-prong straight blade, 115-volt. Right: three-prong straight blade, 230-volt.

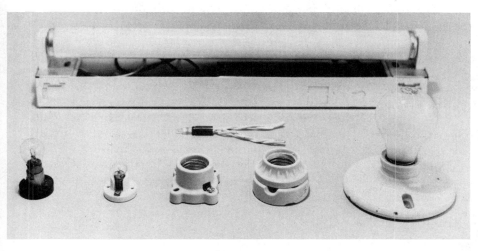

Figure 12–8
Lamp holders. Top: fluorescent fixture and bulb. Center: minature bulb and socket. Bottom, left to right: small bayonet socket, small screw-base socket, two standard-surface cleat sockets, and outlet-box socket.

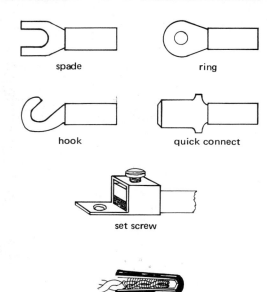

spade

ring

hook

quick connect

set screw

spliced wire

Figure 12–9
Solderless connectors.

socket. A variety of porcelain and bakelite sockets ordinarily used with incandescent or fluorescent bulbs are useful in building lighting devices. (Figure 12–8) Miniature light sockets are available from electronic supply houses.

When wires are fastened to terminal screw points, it may be desirable to have more positive contacts than are achieved by simply fastening the wires to the terminals. In such cases, terminal connectors would be used. These are small spade, ring, quick-connect, or hook-shaped devices that are either soldered or crimped onto the wire. A special crimping tool is used for crimp-style connectors. Some terminal connectors employ set screws that fasten the wires in the connectors. (Figure 12–9)

Solderless, plastic connectors, used on spliced

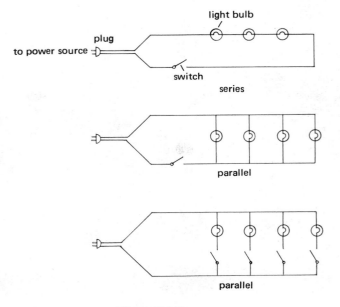

Figure 12–10
Basic electrical circuits.

wire ends in place of tape insulation, have spiral-wire or threaded-metal inserts which are screwed onto the twisted wires; the connectors must screw over the twisted wires to the extent that they also cover the insulation on the wires.

Resistors are used in circuits to control the flow of current. The variable resistor (rheostat) is typically used in light sculpture and in environments to increase or decrease levels of illumination. Motorized rheostats that can be set for different time sequences can produce automatic variable lighting.

Sensors, somewhat like switches, can control electrical or mechanical devices by reacting to phenomena such as temperature, humidity, light, sound, vibration, or air pressure: The thermostat that controls and maintains the temperature in a building is a form of sensor; kilns and furnaces use sensors to control temperature; photoelectric cells sense changes in light intensity; wind control devices for fountains sense air pressure or wind velocity. Many of these devices can be adapted to kinetic and environmental sculpture. The color organ, which reacts to sound, has also been used extensively in light sculpture and environments. Typically, different channels respond to different tone groups, and each channel is attached to a series of colored lights. As music is played, the lights turn off and on depending on the musical tones. Color organs also respond to human voices or other sounds and may have up to eight channels. In working with color organs, the watt capacity of the channel must be observed.

Programmers and timers, concerned with controlling a circuit or circuits, might be simple, mechanical devices using clocks or motorized switches, or complex electronic instruments using capacitors, resistors, and triode tubes combined with relays. Clocks and motorized timers are readily available from industrial electrical suppliers. Complex electronic timers are custom-designed for specific needs. Timers or programmers, used in light sculpture to turn light circuits on and off at varying intervals, are also used in fountain design to vary illumination on the fountain or to energize solenoid valves for changing water patterns.

Two forms of circuits are used in wiring electrical devices; series and parallel, as well as a combination of the two. If, in wiring a group of light bulbs for a light sculpture, you fasten the wires to the terminals of the receptacles so the current must pass through one bulb to get to the next, you have a series circuit; when one bulb burns out, the circuit is opened, and current cannot pass on to the remaining bulbs. In a parallel circuit, each bulb receives its current independently of the other bulbs. (Figure 12–10)

An electrical circuit normally consists of four parts: the electrical force or current, the conductor or wire to carry the current, a load such as a light bulb or motor, and a means of control such as switches, fuses, relays, or rheostats. Most simple wiring systems involving more then one load or device use parallel wiring. Series-parallel wiring is often used in more complex electronic circuits with groups of resistors and other devices. Control devices are wired in series with the devices to be controlled.

LIGHTING

Lighting devices have served many purposes in contemporary sculpture. One of the simplest is to illuminate forms or materials. Light-transmitting materials, such as plastic or glass, combined with light have produced visually dynamic forms. Some sculptors have used light fixtures and devices in environmental settings to create environments of light and form; others have explored the shapes and luminous qualities of light bulbs and fixtures in a more traditional sense, treating them as forms or parts of forms. Combined with mirrors, lenses, and projection devices, light boxes with changing patterns and projected environments of colored images have been produced. *The Unique Lighting Handbook*, published by the Edmund Scientific Company of Barrington, New Jersey, is a good source for lighting-project ideas and devices.

LIGHTING DEVICES

The light bulb, the fluorescent tube, and the neon tube or bulb are the three primary sources for illumination in light sculpture.

The light bulb is an incandescent lamp consisting of a tungsten filament in a glass bulb. When current passes through the filament, it becomes white hot and produces light. Air is removed with a vacuum pump from the bulb to prevent the filament from burning out. Nitrogen and argon gases are placed inside the bulb to extend its life further. Watt rating indicates the amount of light the bulb will produce; standard bulbs have from 15 to 1500 watts; small appliance and indicator lamps have from 3 to 100 watts.

Miniature bulbs with lower watts and voltage are often designed for direct current and can be operated from batteries. A typical 1½-volt miniature bulb can be as small as ¹⁄₁₆ inch in diameter and ⅛ inch in length.

Normal bulb life is from 750 to 1000 hours; extended-service lamps have a life up to 2500 hours but produce less light; some miniature low-voltage lamps have a life expectancy of 15,000 hours. Using 130-volt, industrial bulbs on a 115 to 120 circuit will give longer bulb life.

Although we normally think of light bulbs as being pear-shaped like household bulbs, bulbs also can be conical, global, tubular, straight-sided, or other shaped. Some of these are available in a limited range of color. (Figure 12–11)

Most bulb bases are bipost, screw, bayonet, prong, contact ring, or wire terminal. Wire terminals are usually limited to miniature bulbs. Screw bases turn into the receptacle, whereas bayonet types are held by an interlocking spring action between the base and the receptacle. Bipost and prong bulbs insert into the receptacle. (Figure 12–12)

The fluorescent lamp consists of a glass tube, starter, and ballast. As the filament in the tube heats, the starter breaks the flow of current. This sudden break in the current causes a high-voltage kick from the ballast, which is essential to starting the current to flow between two filaments in the tube. As a current flows, argon gas in the tube reacts with mercury, producing ultraviolet light. The light strikes the phosphor coating inside the tube, causing it to glow and produce light. As with the incandescent bulb, air is removed and a vacuum is provided in the tube.

Fluorescent tubes are available in diameters of ⅝ to 2⅛ inches, to 96 inches long. The 6-inch tube is 4 watts; a 96-inch tube could be up to 200 watts. Tubes folded in circles and square configurations are also

Figure 12–11
Some common bulb shapes.

pear shape reflector R.B. shape

parabolic aluminized reflector tubular **globular** G.A. shape

arbitrary cone shape arbitrary pear shape straight side

screw double contact medium ring

bipost bayonet

Figure 12–12
Basic bulb base types.

available. Fluorescent tubes require less current to operate, produce more light, and last longer than other bulbs; the typical life is 7,500 hours. Tubes are designed to produce cool, warm, or tinted light; yellow, red, green, pink, blue, and black light tubes are available.

Fluorescent light bulbs are also available. They come in cylindrical, spherical, or conventional light-bulb shapes. The design is achieved by fitting miniature folded tubes inside the bulbs. The ballast and starter are mounted external to the bulb location.

The neon tube consists of a glass tube filled with neon or other forms of rare gas, such as argon, helium, xenon, or Krypton. It is commonly available in 4-foot lengths, but longer lengths can be made by melting the ends of two pieces and sticking them together. A high-voltage transformer is attached to an electrode on each end of the tube. As current from the transformer passes through the tube, the molecular activity of the electrically charged gases produces light. Neon sculptures sometimes use several tubes and transformers to achieve the desired effect.

Colors in neon result from the combination of gases used, the addition of mercury in the tube, and the filtering action of colored glass tubes. Using fluorescent coatings in the tube further extends the color range to about forty possible colors.

Because of the high voltage of the transformers (2000 to 15,000 volts), all electrical fittings on a neon tube must be well insulated. All cable or wiring must be coated with a high-resistance insulation capable of withstanding 15,000 volts of more. Porcelain or pyrex housings are used to enclose all terminals and connections.

Quality neon tube must be made with precise fabrication techniques. The interior of the tube must be free of all impurities. The kind and amount of gas, the amount of vacuum, the voltage, and the electrode material being used are all critical and related factors.

Learning to do all phases of neon work would take considerable time. The most practical approach would be to have a neon sign company simply do the fabrication for you. This approach, however, has considerable limitations—for example, you are limited to the skills, technology, and imaginations of the workers in the sign shop. A compromise solution would be to learn as much as possible about the process, to learn to do the glass work, and to become more involved in forming the glass shapes and in developing methods and technology to handle the material. Then you can have the sign company do the rest of the process.

Learning to bend glass, for instance, is not difficult. This is particularly true if you have welded or forged metal or if you have worked with metal and are able to recognize its color at various temperature ranges. Simply taking some practice lengths of tube, heating them one at a time over a burner, and noticing the color and working condition of the glass as you try to bend it should help you produce results.

For relatively sharp bends hold the tube over the cross-fire burner and rotate as the glass is heating. When the color appears right, remove the tube and slowly bend. A small cork is placed in one end of the tube. Then blow slightly into the other end of the tube, while bending; this prevents the inside circumference of the bend from collapsing. Larger circumference circles and curves are made by heating the glass over a ribbon burner. The length of the flame on a ribbon burner is adjustable in relation to the size of the curve being made. (Figures 12–13 and 12–14)

After the tubes have been bent and joined to form the shapes you want, you are ready to attach the electrodes. A small connecting tube is attached to the electrode or to the side of the tube section. The vacuum hose is attached to the small connecting tube. The vacuum pump is turned on and air pressure is reduced in the tube. A valve then closes off the pump from the tube and pressure is trapped in the tube. Next a bombarding transformer is connected to the electrode. The transformer is turned on and the valve is opened momentarily several times to clean out the impurities. The valve is then closed and the bombarding transformer is turned off, bombarding is then again started until the tube gets hot enough to char a small piece of newspaper and the electrodes glow red hot. The bombarding is now turned off, the valve remains open, and the vacuum pump is started to create additional vacuum in the tube. When proper vacuum is indicated on the vacuum pump gauge, the valve is closed and the pump is stopped. The valve on another line leading from the connecting tube to the neon gas supply is momentarily opened and closed. This is repeated several times until the pressure gauge on the line indicates that sufficient gas is in the line. At this point the small connecting tube would be sealed with a hand torch. If needed mercury would be added at this point.

The unit is now attached to the proper transformer and current is passed through the unit to age and stabilize the gas. After several hours the unit should have stabilized to its full luminosity. If there are flickers or the tube does not seem to be operating properly it may have to be redone. (Figure 12–15)

Neon is also used in the manufacture of miniature light bulbs. These bulbs have a considerably longer life than do incandescent bulbs. A resistor that operates in relation to the bulb size is needed in the lamp circuit to protect the bulb from excess voltage.

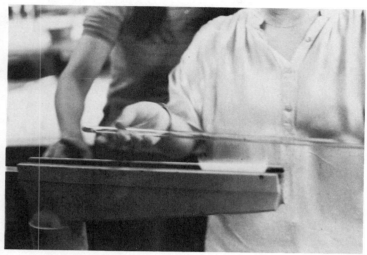

Figure 12–14
Heating glass tubing on a ribbon burner.
Demonstrations courtesy of Ed Waldrum, neon
workshop for sculptors, Waldrum Sign Company,
Irving, Texas.

Figure 12–13
Heating glass tube on a cross-fire
burner.

Figure 12–15
Neon sculpture *Kinetic Energy Field*
1983 by Larry Flukinger and Clark
Harrah. Lyric Office Center, Houston,
Texas.

Several other forms of light bulbs and devices exist that are not as common as the incandescent, fluorescent, or neon. Quartz halogen and mercury lamps are of long life and provide high levels of illumination. Mercury lamps require ballasting. Blacklight mercury lamps can be used when the fluorescent tube proves to be too large. Electronic strobe lights provide brilliant flashes of white light. Low-power laser beams are wire-thin beams that are used to produce visual patterns and light environments. Black light would be used in dark environments with materials that fluoresce.

ELECTRIC MOTORS

Use and understanding of electric motors are essential for operating much of the equipment with which the sculptors work daily, as well as for creating kinetic art. An electric motor should be selected on the basis of voltage, kind of current, the work load it is expected to perform (H.P.), motor type, and the speed at which the shaft turns (revolutions per minute).

Typical motors have 12, 24, 115, 230, and 460 volts. The 12-, 24-, and 115-volt motors are usually 1 H.P. or less. Single-phase, A.C., ⅓-, ½-, and 1-H.P. motors, or larger, are often dual-voltage; in other words, they can be used on either 115 or 230 volts, if the wires on the terminals inside the motor are arranged for the desired voltage. Motors over 1 H.P. are normally operated at the higher voltage. Three-phase motors are usually dual-voltage, 230–460. Some miniature motors operate on voltages from 1½ to 12 volts. A typical miniature motor would be about 1½ inches long and about 1 inch in diameter.

The current would be either D.C., single-phase A.C., or three-phase A.C. Single-phase A.C. motors would be used if the motor were plugged into existing current supplies in homes, shops, or buildings. Industrial areas of the city and large commercial buildings might also provide three-phase current. D.C. motors would be battery-operated; or they could also be plugged into an A.C. system if a rectifier were used to change the A.C. to D.C. Universal motors can be operated on either A.C. or D.C. Fractional amounts of D.C., such as .2 to .5 volts, can be produced with miniature solar cells, which produce their energy by being exposed to sunlight or incandescent light. Silicon solar cells are more efficient when incandescent light is being used.

The work load of an electric motor is rated in terms of horsepower, which concerns foot-pounds of energy. One foot-pound is the amount of energy required to move 1 pound 1 foot in 1 second; moving 550 pounds 1 foot per second is 1 H.P. Motors may possess from a small fraction of a H.P. up to 150 or more. Large motors are used in special industrial situations. Motors are rated at their idling speeds. When required, a motor can deliver a few seconds more power than its rated capacity without being damaged. This feature is especially useful when momentary overloads are needed during starting or while operating equipment. Overloading a motor for a long period of time is not advisable.

Some common types of motors are series (universal motors), induction, split-phase capacitor, repulsion-induction, and synchronous-timing motors. Series motors can be used on either A.C. or D.C. Used in portable electric drills, sanders, polishers, and saws, this type of motor may also be used for some special shop applications, such as flame-cutting machines and electrical controls.

Induction motors, which operate only on single-phase A.C. and are by far the simplest in construction, can be used on fans, blowers, shop equipment, or on kinetic art forms when the starting load is light. These motors do not obtain full power until after starting. The split-phase motor is like the induction motor with a winding added for starting. In the capacitor motor, which is a variation of the split-phase induction motor, a capacitor is added to the starting winding of the motor; the electrical action of the capacitor gives the motor a greater torque for the starting load; used when heavy starting loads exist, it is also more efficient and uses less amperage during starting and in operating. Repulsion-induction motors are used for extremely heavy starting loads. Split-phase, capacitor, and repulsion-induction motors all operate on single-phase A.C.

The synchronous motor, also an A.C. motor, is designed to run at a constant speed. Clocks, record players, tape recorders, and miniature gear motors use his kind of motor.

Three-phase motors, which operate more efficiently than single-phase motors, require three-phase power sources and are available in ½ H.P. or larger. It is advisable to use these motors when a power supply is available to accommodate them.

Motor speed should be selected in relation to the kind of equipment the motor is to operate. Single-phase and three-phase motors normally run at 1725 or 3450 revolutions per minute. Because their speed is fairly constant, they are used in most motorized equipment. Universal motors, on the other hand, run at inconstant speeds, which vary considerably under

load or when the voltage is changed. Electric drills, grinders, and so on, with universal motors, have two speed ratings; a typical ⅜-inch drill, for example, might have a rated speed of 1000 r.p.m. without a load and 600 r.p.m. under load. The speed of D.C. motors, which operate at around 1800 r.p.m., is not as constant as that of A.C. motors. (Figure 12–16)

Motor controls can be added to motor circuits to produce variable speed. D.C. motors' speeds are readily varied by changing the applied voltage or current. Speed is not as easily varied with an A.C. motor; there are some variable-speed A.C. motors, but they are not in wide use and are not readily available. For variable-speed operating from A.C., variable-speed, D.C. motors with A.C.-to-D.C. rectifiers are often used. Because universal motors are both A.C. and D.C.,

Figure 12–16
Typical motors. Upper left: gear motor. Upper right: 115-volt ⅓-H.P. appliance motor. Lower left: 115-volt, fractional-H.P. motor. Lower right: 115-volt, fractional-H.P. gear motor, 1 r.p.m.

Figure 12–17
Floating sculpture which uses complex opposing magnetic fields to float the form off the pedestal. *By sculptor Alberto Collie, ca. 1968. Photograph courtesy of Atelier Chapman Kelly.*

their speeds can be varied easily. Portable hand tools can be readily converted with inexpensive speed controls, which are simply plugged into the A.C. power supply; the tool is then plugged into the control device.

Besides controlling speed electrically, you can reduce speed mechanically by using pulleys or gears. Speed reduction on saws, drill presses, and so on, is achieved often by using a simple pulley arrangement with a belt drive: a small pulley is placed on the motor shaft, and a larger one is placed on the drive shaft of the machine. This is adequate for reducing speeds when the reduction is not too great. For reductions down to just a few r.p.m., reduction gears are used; these gear boxes may be an integral part of a motor housing (called "gear motors"), or they may be mounted separately from the motor.

If there is danger that a motor will become overheated due to overloading, it should be equipped with overload protection. Some motors have built-in thermal overload protection; in others the protective device can be wired into the motor circuit. Motors normally run slightly hot or about 70 degrees above room temperature; if the hand can be placed momentarily on the motor housing, it is probably operating within a safe temperature range. Motors should be well-ventilated. They can overheat in pump pits or enclosures if proper ventilation is not provided.

ELECTROMAGNETS

Besides motors and lighting devices, electromagnets have been used to provide movement in some kinetic sculptures. When electrons move through a conductor, a magnetic field is produced. If the conductor is wound into a coil, the magnetic lines of force join together and reinforce each other. These forces can be used to attract or repel forms. The strength of an electromagnet depends on the number of turns in the coil and the amperage flowing through the conductor. Electromagnets such as solenoids can be combined with switches, relays, and timers to create and control movement. Permanent magnets or magnetized material can be attached to forms to make them adhere to metal surfaces. (Figure 12–17)

Fountains

13

Fountain design poses some special visual and mechanical problems not ordinarily associated with sculpture. Although sculptors may want to become involved with the design of water patterns only, they usually prefer to create fountains consisting of sculpture forms combined with water. The distinct advantage of this approach is that many architectural settings allow year-round presence of a form in relation to the total environment; in climates where fountains can be operated only during warm weather, sculptured fountains serve in winter months as pieces of sculpture, maintaining interest and scale in the architectural setting.

Important considerations in fountain design include the piping system for water movement, the material being used, the kind of water pattern desired, orifice design, electrical installation of pump, filter systems, and such supplementary problems as water-pattern control, lighting, and the relation of the fountain to the area in which it is installed. (Figure 13–1)

Figure 13–1
Sculptured fountain. *By sculptor Roger Bolomey, 1970. Southridge Shopping Center, Milwaukee, Wis. Photograph courtesy of Roger Bolomey.*

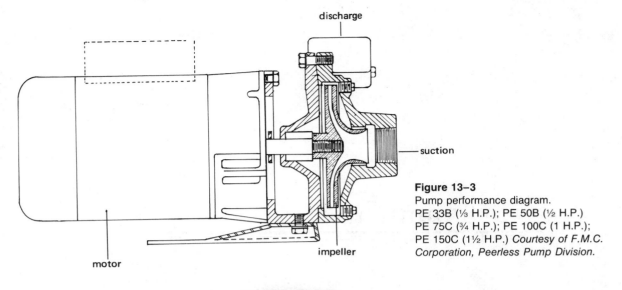

discharge

suction

motor

impeller

Figure 13–3
Pump performance diagram.
PE 33B (⅓ H.P.); PE 50B (½ H.P.)
PE 75C (¾ H.P.); PE 100C (1 H.P.);
PE 150C (1½ H.P.) *Courtesy of F.M.C.
Corporation, Peerless Pump Division.*

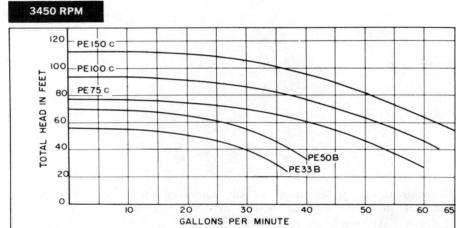

Figure 13–3
Pump performance diagram. *Courtesy
of F.M.C. Corporation, Peerless Pump
Division.*

Movement of water to create the desired water effects in a fountain is accomplished with a centrifugal pump that recirculates the water in the pool. The pump receives the water on the suction end by means of an impeller turning at a high velocity and discharges the water into the piping system of the fountain. (Figure 13–2)

The amount of water that the pump delivers is measured in gallons per minute in relation to the height ("head") that the water is pumped. The head represents the amount of pressure the pump can produce. (Figure 13–3) Manufacturers can help fountain designers determine their pump needs, which include figuring the amount of water necessary to produce the given water effects and compensating for pressure losses resulting from friction and control devices in the piping system. Two basic types of pumps and installations are used in fountain and pool design. Submersible pumps are used when it is not objectionable to have the pump and plumbing visible in the pool and when installations require small volumes of water. They usually do not exceed 1 H.P., and they deliver about 100 gallons of water per minute at a head of 10 feet. (Figure 13–4) Fractional-H.P. submersible pumps are 115 or 230 volts, single phase. Dry-type pumps are available in fractional to 15 H.P. or larger in 115 or 230 volt, single phase, for small pumps and 208, 220, or 440 volt, three-phase, for larger equipment. (Figure 13–5) A typical, large 10-H.P. 220 or 440 three-phase pump delivers approximately 750 gallons per minute at a head of 20 feet. In large installations, several pumps are often used in order to achieve the desired volume and for water control. For the most efficient operation, dry pit-type pumps are usually located below the water level of the pool. If the pump is located above the water level, a lift or check valve must be used on the discharge side of the pump to prevent the pump from losing its prime; this is necessary because water must always be present in the pump when the pump is started to effect pumping action from the impeller. A new installation of a pump above the water level requires

Figure 13–4
Submersible pump with filter screen. *Photograph courtesy of Kim Lighting, Inc.*

Figure 13–5
Dry-type Peerless pump. Note gate valve on the discharge side of the pump to control the volume of water.

that a priming tee be located on the discharge side of the pump so that water can be poured into the pump and piping.

The piping system for a fountain includes the pipes essential within the sculpture and piping from the pool to the pump and from the pump to the sculpture. All piping and fittings should be copper, bronze, brass, copper alloys, or, in some cases, rubber or plastic. Copper tubing for a piping system should be Type K or Type L. Type K has a thicker wall than L and is used for underground service. Type L is less expensive and can be used in the fountain, pool, pumping pit, or building. Tubing is available in hard,

straight lengths or in soft coils. Wherever straight runs of material are needed, hard tubing is used.

A variety of fittings are used to develop a piping system. Gate valves are used to control the volume of water from the discharge side of the pump and to control the water pressure on individual orifices. Gate valves differ from many other valves because when they are in the full open position, they open to the full diameter of the pipes to which they are attached. This is essential when maximum discharge from the pump or within the individual lines of the system is desired. Other valve designs may be used when fully opened lines are not anticipated.

In addition to gate valves, complex fountains with varying water patterns use electrically operated solenoid valves wired to sequencing programmers to change the water patterns. Besides valves, other threaded or soldered fittings used in the system are made from wrought copper or cast bronze; wrought fittings are preferred, to minimize friction loss. Typical fittings are long- or short-radius 90-degree elbows, in which to line changes direction 90 degrees; 45-degree elbows, for 45-degree changes in direction; tees, for 90-degree branches from a line; couplings, for joining two sections of pipe; and male or female adapters, to go from a soldered to a threaded fitting. Reducing couplings and flush-type fitting reducers are used to change from a larger- to a smaller-sized pipe. Unions are used between the pump and the piping system whenever it is anticipated that the system may need to be disassembled. Caps are used to close off the ends of pipes. (Figure 13–6)

Soldered joints are adequate in all piping systems except those in welded fountain forms; heat from the welding operation can damage the soldered joint. In this case, brazed bronze joints should be used.

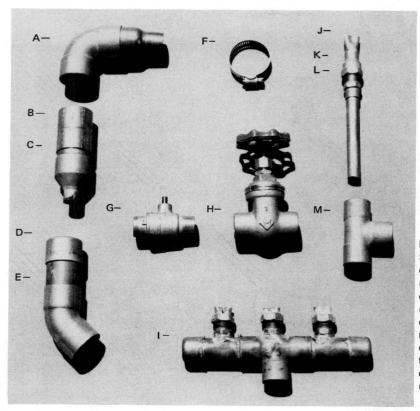

Figure 13–6
Some typical copper fittings: (A) 90-degree elbow with a reducing coupling; (B) straight coupling; (C) reducing coupling; (D) cap; (E) 45-degree elbow; (F) hose clamp; (G) balancing valve for control of orifices; (H) gate valve; (I) manifold with crimped copper-tube orifices; this type of orifice was used in the fountain in Figure 13–9; (J) crimped copper-tube orifice; (K) female adapter; (L) maile adapter; and (M) tee.

The proper soldering of copper fittings requires clean metal. The copper tube and the inside of the fitting should be polished with 00 steel wool, fine sandpaper, or emery cloth. A thin coat of soldering flux should then be applied to the polished portion of the tube and fitting. The joint should be heated evenly by moving the torch back and forth; the joint should reach a temperature hot enough so that the solder will melt when touched to the metal. As the solder is applied to the joint area, it is drawn into the joint by capillary action. The heat should be removed whenever you are feeding the solder to the joint, and reapplied as needed. When the joint is completed, excess solder is brushed off to determine whether the joint is completely filled. Air-acetylene, oxyacetylene, or other types of torches can be used for applying the heat. The solder is either a 50 percent-lead, 50 percent-tin, or 60 percent-lead, 40 percent-tin alloy.

In developing a pumping and piping system, it is important to minimize pressure losses to the system. Undersized tubing, obstructions, fittings, and excessive distances from the pump to the fountain can all cause pressure losses. As a rule, it is advisable to keep the tubing slightly oversized on the suction and discharge sides of the pump. Valves other than gate valves, or reduction of the size of the line, may obstruct the

flow of water. In other words, a pump with a 1¼-inch discharge might need 1½-inch tubing, or larger, if the distance from the pump to the fountain is excessive.

The pump should be located as close to the pool and water level as possible. A pump placed on a basement floor in a building could mean an additional 8 to 14 feet in head requirements. Elbows and tees cause friction losses due to the change in the direction of the water flow. Long radius elbows are thus preferred. As stated earlier, wrought-copper fittings are also preferred, to minimize pressure loss. The piping system should follow as direct a route as possible from the pump to the fountain.

Every fountain plumbing system must include some form of filter to keep out debris. Although the filter is normally included in the system that delivers water to the fountain, a separate filtering system might be used.

For most fountains a simple bronze screen or perforated brass-sheet filter on the suction end of the line is adequate. It is a good practice to oversize the filter in terms of surface area recommended by the manufacturer. Allow at least 1 square inch of surface area per gallon of water pumped, using a perforated brass or bronze screen with ¹⁄₁₆-inch holes on ⅛-inch staggered centers; this would be about eighty holes

per square inch. Prefabricated filters can be purchased, or they can be fabricated easily out of perforated metal fastened to a welded-brass angle frame. Submersible pumps are often designed with the filter as an integral part of the pump (as in Figure 13–4).

The filter should be located in the vicinity of the fountain rather than at the pool's edge, because the splashing water tends to conceal the filter and to drive leaves and debris away from the filter; a filter located in the corner or at the edge of a pool tends to gather a maximum amount of debris. Custom-fabricated, perforated-metal filters can often be concealed in the base of the sculptured fountain, if their presence in the pool is considered visually unacceptable. Another approach is to have the filter recessed in the bottom of the pool; this usually requires adding an antivortex plate over the filter; the vortex plate establishes a water action that keeps leaves and debris away from the suction intake. A removable screen filter underneath the plate removes fine particles of debris. It is also possible to create, remote from the pool, a sump area, into which water flows, and which can be designed to catch large debris, the filter mounted in the sump filters out small particles. Fountains requiring extremely large volumes of water use this system; such large structures can be designed by mechanical engineers.

An inline filter, consisting of a brass screen filter within a container, is located in the suction line; the water passes through the screen prior to entering the pump. The inline filter can be used with an antivortex plate, and may be used as a secondary filter, along with the larger perforated brass metal filter. Secondary filtering would be desirable if the fountain orifices were of such small diameter that it were necessary to filter out particles that could pass through a $\frac{1}{16}$-inch hole.

Using an inline filter as a primary filter is seldom a good practice, because the surface area of the filter is not large enough to accommodate large volumes of debris; this results in excessive maintenance requirements or inefficient operation of the fountain.

In pools that require exceptionally clean water a diatomaceous earth filter is used. (Figure 13–7) This can be a separate system or part of the fountain system itself. Here, water flows over fabric discs covered with a film of diatomaceous earth. An inline filter is used to remove coarse debris prior to passing through the diatomaceous earth filter. A series of valves allow the water flow to be reversed for cleaning the filter. Such a filter is commonly used in swimming pools.

The pump and plumbing from the pump to the fountain are usually installed by electrical and plumbing contractors. One exception is a small fountain with

Figure 13–7
Permanent media filter for cleaning water. Note additional inline filter on pump suction to remove coarse debris. *Photograph courtesy of Kim Lighting, Inc.*

a self-contained pump that can be plugged into an available electrical outlet; units of this kind should always be properly grounded with a third wire. Another exception is a fountain that uses a submersible pump, and that has tubing from the pump to the fountain exposed in the pool. (Figures 13–8 through 13–11) It is possible for sculptors to do their own plumbing and to supply the pumps. However, they should hire electricians to hook up the pumps and electrical contractors to install waterproof junction boxes and the wiring to the pool. For dry installations, plumbing contractors install the pumps, filters, and the piping to the pools. The sculptors need only be concerned with connecting their sculptured fountains to the discharge lines and with specifying the locations at which the discharge lines enter the pools. They must also define their water needs in gallons per minute at a specific head. The sculptors' specifications, combined with the plumbing contractors' (or mechanical engineers') estimates of pressure losses in delivering the water to the systems, determine the pump sizes that are needed. It is a good idea to oversize the pumps slightly, because it is not necessary for centrifugal pumps to operate at full capacity.

Having discussed the basic methods of providing

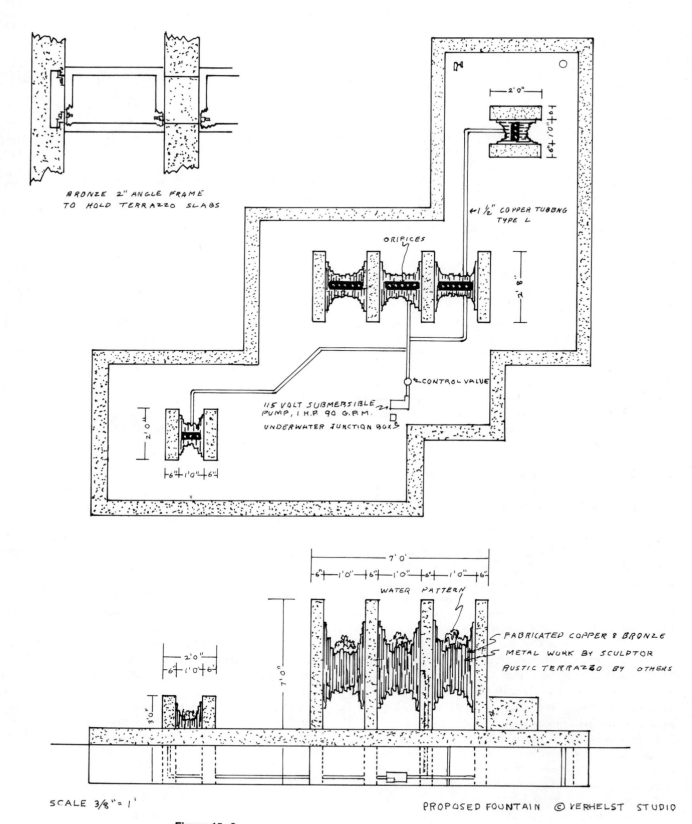

BRONZE 2" ANGLE FRAME
TO HOLD TERRAZZO SLABS

2'0"

1'0"
6'0"

←1½" COPPER TUBBNG
TYPE L

ORIFICES

2'8"

CONTROL VALVE

115 VOLT SUBMERSIBLE
PUMP, I H.P. 90 G.P.M.

UNDERWATER JUNCTION BOX

2'0"

6" 1'0" 6"

7'0"

6" 1'0" 6" 1'0" 6" 1'0" 6"

WATER PATTERN

2'0"

6" 1'0" 6"

7'0"

FABRICATED COPPER & BRONZE
METAL WORK BY SCULPTOR
RUSTIC TERRAZZO BY OTHERS

3'0"

SCALE 3/8" = 1'

PROPOSED FOUNTAIN © VERHELST STUDIO

Figure 13–8
Typical drawing of a fountain installation using a submersible pump and
exposed piping.

Figure 13–9
Completed fountain from drawing in Figure 13–8. *By author, 1971. First National Bank, Arlington, Texas.*

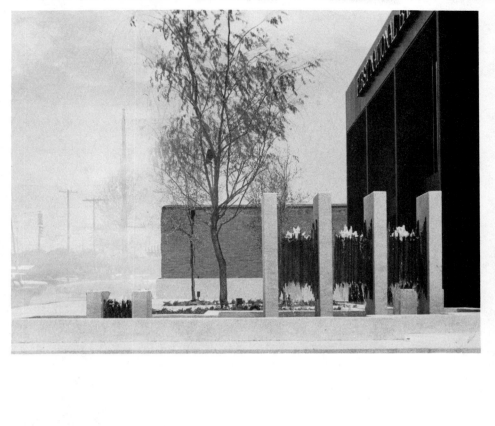

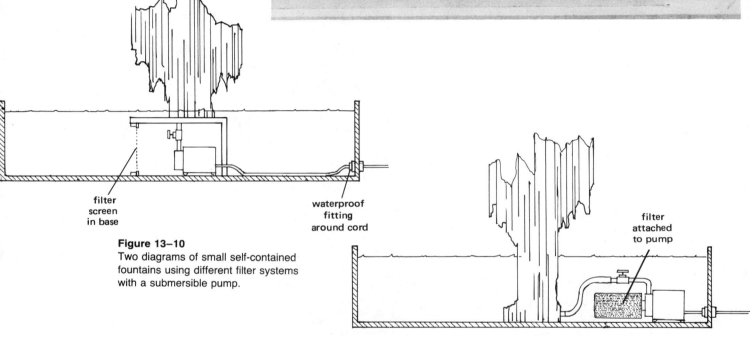

filter screen in base

waterproof fitting around cord

filter attached to pump

Figure 13–10
Two diagrams of small self-contained fountains using different filter systems with a submersible pump.

Figure 13–11
Typical dry-pit installation.

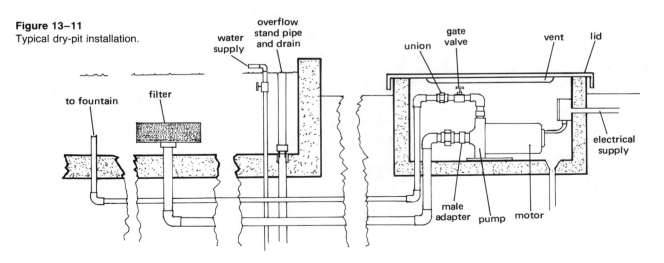

to fountain

filter

water supply

overflow stand pipe and drain

union

gate valve

vent

lid

electrical supply

male adapter

pump

motor

a water system for a fountain, we can now concern ourselves with the design of the fountain. Because water is involved, materials must be noncorrosive. Traditionally, bronze or copper alloys have been used most extensively; in recent years, however, aluminum, stainless steel, natural or artificial stone, fiberglass, plastic, and other materials have been used as well. With the use of water, surface changes in the materials must be expected: Copper alloys ultimately turn dark colors, ranging from antique black to green; aluminum tends to form a white oxide on its surface; stainless steel may turn gray. To compound the problem, minerals in the water tend to collect on the surface of the materials and further alter their appearance. Normally, most of these conditions are acceptable in metal fountains; in fact, metal fountains often receive some form of patination prior to installation. It is important to anticipate changes in the materials, however, because the effect on other materials may be less desirable. Minerals in the water or decomposed material left in the pool can cause white or light-colored cast stones to discolor from yellow ochre to reddish iron oxide colors along with grays and blacks. In these cases, it may be advisable to select colored materials that are compatible with the existing conditions. Water flowing through clear plastic forms may create a striking formation, but in a short time, unwanted mineral deposits destroy the visual effect. Reinforced fiberglass proves to be a reasonably satisfactory material; a wide range of colors can be achieved, and the surface can be cleaned easily. (Figure 13–12)

In building metal fountains, metal materials, should never be mixed because two dissimilar metals in the presence of moisture may produce a galvanic corrosion due to electrolytic action; this can result in the rapid deterioration of the least noble of the metals. Any of the copper alloys can be mixed readily; however, in an aluminum and copper mixture, the aluminum would deteriorate quickly wherever it came into contact with the copper.

Developing a water pattern in relation to the structure of a fountain is undoubtedly one of the most challenging problems of fountain design. Water could flow over forms, jets, sprays, or a combination of all of these. In some cases, the water may be used as a form of energy to move parts of the fountain; jets and sprays may be located in parts of the pool independent of the sculptured fountain.

In designing fountains, it is simple to run copper tubing to the desired locations, and to include control valves on the tubing to control the quantity of water. These control valves are located underneath the fountain or close to the orifice, and they should have removable access panels to allow adjustment. Piping sizes should be as large as possible, with reductions in size taking place at the valve. In other words, in a fountain with a 1½-inch tubing running from the discharge of the pump, it would be desirable to maintain the 1½-inch tubing to the fountain. If a large number of smaller tubes are to branch out to various locations, a good practice is to run the 1½-inch tubing into a manifold, to maintain water volume and pressure.

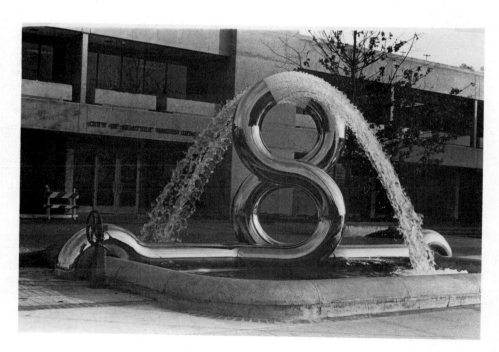

Figure 13–12
Fountain *Interface* by Ted Jonsson. 1975. Polished stainless steel, Seattle Water Control Center, Seattle, Washington.

The manifold can be constructed of a length of 4- or 6-inch copper tubing. (Figure 13–13) Holes can be drilled into the manifold, with couplings welded to the manifold to receive the pieces of tubing.

If the water is to flow over the forms, the open pipe ends simply discharge the water into the desired locations. If jets or sprays are needed, a male or female adapter should be soldered or welded to the tube at the jet location. Orifices for jets or sprays can be purchased from commercial suppliers or fashioned out of copper tubing or other material by the sculptor. If high, straight streams are desired, commercial orifices with adjustable flanges may be used. (Figure 13–14) Adjustable flanges can be purchased separately and used with orifice designs where adjustment of the water stream is critical. Sometimes commercially manufactured orifices may not meet your sculptural needs, especially if you are concerned with creating unusual and nonsymmetrical patterns. Experimentation with orifices made from short pieces of ½-inch, or larger, copper tubing can result in a variety of water patterns. To fashion these orifices, the copper tube is heated to a dull red to soften it. Working with hammers and pliers, bend the copper tube into figure eights, flat, or star shapes to produce different water patterns. If you cut slits in the sides of the tube end, you can produce other results as well. The short length of copper tubing is soldered to a male adapter. The male adapter can be turned into the threaded female adapter or flange at the jet or stream location.

Irregular, fan-shaped water patterns can be created by directing a jet against a flat or spoon-shaped piece of metal or a surface area on the fountain. A simple way to experiment with simple orifice designs is to fasten a ½-inch female adapter to a garden hose with a suitable fitting. Short lengths of copper tubing bent to varied shapes can be slipped into the tubing end of the adapter and held in place with a piece of masking tape. Hold the hose in a vertical position and increase the water pressure until the desired water

Figure 13–13
A fountain manifold and piping system being fabricated by the author.

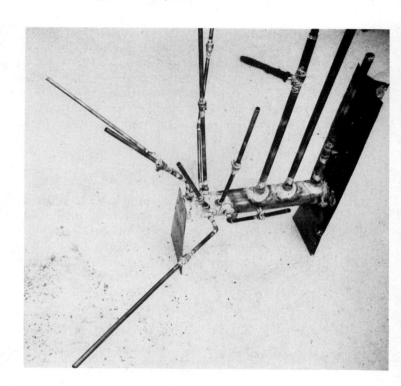

Figure 13–14
Commercially manufactured orifices:
(A) aerating nozzle; (B) geyser nozzle; (C) adjustable smooth-bore nozzle; and (D) jet pod.
Photographs courtesy of Kim Lighting, Inc.

A B C D

pattern is achieved. To determine the approximate gallons per minute, allow the water to flow from the orifice into a 5-gallon pail, and note the amount of time required to fill the pail. The approximate head will be determined by the height of the water pattern.

Experimenting with orifices attached to a small, approximately ⅓-H.P. pump from which gallons per minute are known is a good way to determine quantities of water required to produce various effects. Water requirements for commercially designed orifices are furnished by the manufacturers. For large-scale, complex fountains a mechanical engineer should be consulted.

If variations are desirable in the height of the water patterns or if the volume of water is to be decreased or shut off, timing devices are used. These sequence program control units operate electrically controlled valves to control the water. Timers are also used to turn on lights at varied intervals. (Figure 13–15)

Other components that might be included in fountain design are underwater lighting, wind control units to reduce the height of the water pattern at predetermined wind velocity, and water-level control units. Underwater lighting fixtures are available in 12- or 115-volt systems. In some locations, low voltage would be required as a safety factor. Good-quality underwater fixtures of all-bronze construction can be submerged or built into the walls of the pool. (Figure 13–16)

Wind-control devices are actually devices sensitive to wind velocity; they trigger control panels that operate valves that reduce the water flow and pattern.

Water-level control devices, either mechanical or electronic, are located in recessed niches in the pool walls. Mechanical controls have floats that turn on the water when the pool levels drop. Electronic controls consist of low-voltage systems with sets of probes to sense the water levels. When the water levels drop, solenoid valves on the water lines are energized; these allow the pools to fill to the proper heights.

One last consideration, often overlooked in fountain design, is the suitability of the fountain to the site in regard to water patterns. High patterns are often impractical in small pool areas even with wind-control devices. (Figures 13–17 through 13–21) The splashing of water on a fountain's surface may create wet surfaces outside the pool area which may be slippery or hazardous and which may interfere with normal access to buildings. Sculptured fountains usually have water configurations with relatively low profiles and pose less serious problems than fountains consisting entirely of water patterns.

There is no fixed rule for the control of these conditions. Common sense in designing should dictate that the size of the fountain must be relative to that of the pool and the trajectory created by jets and splash patterns. The need for controlled conditions many times results in unique solutions in the design of the water patterns. A fountain can be designed such

Figure 13–15
Sequencing programmer. *Photograph courtesy of Kim Lighting, Inc.*

Figure 13–16
Underwater lights: (A) underwater fountain light; and (B) underwater reflecting-pool light. *Photographs courtesy of Kim Lighting, Inc.*

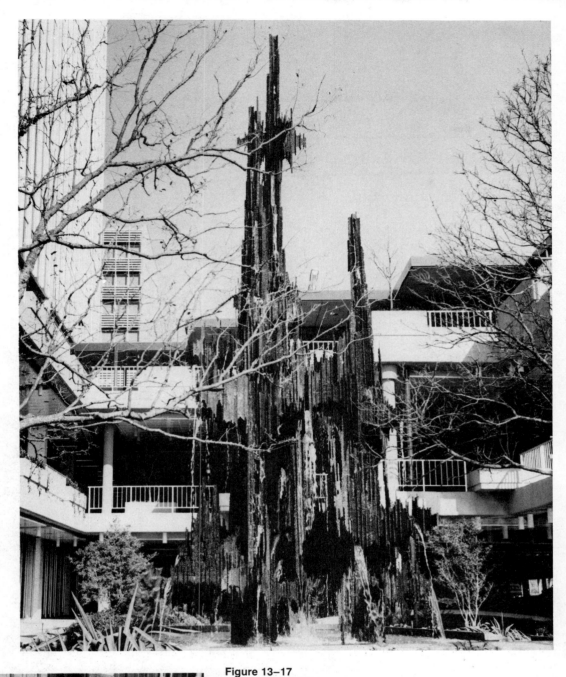

Figure 13–17
Large fabricated fountain, 35 feet high. Exchange Park, Dallas, Texas. The fountain was designed for relatively a small pool area. To control the flow, water was confined primarily to surfaces and inner areas and dropped from one level to the next. *By author, 1963.*

Figure 13–18
Strips of ⅛-inch silicon bronze used in the fabrication of the fountain shown in Figure 13–17.

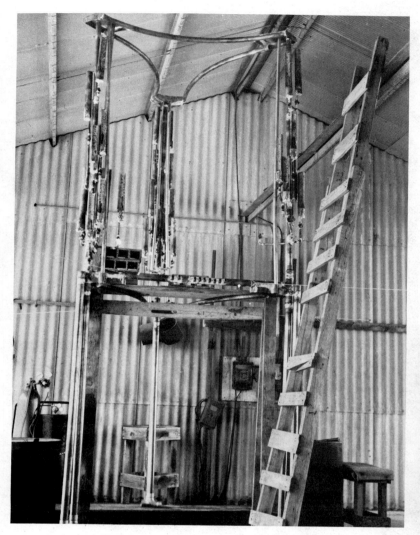

Figure 13–19
Internal piping system for the fountain.

that splash patterns are controlled by the exterior surface, or it may be created so that water flows through interior areas a suitable distance from the pool's edge. The sound of falling water must be considered as well. In an inside environment, a trickling sound may be objectionable, but a stronger, splashing sound may be acceptable. All of these matters should be discussed with clients and architects when planning construction of a commissioned fountain.

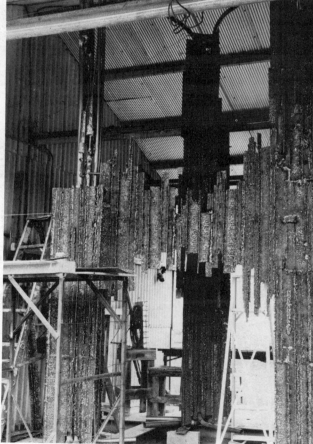

Figure 13–20
Sections of fabricated metal strips being assembled around the internal piping system.

Figure 13–21
Fountain nearing completion prior to
being moved to site.

Studio
Organization

14

Thus far we have discussed the materials, techniques, and problems involved in developing skills and knowledge as a sculptor or designer. In most cases, training takes place in private art schools or university art departments. The atmosphere and conditions in classrooms, however, are often quite unlike those encountered in the studio. The schools take on the responsibility of providing tools, equipment, many materials, and space to work; they also help maintain the space and care for the equipment. At some point, these responsibilities must be assumed by the sculptors themselves. This transition from classroom to private studio is, in fact, less difficult if the students assume responsible attitudes. Caring for tools, putting them back in the proper place, not abusing equipment or wasting material, and cleaning work areas should become part of the work routine.

In a sense, operating a sculpture studio is like operating any other small business: Some form of records must be kept on income and expenditures; items such as taxes, insurance, contracts, sales records, location of works, and business transactions must be attended to; the equipment and physical space for working must be maintained.

Organizational problems and details are, of course, bothersome to most sculptors; however, they are necessary and can make the difference in the success or failure of a studio. Studio space requirements vary considerably in terms of the scale and media in which the sculptors work. Seldom do sculptors have as much space or the kind of space they genuinely need. Studio spaces have been created in buildings as varied as chicken coops, garages, abandoned stores, and factories. Some sculptors find a small space adequate, whereas others, working on a large scale, need not only large amounts of space but also overhead hoists and heavy industrial equipment for moving and handling massive weights. Often, too, sculptors are confronted not only with the problem of having inadequate space but also with the problem of affording the amount of space they do have.

Personalities play a varying role in terms of the space sculptors desire and the degree to which they organize their space and equipment. When the space is small and must be used to its utmost advantage, having a clean, well-organized studio is a necessity. At some point, a poorly organized space will jeopardize efficiency; it also may create dangerous or hazardous conditions for the sculptor, and his or her assistants, clients, or visitors. (An important factor discussed later is that all sculptors are responsible for the safety of helpers, clients, and visitors in their studios.)

Work areas for various media or operations should be defined and isolated. This is essential when more than one individual is working in the studio and multioperations are a daily occurrence. The romantic notion of a large, single-room studio with works, tools, and equipment interspersed throughout may be picturesque but is seldom functional. Operations such as pattern-making, mold-making, welding, metal casting, plastic or wood fabrication, and all forms of finishing need to be isolated from one and another. In a small, one-person studio space can serve many purposes when necessary, but additional attention should be given to cleaning areas and to keeping flammable materials away from welding or casting operations. Portable walls or fireproof screens can be used to isolate these activities further.

When climate permits, roofed work areas out of doors are highly desirable for welding, metal casting, dust-producing finishing operations, and working with toxic fumes and materials. As mentioned in Chapter 15, when working indoors, how to remove dust, dirt, and fumes must be considered, particularly in small spaces where toxic or irritating levels of contamination are quickly reached. Often a clean area is needed to paint and coat. Adequate fire extinguishers should be available; flammable and explosive materials should be stored in areas isolated from sparks or fire hazards. Floors and work areas should be kept clean. Spilled liquids should be cleaned up immediately.

Trash should be stored in metal containers with metal covers. Paper, cloth, or material saturated with flammable liquids or resins should not be packed tightly in a trash container; preferably, they should be stored outside or incinerated daily if possible. Trash should also not be allowed to accumulate on the floor.

Having adequately marked tool boards, racks, and storage cabinets will facilitate clean-up and work efficiency. Closed storage cabinets are preferable. Open-shelf storage should be kept to a minimum, especially in a small, multipurpose studio where irritating or toxic dust from finishing, welding, casting, or molding operations should not be allowed to accumulate.

Equipment should be kept clean and maintained according to manufacturers' instructions; proper maintenance of equipment can mean considerable savings in the life of the machinery.

Good-quality, used equipment can often be purchased at considerable savings. Avoid low-priced, inferior equipment. Accumulating necessary equipment from year to year should be considered an essential part of yearly expenses.

BUSINESS PROCEDURES

As mentioned earlier, operating a studio is like running a small business. In most states, in fact, a studio that produces sculpture is regarded as a small manufacturer; if works are sold out of the studio, it is also considered a retail business. City, state, and federal policies and requirements concerning small retail businesses apply to sculpture studios as well; sculptors cannot avoid these policies and requirements; fines and penalties can be assessed for failure to comply.

Establishing a studio as a small business may seem unnecessary and bothersome; however, it has advantages. As a small businessperson, you are operating in a recognizable form that allows all the reasonable costs for producing sculpture and for maintaining a studio to be deducted against the income from sales of work and other sources. As a manufacturer or retail business, you can often purchase materials and supplies wholesale, effecting considerable savings.

As a small business, the studio must keep some form of permanent records relating to expenditures and income. For most studios, an accurate checkbook listing income, deposits, and expenditures on the check stubs is sufficient. The nature of the expenditure should be recorded, that is, whether it was for rent, materials, utilities, and so on. The source of income should also be recorded when deposits are made. Receipts for all purchases should be retained. Receipts for cash purchases can be recorded in a separate ledger. If a large number of transactions is involved, a monthly summary of expenditures and income should be made. If the volume of work and income is sufficient, it might be advisable to hire an accountant or bookkeeping firm to keep your records and to prepare monthly and yearly statements, particularly if your studio hires individuals and is involved in more complex records, such as payroll, quarterly tax reports, and so on. If transactions are few, as is the case with most studios, a yearly summary, breaking down forms of income and expense, is sufficient. (Figure 14–1) This type of summary can be used by an accountant to prepare the necessary yearly income-tax forms; retaining a capable accountant to prepare income-tax forms is inexpensive, and ability to translate your records into proper tax-return form is indispensable.

Figure 14–1 exemplifies a studio operated independently of the sculptor's residence. If the studio were operated at home, figures such as rent, utilities, and phone would be a reasonable portion of the total expenditures in relation to the scope of activity and the amount of the space devoted to the business. If one vehicle is used for both personal use and business,

(Summary of income and expenditures)
1970
John Jones Studio, 3727 Penn. St.

Income		
Commissions	$13,200.00	
Sales through dealers	3,075.00	
Sales of work in studio	1,650.00	
Private classes & lectures	4,200.00	
	$22,125.00	$22,125.00

Expenditures		
Rent	$ 1,500.00	
Utilities	400.00	
Maintenance	109.00	
Labor	3,120.00	
Hauling & shipping	175.00	
Services	412.00	
Promotion & advertising	255.00	
Entertainment	120.00	
Organizational membership	45.00	
Telephone	178.00	
Expendable small tools & equipment	374.00	
Postage	86.00	
Office supplies	46.00	
Office equipment	64.00	
Travel expense	310.00	
Car expense	275.00	
State sales tax	78.00	
City sales tax	35.00	
Federal excise tax	17.00	
Withholding tax & social security	410.00	
Insurance	268.00	
Checking account charges	34.00	
Tax-return preparation	25.00	
Materials	2,600.00	

Depreciation schedule		
Equipment 10 year life		
1964–$600.00, 10%	60.00	
1968–$350.00, 10%	35.00	
1970–$940.00, 10%	94.00	
5 year life		
1969–$750.00, 20%	150.00	
	$11,275.00	
		$11,275.00
	Net Profit	$10,850.00

Figure 14–1
A typical yearly financial statement for a studio.

studio transportation cost must also be calculated on the basis of the percentage of time it is used.

For sculptors involved in large commissioned works, material costs are usually the major expenditure. Cost of labor and service may follow; services usually mean another business doing work for the sculptor, which might be as simple as sandblasting, steam cleaning, or painting a work, or as complex as fabricating a total work.

Telephone expenses may often be more than anticipated; business transactions with out-of-town galleries or clients often require long-distance calls.

Utilities costs are for gas, electricity, and water. To reflect more accurately the cost of producing work, a separate breakdown of these figures may be desirable—for example, if much electricity or gas is used in welding or metal casting.

Transportation involves the operation of a motor vehicle as an expense to the business, and includes gas, oil, maintenance, and depreciation of the vehicle. Travel expenses, including the cost of airlines and lodging, are usually incurred during gallery or commission contacts, installation of works, or attendance at trade or professional conventions related to the sculptor's activities.

Small tools and equipment are hand tools and small mechanical equipment that would be considered expendable in the course of a single year.

Major permanent sculpture equipment normally depreciates over a period of several years. Records of the date of purchase and itemized lists of major equipment should be kept for the accountant so you can determine the rate of depreciation.

Office supplies are often neglected in recording expenditures. Items such as postage stamps, stationery, pencils, and miscellaneous materials are often purchased on a cash basis and are overlooked in keeping records of cash transactions.

Entertainment expenditures are also often neglected, particularly small expenditures such as paying for a client's lunch or serving him or her a few drinks at the studio; these can be business expenses if you keep a reasonable record of them. The cost of serving refreshments or food at a studio open house or exhibition is also a legitimate expenditure if the occasion is the exhibition or promotion of your work. Promotion and advertising expenses are incurred in the printing and mailing, to architects, builders, collectors, and so on, of brochures announcing exhibition openings or promotional-type material. Expenses for advertising space in newspapers or art magazines may also be incurred in the process of promoting an exhibition or other studio activity.

The cost of books or publications that supply information pertinent to the operation of the studio are legitimate expenses, as are memberships in professional organizations. Taxes and insurance are discussed later in this chapter.

Another important function of keeping income and expense records is that it allows the studio to evaluate its operations from year to year. It is one yardstick sculptors can use to determine whether they are receiving adequate prices for their work in relation to other costs. It also allows them to evaluate expenditures to determine cost for each work, waste, methods of effecting savings, or better distribution of

earnings invested in the development of the studio. The cost of each work is not only a matter of the materials used but a reflection of the other expenditures involved as well. For example, if a piece of sculpture requires 2 months to build, 2 months of rent, utilities, insurance, and so on must be considered a part of the cost of the work. Remember that the cost of experimentation on, or production of, works that do not sell must also be considered in the price of the work that ultimately sells.

If you are about to start a studio, one of your first problems is to locate a suitable space or building. If the space is located in a city, zoning would affect its location in relation to the scope of your work activity. If a large amount of metal casting or welding were to be done, it might require an industrial location. For smaller amounts of work, or for work with other materials, a manufacturing or light manufacturing zone might be appropriate. In some cases, it might be acceptable to locate in a retail area or to operate out of your residence. These matters should be checked with appropriate city-zoning departments prior to renting or leasing a building. Local fire codes and restrictions may also determine the areas in which you would be permitted to operate.

If you sell works out of a studio located in a city and state in which sales taxes are collected, your studio is responsible for collecting these taxes. In fact, you are usually required to obtain a retail sales license and store license, normally a matter of a few dollars. Taxes are normally paid on a quarterly basis; the tax forms are quite short, simple, and require little time to prepare. If jewelry is produced or sold by you, federal excise tax must be collected. License and tax forms can be obtained from the state or federal tax office. If works are sold purely through galleries or other agents, a sales license is not necessary. If your studio is large enough to employ workers, as is the case when executing sculptural commissions, keeping records becomes complex. Payroll records must be kept. Withholding taxes and social security must be withheld from wages and paid on a quarterly basis. When workers are employed, worker's compensation and payment may be required as well. The number of workers and conditions for these may vary according to the state.

Insurance requirements may vary according to the scope of activity and the risks you are willing to assume personally. Generally, insurance is a bargain in relation to the protection it provides to the business and its owner. For a one-person studio producing only studio works, fire protection for the contents of the building, and the building (if you own it), theft insurance for equipment or works, car insurance, and

liability insurance (in the event that a client or visitor suffers injury while on the premises) are recommended.

In commission works, and when employees are involved, insurance requirements may become more complex. The architect and client may want assurance that proper insurance is carried to protect the work while it is being produced or during delivery. You, as an independent contractor, assume the responsibilities and liabilities during your presence on the construction or building site, and this requires insurance as well.

A work being produced in the studio needs to be protected against loss due to fire or other causes. It may need protection against damage or loss during shipment, transportation to the site, and erection or installation. If you are doing the installation, you must have liability insurance in the event that the owner's building or property is damaged in the course of installation and you are responsible. Manufacturers' product insurance may be advisable, because you are responsible for the performance of your work. For example, if a piece of metal breaks off a wall relief, falls, and injures someone, you could be held responsible for defective workmanship. The total cost of insurance, which you would calculate in relation to the volume of business and activity, is a small percentage of total operating expenses and should be included in the expenses for a professionally-run studio. A reliable insurance agent can provide you with insurance and advice.

Besides records of expenses and income, records should be maintained on the works produced, as to cost, date of completion, location when at an exhibition or gallery, and location, and ownership when sold to a collection or client. Routine files on correspondence, exhibition, commission, contracts, insurance material, supplies, and so on should be kept also.

In addition to the problem of maintaining a studio and producing works, one of all sculptors' principal concerns is marketing their work. Although market conditions are undoubtedly improving for sculptors, some sculpture is more marketable than others. The kind of market you need depends on the style and quality of your work. To sell a work or to produce something for sale is simple; if producing marketable works is your objective, you need only cater to the popular tastes—whatever people like and are familiar with. For serious sculptors, however, the first concern is not to sell their object, but to produce forms they feel the need to create; in this case, their market becomes smaller and more difficult to find or develop.

To produce sufficient income solely from the sale of studio-produced work is extremely difficult. Except for a fortunate few, sculptors are seldom successful solely as a result of studio income; usually, they keep their studios operating with income from more than one source, such as:

1. Sales through galleries or other retail outlets.
2. Sales of studio-produced sculpture, directly through the studio.
3. Commissioned work.
4. Income produced through private classes, lectures, and demonstrations.
5. Income produced through design activities related to sculpture.
6. Exhibition prizes.

To develop a market, you must be resourceful and aggressive. If you are interested in making a living from your studio, you must forget snob appeal—although it is a sales approach in some cases—and be concerned with any market that will sell your work; you must seek out galleries, architects, or clients. This is not difficult: Appointments can be arranged by phoning or, in the case of out-of-city contacts, by writing the party you wish to contact.

One of the first requirements before you can make a sales contact is a portfolio to illustrate your sculpture to the galleries, architects, or clients. A select group of mounted, black-and-white or colored photographs in an attractive leather carrying case is perhaps one of the most convenient forms of portfolios; this can be easily handled, placed on a desk or table, or passed around if there are several people present for the viewing. When mailing examples, colored slides are equally effective. It is also a good idea to invest in business cards and in a printed, professional-looking brochure that lists your educational background, exhibitions, prizes, and shows a few examples of your work; these can be left with the galleries, architects, or client so they can file them for future reference. If the galleries, architects, or clients are interested, they may want to visit your studio, have a small example of your work brought to their places of business, or, in the case of architectural works, see the models for the project.

Ideally, it is desirable to leave the whole problem of marketing to a gallery or agent. However, few galleries are successful enough to guarantee artists (except for a few nationally known artists) a reliable income from the sale of their works.

When seeking a gallery, it is important that you be familiar with the gallery that is willing to handle your work. When possible, select a gallery that has been established for some time and has had time to

develop a clientele. The business of selling art is often far more complex than simply hanging works on a wall or placing them on a pedestal and waiting for a buyer. If possible, in order to appraise the gallery clientele and the fashion in which the gallery handles sales, attend several public openings that the gallery might have for artists it represents; evaluate the kind of invitations, brochures, newspaper publicity, and promotion the gallery uses. Also, be concerned with the quality of the work the gallery handles and whether the sales philosophy of the gallery is compatible with, and conducive to, the sale of your work. Ask some of the artists represented by the gallery how successful they feel the gallery has been in handling their work.

One of the most essential items in the relationship between a gallery and an artist is the written contract. This is the only concrete assurance either party has that conditions concerning sales and the handling of the artist's work will be met. The gallery and artist should draw up a contract on which they mutually agree. It may be advisable to have the contract checked by an attorney. A contract should state the percentage of the retail sale to go to the gallery (usually 33⅓ to 50 percent), payment schedules to the artist upon the sale of work, and the insurance provided by the gallery. All other services paid for by the gallery should also be defined, including the cost of mailing brochures, refreshments at openings, packing and shipping costs, and other promotional expenses. If you are to be responsible for any of these items, it should be clearly stated in the contract. The length of time the contract is to be effective and required notice for cancellation should also be stated. If the contract is for exclusive representation, it should state the geographic area that it represents. Unless a gallery operates nationally, exclusive representation should apply only to the city and area in which the gallery does business. An exclusive contract should also state whether it includes commissions. If it includes commissions, the gallery usually takes a smaller percentage (usually 20 to 30 percent) than on the sales of works. Unless the gallery is going to be exceptionally active in obtaining commissions for you, you should hesitate to give the gallery full contract rights in this area. Preferably, the contract can state that the gallery will receive its commission only when it directly provides a commission for you. Obtaining commissions, particularly of architectural sculpture, involves sales approaches that the gallery does not always pursue. Moreover, you may have developed your own clientele in this area; if you are willing, you can as readily, perhaps more effectively, obtain commissions by yourself.

One last point is that when you agree upon a contract with a gallery, as with other contracts, you should live up to the terms of the agreement. The gallery is in business and is working for the artists. A capable gallery fully earns and deserves the commission it charges for selling a work. To remain in business, it relies upon the artists to deliver works on time and to meet the terms of the contract.

Besides galleries, a variety of sales outlets exist. The extent to which you participate in some of these depends on your professional standing and your personal objectives. Belonging to groups that organize sales exhibitions in shopping centers and public buildings, or participating in other forms of sales exhibitions, are two ways of selling moderately priced work. Showing in quality interior-design shops, where works are seen in relation to home or office, may not have the prestige but often yields better sales results than exhibiting in galleries. This is particularly true if the shop has a staff of professional designers who do a lot of residential and commercial interior-design contract work. If the designers like to include sculpture in their overall plans, works are readily sold under these conditions.

The extent to which you might want to undertake retail selling out of your own studio or shop again depends on your ability, temperament, and personality. Some sculptors, especially those who have been in an area long enough to have some form of clientele, have the ability to handle their own sales with as much or more success than a gallery might. They usually need some form of exhibition space or gallery in conjunction with the studio. They must also be prepared to do the necessary work and they must have sufficient capital to survive while developing a clientele.

Three of the most prevalent approaches to personally handling sales are to show works by appointment only, to do occasional exhibitions, or to have an exhibition space or gallery open daily, as if it were a commercial art gallery. The last approach is perhaps the least desirable, unless income from sales merits hiring an individual to attend to the gallery and its operation. A combination of the first two approaches usually works more satisfactorily. One or two exhibitions a year serve to acquaint the public and art patrons with your work. The appointment arrangement makes your work accessible the remainder of the year.

Regardless of the approaches you use, you must be prepared to do the necessary kind of promotion that selling your own work entails. If you are new to an area, one of your first tasks is to develop a clientele. A mailing list of individuals in a community who would

be interested in art can be helpful in this situation. Belonging to groups having access to lists of potential patrons, having museum and art-organization memberships, and carefully reading local art publications or newspapers with articles about persons who collect art can also yield results. Attending other gallery openings and exhibitions is also helpful. Often, if you are opening a studio in the same area in which you attended school, you probably have some contact with clientele through school exhibitions or galleries with which you may have been associated. It is also a good procedure to ask guests attending an exhibition to sign a guest book, which can act as a mailing list.

Newspaper publicity also attracts new individuals to exhibitions or gallery openings. To list notices of exhibition openings in local art columns is not difficult. A simple, typewritten news release sent to the writer of the art column will usually yield some results; you can also phone the writer or newspaper and ask for the form in which they prefer to have such information presented. A news release should include such information as dates of exhibition, number of works, and media, and such personal background as education, commissions, exhibitions, or collections. Several 8 × 10 black-and-white photographs should also accompany the release. In addition, you should send news releases and periodic new information on major commissions received, prizes won, or exhibitions participated in to art columnists.

Obtaining commissions and working with architects, interior designers, and their clients requires a somewhat different approach from dealing with galleries and collectors. These people are often less concerned with education, exhibition, and award records and more concerned with the sculptor's ability to execute, install, and complete the work on time. A sculptor interested in commissions must be aggressive in contacting the people who can provide them. Reading real estate sections of the daily newspaper and trade journals dealing with building, or noticing buildings being constructed in your area, can provide you with leads on prospects for commissions.

It is possible for you to approach architects, landscape designers, interior designers, and building owners in the same manner as other businesses who sell their products. Essentially, two approaches are useful in contacting these individuals; both should be used in an effective sales program: First, direct mailing of information is important; an attractive brochure, mailed once or twice a year, serves to acquaint potential clients with your work and indicates your interest in working with them. Second, direct contact by calling an individual's office and making an appointment to show a portfolio of work is also effective; it is exceptionally useful if you know of a building, interior, or land development that might require sculpture. In many instances, an architect or interior designer may have plans in the formative stage; by calling on him or her at that point, you may persuade him or her to include sculpture in the plans.

Getting your first commission and developing a portfolio to present may often be a problem. An architect needs to be assured that you are capable of doing large-scale works. Unless your portfolio contains several photographs of large works, the architect might hesitate to recommend you for the commission. As a beginning, it is often necessary to do several large works experimentally and photograph them in architectural setting in order to develop an effective portfolio.

Assuming that an architect requests some sketches or ideas for a possible commission, the next problem is to convince the architect and client that the sculpture will add to the total architectural environment. A professional-looking presentation is of utmost importance; if the presentation is poorly executed, the client may very well think that the finished work will be handled in the same fashion. The client and architect will want a convincing presentation of what the finished product will look like. Normally, this should be a colored rendering of the proposed work and a blueprint of the building elevation showing the work in relation to the architectural setting. Print the blueprint, perhaps including construction and installation details, from a drawing on tracing paper; this allows you to make copies of the drawing so that you can keep the original. Figure 13–8 in Chapter 13 is a typical example of a drawing for a fountain. This drawing was accompanied by a colored, larger-scale drawing of the fountain. The blueprint of the drawing and the colored sketch were mounted and presented in a folder made of attractively colored illustration board. If a commission is an exceptionally large, complex work, you might even build a scale model after the drawings have been approved.

Although in theory sculptors should be paid for their sketches and models, clients are often skeptical and unwilling to pay to see the initial ideas. Whether or not you do drawings on speculation is a matter of personal choice. I have often done preliminary drawings and presentations on that basis, and have found it worth the gamble. In a way, these sketches are not produced free of charge, because speculation should be considered as part of the cost of operating a studio and should be allowed for in the price charged for commissions and sales that are realized.

PROPOSED FOUNTAIN
(name of building, city
and state)

Form	—Approximating drawings and model submitted, minor modifications to improve aesthetic or structural elements at the discretion of the sculptor.
Size	—Per scale of drawings submitted, approximately _____ ft. long, ____ ft. high and _____ ft. wide
Material	—(State material)
Finish	—Per sample submitted
Insurance	—(State insurance)
Cost	—(State cost) including all material and labor, delivery to site, installation and sales tax
Payment Schedule	—35% initial retainer, payable prior to beginning the project 35% payable at 50 percent completion 15% payable at completion in studio 15% payable at completion of installation
Guarantee	—One year on material and workmanship with any repair and labor furnished without cost to owner
Contract Limitations	—All conditions of proposal subject to change if not accepted within 30 days from date of proposal
Delivery	—(State date)

Sculptor agrees to furnish sculpture in general accordance with the stated conditions. Sculptor ___(Signature)___ Date _____

Address _____

Owner or agent authorizes sculptor to proceed with sculpture in accordance with above terms and conditions. Owner

Figure 14–2
A simple contract form for commission work.

The clients should, however, pay for designing work beyond the preliminary presentations, such as further clarifications of the plans with models and detailed drawings. It may also be necessary to supply material samples to your client.

If a client and architect accept a proposal, you then have to draw up some form of written contract. Figure 14–2 is a simple form of contract I have found acceptable when doing commissions. Items can be added or deleted, depending on the type of work being produced. In the first item, it is necessary to state the form of the sculpture and your right to make necessary changes in the full-scale development of the work. The size of the work can be defined in terms of referring to the drawings, model, or stated in terms of length, width and height. The kind of material should be specified; material thickness and method of fabrication might also be included in this category. A sample of the finished material can be provided, or the finish can be described as approximating the colors of the submitted sketch or drawing. List the insurance protections provided. Sometimes the client may require written verification from the insurance company or agent providing the insurance.

Cost is all inclusive; it must allow for all emergencies and errors, because the client cannot be expected to assume these risks. The payment schedule is designed to give you operating money as the work develops. The scheduled percentages of payment may vary from those in Figure 14–2, depending on your anticipated costs in producing the work. The initial retainer normally needs to be a high percentage of the total in order to allow for large outlays to purchase materials and to start the project. Never order material or start a project until you receive the first payment. The second and third payments may be distributed more evenly if cost factors permit. At the completion of the project at the studio or at a fabri-

cator, you should have received about 85 to 90 percent of the total charge. In the event that installation is delayed, you would have received the bulk of your fee for services performed. The guarantee assures the purchaser that the work will be executed in a sound and workmanship-like manner.

Contract limitations are merely a routine matter and allow for renegotiation of the contract in the event that the project is delayed and labor, material, or other costs have increased. Every effort should be made to meet the delivery date agreed upon; this is important to owners and architects, because the official opening of a building depends on all contracts' being completed. If you become known as being unreliable in terms of delivery, you may soon discover that you no longer have clients.

Reproduction rights and copyrights are often overlooked by the artist until someone infringes upon his or her work, at which point it is often impossible to do anything about the infringement. There are a few simple things that can be done to protect yourself from infringements: all works assigned to a gallery should be listed on a consignment form that clearly states that reproduction rights are reserved by the artist; the sale of each work should be documented with a bill of sale that states the reservation of reproduction rights and that is signed by you or your agent and by the purchasers of the work. A simple form of copyright is to place a "C" with a circle around it in front of the signature and date on the work. Sculpture, models, and drawings are protected in this fashion. If these simple procedures are followed and your work is still infringed upon, an attorney would have to help you enforce your rights.

Safety

15

Having a cautious attitude toward all sculpturing materials and equipment is one of the best ways to avoid health hazards and injury. Developing good working habits involves taking proper protective and safety procedures, not only for yourself but also for fellow workers in the studio and visitors entering the work area. Contaminants and potential health hazards are present in many sculptural materials used today, and the possibility of injury when working with the tools and equipment is always present. These conditions are not a cause for alarm but should be a matter of continuous concern and impetus to develop good work habits.

When working, you should always think of the materials in terms of their basic properties and possible hazards. You should always read the labels on packages and containers; unfortunately, labels are often incomplete. Moreover, when you purchase materials in bulk, or in such a way that they are not labeled or not required to be labeled, you also may not be aware of potential dangers. Material manufacturers, often do provide safety and toxicity information along with their products. Otherwise, you can consult a good reference, such as *Accident Prevention Manual, for Industrial Operations* by the National Safety Council (Chi-

cago, 1964). Always consider the materials and all of their constituents when evaluating toxicity.

Four basic hazards exist when toxic or dangerous materials are being used: the material, its vapors, fumes, or dust may come into contact with the skin; vapor or dust may be inhaled; the material may be flammable, explosive, or reactive with other material; or the material may be accidentally ingested.

Skin contact with toxic or hazardous material involves risks of surface-skin irritation, dermatitis, burns, and systemic poisoning through absorption. The skin, however, is a highly effective protective barrier against surface penetration of most foreign materials. Absorption into the system through the skin is often more likely to take place through unattended open scratches, cuts, and abrasions. Protective measures against skin contact when toxic materials are being handled are relatively easy to incorporate in the work schedule: You can wear rubber gloves to protect your hands; and long-sleeved shirts, shop or laboratory coats, and other proper clothing to protect your arms and body. Wear a face shield to protect your eyes and face during pouring, mixing, or brushing, or when danger of splashing or spattering exists. Skin irritation due to fumes or vapors is usually controlled by removing

241

the fumes from the atmosphere with a proper exhaust system, or protective hoods and clothing. When handling hot materials, use proper tongs or devices. Wear protective, heat-resistant asbestos or leather gloves, aprons, or other clothing when necessary; if gloves develop leaks or become worn, or if clothing becomes spattered or contaminated, replace them. Always attend to skin contamination immediately.

Inhalation of dust, vapors, or fumes poses the greatest hazard in working with toxic or hazardous materials. Inhaled substances may readily enter the blood stream through the lung tissue. Inert dust may accumulate and ultimately produce respiratory complications. Nontoxic dusts, although not injurious, can be irritating. Accumulation of dust or fumes in the atmosphere can also be flammable or explosive. Safe working procedures require removing contaminating material from the atmosphere or using suitable protective masks.

Removing contaminants from the atmosphere is one of the most desirable ways to control toxic fumes or dusts. A simple, rule-of-thumb approach, such as changing the air every 3 minutes, may be workable in some circumstances but inadequate or excessive in others. Ideally, the rate of air contamination and tolerance levels for a particular material should be determined, and the rate of removal should be based on those factors. The size of the working space, ceiling height, number of other workers in the room, and the kind of ventilating system are all matters you should consider.

Considering the variety of materials with which sculptors work today, every studio or classroom should be equipped with some form of air removal. A good ventilating system involves two principal components: a means of removing air and a means of replacing the air removed. Replaced air often needs to be heated in the winter to maintain comfortable working conditions. Systems with hoods or fume collectors that remove air from selected work areas are not only the most efficient and economical, but also the most workable for work areas involving more than one worker. Exhausting air alone is insufficient.

Ideally, a system should exhaust the contaminated air into the hood or removal system while fresh air is being driven past the worker. In a one-person studio, a simple approach is to have an exhaust fan mounted in a wall next to the work area. The other end of the work area should have a smaller fan to blow air past the worker in the direction of the exhaust fan. (A fan with a volume of air greater than the exhaust fan would cause the fumes to be recirculated in the room before they could be exhausted.) A window or door should be open on the opposite end of the room to supply make-up air. In the winter, a heated air supply should be used for make-up air. An economical way to solve this problem is to localize the make-up air. Positioning a flexible duct on the air supply that can blow the make-up air past the worker, and thus drive the fumes into the hood or exhaust, is a practical approach. In this case, the volume of air need not be as great as if you were trying to supply air to the whole room.

Fans and motors for exhausting flammable dusts and fumes should be explosion-proof and fireproof. When large volumes of exhausted, contaminated air are handled, city or state antipollution codes may require the air to be filtered or washed prior to its discharge into the atmosphere. The design of a ventilating system can therefore become complex. The volume of air desired, the kind of fan used, the type of filter, ductwork, or means of placing the air where desired, air velocity or feet per minute of air in the ducts and at the work station, and the kinds of hoods or fume collectors used are all factors to consider. As just stated, for the one-person studio, these problems can usually be solved in a rather simple fashion. However, if a space involves several or more workers and large volumes of contaminants are used, good safety engineering advice is essential.

Another common practice for sculptors working with toxic materials is to work outdoors when climate permits. This approach is not foolproof; on a day when there is little wind or moving air, the fumes may not be adequately cleared or dissipated. A fan should be used in these circumstances to blow across the work area.

Often, simply removing air is not sufficient, particularly if the sculpture on which you are working is large and you have to move around it a great deal. Under these conditions, you may find yourself in the path of the fumes being removed. The same problem exists when working over a piece. In this situation, the only solution is to use a suitable respiratory device for working in fumes, vapors, or dust-contaminated atmospheres. (Figure 15–1) A face mask with a mechanical filter for removing dust or particles is the simplest form. It is adequate for sawdust, stone or silica dust, and dust from abrasive grinding or finishing. Toxic dusts require special filters. For fumes and vapors, masks with chemical filters that remove the toxic material should be used. These must be purchased with specific filters for particular contaminants or classes of contaminants; be sure they have the approval of the U.S. Bureau of Mines. Dual-filter masks provide greater filtering surface and less resistance to

Figure 15–1
Respiratory masks. Right to left: dual-filter mask with chemical cartridge-type filters for removing toxic fumes and dust, inexpensive dustmask, single-filter mask with mechanical filter for removing nontoxic dusts.

breathing. Less breathing discomfort is experienced when this type of mask is used. If an air supply is available, an air mask is the most ideal and convenient means of protection, because it eliminates the problem of resistance and breathing discomfort associated with a filter mask. The air supply can be provided by an air compressor or low-pressure blower. The air must be supplied from a source other than the work area. Air compressors must have proper filters, pressure gauges, and protective devices. Air supplied by low-pressure blowers is more desirable; air from a poorly maintained air compressor can contain dangerous carbon monoxide produced by decomposing oil lubricants in the compressor.

Protective masks should be of good quality, with adequate straps and adjustments to assure a good fit with no air leakage. Filters should be replaced as required. Masks should be checked daily for faulty valves or defects. Inexpensive paper, cloth, or fiber masks should be avoided. They rarely fit adequately and serve only to remove small portions of dust or other material.

Dust is usually removed by using dust collectors rather than exhausting it. Dust collectors may be built with a central collecting and air exhausting system into the shop, or an individual dust collector can be attached to each individual machine. For a small, one-person shop, simple attachments can be purchased or easily made to equip a shop vacuum for low-volume, nontoxic, nonflammable dust removal. An individual dust collector can also be used and moved to the machine being used. (Figures 15–2 and 15–3) When dust

Figure 15–2
Stationary dust collector, flexible hose can be moved and attached to equipment in the near vicinity.

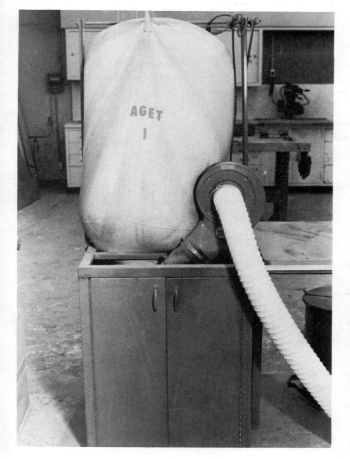

Figure 15–3
Portable dust collector that can be moved around studio.

is not removed from the atmosphere, suitable masks provide adequate protection from nontoxic dusts. Toxic dusts require the use of masks with chemical filters, as well as protective face shields, hoods, and clothing.

Vapor, fumes, and dust may often be flammable or, at concentrated levels, explosive. All dust-collecting and ventilating equipment should be flame- and explosion-proof; which is usually accomplished by use of enclosed motors or motors remote from the exhaust system whose fans are rigid and are so designed that the possibility of metal parts' striking and causing sparks is eliminated. Fans and other metal parts may also be made of or coated with nonmetallic materials. Any finishing or fabricating room using flammable materials must also involve other precautions: Smoking should not be allowed; heating systems should be remote from the work area or they should be explosion-proof; appliances with open flames, such as water heaters or heating devices, should not be present in the room; and electric hand tools should not be used if fumes are at a concentrated level, because sparks from the motor brushes can start fires. Air tools should be used in these circumstances.

Caution should be exercised in the mixing of chemicals, catalysts, plastics, resins, and other materials. Improper mixtures may be flammable, explosive, or highly reactive. Indiscriminate mixing of chemicals may result in the formation of toxic fumes and gases. Heating materials can also be hazardous because it causes changes in, or acceleration of the reactions between materials. The most essential precaution in these circumstances is not to deviate from manufacturers' recommendations or recommended formulas unless the chemistry of the material is understood.

Ingestion of toxic materials is the least frequent of accidents, yet it is possible. The most obvious and usual means of ingesting toxics results from contaminating your hands and subsequently handling foods or cigarettes. Smoking while handling some toxics can be particularly hazardous; fumes or small quantities of material transferred to a cigarette can be extremely dangerous when they combine with burning tobacco and inhaled smoke; a no-smoking policy while working should be enforced. Removal of gloves and proper cleanup should precede the handling of food.

Most hazards involving equipment can be minimized or eliminated with proper work procedures and the use of safety equipment. Be sure all electrical equipment is properly grounded to avoid the possibility of electric shock in case the equipment shorts out or malfunctions. Also be sure mechanical equipment has proper guards over exposed wheels, gears, grinding, and cutting devices. Properly fasten or mount stationary equipment on the floor or workbench. Also equipment should be properly maintained. Loose bolts, pulleys, and other malfunctioning parts should be repaired immediately. The equipment should be kept clean. Electrical equipment should be disconnected during repair or maintenance. When equipment is being operated, it is important to become aware of the normal working sounds of the machines. A change in the usual sound is usually an early indication that something is not functioning properly and is in need of repair or adjustment; odors may indicate overheating. Adequate work space should be allowed around each piece of equipment. In classrooms, it is often helpful to paint lines defining work space around each machine and to restrict the area to the operator of the machine. Maintaining a clean, well-organized studio or shop can contribute immeasurably to safety. Accumulated trash can pose a fire hazard. Debris and obstacles in a work area can also inhibit material handling and hinder the feeding of material through a machine. It is easy to slip on small scraps of doweling, welding rod, or spilled liquids. Abrasive, nonslip strips can be attached to the floor around machinery to avoid slipping. Shop floors should never be waxed or maintained with an excessively smooth finish. Good lighting is important for good craftsmanship as well as for contributing to the safe operation of equipment.

Loose clothing can be hazardous around moving parts. Proper protective goggles, masks, gloves, and clothing should be worn while welding, metal casting, sandblasting, woodworking, or metalworking, or when working with hazardous machinery. Construction-type clothing, such as hard hats, safety shoes, and other garments may be necessary when you are building or installing large sculpture.

Lifting and handling material and sculpture are always concerns for safety. Commercially, fork lifts, gantries, lift tables, cranes, and other devices are used to move material. These are generally too expensive for the typical studio situation, so other methods are needed. With a simple chain hoist or ratchet cable hoist, considerable weight can be handled. (Figures 15–4 and 15–5) Sometimes work can be hoisted from overhead beams or trusses and lowered on wheeled dollies. Simple tripods can be rigged if overhead structural members will not support the weight. (Figure 15–6) A portable hoist, as shown in Figure 15–7, is not expensive and will lift a large variety of works. For larger and heavier jobs you can buy a portable gantry. (Figure 15–8) If you have welding equipment it is relatively easy to build a portable gantry. Building sculpture on wheeled platforms is also a good practice

Figure 15–4
Chain hoist.

Figure 15–5
Ratchet cable hoist.

Figure 15–6
Tripod design that can be constructed
out of wood or steel.

Figure 15–7
Portable hoist.

Figure 15–8
Welded steel gantry.

so that work can be readily moved around the studio.

Since sculptors have become involved in using a wide variety of mechanical equipment, noise can become a hazard as well. Prolonged exposure to excessive noise can result in temporary or permanent impairment or loss of hearing. Ear plugs or ear muffs can be worn to reduce noise levels. These must fit well; small leaks can reduce considerably the effectiveness of the protection.

Perhaps the most essential aspect of safety involves your attitude. If you do not take a problem seriously, even well-designed protective devices for equipment and work areas, clothing, goggles, masks, signs, color codes as reminders, and so on, will be ineffective. It is imperative that you enter a work area with a concern for safety. You must be willing to take the time to provide yourself with necessary protection. An attitude of awareness toward hazards must be uppermost in your mind at all times. This is the only way to ensure that you will be safe.

WOODWORKING

Woodworking accidents are avoided by keeping equipment in proper condition and by use of proper jigs and protective devices. You should be aware of the proper techniques for using equipment. While blades are being changed or while woodworking equipment is being worked on, the equipment should be unplugged from the electrical outlet, or a suitable

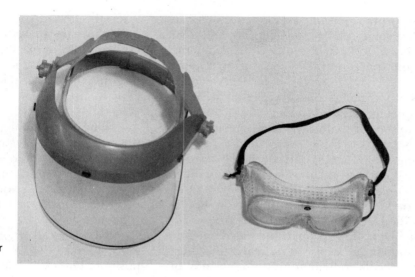

Figure 15–9
Protective face shield and goggles for eye protection.

cutoff switch should be provided. Safety goggles should be worn in all woodworking operations. (Figure 15–9) Saw blades and cutters can throw wood splinters and chips at a velocity great enough to embed them in the eye. Loose clothing should not be worn. Free-hanging shirttails, loose, unbuttoned jackets, unbuttoned long sleeves, neckties, or any loose-hanging accessories around the neck are especially hazardous. Long-haired shop workers should tie back their hair. Sawdust and woodchips should be cleaned away from blades and cutters with a brush or stick, with the machines off.

Accidents on the circle table saw usually result when hands that are very close to the saw blade slip off the material. Another common accident occurs when the material kicks back during ripping operations. Hands can be kept away from the blade by use of a proper push stick. Kickback can be prevented by use of a spreader on the outfeed side of the saw blade or by using antikickback devices. Feathered boards clamped to the fence and table for ripping operations hold the material in place and are adequate to prevent kickback in a small studio.

Improper alignment of the rip fence can also be hazardous. The front and rear of the fence must always be locked securely and must be in line with the saw blade. In cross-cutting operations, stock should be held or clamped against the miter-gauge guide; it should never be cut freehand. Attempting to remove small scraps and cutoffs next to the saw blade with the blade in motion can also result in accidents. In all sawing operations, stand out of line of possible kickback material.

Saw blades should be kept sharp and clean, and inspected periodically for defects. Dull or gummed-up blades can bind on the material and cause kickback or unsafe cutting action. Saw blades should not be used improperly—for example, ripping with crosscut blades or crosscutting with rip blades should be avoided. For safe operation, blades should not project more than about ¼ inch above the material being cut.

The safety recommendations for the table saw also apply generally to the radial-arm or the cutoff saw. If stock is held firmly against the fence and the hands are kept a proper distance from the blade, there is little cause for accidents in cross-cutting. Reaching across the path of the blade frequently causes accidents. Ripping should be done from the proper side of the blade, and the antikickback device should be used. A saw should not be operated without its guard when ripping or cutting is being done. The saw should be mounted with its arm slightly higher on the end away from the column preventing the saw from creeping out or forward while it is in an idling position.

When the saw is positioned for cutting angles or special details, extra precaution should be exercised, particularly when the operation calls for running the saw without a guard or when using shapers and routers.

Band saws and jig saws are normally not considered vary hazardous. Most accidents occur at the completion of a cut, particularly when cutting curves, because the stock is inclined to jump forward as the pressure of the blade is released upon completion of the cut. Easing pressure on the stock, keeping fingers clear of the path of travel, and feeding slowly to complete the cut minimize this danger. Cutting with dull blades that require greater feed pressure contributes to this hazard. The band saw upper guard and guide should be set just above the material. The jig saw hold-down foot should rest on the material. Blades should

be adjusted to proper tension; excessive tension can cause blade breakage. Using good lighting and a jet of air or a blower to keep the dust away from the markings on the stock contribute to safer operations as well.

Jointers are as dangerous as circle saws. When short stock is being surfaced, fingers are inclined to get too close to the cutting head. When surfaced, the wide side of a board is being done, the heel of the hand is in danger of touching the cutting blades. Using a push stick in these circumstances can minimize the hazard. A proper guard should be in place at all times. The standard leg-of-mutton guard on most machines keeps the blade covered except for the width of the material being fed through the machine. The depth of cut should never exceed more than 1/16 inch. Excessively deep cuts contribute to the possibility of kickback; the worker should stand to the side of the machine while feeding in the stock.

Accidents on the shaper, as on the jointer, usually involve the fingers or hand coming into contact with the cutting edges as stock is being cut. A proper jig should be used in these circumstances to keep the fingers an adequate distance from the cutters. Standard guards can be used, or guards can be fashioned for special detailing operations. Cutters should be covered except for the cutting edges that need sufficient exposure to cut the stock. Knives breaking or working loose from the cutter heads also cause accidents. Using ring guards for the shaper cutter head or using solid cutter heads provides some protection. Deep cuts should be avoided; it is safer to make several passes to achieve the desired cut. Be particularly aware of the machine sound, as vibration and unusual sound may mean that the blades are loose or defective or that cutters are out of balance. The fence or guide pin should always be used to support and guide the material past the cutters.

In operating planers, keep your fingers away from the feed rollers and stand to the side as the stock feeds through the machine. A board thinner than the machine setting would not make proper contact with the feed rollers and could be kicked back. Stop the machine completely to remove chips or to make adjustments. Keep other workers or spectators an adequate distance from the discharge side of the machine.

Although accidents caused by sanders are seldom as serious as those caused by saws, jointers, or planers, painful bruises and abrasions do occur. Minor abrasions are usually the result of the fingers' touching the sanding belt or disc. Serious cuts and abrasions that can result in the loss of fingertips occur when the fingers touch the abrasive surface and are pulled into the space between the belt or disc and the sander table or backstop. To minimize risk, miter guides, backstops, and jigs should be used to hold or guide the material when possible. Belts should be kept in line. Worn or frayed belts should be replaced.

The principal hazard in working with wood-turning lathes is flying wood chips, fingers getting caught between the revolving stock and the tool rest, or loose clothing catching on the machine. Wearing proper goggles and clothing and keeping the tool rest properly adjusted are the normal precautions to prevent such accidents.

Good stock without loose knots should be used; tools should be kept sharp and held in the proper position. On a variable-speed lathe, always bring the machine back down to the lowest speed or to a stop before turning it off to discontinue operations. Proper lathe speeds should be observed. Before starting the lathe, revolve the material by hand to be certain that it clears the tool rest. Check that the machine is set at its lowest speed before putting in stock for the rough cutting. Be sure that the tailstock is locked in place and that the work is properly centered.

Although hand woodworking tools do not present the hazards normally associated with power tools, injuries can occur if tools are defective or improperly used, or if your hands and fingers are in a position where they can come into undesirable contact with the tools. Saw cuts on the fingers occur when guiding the blade to start a cut, or during, or upon completion of, a cut. Hands and fingers in the paths of chisels, punches, and drills, or fingers too close to nails being driven, also result in injury.

Operating power hand tools involves a number of risks peculiar to this form of equipment. Loose clothing can get caught in revolving drill chucks, saw blades, or belt-sanding mechanisms. A drill can be driven through material and into the hand when material is hand-held. Hand holding stock while cutting with a saber saw or a portable circle saw is also dangerous. Always place stock on saw horses, low worktables, or workbenches. Hold it down firmly with clamps, jigs, a free hand, or with a knee resting on the material. Be certain the cord is clear of the operating parts of the tool and not in the path of travel for the tool. Tools should have proper guards and guides. Keep them clean and inspect them periodically for defects in the cord and the tool.

Wood dusts from woodworking operations are usually a nuisance that can be controlled with dust-removal equipment or mechanical-filter dust masks.

Concentrated levels of wood dust can be explosive; some wood dust may cause dermatitis or allergies; East Indian Satinwood and South American boxwood are toxic; allergies may be developed to woods such as pine, birch, dogwood, and mahogony. Power tools and equipment should be periodically cleaned by blowing the dust out of motors and mechanisms with low-pressure air.

WELDING

The principal dangers of welding are the handling of hot materials; the spattering of metal; the radiant energy from the welding flame or arc; toxic fumes and gases; electrical shock in arc welding; and the combustible nature of acetylene or other gases.

Eyes can be protected by using suitable goggles in acetylene welding and a helmet to protect the eyes and face in arc welding. The darkness or shading of the lens in the goggles or helmet depends on the size tip being used in oxyacetylene welding or the amperage in electric welding. Ordinary dark glasses are not suitable protection; special optical glass is used to make welding glasses. In oxyacetylene welding, lens shades may be from 3 to 4 for light work and from 5 to 8 for medium to heavy welding or cutting. In arc welding, a number 10 or 11 is usually adequate for amperages up to 200 amps. If the amperage is lower than 50 amps, use a lighter lens; for amperages between 200 and 400, use a number 12 or 13. Amperages in excess of 400 require a number 14. (Figure 15–10)

Burns can be avoided by wearing adequate protective clothing. Leather or asbestos gauntlet-type gloves, aprons, jackets, leggings, and hats provide the most desirable protection. Fabric flame-resistant and ultraviolet-resistant garments can be worn and are often satisfactory for light and medium work. Wool fabric is preferred because it is less flammable and less susceptible to ultraviolet deterioration than cotton. Fabric should be dark in color to be less reflective. Pockets, the belt line, cuffs, and low shoe tops readily catch sparks and hot particles of slag: Pants should therefore be cuffless; jackets or aprons should have no pockets and should hang over the beltline of the pants. Also, high, leather boots are advisable, so the pants legs can hang over the boots. In electric welding it is essential that all skin areas be covered. Ordinary cotton clothing is not adequate protection because the ultraviolet rays can penetrate the material. Hot metals should be picked up with pliers or tongs. Always use a friction lighter when lighting the oxyacetylene torch; never use matches. Welding should be conducted in an isolated area, or protective screens should be used to protect other workers or visitors. In electric welding, screening should be sufficient to completely isolate the ultraviolet rays because rays bouncing off white, metallic, or reflective surfaces can cause burns. Welding-booth walls should be dark-colored and nonreflective. Screens should be placed so that they do not shut off cross ventilation. Warning signs should be posted outside shop or work-area doors, advising personnel or visitors of welding operations in progress; warning signs should be placed next to hot materials if they are left unattended.

Toxic fumes from welding should be removed from the atmosphere or protective masks should be worn; in some cases, both precautions may be necessary. Fumes are removed by localized means: work-

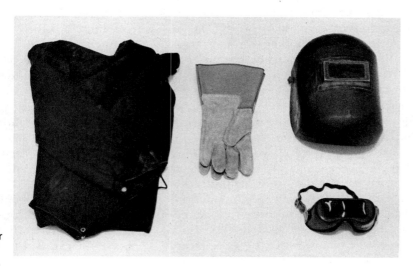

Figure 15–10
Basic protective devices for welding. Right to left: fire-resistant jacket, leather gloves, arc-welding helmet (top), oxyacetylene-welding goggles (bottom).

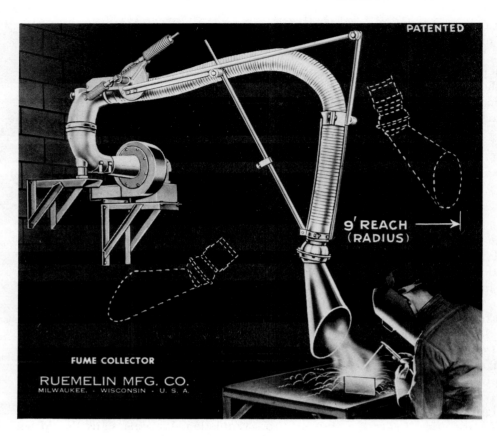

PATENTED

9' REACH
(RADIUS)

FUME COLLECTOR

RUEMELIN MFG. CO.
MILWAUKEE · WISCONSIN · U. S. A.

Figure 15–11
Fume collector with exhaust fan. Note great range of hood for use in varied working positions. *Photograph courtesy of Ruemelin Manufacturing Company.*

ing with the object under a hood, with a fume collector placed next to the weld zone, or working with general ventilation. (Figure 15–11) Under most circumstances, it would be reasonable to assume that the majority of studios and sculpture classrooms are not large enough and do not have sufficient ceiling height to permit any amount of welding without some form of ventilation. Ventilation is even required for welding or cutting uncoated, ferrous metals such as steel, unless the space is large enough to prevent an undesirable level of fume concentration. For one worker, a space smaller than 20 by 35 feet, with a ceiling height less than 16 feet, would be considered inadequate for any form of sustained welding operation, unless ventilation were supplied.

Welding fumes are usually the result of melting or burning metal or welding rods during cutting or welding, fluxes or coatings on the rods, and coatings or contaminants on the metal, which are usually additives or alloys. Metals, welding rods, or fluxes containing lead, zinc, copper, cadmium, mercury, fluorine, beryllium, and manganese can produce toxic fumes; paints and coatings on new or used materials may contain some of these materials. Excess exposure to fumes often results in metal-fume fever, which may

occur during or a few hours after welding. Symptoms are usually chills, fever, nausea, headaches, or a weak and ill feeling. Some people may acquire immunity with daily exposure to some of the less toxic agents. However, concentrated exposure to toxic materials such as cadmium fumes can cause death. Some common materials and welding operations involving toxic fumes are welding or cutting galvanized metal, bronze, copper, or brass; silver soldering; lead soldering; and welding or cutting metals that have been painted or primed with lead- or zinc-filled coatings.

Arc welding produces dangerous oxides of nitrogen in the high-temperature area of the arc. Ozone is also formed by the ultraviolet radiation acting on the air. The latter is more prevalent in gas-shielded arc-welding operations. Usually, the gases dissipate and combine with the atmosphere a few feet from the arc and do not reach toxic levels. However, in high-volume welding and in confined spaces, ventilation should be provided.

Fire hazards are caused by welding near combustible material, misuse of welding equipment, or working with defective equipment. Work areas should be kept clean and free of combustibles; oil and flammable contaminants should be cleaned off metal be-

fore welding the material. When welding in areas next to combustible materials such as wood metal, or asbestos board shields should be used to confine the sparks to the welding area. Check the area thoroughly upon completion of the job to be certain that sparks have not ignited any material. A 30-minute fire watch with another spot check 30 minutes later is recommended if there is any possibility of sparks having dropped into concealed places. Welding should not be carried out close to any containers of highly flammable liquids. Oily and greasy clothing is also a fire hazard. In sculpture classrooms or work areas, be certain your make-up supply of air is not coming from a room which contains large quantities of flammable liquids or in which work with flammable materials is being done.

When handling oxyacetylene equipment, always keep tanks chained or fastened to a wall or support so that they cannot be tipped over. Work at proper recommended pressures; never exceed 15 pounds of pressure on the acetylene. Oxygen is not flammable but supports and accelerates combustion. Oil should not be used on any oxygen fittings, and oxygen should not be released around oily metal or material; both of these situations are potentially highly explosive and flammable. Oxygen valves and equipment should not be handled with oily hands or while wearing oily gloves; keep oil off gloves used to handle the welding torch; if oily metal must be handled, use separate gloves for handling the material and change into clean gloves for the oxyacetylene welding or cutting materials.

Check the oxyacetylene equipment periodically for defects and for leaks; leaks can be checked by brushing soap suds on the fittings and watching for soap bubbles to form.

Never weld or flame-cut containers that have contained inflammable materials without first cleaning them; filling a container with water about up to the weld zone and properly venting the remaining space are recommended as a further precaution. Never weld enclosed forms without providing a vent hole so that pressure and gases built up by heat can escape. Forced venting can be achieved by directing compressed air into the container; a vacuum cleaner can also be used as an air supply. Keep cylinders a sufficient distance from the work area. Be certain that the lighted torch is never turned so that it might accidentally direct heat on the cylinder.

Accidental electric shock can be avoided in arc welding if the equipment is properly grounded and the operator of the equipment is properly insulated to handle the equipment. If gloves and clothing are dry and equipment is in good repair, there is very

little hazard involved. Clothing and gloves frequently become moist from perspiration in warm weather, however, although changing clothing is often impractical, changing gloves periodically is possible and is a good practice. Welding cables and electrode holders should be checked for breaks in the insulation and for defects. Cables should be placed so that they do not become damaged by flying sparks, slag, falling hot scraps of metal, and so that they do not come into contact with the hot work. Hanging the cables overhead is a good practice. The electrode holder is well insulated. Electrodes should never be changed with bare hands or while wearing moist gloves. Never work on moist floors. Working on metal ladders can also be hazardous.

CARVING

Sawdust and contact with wood in wood carving pose hazards similar to those discussed for woodworking. Cuts and bruises are perhaps the most common problems. Dull tools and tools loosely mounted in their handles contribute to accidents in wood carving. In finishing work, when the chisel is pushed with one hand, accidents often occur if the chisel slips and a hand is in the path of the chisel. When roughing out with an axe, injury can occur if the axe is being swung improperly; the blade may glance off the log and strike a leg or a foot. Obstacles or bystanders in the path of an axe when it is being swung are also in danger of being injured. When an adze or hatchet is being swung, it is also necessary to be cautious that a wrong or glancing blow does not strike any part of your body. Loose heads on axes, adzes, and hatchets can also fly from the handle, and strike other workers in the area.

When pneumatic chisels are being operated for both wood and stone carving, noise levels may be objectionable or harmful, necessitating the use of ear plugs or muffs. Exposure to the continuous vibration of the tool and the exhausted air, and hand strain from holding the tool, can result in a condition known as "dead hand" or "white finger." Although this damage to the circulatory system of the hand is usually temporary, prolonged and continuous exposure has in some cases produced permanent injury. Exhausted air from pneumatic tools also causes greater quantities of dust to become air-borne, increasing dust hazards. Directing the air away from your hands and using a comfortable tool size for your hands can reduce the possibility of dead hand.

Hazardous dusts in stone carving are primarily the dusts containing crystalline free silica. Inhaling large quantities of these dusts over a long period of time may result in silicosis. Quartz, sandstone, and granite contain high percentages of crystalline free silica, which is also present in varying amounts in some marbles, travetine, soapstone, and some limestone. Because most dusts may be irritating, it is probably advisable to use a suitable dust mask or dust-removal ventilating system during any carving operation when dust-particle levels are high. Suitable protection from the crystalline free silica dusts is imperative.

Stone-carving chisels have a tendency to mushroom on the ends because of the striking force of the mallet. Keeping chisel ends trimmed, with a slight bevel, can prevent serious cuts from mushroomed ends.

ABRASIVE GRINDING

Hazardous materials in abrasive grinding are often present in the material being ground as well as in the dusts from abrasive wheels. Besides the potential danger you face from these materials, being struck by pieces of wheels that break at high speed is another danger. Wearing proper protective garments and using adequate dust-collecting systems minimize these dangers. Protective goggles or face shields should be worn at all times. In operating abrasive wire brushes, a full-face shield is essential; a leather apron and arm guards should also be used as protection against possible loose wires being propelled into space from the revolving wheel.

If dust collectors are not used, proper dust masks should be worn. Dust from most metals can be hazardous and irritating. Accumulations of magnesium dust are exceptionally explosive and flammable. Magnesium dust requires special wet-dust collecting systems.

Standard abrasive wheels should be mounted on the shaft of the grinder with protective flanges. The flange diameter should be approximately one-third the diameter of the wheel. Larger-diameter safety flanges are used for wheels when they are operated without protective guards, which should be used whenever possible. Wheels should not be operated in excess of the recommended speeds, should be inspected for cracks and defects, and should be dressed when they become worn, to restore the working surface and balance to the wheel. A proper work rest should be used to support and guide the work. Grinding should be confined to the work surface of the wheel; the flat side of the wheel should not be used except when necessary in the sharpening of some types of chisels and tools.

METAL CASTING

Hazards in foundry work result primarily from dust and fumes and from the handling of molten metal during casting. Dust conditions are usually produced when such mold-making materials as talc, flint, silica flour, silica sand, plaster, portland cement, and asbestos are being used. Dust and fumes from lead, chromium, iron, phosphorous, tin, zinc, magnesium, and copper-based alloys that contain beryllium produce conditions that are hazardous or irritating. Aluminum and magnesium dust pose fire and explosion hazards in dust-collecting systems.

Fumes from resins used as binders that contain phenol-formaldehyde, urea-formaldehyde, furfural alcohol, phosphoric acids, or others are also toxic. Binders and additives or catalysts, which should always be added to sand according to manufacturers' recommendations, should never be mixed together in the liquid form; severe chemical reaction can occur. Fumes from solvents may also be toxic. Silicone in mold-release materials may be irritating to the skin and can be hazardous if inhaled. During melting operations, toxic metallic fumes are present in the dross and disintegrating, oxidizing, low-melting point alloys in the metal. Properly using fluxes, controlling temperature, and minimizing the holding period for molten metal reduces these hazards. Fumes from burning polyurethane or polystyrene foam in displaced-foam casting can also contain toxic fumes. Prolonged skin contact with sand and chemical additives in mold construction may cause dermatitis. Adequate ventilation or protective masks should be used when exposure to dusts and fumes is a possibility.

Melting and handling molten metal are particularly hazardous and require precaution. Proper care of crucibles is essential; metal should not be wedged or forced into the crucible; crucibles must be dry, and the metal that is added to molten metal in a crucible, is dry—moisture coming into contact with molten metal can produce severe reactions. Proper lighting procedures for furnaces and ovens should be adhered to strictly.

Safety goggles or face shields should be used at all times. Long sleeves, shirts buttoned around the wrists, and cuffless pants over high-topped shoes, provide protection in the average sculpture studio. Asbestos or leather gloves that fit snugly around the

Figure 15–12
Protective clothing for metal casting.
Left to right: leather jacket, leather
apron (top), asbestos leggings (bottom),
asbestos gloves (top), face shield
(bottom).

wrist, with the shirt sleeve or jacket sleeve over the glove, provide the best protection. Asbestos or leather protective hoods, jackets, aprons, leggings or spats, skull caps, and gloves should be worn in handling large quantities of molten metal. (Figure 15–12)

Pouring areas should be kept well-organized. Particular attention should be given to keeping obstacles out of the way of workers handling crucibles of molten metal. Crucibles or ladles of metal being transported on overhead tracks should never be allowed to pass over other workers. Ladles should be equipped with manual or automatic safety locks to prevent accidental overturns. When large castings or heavy molds are being handled, proper lifting devices should be used, and care should be exercised when they are being hand-lifted. Wearing hard-toed shoes is a good practice. Injury to the fingers or toes is commonplace in the handling of heavy materials.

PLASTICS

Although plastic materials are generally inert and nontoxic in their finished forms, the raw materials used to produce finished products are often toxic: Skin contact with adhesives; fumes from coatings, resins, solvents, and from heating or welding plastic; and dusts from fillers and from sanding and milling coatings produce hazardous working conditions. Reasonable precautions—such as providing adequate ventilation, dust-collecting equipment, or protective gloves, face masks, and clothing—are necessary and should be considered mandatory.

Polyester, epoxy, and urethane resins, coatings, their solvents, and catalysts are being used today in considerable quantities in studios and classrooms. Working with these materials under unsatisfactory conditions has produced skin irritation, dermatitis, eye irritation, temporary illness, and permanent internal injury.

Styrene monomer, cobalt or aniline accelerators, and methyl ethyl ketone or benzoyl peroxide catalysts are toxic materials used in the formulation of, or when working with, polyester resins. Normally, the accelerators, present in the resin, are not handled in quantities sufficient to cause a problem. Accelerators and catalysts are highly reactive and flammable, and they should never be mixed together. Dispersing each one individually into the resin reduces their reactions to safe working limits. Although acetone, used to clean brushes and equipment, is not highly toxic, it can be irritating to the eyes, nose, throat, and skin; excess inhalation of the fumes may result in headaches, temporary illness, and depression. Excess exposure can cause internal injury.

Although epoxy resins are normally considered safe and nontoxic, the amine curing agents added to the epoxies to effect polymerization are extremely irritating to the skin; concentrated vapors or fumes from the liquid curing agents, or those formed during the curing of the resin, can cause nose and throat irritation; continuous exposure can cause internal injury. Alkanol amines and anhydride curing agents, used more frequently today, are less toxic.

Urethane resins have also been compounded that are fairly safe; the toxicity of the fumes has been

reduced considerably over earlier foam systems. It is the isocyanate or diiocyanate used in foam formulas that produces the toxic fumes. The first symptoms of excessive exposure are bronchial irritation and asthma-like attacks; prolonged contact and inhalation may result in internal injuries to the lungs, liver, and kidneys. Skin contact with the resins should also be avoided.

Skin contact and fumes from methyl methacrylate (acrylic resin), urea-formaldehyde and melamine-formaldehyde resins, phenolic, and polystyrene resins may have varying degrees of toxicity. Burning most plastics causes toxic fumes due to chemical decomposition (pyrolysis).

Dust from most polymerized plastics is inert and harmless if the material is completely polymerized or cured. When plastics that have not been completely cured are machined, sawed, or sanded, not the dust but the release of fumes that are still internally present in the material that is irritating and toxic. A typical example would be sawing or sanding freshly cast polyurethane blocks or castings. Vapors would not have completely dissipated, and some would be trapped in the closed cells of the material. When reinforced fiberglass or cast blocks of plastics are sanded, dust from fillers—typically, glass fiber, metal fillers, asbestos, and silica—added to the resin may be a hazard.

Normal precautions should be exercised in handling any of the flammable solvents or resins. Particular care should be exercised in disposing of polymerizing plastic scraps, solvent-soaked cloth, or cleaning materials. When packed in a waste container these materials can readily produce spontaneous combustion; they should be collected in small containers and emptied periodically into large open metal containers out of doors. The materials should be loosely packed in the containers so that vapor and heat can dissipate, minimizing combustion hazards. Even small quantities of scrap should not be allowed to remain in the studio or unattended for a long period of time.

Dyes and pigments added to resins are sometimes hazardous or toxic. Pigment dust should not be inhaled. Skin contact with these should be avoided; skin contact with aniline dyes is particularly dangerous, because aniline is readily absorbed through the skin and is extremely toxic.

COATINGS AND SURFACE PREPARATION OF MATERIAL

In recent years, the coating industry has developed some coatings that are extremely safe and convenient to use. On the other hand, this new technology has also produced coatings that need to be handled with considerable care. The typical oil- or water-based paints purchased in the neighborhood paint store are relatively free from toxic materials, but epoxy and urethane coatings need to be handled with care. Many industrial coatings containing plastic materials that are extremely durable require special precautions in handling and applying. Primers containing lead or zinc should be handled carefully; solvents, vehicles, and additives to paints may be toxic and flammable. Paint thinner, turpentine, lacquer thinner, acetone, and solvents for plastics should be used with caution. Hardeners or curing agents for resins are often toxic. Labels on all coating or solvent containers should be read for handling precautions.

Utmost attention should be given to working conditions when coating is being applied. Good ventilation should be provided, particularly during spray painting. Paint application with brush, spray, or roller should not take place near open flames from space heaters, hot-water heaters, stoves, welding operations, or other sources if it contains flammable resins or solvents. When spraying, it is a good idea to use a face mask to filter out paint particles; if fumes are toxic, a cartridge-type face mask with suitable filters should be used. It is good practice to cover up surrounding areas that could be damaged by overspray; a suitable spray booth should be used when possible. If there are other workers in the area, they should be advised that toxic material is being used.

Most of the acids or chemicals used in metal plating, cleaning, or oxide-application operations are toxic to some extent; nitric and sulfuric acid can produce severe burns. Fumes must be removed from the atmosphere. Alkaline cleaning compounds are somewhat less hazardous to handle. Suitable rubber gloves, protective masks, and clothing should be worn. Eyes should be protected from spattering by goggles or a face shield. When mixtures containing such acids as nitric or sulfuric are being used, they should be added to the water when the solution is being made; the reverse procedure can produce strong and hazardous reactions. In mixing chemicals for oxide finishes, materials should never be mixed unless familiarity has already been established with the possible results: Some chemicals may be highly reactive with other materials, producing deadly toxic fumes.

In surface preparation of material for painting or adhesive bonding, good ventilation should be provided when cleaning is being done with solvents such as acetone, mineral spirits, methyl alcohol, or other flammable materials that may also contain toxic fumes. Trichloroethylene and perchloroethylene are good

nonvolatile substitutes for many of these solvents; however, the fumes are toxic. Precautions should also be exercised in swab or dip applications of acid or alkaline solutions. In steam-cleaning operations, rubber gloves, apron, and boots should be worn. The instructions for the operation of the steam cleaner should be carefully followed. It is good to be certain that all safety devices are functioning properly and to be on the alert for excess pressure in the system. For maximum protection a hood with an air supply or a dust mask with goggles or face shield should be worn at all times.

Bibliography

AMMEN, C. W. *The Metalcaster's Bible*. Blue Ridge Summit, Pa.: TAB Books Inc., 1980.

ANDREWS, OLIVER. *Living Materials, a Sculptor's Handbook*. Berkeley, Calif.: University of California Press, 1983.

BARAZANI, GAIL CONINGSBY. *Safe Practices in the Arts and Crafts, A Studio Guide*. College Art Association of America, N.Y.C., N.Y., 1978.

BRODIE, REGIS C. *The Energy Efficient Potter*. New York: Watson Guptill Publication, 1982.

BROWN, NELSON COURTLANDT, AND BETHEL, JAMES SAMUEL. *Lumber*. New York: John Wiley & Sons, Inc., 1958.

BURNS, ROBERT MARTIN, AND BRADLEY, W. W. *Protective Coating for Metal*. New York: Reinhold Publishing Corp., 1967.

CAGLE, CHARLES V. *Adhesive Bonding*. New York: McGraw-Hill Book Company, 1952.

COLEMAN, DONALD G. *Woodworking Fact Book*. New York: Robert Speller & Sons, 1966.

COLEMAN, RONALD L. *Sculpture*. Dubuque, Iowa: Wm. C. Brown Company, 1968.

COLLINGWOOD, G. H., AND BRUSH, WARREN D. *Knowing your Trees*. Washington, D.C.: American Forestry Association, 1955.

DOYLE, LAURENCE E. *Manufacturing Processes and Materials*. Englewood Cliffs, N.J.: Prentice-Hall, Inc., 1961.

EDLIN, HERBERT T. *What Wood is That?* New York: Viking Press, 1969.

GUTTMANN, WERNER H. *Concise Guide to Structural Adhesives*. New York: Reinhold Publishing Corp., 1961.

HAMMOND, JAMES J., DONNELLY, EDWARD T., HARROD, WALTER F., AND RAYNER, NORMAN A. *Woodworking Technology*. Bloomington, Ill.: McKnight & McKnight Publishing Co., 1966.

HAYWARD, CHARLES H. *Complete Book of Woodworking*. Philadelphia and New York: J. B. Lippincott Co., 1955.

HOWARD, E. D. *Modern Foundry Practice*. New York: Philosophical Library Inc., 1959.

LINDBERG, ROY A. *Processes and Materials of Manufacturing*. Boston: Allyn & Bacon, Inc., 1965.

LISTER, RAYMOND. *The Craftsman in Metal*. Cranbury, N.J.: A. S. Barnes and Co. Inc., 1968.

LITTLETON, HARVEY. *Glassblowing: A Search for Form*. New York: Van Nostrand Reinhold Co., 1971.

MILLER, SAMUEL C. *Neon Signs and Cold Cathode Lighting*. New York: McGraw-Hill Book Company, 1952.

MILLER, S. C. *Neon Technology and Handling, Handbook of Neon Sign and Cold Cathode Lighting* (3rd ed.). Cincinnati: Signs of the Time Publishing Co., 1977.

MILLER, WILLIAM G. *Using and Understanding Miniature Neon Lamps*. Indianapolis: The Bobbs-Merrill Company, Inc., Howard W. Sam & Co., Inc., 1969.

MORRIS, JOE L. *Metal Casting*. Englewood Cliffs, N.J.: Prentice-Hall, Inc., 1957.

NELSON, GLENN C. *Ceramics*. New York: Holt, Rinehart & Winston Inc., 1960.

NEWMAN, THELMA R. *Plastics as an Art Form*. Philadelphia: Chilton Company, 1964.

PATTON, W. J. *The Science and Practice of Welding*. Englewood Cliffs, N.J.: Prentice-Hall Inc., 1967.

Pattou, Albert B. *Practical Furniture and Wood Finishing.* Chicago: Frederick J. Drake & Co., 1956.

Rich, Jack C. *The Materials and Methods of Sculpture.* New York: Oxford University Press, 1947.

Richter, H. P. *Wiring Simplified.* Minneapolis: Park Publishing, Inc., 1965.

Rhodes, Daniel. *Kilns: Design, Construction and Operation.* Philadelphia: Chilton Book Co., 1968.

Rothenberg, Polly. *The Complete Book of Creative Glass Art.* New York: Crown Publishers Inc., 1974.

Roukes, N. *Sculpture in Plastic.* New York: Watson Guptill Publications, 1968.

Sams, Howard W. *Basic Electricity and an Introduction to Electronics.* Indianapolis: The Bobbs-Merrill Company, Inc., Howard W. Sams & Co., Inc., 1967.

Schmitt, Buban P. *Understanding Electricity and Electronics.* New York: McGraw-Hill Book Company, 1962.

Simonds Herbert R. and Bregman, Adolph. *Finishing Metal Products.* New York: McGraw-Hill Book Company, 1946.

Sloane, T. O'Connor. *Henley's Twentieth Century Book of Ten Thousand Formulas, Processes and Trade Secrets.* New York: Books Inc., 1970.

Soderberg, George A. *Finishing Materials and Methods.* Bloomington, Ill.: McKnight & McKnight Publishing Co., 1959.

Stern, Rudi. *Let There Be Neon.* New York: Harry N. Abrams, Inc., 1979.

Walker, John R. *Modern Metal Work.* Homewood, Ill.: Goodheart Willcox Co. Inc., 1965.

Weyger, Alexander G. *The Modern Blacksmith.* New York: Van Nostrand Reinhold Co., 1974.

Accident Prevention Manual for Industrial Operations. Chicago: National Safety Council, 1964.

Encyclopedia of Science and Technology. New York: McGraw-Hill Book Company, 1966.

Metal Finishing Guidebook and Directory. Westwood, N.J.: Metals and Plastics Publications Inc., 1970, 1971.

Modern Plastics Encyclopedia. New York: McGraw-Hill Book Company, 1970–71, 1971–72.

Plastics Engineering Handbook. New York: Reinhold Publishing Corp., 1960.

Proceedings of the National Sculpture Conference. Lawrence: National Sculpture Center Publications, University of Kansas, 1960, 1962, 1964, 1966, 1968, 1970.

The Oxy-Acetylene Handbook. New York: Linde Air Products Company, A Division of Union Carbide Corp., 1957.

Unique Lighting Handbook. Barrington, N.J.: Edmund Scientific Co., 1969.

INDUSTRIAL BOOKLETS AND TECHNICAL PUBLICATIONS

Acrylic Foundation Manual. Publication no. C.S. 101460M 267. Wakefield, Mass.: American Cyanamid Co., Building Products Division, 1967.

Adhesive Bonding Copper and Copper Alloys to Other Building Materials. Technical report 406/6. New York: Copper Development Assoc. Inc., 1966.

Adhesive Applying (Methods and Equipment). Adhesive Reference Series. Middleton, Mass.: USM Corporation, Chemical Division, 1970.

Brass and Bronze Casting Alloys. Bulletin no. V-1. New York: American Smelting and Refining Co., Federated Metals Division, 1967.

Brushing Tools for Industry. FORM MC1-764-1. Worcester, Mass.: Anderson Corporation.

Cement Masons Manual. Publication no. EBO15.01T. Skokie, Ill.: Portland Cement Association, 1960.

Cincinnati Grinding Wheels. Publication no. PG-320-1. Cincinnati, Ohio: Cincinnati Milacron Inc., Products Division, 1965.

Cor-Ten Steel. AIA. File no. 13-A. Pittsburgh: United States Steel Corp., 1966.

Design and Control of Concrete Mixtures. Publication no. EBOO1-11T. Skokie, Ill.: Portland Cement Association, 1968.

Fabrication of Plexiglass. Publication no. 383d. Philadelphia: Rohm and Hass Co., 1959.

Fabrication of Stainless Steel. Publication no. ADVCO-03092-62. Pittsburgh: United States Steel Corp.

Flame Spray Handbook. H. S. Ingham and A. P. Shepard. Westbury, L. I., N.Y.: Metco Inc., 1964.

Getting the Most Out of Your: Circle Saw and Jointer, 1953; Shaper, 1954; Bandsaw and Scroll Saw, 1954; Abrasive Tools, 1955; Drill Press, 1954; Radial Saw, 1956; Lathe, 1954 (separate publications on each item). Pittsburgh: Rockwell Manufacturing Company, Delta Power Tool Division.

Guide to Plastic Welding, Equipment and Techniques. Norwood, Mass.: Kamweld Products Co. Inc., 1972.

Guide to Plywood Properties and Grades. AIA. File no. 19-F. Tacoma, Wash.: American Plywood Association, 1966.

How to Apply Surface Colors. Technical report 121/8. New York: Copper Development Association, 1968.

Guide
to Materials
and Suppliers

You can often purchase the materials listed here locally. The yellow-page section of the telephone book usually lists local sources for material or representatives of major companies.

Explore local sources before contacting major manufacturing companies. If you still have to contact a major company, ask for the nearest source for its product.

For additional information on materials and manufacturers not listed in this guide, consult *Thomas Register of American Manufacturers*, which is available in most university or public libraries. Most products and their manufacturers can be located in this manner.

NOTE: Numbers following guide entries correspond to the numbered list of suppliers and manufacturers starting on page 267.

Abrasives, belts, discs, wheels, etc., 33, 37, 66, 90, 101, 125, 141, 145, 159
Abrasive compounds, 33, 66, 76, 141
Abrasive power tools, 51
Accelerators, 76, 116
Acrylic resins, 76, 123
Acrylic sheet, rod, etc., 12, 32
Adhesives, 32, 47, 76, 116, 145
Air arc torch, 18

Air compressors, 24, 45, 48, 66, 146
Air tools, 19, 66, 67, 69, 76, 146
Alabaster, 39
Alcohol, isopropyl, 116
Aluminum, 9, 14, 35, 121, 130
Arcair torch, 20
Arc welders, 92, 147
Armatures, 126, 128
Asbestos fiber, 110, 137
Asbestos gloves, aprons, etc., 76, 77, 85, 140

Binders, 61, 79, 115, 158
Black light, 52
Blowers, 45, 66, 80
Bolts, 23
Bronze for casting, 14, 130
Bronze sheet, angle, etc., 35
Brush plating, 129
Buffing compounds, 42, 59, 88, 125, 141
Buffs, 11, 42, 59, 76, 88, 137
Bulbs, 52, 62, 66
Burners, 80
Burning bar, 31
Burnout furnace, 3, 7, 85

Cab-O-Sil®, 32, 76, 110, 116
Carving tools, 42, 67, 99, 126, 128
Casting compounds, 1, 46, 76, 126, 127, 136
Casting resins, 1, 32, 40, 76, 110, 116, 118, 119
Catalysts, 32, 76, 110, 116
Ceramic-shell materials, 7, 96, 98, 118, 131
Clamps, 2, 56, 66, 146, 160

List
of Suppliers
and Manufacturers

1. ADHESIVE PRODUCTS CORP.
 1662 T Boone Ave.
 Bronx, N.Y. 10460

 Casting compounds, epoxy and polyester resins for casting, rubber-mold materials, coloring agents for resins, resins for rigid and flexible polyurethane foam.

2. ADJUSTABLE CLAMP CO.
 414 North Ashland Ave.
 Chicago, Ill. 60622

 Spring and hinged clamps.

3. A. D. ALPINE, INC.
 3051 Fujuta St.
 Torrance, Calif. 90505

 Gas-fired ceramic and burnout kilns.

4. ALABAMA METAL INDUSTRIES, INC.
 3245 Fayette Ave.
 Birmingham, Ala. 35208

 Steel- and aluminum-expanded metals for decorative use.

5. ALCAN METAL POWDERS
 DIVISION OF ALCAN ALUMINUM CORP.
 100 Erieview Plaza
 Cleveland, Ohio 44101

 Manufacturers of metal powders.

6. A.L.C. CO., INC.
 Box 506
 Medina, Ohio 44256

 Good low-cost sandblasting gun and tank.

7. ALEXANDER SAUNDERS AND CO.
 Box 265, Route 301
 Cold Spring, N.Y. 10516

 Investment materials, furnaces, and casting equipment; colloidal silica and materials for ceramic-shell molds; waxes for patterns.

8. AGET MANUFACTURING CO.
 1408 Church St.
 P.O. Box 248
 Adrian, Mich. 49221

 Good variety of dust-removal equipment, both portable and high-volume stationary systems.

9. ALUMINUM CO. OF AMERICA (ALCOA)
 425 Sixth Ave.
 Pittsburgh, Pa. 15219

 Producers of aluminum sheet, casting alloys, and many other aluminum materials.

10. AIR TECHNICAL INDUSTRIES
 7501 Clover Ave.
 Mentor, Ohio 44060

Good source for hoists, lift tables, storage racks, and other material-handling equipment.

11. AMERICAN BUFF INTERNATIONAL, INC.
 624 West Adams St.
 Chicago, Ill. 60606

Nylon-web buffing wheels.

12. AMERICAN CYANAMID COMPANY
 PLASTICS DIVISION
 One Cyanamid Plaza
 Wayne, N.J. 07470

Manufacturers of acrylic sheet and alkyd, melamine, polyester, and urea molding compounds; polyester resins and other materials.

13. AMERICAN INDUSTRIAL SAFETY EQUIPMENT CO.
 3500-T Lakeside Ave.
 Cleveland, Ohio 44114

Manufacturers of safety goggles, glasses, face shields, helmets, respirators, welders' plates, replacement lens, etc.

14. AMERICAN SMELTING AND REFINING CO.
 FEDERATED METALS DIVISION
 9200 Market St.
 Houston, Texas 77029

Aluminum, bronze, brass, and low-melting-point alloys for casting.

15. ARCO METALS CO.
 2 Continental Tower
 1701 Golf Rd.
 Rolling Meadows, Ill. 60008

Manufacturers of a wide variety of brass and copper-alloy sheet, tube bar, angles, and other shapes; silicon-bronze conduit and electrical fittings.

16. ANDERSON DIVISION
 ANDERSON DRESSER INDUSTRIES
 1040-T Southbridge St.
 Worcester, Mass. 01610

Manufacturers of wire and fiber brushes

17. A. P. GREEN FIRE BRICK CO.
 Mexico
 Missouri 65265

Firebricks and castable refractories.

18. ARCAIR COMPANY
 Box 406, Route 33 North
 Lancaster, Ohio 43130

Manufacturer of Arcair cutting torch.

19. THE ARO CORPORATION
 INDUSTRIAL DIVISION
 One Aro Center
 Bryan
 Ohio 43506

Manufacturer of a wide variety of air tools.

20. ATLANTIC COMPOUND CO.
 2 Charles St.
 Chelsea, Mass. 02150

Manufacturer of greaseless buffing compounds.

21. BABCOCK AND WILCOX CO.
 INSULATING PRODUCTS
 Old Savannah Road
 Augusta, Georgia 30930

Refractory materials; ceramic refractory material called "Kaowool®," available in blanket, paper, strip, block, and mesh-covered forms; also available in castable and tamping mixtures; will stand temperatures up to 2300 degrees.

22. BARRE GRANITE CO.
 Box 481
 Barre, Vermont 05641

Granite.

23. BETHLEHEM STEEL CORPORATION
 Bethlehem
 Pennsylvania 18016

Producers of a wide variety of steel materials and products, such as I beams, nails, bolts, wire, etc.

24. BINKS MANUFACTURING CO.
 9201 W. Belmont Ave.
 Franklin Park, Ill. 60131

Spray-painting equipment, spray guns, booths, air compressors, pressure tanks, hose, and all accessories.

25. BIRCHWOOD CASEY
 DIVISION OF FULLER LAB, INC.
 7900-T Fuller Rd.
 Eden Prairie
 Minnesota 55344

Swab-on solutions for black finishes on metal; BST 4 for iron and steel; M 24 for brass, bronze, copper, and zinc; A 14 for aluminum; available in quarts and larger.

26. BLACK AND DECKER MANUFACTURING CO.
 701 East Joppa Rd.
 Townson
 Maryland 21204

Portable power tools, air and electric traveling saws.

27. BRADFORD PARK CORP.
7 Tamarack Lane
Elnora, N.Y. 12065

B–P metal cleaners for ferrous and nonferrous metals; harmless to normal skin and materials, give off no toxic fumes; available in paste or liquid, 1 gallon or larger.

28. BREVEL PRODUCTS CORP.
Broad Ave. & 16th St.
Carlstadt, N.J. 07072

Manufacture of slow-speed electric motors, fractional horsepower; 1 to 120 r.p.m.

29. BRISTOL SAYBROOK CO.
500 Coulter Ave.
Old Saybrook, Conn. 06475

Manufacture of slow-speed, fractional-horsepower miniature motors, speeds above and below 1 r.p.m.

30. BUCK BROTHERS, INC.
Dept. T.R., Box 192
Millbury, Mass. 01527

Fine wood-carving tools.

31. BURNING BAR SALES CO.
6010 Yolanda Ave.
Tarzana, Calif. 91356

Burning bar for cutting slag, metal, concrete, etc.

32. CADILLAC PLASTIC & CHEMICAL CO.
P.O. Drawer 2020
Birmingham, Mich. 48012

Good variety of plastic sheet, rod, tube, film, and other shapes; polyester and epoxy resins; adhesives for all forms of plastics and other material; good source for almost any plastic needs.

33. THE CARBORUNDUM COMPANY
BONDED ABRASIVES DIVISION
Box 350
Niagara Falls, N.Y. 14304

Manufacturer of coated and bonded abrasives and other abrasive products.

34. CERRO SALES CORPORATION
250 Park Ave.
New York, N.Y. 10022

Low-melting-point alloys.

35. CHASE BRASS & COPPER CO.
6180 Cochran Rd.
P.O. Box 39548-T
Solon, Ohio 44139

Manufacturer of copper, copper-alloy sheet, angle, bar, strip, plumbing copper fittings and valves; also aluminum and stainless-steel materials.

36. CINCINNATI FOAM PRODUCTS INC.
3244-T McGill Lane
Cincinnati, Ohio 45239

Foam beads, molded boards, and slabs of polystyrene.

37. CINCINNATI MILACRON, INC.
PRODUCTS DIVISION
4701 Maxbury Ave.
Box 9013
Cincinnati, Ohio 45209

Manufacturers of a wide variety of bonded abrasive wheels.

38. CLEMCO INDUSTRIES
1956 Elkhorn Court at 20th
San Mateo, Calif. 94403

Sandblasting equipment.

39. COLORADO ALABASTER CO.
1507 N. College Ave.
Fort Collins, Colo. 80524

Alabaster.

40. COOK PAINT AND VARNISH CO.
919-T E. 14th Ave. North
Kansas City, Mo. 64116

Polyester laminating resins, clear cast, and casting resins to be used with fillers; urethane-foam resins; good range of colored gel coats and pigment concentrates; alkyd, epoxy, chlorinated rubber, coal-tar epoxy, polyester, vinyl, acrylic latex, vinyl urethane and zinc-rich primer industrial coatings; also good source for many other coating supplies.

41. CPR DIVISION
THE UPJOHN COMPANY
7000 Portage Rd.
Kalamazoo, Mich. 49001

Urethane blocks for carving.

42. THE CRAFTOOL COMPANY
2323 Reach Rd.
Williamsport, Pa. 17701

Sculpture plaster and clay tools, ceramic supplies, buffing compounds and wheels, stone- and wood-carving tools, small flexible-shaft machines, metal craft hammers, small portable spray-paint equipment, sharpening tools, and other supplies.

43. CROWN INDUSTRIES PRODUCTS CO., INC.
 100 State Line Rd.
 P.O. Box 326
 Hebron, Ill. 60034

 Wide variety of cleaners, lubricants, etc., in aerosol cans.

44. DAKE, DIVISION OF JSJ CORPORATION
 724 Robbins Rd.
 Grand Haven, Michigan 49417

 Horizontal cutting bandsaw.

45. DAYTON ELECTRIC MFG. CO.
 5959 W. Howard St.
 Chicago, Ill. 60648

 A large variety of ventilating fans, motors, pumps, air compressors, and hand and electric tools.

46. DESIGN CAST CORP.
 P.O. Box 134
 Princeton, N.J. 08540

 Polymer cement-like material for casting and direct modeling.

47. DEVCON CORPORATION
 59 Endicott St.
 Danvers, Mass. 01923

 Adhesives, epoxy coatings, zinc-rich coatings and primers; epoxy putty with bronze, aluminum, lead, steel carbide or stainless steel fillers; Devcon rubber for caulking, repair, sealing, etc.; Devcon two-Ton epoxy adhesive readily available at most hardware stores, etc.

48. THE DEVILBISS CO.
 Box 913-T
 Toledo, Ohio 43601

 Manufacturer of conventional, airless, and hot spray-painting equipment. Air compressors, hoses and fittings, spray booths, air-replacement equipment.

49. DOW CHEMICAL CO.
 2030 Willard H. Dow Center
 Midland, Mich. 48640

 Producers of polystyrene foam, plastic film, sheets, resins, powders, and pellets; wide variety of chemicals and other products; available in industrial quantities or through appropriate distributors.

50. DRY KILN DESIGN
 P.O. Box 7527
 Oakland, Calif. 94601

 Glass-blowing equipment and furnaces.

51. DYNABRADE INC.
 72 East Niagara St.
 Tonawanda, N.Y. 14150

 Abrasive power tools, good line of narrow-belt sanders.

52. EDMUND SCIENTIFIC CO.
 A415 Edscorp Bldg.
 Barrington, N.J. 08007

 A wide variety of useful devices, projectors, lenses, miniature light bulbs, motors, lasers, black light, etc. Write and ask for catalog.

53. ELLEN PRODUCTS CO.
 130 South Liberty Dr.
 Stoney Point, N.J. 10980

 Zinc stearate, paintable silicone, and polymer release agents in aerosol cans. Available in small quantities.

54. ENGELHARD INDUSTRIES, INC.
 HANOVIA LIQUID GOLD DIVISION
 70 Wood Ave.
 S. Iselin, N.J. 08830

 Metallic-luster glaze materials.

55. ERDLE PERFORATING CO., INC.
 100 Pixley Industrial Parkway
 Box 1568 T
 Rochester, N.Y. 14603

 Perforated metal, square, round, hexagonal patterns. Aluminum, bronze, steel, monel, and other metals as stock items.

56. ERICO PRODUCTS, INC.
 PLASTIC EQUIPMENT DIVISION
 34600 Solon Road
 Cleveland, Ohio 44139

 Clamps.

57. EUTECTIC CORP.
 40-40 172nd St.
 Flushing, N.Y. 11358

 Manufacturer of special-purpose welding rods for oxy-acetylene and arc welding; also cutting rods.

58. THE FINE TOOL SHOPS
 P.O. Box 1262
 20 Backus Ave.
 Danbury, Ct. 06810

 Fine and unusual woodworking tools; rasps, vices, chisels, drills, etc.

59. FORMAX MFG. CO.
 3171 Bellevue Ave.
 Detroit, Mich. 48207

 Grease and greaseless buffing compounds for metal and plastic; case quantities; cloth and sisal buffs primarily for large industrial machines.

60. FORREST MFG. CO.
 250-T Delawanna Ave.
 Clifton, N.J. 07014

40-, 60-, 80-, and 100-tooth saws for cutting plastics; also carbide-tipped blades.

61. FOUNDRY SERVICE & SUPPLY CO.
 1505 Greenwood Road
 Baltimore, Maryland 21208

A source for almost any foundry-room equipment and supplies.

62. GENERAL ELECTRIC CO.
 LAMP PRODUCTS
 3135 Easton Tpk.
 Fairfield, Ct. 06430

Manufacturer of incandescent and fluorescent lamps, mercury lamps, large and miniature; special-purpose lamps, such as heat lamps, black light, and others; most lamps ordinarily available in local markets.

63. GEORGIA MARBLE CO.
 2575 Cumberland Pkwy, N.W.
 Atlanta, Georgia 30339

Marble and limestone blocks.

64. GILMOUR MANUFACTURING CO.
 P.O. Box 838
 Somerset, Pa.
 15501–0838

Inexpensive pressure cleaner.

65. GLAS-CRAFT OF CALIFORNIA, INC.
 7225 Woodland Dr.
 Indianapolis, Ind. 46278

Spray equipment for fiberglass and urethane foam.

66. W. W. GRAINGER INC.
 5959 W. Howard St.
 Chicago, Ill. 60648

Wood- and metalworking power tools, hand tools, motors, lighting devices, air compressors, dust collectors, welders, and many other items. Large wholesale outfit that will probably sell to you if you have a state sales licence. (Ask for local distributor.)

67. GRANITE CITY TOOL CO.
 P.O. Box 411
 Barre, Vt. 05641

Wood- and stone-carving tools for pneumatic equipment; hand stone-carving tools, pneumatic tools, air grinders, sanders, sandblasting and fume-collecting equipment.

68. GLIDDEN COATING AND RESIN DIVISION
 925 Euclid Ave. Tower
 Cleveland, Ohio 44115

Manufacturer of Glidden paints; a wide variety of excellent coating materials for interior and exterior use.

69. HARBOR FREIGHT SALVAGE COMPANY
 3491 Mission Oak Blvd.
 P.O. Box 6010
 Camarillo, Calif. 93011–6010

Good source for low prices on air and electric tools, hoists, stationary wood- and metalworking power tools, and small wrenches and hand tools.

70. HARDMAN INC.
 600 Cortlandt St.
 Belleville, N.J. 07109

Relatively inexpensive flexible-mold material; ask about compound 336 or 7153.

71. HI-ALLOY WELD SPECIALTIES, INC.
 DIVISION OF VAN DRESER & HAWKINS, INC.
 Box 916
 Pearland, Tx. 77581

Manufacturer of welding rods for oxyacetylene and arc welding.

72. HOSSFELD MFG. CO.
 IRON BENDER DIVISION
 Third St. and Grand Ave.
 Winona, Minn. 55987

Universal iron bender.

73. HOTPACK CORP.
 10942 Dutton Rd.
 Philadelphia, Pa. 19135

Industrial ovens.

74. HYDREL MFG. CO., INC.
 9415 Telfair Ave.
 Sun Valley, Calif. 91352

Fountain supplies: submersible and dry pit pumps, filters, underwater lighting fixtures, and other fountain controls and components.

75. HYPRESSURE JENNY DIVISION
 HOMESTEAD INDUSTRIES INC.
 11 Johnson St.
 Coraopolis, Pa. 15108

Steam-cleaning equipment.

76. IASCO INDUSTRIAL ART SUPPLY CO.
 5724 West 36th St.
 Minneapolis, Minn. 55416–2594

Polyester, epoxy, polyurethane, acrylic, resins; plastic beads, fiberglass matt, cloth, and shorts; fillers, R-2-like spray gun, many other materials.

77. INDUSTRIAL SAFETY & SECURITY CO.
1390 Neubecht Rd.
Lima, Ohio 45801

Extensive line of safety clothing, goggles, material-handling equipment, etc.

78. INSTA-FOAM PRODUCTS, INC.
1500-T Cedarwood Dr.
Joliet, Ill. 60435

Insta-Foam urethane-foam spray containers.

79. INTERNATIONAL MINERAL & CHEMICAL CORP.
2315 Sanders Rd.
Northbrook, Ill. 60062

Manufacturer of Aristo no-bake binder.

80. JOHNSON GAS APPLIANCE CO.
520 E. Ave., N.W.
Cedar Rapids, Iowa 52400

Gas equipment: crucible furnaces, forge furnaces, safety and temperature controls, atmospheric and forced-air burners, pyrometers, crucible tongs, and shanks.

81. KAMWELD PRODUCTS CO., INC.
92 Access Road
Box 91
Norwood, Mass. 02062

Plastic-welding equipment and supplies.

82. KELLER DIVISION
SALES SERVICE MFG. CO.
2363 University Ave.
St. Paul, Minn. 55114

Manufacturer of power hacksaws.

83. KIM LIGHTING AND MFG. CO.
Box 1275
City of Industry, Calif. 91747

Excellent source for submersible and dry pit pumps, underwater lighting fixtures, filters, orifices, and other fountain components and controls.

84. LASKOWSKI ENTERPRISES INC.
8180 West 10th St.
Indianapolis, Ind. 46224

Reasonably priced three-wheel bandsaw for deep cuts.

85. L & R SPECIALTIES
202 East Mt. Vernon
P.O. Box 309
Nixa, Mo. 65714

Melting furnaces, precast furnace linings and lids, crucibles, asbestos gloves, aprons and leggings, pyrometers, clay tools, and other foundry and sculpture supplies.

86. LUTRON ELECTRONIC CO., INC.
Suter Rd., P.O. Box 205
Coopersburg, Pa. 18036

Manufacturer of Speed Dial: a variable speed adapter for drills, sanders, and tools with universal motors; available in varying capacity.

87. MASTER APPLIANCE CORP.
Box 545
2420 18th St.
Racine, Wis. 53401

Manufacturer of heat guns, air-heater blowers, and flameless heat torches for heating, drying, and welding plastic.

88. MATCHLESS METAL POLISHING CO.
844 W. 49th Pl.
Chicago, Ill. 60609

Buffs and buffing compounds.

89. MERIX CHEMICAL CO.
2234 E. 75th St.
Chicago, Ill. 60649

Antistatic and cleaning solutions; "ANTISTATIC NO. 79," for destaticizing all types of plastic.

90. MERRIT ABRASIVE PRODUCTS, INC.
201 W. Manville
Compton, Calif. 90224

Sand-O-Flex® wheel, all kinds of unusual-shaped sanding drums, discs, and devices for abrasive finishing of contours and hard-to-reach areas.

91. METCO, INC.
1101 Prospect Ave.
Westbury, N.Y. 11590

Metallizing equipment and supplies.

92. MILLER ELECTRIC MFG. CO.
781 Bounds St.
Appleton, Wis. 54911

Good quality A.C. and D.C. electric arc welders.

93. MILLER-STEPHENSON CHEMICAL CO. INC.
George Washington Highway
Danbury, Ct. 06810

Aerosol spray products; plastic cleaners, rust inhibitors, release agents, acrylic, and urethane coatings, etc.

94. MIXING EQUIPMENT CO., INC.
138 Mt. Read Blvd.
Rochester, N.Y. 14603

Manufacturer of heavy-duty portable mixers for mixing materials such as ceramic-shell slurry.

95. MMFG MORRISON MOLDED FIBERGLASS CO.
Box 580
Bristol, Va. 24203-0580

Structural fiberglass shapes such as I beams, tubes, angles, etc.

96. MONSANTO COMPANY
INORGANIC CHEMICAL DIVISION
800 N. Lindberg Blvd.
St. Louis, Mo. 63166

Manufacturer of plastic resins and compounds in industrial quantities; also colloidal silica for ceramic-shell molds; ask for bulletin 1-199 on colloidal silica; product called "Syton® 200-1C."

97. MONTOYA ART STUDIOS
4110 Georgia Ave.
West Palm Beach, Fla. 33405

Sculpture tools and supplies.

98. NALCO CHEMICAL CO.
METAL INDUSTRIES DIVISION
9165 South Harbor Ave.
Chicago, Ill. 60617

Nalcoag® colloidal silica and Nalcast® fused silica for ceramic-shell molds; booklet available on the process; colloidal silica available in 5-gallon containers; fused-silica in 100-lb. bags.

99. NATIONAL SCULPTURE SERVICE
9 East 19th St.
New York, N.Y. 10003

Clay and plaster tools, rasps, stone- and wood-carving tools, sculpture stands, and other supplies.

100. NORTHERN HYDRAULICS
801 East Cliff Rd.
Burnville, Minn. 55337

Hydraulic components, gas engines, air compressors, cutoff saws, variety of hand and stationary tools, small portable welding rigs, sandblasting equipment, and hoists.

101. NORTON COATED ABRASIVE DIVISION
NORTON COMPANY
50 New Bond St.
Worcester, Mass. 01606

Manufacturer of belts, discs, flap wheels, abrasive cut-off wheels, and special shapes.

102. PECK, STOW & WILCOX CO.
Mill St.
Southington, Conn. 06489

Manufacturer of foot-squaring shears, bending brakes, roll-forming machines, steel stakes, and other sheet-metalworking equipment.

103. PEERLESS PUMP DIVISION
FMC CORPORATION
1200 Sycamore St.
Montebello, Calif. 90640

Manufacturer of dry pit pumps for fountains.

104. PERMACEL
U. S. Highway No. 1
New Brunswick, N.J. 08903

Manufacturer of pressure-sensitive tapes.

105. PERMA-FLEX MOLD COMPANY
1919-T Livingston St.
Columbus, Ohio 43209

Good source for flexible materials: Koroseal®, reusable P.V.C. polysulfide mold materials called "Blak-Tufy®," "Blak-Stretchy®," "Gra-Tufy®," and others; polyurethane flexible-mold materials; water- and oil-based clays; fibers for reinforcing plaster molds and release agents; excellent technical bulletins on their products.

106. PETROLITE CORP.
BARECO DIVISION
Drawer K
6910 E. 14th St.
Tulsa, Okla. 74115

Supplier of ceraweld brown wax, Microcrystalline wax, etc. (Order their wax from Premier Wax Co., 3327 Hidden Valley Drive, Little Rock, Arkansas 72212.)

107. PITTSBURGH CORNING CORP.
Dept. T. R.
800 Preque Isle Dr.
Pittsburgh, Pa. 15222

Manufacturer of glass nodules that can be used as a light-weight filler material, Foam Glas® board.

108. PLASTI-VAC, INC.
Box 5543
214 Dalton Ave.
Charlotte, N.C. 28206

Commercial vacuum-forming machines.

109. THE POLYMER CORPORATION
2140 Fairmont Ave.
Reading, Pa. 19603

Manufacturer of plastic mill shapes, rods, tubes, etc., in nylon, acetal, fluorocarbon, polycarbonate, and acrylic; powder-coating materials and custom powder-coating service. Facility for coating parts up to 10 feet long and 3 feet in diameter, weighing up to 2000 pounds.

110. POLYPRODUCTS CORPORATION
28510-T Hayes Ave.
P.O. Box 42
Roseville, Mich. 48066

A good source for student quantities of resins, additives, fiberglass, pigments, fillers, metal powders, and mold materials; write for *Polyproducts General Material Information* and *Polyproducts Project Guide* (cost: $2.00).

111. POTTER INDUSTRIES INC.
377-T State Highway 17
Hasbrouck Heights, N.J. 07604

Manufacturer of glass spheres that can be used as a filler material.

112. POWERMATIC DIVISION
HOUDAILLE INDUSTRIES, INC.
Morrison Rd.
McMinnville, Tenn. 37110

Manufacturer of excellent-quality woodworking and metal-working machines, drill presses, scroll saws, jointers, table saws, bandsaws, shapers, lathes, and planers.

113. P.S.H. INDUSTRIES, INC.
5346 East Ave.
Countryside, Ill. 60525

R-2 plaster and plastic spray gun, flocking gun, mixing containers, mixers, hand cleaners, mixing blades, and other plaster and plastic supplies.

114. PULMOSAN SAFETY EQUIPMENT CORP.
30-46 Linden Place
Flushing, N.Y. 11354

Manufacturer of goggles, face shields, respirators, asbestos gloves and clothing, welding helmets, and other safety equipment.

115. QUAKER OATS COMPANY
CHEMICAL DIVISION
Merchandise Mart
Chicago, Ill. 60654

Producers of industrial chemicals, Furan no-bake binders.

116. RAM CHEMICALS DIVISION
WHITTAKER CHEMICAL CORP.
P.O. Box 192
210 E. Alondra Blvd.
Gardena, Calif. 90248

Suppliers of accelerators, adhesives, fiberglass materials, fillers, gel coatings, moldmaking products, polyester resins, release agents, solvents and thinners, clear resin colors for casting, pigment dispersions, coatings, and wide variety of other products.

117. RANSBURG ELECTRO-COATING CORP.
3939 W. 56th St.
Indianapolis, Ind. 46208

Manufacturer of electrostatic spray guns and necessary components.

118. THE RANSON & RANDOLPH CO.
324 Chestnut St.
Toledo, Ohio 43691

Ceramic-shell and other investment materials.

119. REICHOLD CHEMICALS, INC.
120 N. Broadway
White Plains, N.Y. 10602

Epoxy, urethane, and polyester resins, clear-cast resins in industrial quantities.

120. REMINGTON ARMS CO. INC.
Abrasive Products Sales
Bridgeport, Ct. 06602

Carbide edged jig-saw, hacksaw, and band-saw blades for metal, ceramic, glass, etc. Rod-saw blade for short radius cuts.

121. REYNOLDS METALS
6601 Broad St.
Richmond, Va. 23261

Manufacturers of aluminum sheet, building panels, expanded metals, and mill shapes.

122. ROGERS COLLEGE FOUNDATION
Claremore, Ok. 74017

KellStone and KellGlaze.

123. ROHM AND HASS
Independence Mall West
Philadelphia, Pa. 19105

Producers of acrylic, alkyds, melamine, phenolic, polyester, and urea resins and compounds in industrial quantities.

124. RUEMLIN MFG. CO.
3860 N. Palmer St.
Milwaukee, Wis. 53212

Fume-removal and sandblasting equipment.

125. SCHAFFNER MFG. CO., INC.
21 Schaffner Center
Pittsburgh, Pa. 15202

Buffing compounds and coated abrasives.

126. SCULPTORS SUPPLIES LTD.
99 East 19th St.
New York, N.Y. 10003

Clay and plaster tools, rasps, carving tools, sculpture stands, and other supplies.

127. SCULPTURE ASSOCIATES LTD. INC.
40 East 19th St.
New York, N.Y. 10003

All kinds of sculpture supplies.

128. SCULPTURE HOUSE
38-T East 30th St.
New York, N.Y. 10016

Clay and plaster tools, wood- and stone-carving tools, domestic and imported woods, kilns, clays, casting compounds, rasps, rifflers, sculpture stands, and other supplies.

129. SELECTRONS LTD.
137-T Mattatuck Heights Rd.
Captain Neville Dr.
Industrial Park
Waterbury, Ct. 06705

Brush-plating equipment, solutions, and supplies.

130. S. G. METAL INDUSTRIES, INC.
P.O. Box 2039
Kansas City, Kas. 66118

Aluminum and copper alloys in small or large quantities for casting.

131. SHELLSPEN
P.O. Box 113
Sarasota, Fl. 33578

Ceramic-shell slurry that does not require continuous mixing.

132. THE SHERWIN WILLIAMS CO.
101 Prospect Ave.
Cleveland, Ohio 44101

Manufacturer of acrylic enamels and other coatings and materials. Dual-Etch metal preparation primer.

133. SKIL CORPORATION
4801 W. Peterson Ave.
Chicago, Ill. 60646

Manufacturer of portable power tools for wood and metal.

134. SMITH GRANITE CO.
Westerly
Rhode Island 02891

Granite.

135. SMITH WELDING EQUIPMENT DIV.
TESCOM CORPORATION
12618 Industrial Blvd.
Elk River, Minn. 55330

Manufacturer of excellent-quality oxyacetylene welding equipment.

136. SMOOTH-ON, INC.
1000 Valley Road
Gillette, N.J. 07933

P.V.A. and other release agents, flexible urethane-mold material, and epoxy casting compounds.

137. SPECIAL ASBESTOS CO.
3628 W. Pierce St.
Milwaukee, Wisc. 53215

Asbestos fibers ⅛ to ¼ inch long.

138. SPRAY PLATING SYSTEMS, INC.
Box 6468
Greensboro, N.C. 27405

Equipment for spray application of silver or copper plating.

139. STANLEY POWER TOOLS
DIVISION OF THE STANLEY WORKS
77 Lake St.
New Britain, Conn. 06050

Manufacturer of hand and power tools for woodworking.

140. STEEL GRIP SAFETY APPAREL CO., INC.
700 Garfield
Danville, Ill. 61832

Asbestos and leather protective clothing.

141. SWEST INC.
10803 Composite Dr.
Dallas, Tex. 75220

Good assortment of buffs, buffing compounds, plaster-investment material, wax sprue, and vent material, Foredom flexible-shaft machines, small grinding burrs and wheels, metalworking tools and stakes, and many other tools and materials.

142. THEIM CORPORATION
121 Crescent St.
P.O. Box 6
Oak Creek, Wisc. 53154

Oil- and water-based no-bake binders for sand molds.

143. TWINROCKERS
R.F.D.
Brookstone, Ind. 47921

Rag-content paper pulps.

144. THERMATRON
DIVISION OF WILLCOX & GIBBS, INC.
1440 Broadway
New York, N.Y. 10036

Industrial heat-sealing equipment.

145. 3M COMPANY
3M Center
St. Paul, Minn. 55101

Manufacturer of a wide variety of industrial adhesives, coatings, tapes, abrasive belts, discs, and special abrasive shapes, nylon-web abrasive wheels, flap wheels, and many other materials.

146. TOOLS UNLIMITED
P.O. Box 5757
Toledo, Ohio 43613–0757

Discount prices on a wide variety of wood- and metalworking tools, wrenches, hoists, cranes, air tools, pressure-water cleaners, etc.

147. UNION CARBIDE CORP.
LINDE DIVISION
Old Ridgebury Rd.
Sctn. C-2
Danbury, Ct. 06817

Manufacturer of oxyacetylene and arc-welding equipment of all kinds; also thermal torch for stone cutting.

148. U.S. GENERAL
 100 Commercial St.
 Plainview, N.Y. 11803

Wide variety of tools at discount prices similar to Tools Unlimited.

149. U.S. GYPSUM COMPANY
 101 S. Walker Dr.
 Chicago, Ill. 60606

Manufacturer of molding plasters, HYDROSTONE® and HYDROCAL®, plaster-investment materials; excellent technical bulletins available on all its materials.

150. UNITED STATES PLASTIC CORP.
 1890 Neubrecht Rd.
 Lima, Ohio 45801

Plastic containers, pipes, fittings, valves, and many other plastic products.

151. UNITED STATES STEEL CORP.
 600 Grant St.
 Pittsburgh, Pa. 15230

Manufacturer of steel materials, hot- and cold-rolled steel, many alloys for special applications, stainless steel, copper-alloyed steel called "Cor-Ten®"; materials in many forms, such as sheet, bar, strap, tube, I beams, angles, etc.

152. VERMONT MARBLE CO.
 61-T Main St.
 Proctor, Vt. 05765

Marble.

153. B. E. WALLACE PRODUCTS CORP.
 P.O. Box 70
 Exton, Pa. 19341

A-frame gantries and hoists.

154. WESTERN RESERVE LABORATORIES, INC.
 Box 18789
 Cleveland Heights, Ohio 44118

Producers of Manganesed Phospholene No. 7, a room-temperature, water-based liquid that can be brushed or sprayed onto steel, aluminum or zinc for a phosphatized primer surface; also serves as a temporary corrosion inhibitor; ask for technical manual on its uses.

155. WETZLER CLAMP CO., INC.
 43–15 11th St.
 Long Island City, N.Y. 11101

Manufacturer of a wide variety of clamps.

156. EDWIN L. WIEGAND DIVISION
 EMERSON ELECTRIC CO.
 800 W. Floissant Ave.
 St. Louis, Mo. 63136

Chromolox electric-heating elements, a wide variety of strip heaters, immersion and wrap-around; hot plates, melting pots, infrared units for ovens, thermostatic controls for electric ovens.

157. WILSON PRODUCTS DIVISION
 ESB INCORPORATED
 Box 622
 Reading, Pa. 19603

Manufacturer of safety equipment, goggles, welding helmets, respirators, sandblasting hoods and sound-barrier ear muffs.

158. WOLVERINE FOUNDRY SUPPLY CO.
 14325 Wyoming Ave.
 Detroit, Mich. 48238

Aristo no-bake binder called "W-10" and additive; silica sand for molds, mold and core wash, and other foundry supplies.

159. WOOD CARVERS SUPPLY CO.
 3056 Excelsior Blvd.
 Minneapolis, Minn. 55416

Wood-carving tools, mallets, sharpening stones, hand saws, vises, Sand-O-Flex® wheels, flap wheels, other supplies.

160. THE WYCO TOOL CO.
 4601-T W. Addison St.
 Chicago, Ill. 60641

Flexible-shaft machines, concrete vibrators.

Index

Wilbert Verhelst has 35 years experience as a sculptor and a teacher of sculpture. He spent 23 of these years at Southern Methodist University, where he was a professor and the director of the Division of Fine Arts. In his courses, he emphasized variety and encouraged his students to experiment with different forms and materials. His own sculpture reflects his interest in experimentation, and he has produced works in wood, metal, plastics, and cast materials. Between 1956 and 1974, he executed 20 major commissions for churches and commercial, public, and private buildings. During this period he also exhibited his work and created pieces for private individuals. Currently he is retired from teaching and works full-time as a sculptor.